The Dancer Within

The Dancer Within

INTIMATE CONVERSATIONS WITH GREAT DANCERS

PHOTOGRAPHS AND TEXT BY Rose Eichenbaum

EDITED BY ARON HIRT-MANHEIMER

Wesleyan University Press *Middletown, Connecticut*

Published by Wesleyan University Press,

Middletown, CT 06459

www.wesleyan.edu/wespress

Photos and text copyright © 2008 by Rose Eichenbaum

All rights reserved

Printed in China

5 4 3 2 1

Library of Congress Cataloging-in-Publication Data

Eichenbaum, Rose.

The dancer within : intimate conversations with great

dancers / photographs and text by Rose Eichenbaum ;

edited by Aron Hirt-Manheimer.

 p. cm.

Includes bibliographical references and index.

ISBN-13: 978–0–8195–6880–9 (cloth : alk. paper)

ISBN-10: 0–8195–6880–5 (cloth : alk. paper)

1. Dancers—United States—Interviews.

2. Dancers—United States—Portraits.

I. Hirt-Manheimer, Aron, 1948– II. Title.

GV1785.A1E52 2008

792.802'80922—dc22 2008001416

In memory
of Rose Gold,
my first dance teacher,
who awakened the
dancer within me.

Contents

Audacity sometimes springs from purity of purpose, and the result can be stunning. *The Dancer Within*, like Rose's earlier study of the art form, *Masters of Movement*, owes its existence to her quest to reawaken the long-slumbering dancer within herself.

Rose found her calling in dance as a teenager after reading Isadora Duncan's autobiography *My Life*. In the early 1970s, Rose studied dance at the Reuben Academy in Jerusalem and later earned a master's degree in dance ethnology at UCLA. Marriage and motherhood followed, thwarting her ambitions. Thirty years of teaching dance did little to quell her quiet longing for performance—the real thing. But at forty-four, an age when most dancers are hanging up their dance shoes, could Rose enter that lost world?

Her portal was the lens of a camera. Rose discovered her talent for photography as a young mother seeking to record the stages of her children's lives. She would later study with Leigh Weiner, one of the original *Life* magazine photographers, with master teacher Bobbi Lane, and others. In 1987 she published her first photos in the award-winning children's book, *The Number on My Grandfather's Arm.* Her debut dance photograph appeared in a 1995 edition of *L.A. Dance and Fitness*, a magazine aimed at dancers looking for commercial work on the West Coast. Five years later her photos were appearing on the covers of leading national dance magazines.

As a practical matter, Rose learned that she could get more of her photos published if they illustrated articles, and so began her writing career, which included a column in *Dance* magazine called "Faces in Dance." The stage was now set for her first major work, *Masters of Movement*, a six-year project she initiated in 1998 comprising interviews and photographic portraits of America's great choreographers. Her goal was to discover the creative thread that defines and drives these artists. With camera in hand, she talked her way into the studios, hotel rooms, and homes of many of the most celebrated figures in the world of dance—from the concert stage and Broadway to Hollywood and television. And she did so with a single-minded determination that prompted choreographer Paul Taylor to remark upon finally consenting to a photo session:

"You are the most persistent person I've ever met!" That same persistence was at work in the creation of *The Dancer Within*.

With few exceptions, Rose's subjects immediately took her, a stranger, into their confidence, many of them entrusting to her stories of a confessional nature about both their personal and professional lives. In Rose's presence many of these guarded celebrities shed their armor and masks, revealing their vulnerabilities to one they perceived as their own—a once-aspiring dancer turned photographer/writer but an artist no less. Rose's interviews reflected her own passion for the dancer's life, and her thoroughly researched questions demonstrated a level of preparation that endowed her with instant credibility and trustworthiness. Add to that her engaging personality and the rest fell into place.

Once Rose completed her exploration of the choreographer in *Masters of Movement*, she turned her attention to the dancer, the instrument of the choreographer's creative expression. Here again Rose engaged the artists on many levels, challenging them to bear witness to their own lives as dancers and to pass along their insights to new generations of aspiring dancers.

What does *The Dancer Within* mean to Rose at this point in her quest to revive the dancer within herself?

Rose says: "This book is my dance, my choreography, my homage to dancers."

How do I know so much about Rose Eichenbaum? Not only have I been her editor and artistic collaborator for many years, I am her brother.

Aron Hirt-Manheimer
Ridgefield, Connecticut
August 2007

Acknowledgments

Leonard Crofoot said it so well: "Artists who are lucky enough to be taken care of have the ability to focus on their art without fear for their personal and professional survival." I am one of those lucky ones. To my husband, Betzalel (Bitzy) who has for more than thirty years helped finance my personal work, encouraged and inspired me to go on when I hit road-blocks and detours, and picked up the slack when traveling kept me away from home for long periods, I am eternally grateful.

Everyone should have a mother like mine: Adela Manheimer. Ma serves up unconditional love and support with a steady supply of chicken soup with matzoh balls.

I am most indebted to my editor, creative collaborator, and big brother, Aron—who still takes hold of my hand before we cross the street. Working with a master editor has brought great joy to a process that might otherwise have been a solitary literary journey.

A very special thanks as well to Editor-in-Chief Suzanna Tamminen and her staff at Wesleyan University Press for embracing this work, for making dance a priority, and for bringing to the table an admirable knowledge and respect for the subject.

To all of the dancers who contributed to *The Dancer Within*, I am especially grateful. Their willingness to pose for my lens and share their personal stories is testament to their passion for the art form.

Many others have supported me in completing this work: Russell Adams of Schulman's Photo Lab; Lori Belilove of The Isadora Duncan Dance Foundation; Maria Bujones; Business Machines Consultants, Inc.; Connie Chin of Jacob's Pillow Dance Festival; Lisa Zeno-Churgin; Pamela Cooper, Rachel Cooper of The Asia Society; Christine Dobush; Janet Elber of the Martha Graham Dance Company; Mitzi Gaynor of the Professional Dancers Society; Judy Hirt-Manheimer of the Enchanted Garden Conservatory of the Arts; Judy Kitzman of the Pacific Northwest Ballet, Dena Makarova; Julie McDonald of McDonald/ Selznick Associates; Karen Nelson of UCLA Live!; Caroline Newman of Smithsonian Books, Dale Olson; my agent Lynne Rabinoff, Elka Samuels Smith of Divine Rhythm Productions, and Renae Williams of the Dorothy Chandler Pavilion.

The Dancer Within

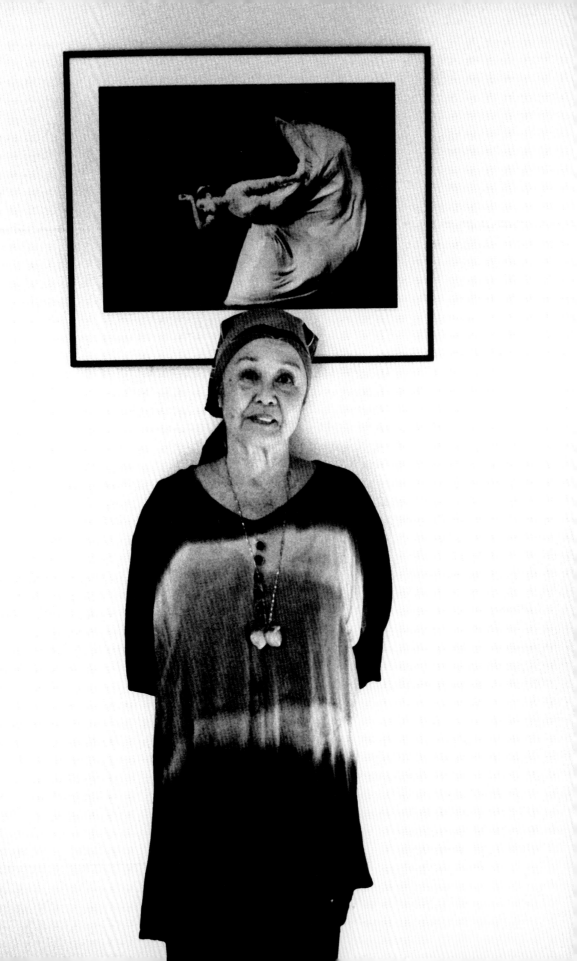

Yuriko (Anemiya Kikuchi)

"Come in," Yuriko said, opening her front door partway to prevent her cat from escaping. I slid through the narrow space, blocking the door's entrance with my foot. "Please make yourself comfortable. I'm not quite finished dressing. I'll be right out."

I put my camera bag down on a low bench and began to survey Yuriko's living room. An assortment of Japanese masks, miniature figurines, and geisha dolls populated shelves and cases, lining the walls. The furniture consisted of one blue upholstered chair flanked by several floor cushions with back supports, like the kind you take to the beach. On the wall behind the blue chair hung Barbara Morgan's famous photograph of Martha Graham known as "The Kick." I was admiring a beautiful hand-sewn kimono displayed on another wall when Yuriko walked into the room.

"You have some lovely things."

"Many of those dolls belonged to my mother. They are over a hundred years old. Come, please sit," she said gesturing me toward the blue chair. "I prefer to sit on the floor."

"Yuriko, when did you first know that you'd become a dancer?"

"I knew it from my very first dance step. I was six years old. I was young but I knew. I've had a most interesting life. I was born in San Jose, California, in 1920, but was sent to live with relatives in Japan when I was three. My mother thought she could save me from the influenza that had killed two of my sisters and my father. I returned to California when I was six, and it was around that time that my mother decided that I should become an artist. She started me in music, then dance, and finally painting. But dance was the thing I enjoyed most. I went back to Japan again when I was nine, and was left in the care of the great dancer, Konami Ishi."

"Was she responsible for your early training?"

"Yes, she taught me rhythm and movement based on Dalcroze's Eurythmics, which was very popular at the time. I remember walking in circles with corresponding arm movements and patterns. So from a very early age I understood the relationship of rhythm to movement. By the age of ten, I was performing in Konami's dance recitals and in her tours of the Orient. Konami was very influenced by what they called 'European

Dance'—a sort of ballet without shoes in the style of Mary Wigman and Harald Kreutzberg. After graduating from high school I returned to California and studied with Dorothy Lyndell in Los Angeles. She taught ballet and modern dance and was the first to encourage me to choreograph."

"Sounds like your dance life was preordained."

"From as far back as I can remember my life was directed towards the dance. Invitations and opportunities to dance just presented themselves. I didn't have to plan anything. I never dreamed of becoming famous. I only wanted to be a really good dancer.

"But my plans were interrupted when World War II broke out. The Japanese Americans were rounded up and put into relocation camps. We really didn't know what would become of us. I was one of ten thousand to be taken to Gila River Relocation Camp in Arizona. Forced into trains, we were treated like prisoners and hidden from the public behind drawn curtains. As we passed communities, no one on the outside really saw what was happening.

"It was 110 degrees when we arrived at the camp. Each one of us was handed an army cot and blanket and then assigned to a barrack. I remember rows after rows of barracks separated only by toilets and laundry rooms. And the spiders . . . there were tarantulas and scorpions everywhere."

"Did you want to rebel or run away?"

"Rebel?" she shouted. "How can you rebel? We understood that this could not be helped. Our Japanese sensibility accepted that there was nothing one could do. You just took it."

"What became of your dancing?"

"Here in this barren part of Arizona the children had nothing to do. I thought maybe I could contribute something so I asked the authorities if I could teach dance to the children. They said yes and allowed me to turn one of the barracks into a dance studio, complete with ballet *barre*. Despite our imprisonment, we lived in a functioning community. Professionals like doctors and teachers got paid for their work. My salary was nineteen dollars a month. I had about a hundred students, only girls and some of the mothers. We gave performances and made our own costumes out of crepe paper and tablecloths. We even danced the *Nutcracker Suite*."

"How long were you confined in Gila Relocation Camp?"

"I was there for a year and a half and then the East Coast opened up and some of us evacuees were allowed to resettle. In order to leave the camp one had to be given clearance from the Army and Navy Intelligence, as well as the FBI. Sponsorship by another person was required. I was one

of the first to leave, but the camps would stay open for another three, maybe four years. When I applied for resettlement I asked to go to Detroit because I had a girlfriend there, but Clara Clayman, one of the camp's administrators advised me to go to New York City. She said, 'If you want to be a dancer, you have to go to New York. That's the center of dance.' So I changed course. Clara agreed to sponsor me and arranged a job for me working as a seamstress. The authorities gave me fifty dollars and I saved fifty dollars from teaching. And so with a hundred dollars and my one suitcase, I arrived at the Phoenix train station. I was just about to cross the street to buy my ticket when I noticed the light signal." Yuriko paused. "It flashed red . . . turned green . . . then red . . . green. . . . I stood there for I don't know how long, mesmerized by the flashing colored lights, and then it hit me: I'm outside! I'm free," she said in a whisper, her eyes wide. "I'm free! The red and green flashing lights symbolized my freedom and my future. I was completely overcome with emotion."

"When did you arrive in New York City?"

"I arrived in New York City on September 23, 1943."

"You remember the exact date?"

"Oh, yes. Oh, yes. I will never forget that date. I found a rooming house on Sixth Avenue between 55th and 56th Streets near the shop where I was to work as a seamstress. About a month later, I borrowed a phone book and looked up the studio addresses of Doris Humphrey, Hanya Holm, and Martha Graham. I had seen them perform in Los Angeles before I was sent away. I loved their work but wasn't sure which of their techniques would be best for me. I planned to visit each of their studios. So, one day after work, I took the Fifth Avenue bus to 14th Street. Standing on the street corner I looked at my list of addresses and saw that I was closest to Martha's studio on 15th Street, so I went there first. Hanya was on 10th Street and Doris's was on 16th Street. I went up in the elevator to the ——— floor and saw a glass door with a sign that read: MARTHA GRAHAM DANCE STUDIO. I knocked and a lady dressed all in black opened the door.

"'I'm Martha Graham, please come in,' she said. I didn't expect to meet Martha; I was just coming to get her class schedule. 'Where did you come from?' she asked. I told her that I'd just been released from a Japanese-American relocation camp in Arizona. 'Have you ever danced before?' she asked. 'Yes,' I replied. 'Here, I have a leotard. Why don't you put it on so I can see how you move.' 'Oh no. I can't do that,' I said. 'I'm not in condition.' 'But I just want to see you move,' she said. 'No, no,' I persisted. 'All right, I'm teaching tomorrow, come to one of my classes.' 'Oh, no, no,' I cried. 'I can't do that. I do not know your technique. To take from the

master, I must know the technique. This you know, is the Japanese way.' Martha couldn't understand. She said, 'But everyone comes and takes my class!' 'You'll have to send me to your company members or students so that I can learn your technique first,' I insisted. Finally she gave up trying to get me to dance and arranged for me to study with Sophie Maslow and Jane Dudley. But before I left, she said to me, 'Yuriko, if you're good, you will be accepted.' I never made it to Hanya's or Doris's studios."

"Another stroke of fate?"

"Yes, Rose. I left Martha's studio that evening and walked all the way home, from 15th all the way to 56th Street and cried every step of the way. That first meeting with Martha reminded me of those flashing red and green lights at the train station in Phoenix. I saw freedom in Martha, my rescuer. Her simple words, 'If you're good, you will be accepted,' hit me deeply in my soul. For me it meant survival. Here I was having just come out of camp, I'd barely had a family, never really knew my mother, and had everything I owned taken from me. I was not accepted as an American, or even as a person, for that matter. Martha's words filled me with hope and encouragement. What a wonderful gift. To this day I owe her everything. I owe Martha everything!"

"So Sophie and Jane began training you?"

"Yes, I started working with them in October, and that February Martha phoned me and offered me a scholarship, and she still hadn't seen me dance. Sophie and Jane immediately put me in their advanced class and told Martha all about me."

"Do you remember your first class with Martha?"

"I'll never forget it. I came in and took a place in the back of the room. Louis Horst was playing the piano. Martha stood at the front of the room and demonstrated a contraction." Yuriko now sat up, her eyes shining. "As Martha's torso hollowed I thought to myself, that's what I want in my body. Here was drama. Here was creativity. I had to find out where it comes from. In time, I understood that the contraction comes from the breath, and that its shape originates from a deep source within the body. This source extends to all the extremities in the physical body. Take for example, Martha's famous cupped hand," she said, demonstrating. "This is not a position or a shape. It comes from here," she said, pointing to her solar plexus and then drawing her finger up the chest, through the armpit, down her arm to the center of her hand. "The body's center is like the roots of a tree that sends nourishment out to all its branches. A contraction vibrates through the body and ends right here," she said, pressing her index finger into the center of her cupped

hand. "It's alive. A shape is not alive. To achieve this, you have to steal it," she said, looking me in the eye.

"Steal it?"

"Yes. I stole so many things from Martha. I stole everything."

"Wasn't she giving it, offering it to you?"

"Oh, yes, I'm sure that she was. But . . . I stayed with her for twenty-five years and took from her whatever I could take. When she opened her door on that first day, she opened my dancer's door and I walked all the way through."

"How did you come to dance in her company?"

"After I was in her class for one week, she called me into her dressing room and said, 'Yuriko, I've never said this to anyone. You are a born dancer. But if my technique doesn't agree with you, then you should go somewhere else.' I told her that I loved her technique, and that's when she asked me if I wanted to learn her repertory. I didn't know that she was planning her first New York season in May of 1944, and that my sessions with John Butler, Jane, and Sophie were leading up to a big performance. I thought it was just repertory class. The first pieces I danced in were *American Document* and *Primitive Mysteries*."

"After twenty-five years working with Martha, I imagine the two of you were very close."

"Yes, we were close. Martha gave me this," she said, holding up a jade pendant that hung from her neck on a long chain. "It's in the shape of two adjoining plums. This is one of my most cherished possessions. We were very close, Martha and I, but at times she was very envious of me because I had a husband and children. I felt as a woman it was important to have a family. Now I'm a grandmother. These are my grandchildren," she said, pointing to a formation of framed photographs on a small table. "Martha gave birth to all her dances. Those were her children. But towards the end of her life she was drinking heavily and would call me after midnight and wake me up. Eventually I put the telephone on my husband's side of the bed. One night she called and my husband answered. She complained to him about her life. 'Oh, I envy Yuriko so much,' she told him. 'She has you and the children, a house and a career. And I have nothing.' She thought compared to me she had nothing."

"Everyone knows that Martha chose her work over everything else."

"Yes, she did, but she was still envious of those who aspired to have more. I had both, a family and career. But I'm not a genius. It doesn't take a genius to figure out that wanting a family is a normal human desire. I never saw myself as such a big shot that I had to sacrifice the most basic

things in life. To some people it's more important to change the world and become famous. I never looked for fame, only to be a better dancer."

"Do you still dance?"

"No, I'm long retired, but I teach class at the Graham school and coach the dancers. I try to give them the source of Martha's work, the concept, not the shape. When Martha choreographed, she didn't choreograph for shape—even though her shapes are very interesting. Her movement was very organic and the concepts for all her pieces were very human, including the abstract pieces, like *Dark Meadow*. This one was very mysterious, very beautiful. It was very deep in a religious sense with elements of ritual and sacrifice."

"Martha's choreography grew out of her own life experience—very different from your own. What did you get out of it?"

"I got out of it the experience of going on a journey—the human journey. All her work came from the center of her being. That's why I referred to her dances as her children. She birthed them. To give birth is a human experience. When she choreographed *Deep Song* [1937], for example, she was expressing profound grief over the horrors of the Spanish civil war, in the same way that Picasso was, when he painted his *Guernica*. Martha choreographed steps, but beneath those steps we see devastation, homelessness, and exile. Recently while rehearsing *Deep Song* with the Martha Graham Dance Company, I thought to myself—this dance is contemporary! Look at what's happening in our world, in our century. We have had such devastation with the tsunami in Asia, Hurricane Katrina in New Orleans, and the earthquake in Afghanistan. Even though Martha's work was choreographed decades ago about the human condition of her time, it works for our time . . . it's still relevant. But . . . if dancers just do the choreography by representing shapes on the stage, it won't speak, it won't have relevance."

"Do today's dancers understand this?"

"I'm afraid most don't. They must be told. Dancers, listen up! You have bodies to express emotions and experiences. After Hurricane Katrina we watched the people of New Orleans on television—the death and destruction, the hungry and the homeless. People had to stand in long lines just to get a bottle of water. It's degrading. 'Can you help me? Help me?'" Yuriko pretended to be one of the homeless and demonstrated how the body could be used to illustrate real human suffering with facial expressions, body spirals, and contractions. "We all have imaginations, don't we? Use it to express life! I'm talking about body language. That's Dance!"

New York, 2005

Barrie Chase

Barrie Chase became an overnight sensation after dancing with Fred Astaire on his 1958 Emmy Award–winning TV special. She was twenty-four; he was fifty-nine. Now in her early seventies, she lives in the beach community of Venice, California.

"Hello," I called from behind a locked gate on the side of her house.

"Yes, Rose, I'll let you in. Let me find the key." Moments later Barrie appeared—a tall, slim woman with the look of a former showgirl. I followed her into a two-story, modernized beach house with countertops of black marble, cut flowers in streamlined vases, ultramodern fixtures, and contoured furniture.

"Since it's such a beautiful day, Barrie, perhaps I could photograph you dancing on the beach."

"Yes, we can do that. Why don't I go and change." She returned a few minutes later carrying a couple of beach towels.

After we parked our things on the sand, I asked Barrie to use the shore as her stage.

"Hmmm, what can I do?" she asked herself.

Soon she was in motion: a Jack Cole run, a Fosse-style *passé*, a *chaîne* turn, a *grand battement*. I planted myself in the sand, waiting to catch the top of her kick, the spiral of her back, the pause in her balance pose. I marveled at how easily the dancer within revealed itself.

"Ooh, this feels good," she said slightly out of breath. "Am I giving you what you need?"

"Oh, yes, this is perfect. I think I have some great shots."

"Good. Let's go back and have a drink."

"Great idea."

Back at the house, while I retrieved my notes and tape recorder from my bag, Barrie poured us some wine, and set out a round of cheese and a bowl of peanuts.

"When did you have the first inclination to dance?"

"I don't remember when I *didn't* have the inclination to dance. It goes back as far as I can remember. Music has always been my impetus for dance. My mother was a concert pianist. As a child I would sit under the

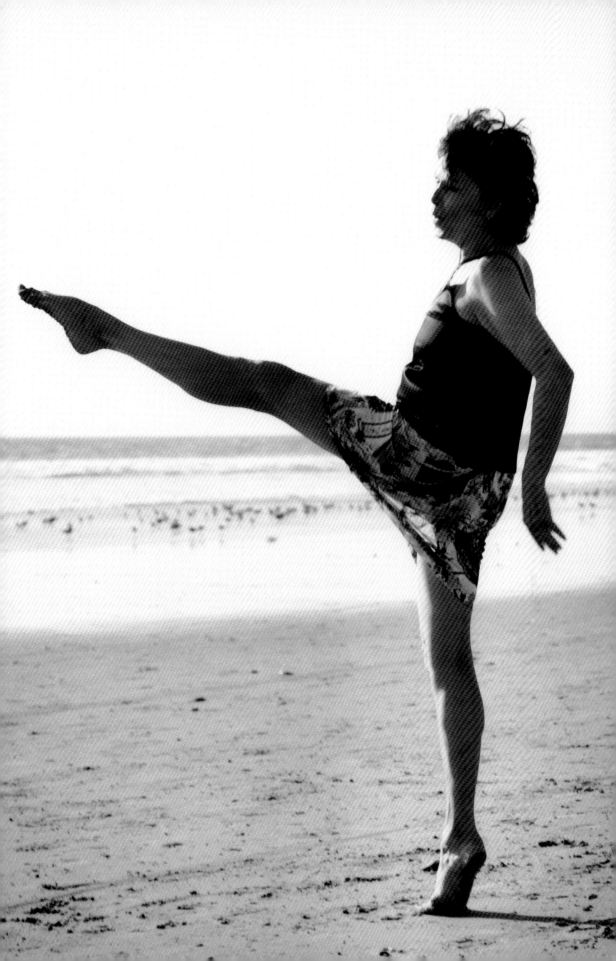

piano for hours listening to her play. She loved both classical and popular music, so I was exposed to all kinds of music."

"When did you begin formal dance lessons?"

"I was three when my mother took me to study with the ballet mistress for the New York City Opera. I studied with her in Great Neck until I was six and a half, and then we moved to California. My father insisted that I study with a serious teacher, so I was enrolled in classes with the former Ballet Russes dancer, Adolph Bolm. I studied with him from the age of nine to fifteen. After he died in 1951, I began taking classes with Maria Bekefi, a Kirov-trained Russian ballerina. I became devoted to her and never studied with anyone else after that."

"You didn't want to learn jazz or tap?"

"No. I dreamed of becoming a ballerina and performing with the New York City Ballet."

"So what happened?"

"Well, my parents had a very ugly divorce when I was fifteen. My father was very powerful in the movie industry and managed to pretty much shaft my mother financially. This happened around the time that I was planning to go to New York to audition for George Balanchine. My mother was in such a bad psychological state, I just couldn't leave her."

"And your ballet dream?"

"Well, I remained committed to my dream and even more serious about my training. My mother allowed me to drop out of school and take ballet class every day, all day, except for Sundays. Later, when I wanted to move to New York to pursue my ballet career, she refused to leave Los Angeles. And I couldn't get myself to go without her. Meanwhile, money was getting tight and I had to find a job."

"That's when you broke into the movies?"

"Yes, at that time what you did was join the Screen Extras' Guild. Central casting would call you for an audition or a job. Usually that meant you'd get called to be in the background of a movie. I hated it. I wanted to be dancing. Finally I said to my mother, 'If they don't give me a dance call, then they can expel me from the union. I don't care. I'm a dancer, not an extra.' It just so happened that our neighbor was the union liaison for Columbia Studios. My mother asked him to intervene and suddenly I started getting small dance parts in the chorus of feature films."

"What happened next?"

"One of Jack Cole's dancers saw me dance and arranged for an audition with Jack at MGM. He liked me and gave me a job in the chorus of the film

Kismet. Eventually I became one of his five regular dancers—four boys and me. I danced in *Designing Woman, Delores Grey,* and *Les Girls.*"

"Is it true that Jack Cole was tough on everyone?"

"Yes. Jack Cole was sadistic. He'd start rehearsals at 9:00 A.M. and not break for hours. He worked you until you collapsed. I'd be so exhausted I couldn't get up off the floor. I'd be lying there heaving, gasping for air. He'd tell you what he wanted, but make you figure out how to do it yourself. And he insisted that we rehearse wearing close to nothing. If it were legal to be naked, we would've been naked. He wanted to be able to see the lines of the body. We couldn't even wear a T-shirt. I usually wore a simple bandanna tied around my top and short shorts."

"Would you say that in working with him you made a big shift from classical ballet to jazz?"

"I didn't really think of it in terms of making a shift. Jack Cole gave me a movement vocabulary to express how the music made me feel. I had it in me—in my gut—to move that way. You either have a feeling for jazz or you don't. No amount of technique class will give it to you. You have to be able to groove inherently."

"When did you meet Fred Astaire?"

"Fred Astaire was working on the film *Silk Stockings* with Cyd Charisse in an adjacent soundstage at MGM. We were rehearsing some number and Fred kept sticking his head in, no doubt attracted by the sound of the drums. Jack liked to rehearse with a drummer as well as a pianist. Then one day I saw Fred talking to Jack. Later Jack came over to me and said, 'Fred wants you to do a number in *Silk Stockings.* What do you say?' 'Sure,' I told him. So Jack loaned me out for a solo in the film, and less than a year later Fred invited me to dance on his first TV special."

"What was it like working with two of the greatest dance artists of that era?"

"Jack, Fred, and I became very close friends. We used to go out drinking together at this little joint near central casting. But Jack always drank too much. It would be his undoing. He was a terribly frustrated man because for all his brilliance, his work never showed up on the screen like it was in rehearsal—never. The cameraman didn't shoot it right or the editor didn't cut it right, and it ate Jack up inside. Instead of fighting with the producer, director, or editor, he would just drink."

"How did you end up dancing on Fred Astaire's TV special?"

"One night when we were out for drinks, Fred asked me if I was serious about dance. I thought, what a hilarious question. Here I was killing myself with Jack Cole, enduring his physical torture. I'd have to

be crazy if I weren't serious about dance. Then he said, 'I think I'm going to do a television show for NBC. Would you like to do it?' 'Sure,' I told him. I had no idea that he meant for me to be his partner. At that time I hadn't danced for about a year. I was feeling like I'd never break out of the chorus. I was preparing to give it all up for an acting career. Fred told me to meet him at a studio where he and Hermes Pan were working on the choreography for the show. I arrived thinking that I was there to assist. I remember being totally shocked when during one of the numbers it hit me—I'm not here to assist. He means for me to be his partner."

"What does it feel like to dance with Fred Astaire?"

"It spoils you, Rose. I can tell you that. Fred was a perfectionist. If something was wrong with the choreography, he'd figure out a way to make it right. One time we were having trouble with a step and the next morning he came in and said, 'I think I have it figured out. I got up last night and I worked it out.' 'Wait a minute,' I said. 'You mean you got out of bed in the middle of the night and worked on it?' 'Yeah,' he said, 'I figured it out.' He didn't think anything of working on something in the middle of the night. That's how he was. Not me, once I'm in bed, I might try to work it out in my head, but I'm too bloody tired to get out of bed and dance at two or three in the morning.

"There was something else Fred did that I absolutely adored. He'd talk to you while you were dancing—very quietly under his breath. If he liked what you were doing, he'd say, 'Now you're dancin'!' I just loved that. It always made me feel so great. And the other thing I really appreciated about him was that he gave you breathing room. Some partners make you feel so constricted, like you're in a vise. But not Fred. He demanded precision but within all that precision, you felt remarkably free, like you're floating. You know how music lifts you and carries you? That's what it was like to partner with Fred."

"He obviously enjoyed dancing with you."

"I'm sure that he did. He liked to describe me as 'a mover.' For the longest time I thought it was some subtle put-down. Why doesn't he call me a dancer? Cyd Charisse is a dancer, and I'm just a mover? What's that all about? Then one day I heard him tell someone that he thought horses were the best movers. Fred simply adored horses. And I thought, my God, all this time he's been praising me and I didn't see it."

"I imagine the TV special got you out of the chorus?"

"Yes. After the first TV special with Fred, I received an avalanche of telegrams, phone calls, and job offers. It was unbelievable. My world

totally changed after that. I even got a call from Irving Berlin congratulating me on my performance."

"And yet you quit show business fairly young."

"Yes, I was thirty-eight, just a few years after my last special with Fred. I felt it was time to concentrate on my personal life. I'd already had two failed marriages and didn't want to mess up my third. Hollywood makes many demands on your private life. When the time came, I remembered something that the great dancer Nora Kaye had told me. She said, 'Barrie, you won't know that you've really stopped dancing until you've gotten rid of your ballet slippers and rehearsal clothes. That will be the defining factor.' One day, many years after I had stopped dancing, I looked at my closet shelf and there were my leotards, my stockings, and my rehearsal shoes neatly arranged, just sitting there as if waiting to be put to use. Nora's words came back to me and I thought, why am I keeping all these things? It's time to let go of them. But it was very hard to do, very hard to do."

"What did you do with them?"

"I arranged them in a box and put them in storage," she said, bursting into laugher.

"So you didn't really get rid of them?"

"Well, I don't know where they are. They've probably disintegrated by now. I don't think I could find them even if I tried. To me, that means they're gone."

"I was five years old in 1958 when you made your first TV special with Fred. I'd really love to see it."

"I have all four specials on tape." Barrie dug into a storage area under her big-screen TV, slipped in the tape, and forwarded it to the "St James Infirmary" number.

Barrie came up on the black-and-white screen—a young ponytailed beauty wearing black ankle-length tights and a tight black sweater. On her feet were the Greek-style Hermes sandals she made popular for Capezio. Fred appeared in a short-sleeved shirt and slacks with a sash around his waist.

"Wow! Look at you!"

"Yes, I was young," she said matter-of-factly. Barrie danced the role of a seductive beatnik girl who spurned Fred's advances. The sexual energy they exuded was palpable.

"I can't believe he was almost sixty at the time," I said.

"He was at an advanced age in all the specials, but it was not until our last, when he was seventy, that I realized how frail he had become. Here, let me show you that one." She ejected the tape and inserted another one.

"This was Fred's favorite number—'Oh, You Beautiful Doll.' I am now the age he was then, and I think he was a lot weaker than I am now. In this show he seemed to have no power."

A more mature Barrie appeared on the screen in color. She wore a miniskirt, and her strawberry blonde hair was cut short. "Here, watch this part," she said. "See how I'm lying on the floor? Fred is supposed to pull me up. I give him my hand, but there is no strength on the other end. I have to make it look like he is pulling me up. That move completely wrenches my abdominal muscles. There's another section too where he is supposed to lift me—I jump it so he won't strain himself."

"Did he let on that he was weakening? Did he ever say anything?"

"No, we never spoke about it. I would never mention it. After our last show he developed an inner ear problem that affected his balance. He couldn't dance any more. I knew it was very hard for him. When I retired from dancing he said to me, 'Barrie, it's one thing to give up dancing because you choose to. It's another if you have to.' I knew he was referring to himself. I found it so very touching."

Venice, California, 2005

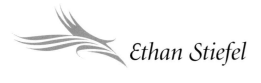

Ethan Stiefel

Considered by many to be the finest American-born male dancer in forty years, Ethan Stiefel's technical brilliance, athleticism, and captivating presence have called into question the predominant view established by George Balanchine that *ballet is woman*. While Stiefel may not have set out to change the image of ballet, he and talented dancers like him have helped usher in a new era for classical dance—one where *ballet is man and woman*.

I taped the first of several conversations with Ethan a few months after he underwent double knee surgery, sidelining him for the entire American Ballet Theatre 2006 season. He told me that he'd been looking forward to dancing again, especially after working so hard to get back in shape from two earlier, less invasive surgeries. I asked him how he'd injured himself.

"I was in rehearsals for the upcoming season when I felt something break in my left knee. I had it checked out and was told that I had a fractured bone spur about an inch long floating around inside my patella tendon. It caused severe tendonitis. I was given cortisone injections to relieve the pain. Then two weeks later the same thing happened to the other knee."

"What went through your head when you realized that these injuries might keep you from performing?"

"I didn't panic. I kept rehearsing. The season was opening in five days and I tried to grit it out and dance with the pain. I continued performing for the next five months including the engagements for *Kings of the Dance,* which was a project Angel Corella and I conceived for four male dancers."

"How were you able to get through it?"

"I tried to be as prepared as I could by warming up extensively before dancing but in all honesty, it came down to, 'Okay, I have to just go out there and try to block out the pain.' I was on anti-inflammatory medication every day just to make sure that I could get through it."

"Did the injury distract you while performing?"

"When you're on the stage your adrenaline and mental toughness kicks in and whether it's physical pain or something going on in your personal life, somehow magically it dissipates and you're focused on the moment

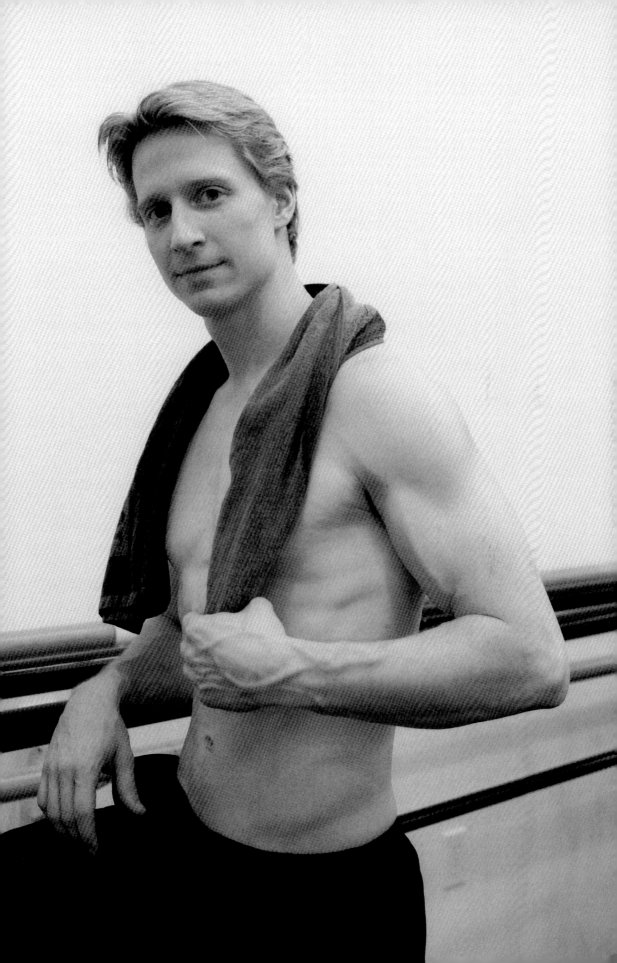

and what's before you. That's one of the reasons why I love to perform. Dancing offers you a different plane to function in—where life is almost stress-free. Unfortunately toward the end of *Kings*, doing a run of seven or eight performances in a row, the pain was fully present and when the medical reports indicated that my injuries required surgical treatment, I had to accept this reality."

"Once you've recovered, do you think you'll be able to dance at the same level as before?"

"I don't know. I hope so. I don't know how long it will take to get back into condition after not dancing for four to five months. I think all these things change you. I think I'll be different. I'm thirty-three and have been a professional dancer since the age of sixteen. That's seventeen years of wear and tear. As you get older you have to make adjustments—not that I'm at any kind of breaking point yet. I look at athletes in their forties and realize that one's training and mental approach has to be different. They maintain a particular regimen, diet, and work ethic, even in their off-season. It may come to that for me."

"Did you realize at the beginning how demanding and consuming a professional career in dance could be?"

"When I was a boy growing up in Wisconsin, I didn't know any professional dancers, so I didn't realize that the profession is so hard, that there would be obstacles to overcome."

"What were some of the obstacles you had to overcome?"

"If you're a boy going into dance, you open yourself up to ridicule. People can be negative and ignorant. You find yourself asking, 'Why are people making fun of me for something that I enjoy?' When you get older you realize that your obstacles change. You become aware that you have a limited amount of time to achieve your goals and fulfill your ambitions. In dance, the clock is always ticking. I am well aware of the fragility of the dancer's life and that my career could be over tomorrow."

"Can you recall a moment of clarity when you knew that you wanted to go all the way in dance?"

"Yes, when I was around fourteen I came to study with Stanley Williams at the School of American Ballet, where I was exposed to some of the great male dancers of our time and could see what you had to do to be successful. I told myself, 'You've really got to focus and work if you want to achieve greatness.' I knew that I had the tools to be good, hopefully very good, but needed to apply myself differently than before. That's where Stanley Williams really made a difference. He created an atmosphere and method for teaching that required that students be stimulated intellectually and

take his corrections through their own individual process. He understood that a dancer is not just a physical and technical machine, but someone who has to confront life and develop their own individuality."

"What keeps you going, Ethan?"

"The possibility for greatness. It's not about vanity; it's about testing the limits of humanity—being a vessel to reach great heights and inspire others to do so as well. I think I have a great deal of untapped potential left in dance. But if I don't give myself the opportunity to see what's possible, I'll never know."

"What kind of legacy do you want to leave?"

"I'd like to be remembered as a good person—a good human being. I'd like for my parents to say they are proud to call me their son. This is more important to me than anything else. Those of us who live in the dance world view what we do as valuable to our society and culture. But as one who has danced on the great stages of the world—performed with the Kirov Ballet, the Royal Ballet, and New York City Ballet, and American Ballet Theatre—I find myself asking, what does it all really mean? When you consider that there is hunger, disease, terror, and war in the world, you realize that what we do is of secondary importance."

"Do you think your ambition to be a decent and honorable human being comes across in your dancing?"

"Time will tell what audiences actually understand about me. I think what makes a dancer an artist is the ability to project one's individuality. I don't think you can have a weak personality and have something come across from the stage. Unlike a writer who can be more literal about his views, I'm working in nonverbal communication and interpreting the expression of others—the choreographer and the composer. But I do think it's possible for people to learn something about me from the aesthetic choices I make. And I'd like to believe that my core essence—that thing that distinguishes me from someone else—will always be understood on some level. If not, then I should probably stop dancing."

"As a dancer your job is to interpret your character or, in an abstract ballet, a story or viewpoint. What's it like for you when you feel your own identity surface?"

"I can't really describe what that feels like, but I do know that it's what keeps me going, even through all these injuries. I can try to explain it with words like joy, fulfillment, euphoria, but these words are insufficient and inaccurate."

"When you get into that emotionally charged place, do you try to linger there a while?"

"To try to linger there would suggest that you have some control over it. I don't. I'm only in control of the steps that I'm doing and the training and the musicality that I possess. I only have the tools to go for the ride. I'd be foolish to think I control what happens out there. I'd be foolish to want to."

"Are you in search of artistic perfection?"

"I think to strive for perfection is a misdirected ambition."

"Why?"

"Because perfection doesn't seem relative to what we do. Art is about creating something that will inspire, engage, confront, and enrich. How can you say we're striving for perfection when, being a subjective medium, this is not art's original intention? Yes, you aim to be clean and precise while always giving your all, but dance is a refine and redefine art form."

"What's a typical day in the life of a professional ballet dancer?"

"My routine has changed over the years, but in general I try to sleep as much as I can and wake up at the last minute. Sometimes I only get three hours of sleep a night. During the performance season, I try to get into the studio about thirty to forty minutes before the others. I believe in preparation for class. It sets up you physically and mentally, and when it's quiet you can shut out distractions. The studio is where you put in the blood and the sweat. That's where you figure it all out, where things are molded and shaped. Typically class takes an hour and a half and is followed by a rehearsal that usually runs five to seven hours, depending upon what I'm dancing."

"Do you feel a responsibility to enlighten society about the beauty and wonder of dance?"

"All I really know how to do is function as a principal dancer and teach what I've learned. That's why I mentor others, created a dance camp in Martha's Vineyard. I hope one day also to direct my own company or school. We spoke earlier about the fragility of the dancer's body, but the truth is that the art form itself is fragile. And while I'm not a crusader, I am interested in keeping dance alive the only way I know how—by maintaining respect for the history of ballet, while continually trying to promote innovation and progress."

It had been more than a year since I last saw Ethan, when I noticed that American Ballet Theatre was coming to the Orange County Performing Arts Center for their 2007 season. He would be dancing the role of Prince Désiré opposite Gillian Murphy in the West Coast premiere of *The Sleeping Beauty.* Curious to know whether Ethan had maintained his powerful

stage presence, I purchased a ticket. When Ethan made his entrance in the second act, the audience burst into applause. Adapted from Marius Petipa's 1890 original choreography, Ethan's role called for highly athletic moves—jetés, cabrioles, and entrechats—as well as subtle displays of character and physical strength for lifts, which he performed with astonishing ease and skill. Watching him perform, I knew that the only thing he had lost during his convalescence was time. His artistry and technical skill remained as vital as ever. During the bows, Gillian acknowledged Ethan by handing him a rose from her bouquet. Ethan accepted it and then tossed it lovingly to the audience. Then he kissed her on the lips in a clearly unrehearsed expression of pure joy.

New York, 2006
Costa Mesa, California, 2007

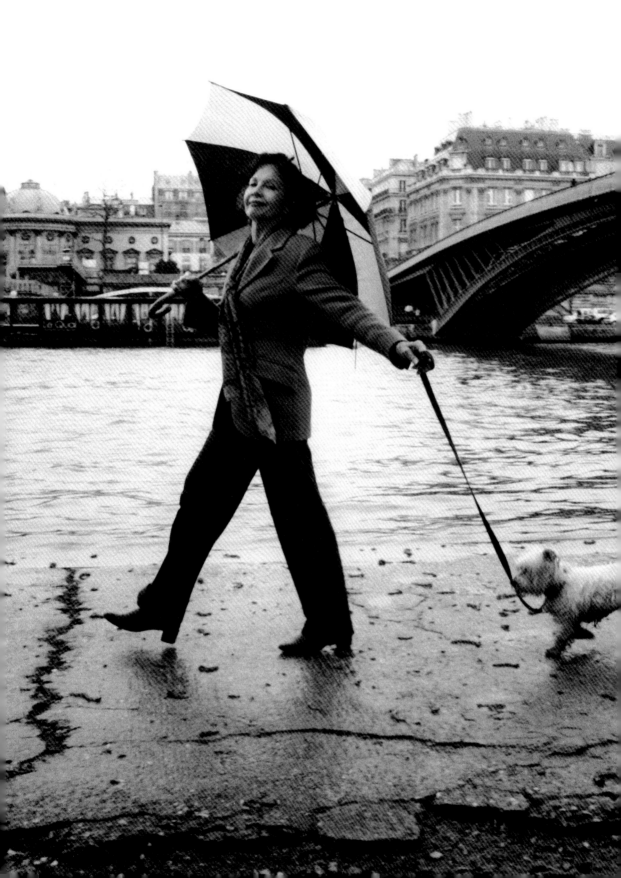

The morning of our scheduled meeting, Paris was dark and chilly. On the Métro I worried that if it rained, my planned outdoor portrait of Leslie would have to be scratched. I was traveling with my twenty-five-year-old daughter, Ariella, who would assist me with the shoot. Once we arrived at the entrance to Leslie's building in one of Paris's most fashionable districts, I pushed the button next to her apartment number and whispered to my daughter, "Prepare to meet a living legend." Moments later Leslie Caron responded over the intercom. I recognized her low-timbred voice and French accent from her many films.

"Yes, Rose, so sorry to keep you waiting. I'll buzz you in, just take the elevator to the second floor." Leslie was waiting for us in the hall when we stepped out of the elevator. Even without makeup and her hair hidden inside a beret, she displayed striking beauty and refinement.

"Thank you so much for having us."

"Please do come in," she said, opening the door wide and leading us through her foyer decorated with romantic oil paintings and sculptures. Placing my camera bag on the rug of her parlor floor, I scanned the airy room for mementos of her fabled career. On a small dresser in an alcove stood a bronze statue of a ballet dancer alongside a framed portrait of a smiling Rudolf Nureyev. On the coffee table lay a copy of *Secret Muses: The Life of Frederick Ashton*.

"May I offer you some coffee? Please make yourselves comfortable." Leslie excused herself and returned moments later holding a silver tray bearing three cups of espresso and a small bowl of sugar cubes. She was no longer wearing her beret. Her brown curls now framed her face and accentuated her delicate features. She sat down next to me.

Turning to Leslie, I asked, "Is it all right to begin the interview now?"

"Yes, of course."

"Once you've committed yourself passionately to the dance, does that passion ever leave you?"

"Probably not. Dance is something I know so well, so profoundly, so intimately. It's been over forty years since I danced professionally, but when I hear music, I still feel like dancing. When I gave up my dance career, it was like getting a divorce. I had to make a painful decision—to be

a movie star or a ballerina. I was only eighteen when Hollywood came calling, and I knew if I were going to pursue acting, I would not be able to keep up with my ballet training. To be a prima ballerina you have to be in top form and possess a victorious attitude toward every aspect of life. I found myself deeply conflicted. After much soul-searching I decided to stop dancing. I gave away my toe shoes and informed MGM executives that I wouldn't dance anymore. I was twenty-three."

"This must have been terribly painful."

"Yes, it was. I was heartbroken. But I did not want to disrespect the ballet by performing it in a *Hollywood* way. Either I was going to be a prima ballerina and dance on the concert stage, or I would be an actress. I couldn't do both. The last time I danced on the stage was in *The Glass Slipper* for Roland Petit's Ballet des Champs-Élysées."

"Have you ever regretted your decision?"

"No, I felt it was the right thing to do because by that time Hollywood musicals were beginning to lose their glamour. Filmmakers and screenwriters had recycled the song and dance formula so often, it had become banal and clichéd. The public was growing tired of them. Realistic films were appearing on the scene like *On the Waterfront, Blackboard Jungle, A Place in the Sun, East of Eden, Cat on a Hot Tin Roof, From Here to Eternity,* and many others. I wanted to be part of that era in cinema."

"You left the concert stage just as you are making a name for yourself. You could have gone all the way."

"Yes, I could have. I wanted to be a second Pavlova. I had even decided to call myself Caronova. But the first time I was in Roland Petit's ballet class he said, 'Hey you there, what's your name?' Very nervous and trembling, I answered Leslie Caron, my real name, and that was it. He hired me immediately and gave me a solo in one of his ballets. That was the beginning of my professional dance career. I was sixteen years old."

"How did you first come to dance?"

"My mother had been a dancer and she strongly encouraged me to pursue a dance career."

"And your ticket was Roland Petit's Ballets des Champs-Élysées?"

"Yes, my first year in the company was in 1948. I was given a solo in David Lichines's *La Rencontre*, which is the story of Oedipus and the Sphinx. I was to dance opposite Jean Babilée, the greatest dancer since Nijinsky and before Nureyev and Baryshnikov. The premiere received sensational reviews."

"How did Gene Kelly discover you?"

"Gene was at the premiere of *La Recontre*. After the performance he came backstage looking for me, but I had left the theater right after the final curtain. *La Rencontre* became a huge sensation, and I the star of the moment. Before that I was the baby of the company—sixteen years old, the last dancer to join the chorus. My relationship with all the girls in the company changed in that one instant. Rather than face all that, I quickly changed out of my costume and walked home. So I did not meet Gene Kelly that night. I met him a year and a half later when he came to Paris to audition girls to be his partner in a film called *An American in Paris*. Word got out that he wanted to meet me. I had never heard of this man, Gene Kelly, but I figured, why not? A meeting was arranged at Hôtel Georges V. Gene was very courteous and respectful, and he could see that I was extremely shy. He said, 'I would like to give you a screen test. I know that you can dance, but I don't know how you photograph or if you can act. We can film this little scene and send it to the studio, and if they think it's all right, then you'll be my partner.' I agreed, just to be polite and to please my mother. I then promptly forgot about it. I was in rehearsals for *Les Sylphides* when suddenly I get this call, 'the studio picked up your option and you're leaving in three days. They want you for *An American in Paris*.' Well, all that was far too big for me. I wasn't dreaming of being a movie star in Hollywood. But on the advice of my mother, I dropped everything and flew to America. Rehearsals began immediately."

"Did you speak English?"

"No, not at all. My lines in the film are spoken phonetically."

"Did Gene work closely with you?"

"Gene did not work with me exclusively because he had to get himself back into training. In between films he didn't dance and would usually drink too much and get a little out of shape. He had two assistants—Jeannie Coin, who would later become his second wife, and a remarkable dancer named Carol Haney, who had been trained by the great Jack Cole. Carol, who worked very closely with me, explained that there was no time to teach me modern ballet or jazz. She asked me to show her what I could do and saw immediately that I had a strong *développé*, could do the splits fairly easily and perform turns well. She would then have me show these things to Gene. The two of them then choreographed around what I could do best."

"That's very practical—to choreograph with the dancer's capabilities in mind."

"Oh, Gene was immensely practical."

"Your dance with a chair at the beginning of that film was very controversial. Even by today's standards it's pretty hot!"

"What you're seeing there is pure Jack Cole. Carol choreographed that sequence on her own, without Gene. Carol taught me all those sexy moves. I just copied her. I think I enjoyed that dance best of all. In those days, film studios were closely monitored by censors from the Hays Office. They would send someone to look at everything before it could be approved for audiences. One day a woman came to watch me rehearse that number. 'No, no, no' she cried. 'This is far too suggestive.' I was dancing with a *chair,* for God's sake. What can you do with a chair? So to appease the censors, it had to be toned down. The version you see in the film is the toned-down version, as was the scene I did with Gene at the fountain."

"Did you enjoy dancing with Gene?"

"Gene Kelly had all the qualities of a great dancer, remarkable build and musculature, excellent timing, rhythm, drama, and beauty of movement. If you're asking, was it sensual to dance with Gene, the answer is no. When you're dancing on a set with cameras and lights, you're involved technically in what you're doing. The dancing is paramount, not personal feelings."

"Do you think *An American in Paris* is your most memorable work?"

"No, I think my best contribution was *Gigi.* By the time I made *Gigi,* I knew what I was doing. I wasn't so utterly uncomfortable in the medium. Also, I had been very lonely during the making of *An American in Paris.* Here I was in a totally alien environment where everyone spoke a language that I didn't understand. It was a good thing I was so disciplined, otherwise I would not have survived. I was also very ill during the filming. No one knew it, but I had—how do you call it?—mononucleosis. How I managed to get up every morning and get to the set I don't know. I was also anemic, having been deprived of nutritious foods like meat, fruit, and cheese during the war years. During the eight months it took to complete the film, I struggled to keep up appearances. Gene and his wife, Betsy Blair, were very warm and welcoming. But I spent all my evenings alone in a motel behind the studio next to MGM's massive power generator."

"All told, were you happy with the outcome of the film?"

"No, I was just a baby and had no objectivity. I remember going to the sneak preview with Gene and all the executives. After viewing the film I had a headache and felt flushed and feverish. Gene came up to me and asked, 'So how do you feel?' 'Gene,' I said, 'I think I've caught the flu. I feel terrible.' 'No,' he said, 'you didn't catch the flu, you've just seen yourself

on the screen for the first time.' For someone as shy and inward as I was, seeing myself onscreen was a major shock. Hearing myself speak was the most difficult. I had been trained as a dancer who performed in silence. Suddenly I had to say lines like, 'Jerry, if it means anything to you, I love you.' Saying those lines practically gave me a nervous breakdown. To this day I don't like myself in *An American in Paris.* Everybody seems to think that I acted charmingly, but all I see is a girl who's sick with shyness. The pain of embarrassment is present in every scene."

"Later you partnered with Fred Astaire. How did the film *Daddy Long Legs* come about?"

"Well, I had done this modest film for MGM called *Lili,* for which I received an Oscar nomination. Fred saw the film and asked for me. I really enjoyed dancing with Fred on that picture. He would take you in his arms and guide you ever so gently. He had a very special bone structure, muscle structure, nerve structure—so that everything was fast, easy and light, and responded instantly to the brain messages about rhythm. The brain said 'rhythm,' and he was there half a second before. He was simply born like that. Fred was never out of breath and never off balance—never. And he truly enjoyed dancing."

"How do you think your dance training and your ability to express yourself nonverbally helped you as an actor?"

"Body movement was never a problem for me. You build your character using the whole of you—not just in your brain. With the Stanislavsky method of acting you learn that the character comes from inside of you and has a particular appearance with physical characteristics. I have always been aware of this in the characters I've played. In *Gigi,* for example, I became physically awkward, my feet turned in like this [standing and demonstrating], and I stood more on one side—sort of off center."

"If you could relive your life, would you have done anything differently?"

"Yes. I wish I had been just a dancer or just an actor. I think my having been a dancer impaired my acting career. By the time I decided I was finished with ballet and wanted to be an actress, there was a label put on my name. Very few can get out of dancing and go into real drama. You're viewed as someone who only knows how to do light entertainment. You can't play Medea after Cinderella."

Just then I heard the sound of rain hitting the windows.

"Oh, no. I wanted to photograph you outside against the Paris skyline."

"We can still do that, Rose. We have umbrellas, don't we? Let me go and change, and we'll take a walk out toward the Seine. I know a nice spot only minutes away."

Leslie returned wearing a pair of plaid pants and an apple-green jacket with matching scarf. Grabbing an umbrella and a leash for Prunelle, her Bichon maltais, she led the way.

"How's this?" she asked when we reached the river.

"It's a great location. I just hope I can manage."

Ariella held an umbrella over me as I removed a camera from my bag. Leslie waited patiently while I loaded film and checked the camera's settings.

"I'm ready now. Action!" I called out.

Leslie began to walk along the edge of the Seine with little Prunelle following closely behind.

"Look here," I called out. Leslie turned toward me and threw me a warm smile. I felt like the luckiest American in Paris.

Paris, March 2005

Fernando Bujones

I arrived the day before the premiere of the Orlando Ballet's 30th year gala at the Carr Performing Arts Center. Entering through the stage door, I encountered a bustle of activity: stagehands building sets, props being sorted, dancers stretching and rehearsing.

"Do you know where I can find Fernando?" I asked a long-legged ballerina.

"He's on the stage," she said pointing. Spotting Fernando working with a group of dancers, I waited in the wings so as not to disturb the rehearsal. After he dismissed the dancers, I stepped out into the light.

"Hello, Fernando."

"Rose," he said with delight, wrapping his arms around me.

"This is some company you have here."

"Well, just wait until you see them dance! Come, let's talk in my dressing room," he said leading me backstage.

"I have a very unusual story, Rose. When I was five years old, I was very thin and didn't have a good appetite. My mother became alarmed and took me to see a psychiatrist. After examining me, he told her there was nothing physically wrong with me and that my not eating was a ploy to get attention. He prescribed exercise, which he said would boost my appetite and solve the problem. So my mother put me in ballet classes. By the end of the first day, I was starving. My appetite improved and, without knowing it, she started me on my career path."

"I understand you received your early training in Cuba."

"Yes, that's correct, at the Ballet Nacional de Cuba in Havana, with Alicia Alonzo. But I was born in Miami, Florida, on March 9th in 1955. I'm proud of that date because I'm born around the same time as two legendary dancers, Vaslav Nijinsky, born on March 12th and Rudolf Nureyev, born on March 17th. My family moved to Cuba when I was very young, which is where I received my ballet foundation. My professional training began when I received a scholarship to study at the School of American Ballet. This came about when my mother had the opportunity to meet New York City Ballet dancer Jacques d'Amboise. She told him about me, and he offered to watch me dance. Afterwards, he turned to her and said, 'I will personally see to it that Fernando receives a scholarship for the

summer program at the School of American Ballet in New York City. When Diana Adams, one of the company's principal dancers saw me in class, she began a campaign to keep me in New York. I was offered a full-year scholarship. 'We are a very close Latin family,' my mother protested. 'I can't possibly leave my twelve-year-old son alone here in New York City.' A good negotiator, my mother worked it out so that SAB would relocate her to New York and give her a living allowance. I would be enrolled in the professional students' school for my general studies and SAB would pay the tuition. We returned to Miami, packed our things into a little Volkswagen, and followed I-95 north to New York. This was the beginning."

"I imagine the teachers at SAB immediately began grooming you for a place in the New York City Ballet."

"Yes, I received a good deal of attention. They were so impressed with me that my scholarship was extended year after year for the next five years. Mr. Balanchine asked me to join New York City Ballet when I was only fourteen, but I felt that I was too young and not ready. He invited me again when I was seventeen, after my graduation performance. But Lucia Chase, artistic director of American Ballet Theatre, along with Erik Bruhn, one of ballet's most prominent male dancers, had seen me perform in SAB's school productions and wanted me for ABT. Lucia Chase told me, 'I've seen you dance and I know your talent. Then she offered me a corps de ballet contract—no audition required. I was faced with a big decision—New York City Ballet or American Ballet Theatre."

"How did you decide?"

"Well, I had an experience when I was around fifteen that helped me make up my mind. I was in class at SAB when the studio door opened and a head peeked in—a man with a very strong face and high cheekbones. He entered and took a place at the *barre* right in front of me. And from the minute he arrived, he didn't take his eyes off of me. His gaze was so intense I felt as if he were seeing right through me. Before class was over he pulled my teacher aside and spoke to him quietly. After class my teacher approached and said, 'Fernando, Rudolf Nureyev is very impressed with you. He called you a first-class dancer.' Can you imagine what that meant to me? I was flying high. I left the studio to get a sip of water in the hallway fountain, when I heard the door of the men's dressing room open and the sound of boots coming towards me. I looked up, and there standing over me was Nureyev. He clicked his heels together and said, 'It was a pleasure to watch you dance.' I practically choked on the water. He extended his hand to me and said, 'I wish you all the best and I hope you make the right decision about what company you choose

for your future.' I knew instantly what he meant. He was saying that with my classical training, I should be dancing classical ballets and full-length story ballets. New York City Ballet's repertory was based on Balanchine's neoclassic pure dance ballets—short ballets intended to highlight the physical body, not character or story."

"Did you feel that if you remained with New York City Ballet you would not fulfill your potential as a dancer?"

"I felt that I would not become the complete artist that I hoped to be. I would be an instrument for a wonderful choreographer, yes, but as dancer, I would be limited. A dance career is not complete unless you grow technically and artistically. To grow you must be challenged. I wanted to be challenged. I wanted to interpret characters and express myself through dramatic roles. And remember, Balanchine always said, "Ballet is woman." What of the male dancer? I felt there had to be more than performing pirouettes and functioning as a support for the ballerina. I took very seriously Nureyev's words and kept them in mind when I made my decision. Later in my career I would work with him on several of his European productions. Over the years, he would teach me a great deal and became one of the primary influences in my career."

"Are you saying that the artist should always do what's in his own best interest?"

"Yes, absolutely. I think we are entitled to do what we need to do to develop as artists. This is not a selfish thing. We work so hard, year in and year out, staring in the mirror in a narcissistic way to improve ourselves. It's up to us to make decisions that will further ourselves. As a principal dancer with ABT, I would have the opportunity to interpret roles like Romeo in *Romeo and Juliet* or Billy in *Billy The Kid* and the princely roles. Ultimately it was because of its repertory that I chose American Ballet Theatre."

"Fernando, what is the ultimate goal of the dancer?"

"I think most dancers want to be recognized internationally and perform on the great stages of the world in front of enthusiastic audiences. I had a very successful career with my home-base company ABT, and I also developed an international career as a guest star with most of the major companies of the world: the Royal Ballet, Vienna State Opera, the Paris Opéra, Stuttgart Ballet, and La Scala de Milano. I partnered with some of the most wonderful ballerinas in the ballet world, including Dame Margot Fonteyn, Merle Park, Cynthia Gregory, Gelsey Kirkland, Natalia Makarova, and Marianna Tcherkassky. And I had a dream repertory, dancing in some of the greatest ballets ever choreographed, among them *La Fille mal gardée, Les Sylphides, Don Quixote,* and *La Bayadère*."

"Does one need impeccable technique to achieve true greatness as a ballet dancer?"

"One can be a great artist without being a great technician. There have been many famous ballet stars who did not have the ideal body or total mastery of all aspects of the art form, but on the stage they possessed magnetism—true artistry, by which I mean a charismatic quality. You can work with a coach to try and develop it, but a true artist has the ability to express his inner feelings naturally. Some roles bring this out more than others. When I danced the role of Solor in *La Bayadère*, I was not Fernando Bujones interpreting a role. The minute I put on his turban, I was that Hindu warrior in the palace."

"How does one make this shift?"

"I don't think there is a technique for this. It is governed by one's soul. As soon as I began rehearsing *La Bayadère,* I felt this character in my skin. The same thing happened when I danced the role of the flamboyant Basilio in *Don Quixote.* With my Hispanic roots, no one had to say to me, 'Let me see that Latin fire.' It was there from day one. I felt it deeply in my soul. And there were other characters, like the Scotsman James in *Les Sylphides.* James is noble and romantic, a dreamer and a poet. His lyrical nature brought out the softer side in me. Dancing these roles I found within myself the capacity for both fire and poetry. Sometimes I feel so powerful I can break down a wall with my temper, my fire, my strength. At other times I can hand a woman a handkerchief and tenderly caress her. My wife Maria says she fell in love with me because I am half barbarian and half prince," he added with a burst of laughter.

"You exude a great deal of confidence and self-assurance. I imagine this served you well throughout your career."

"Some people confuse that confidence and determination with arrogance. I'm not arrogant. I am confident. When I stood on the stage as a dancer, I felt as if I were ten feet tall. How is the audience going to take you seriously if you don't have a captivating stage presence, one that comes from inside of you?"

"You were criticized in the past for making derogatory remarks about Baryshnikov. What prompted your remarks?"

"I was nineteen when I said in a *New York Times* interview that 'Baryshnikov has publicity, but I have talent.' I had just won the gold medal at the International Ballet Competition in Varna, Bulgaria—the first American male dancer to do so. I was standing up for myself, and for the American dancers. I wasn't saying that Baryshnikov had no talent. My intention was to point out that the Russian defectors were getting all

this publicity, but their talent did not exceed ours in the United States. That statement went around the world like lightning and created a big controversy."

"Did the two of you become rivals?"

"Yes, Baryshnikov and I had a strong rivalry, like Placido Domingo and Luciano Pavarotti had at one time. After he became artistic director of ABT, many thought I would leave but I stayed for six years. Our backstage rivalry played out on the stage and audiences loved it. It helped sell tickets. We never did become friends. The rivalry always seemed to be in the way."

"Your dancing career spanned thirty years. It must have been very tough for you to retire."

"I gave my farewell performance with ABT in 1995 at the Metropolitan Opera House. I was forty years old. It was an emotionally heartbreaking evening for me. I knew that I was closing a chapter of my life and tried to prepare for it. When I made my entrance, the audience burst into applause and bravos for almost a minute and a half. I could hardly hear the music over the din. The evening ended with a twenty-minute standing ovation."

About a year later, on a hot muggy day in New York City, I met Fernando and his wife, Maria, on the plaza at Lincoln Center, hoping to snap a few photographs of the legendary ballet dancer. Before posing Fernando in front of the Metropolitan Opera House, where for three decades he had mesmerized audiences with his brilliant dancing, Maria patted clear powder on his face to remove any shine that might show up in the photos. He kissed her, stepped out in the sun, and turned on the charm. Wearing a blue shirt, dark suit, and robust smile, he looked majestic before the lens in a pose reminiscent of *Don Quixote.* I had no idea that this would be the last time he would pose for a portrait. Only a couple of months later, Fernando would be diagnosed with malignant melanoma, which would take his life on November 10, 2005, at the age of fifty. My photograph of him in front of the Met would appear on the opening page of a tribute in the January issue of *Dance Magazine,* which hailed Fernando as a dancer of spectacular bravura and styling.

Orlando, 2004
New York, 2005

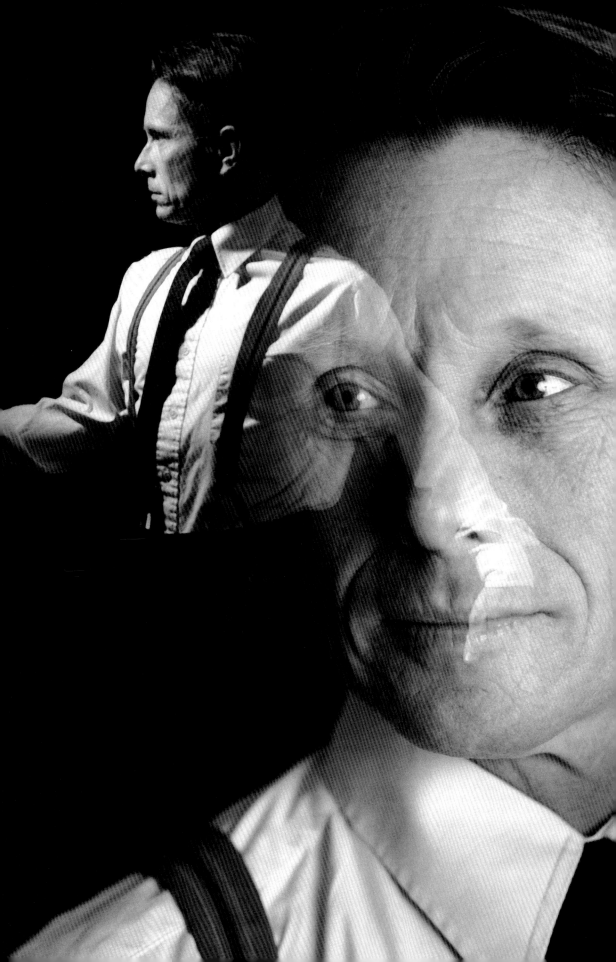

Leonard Crofoot

Leonard arrived for our session at 10:00 A.M. sharp. I invited him into my kitchen to keep me company while I poured us some coffee and arranged some muffins on a plate.

"I brought something to show you, Rose," he said, handing me an oversized book entitled *Nijinsky Dancing*, by Lincoln Kirsten. I took a minute to flip through the pages, stopping to study some of the photographs of Nijinsky in his various roles. If Leonard's intention was to stir my interest in this dance legend—as famous for his dancing as for the tragic culmination of his life—then he succeeded. I handed him the plate of muffins and led him past my photo studio to the family room.

"Leonard," I began. "How did you come to dance?"

"My doctor recommended that I take ballet to strengthen my legs. At the age of four I was diagnosed with a form of polio. I was in a wheelchair for a couple of years before graduating to a leg brace and a 'Frankenstein shoe'—you know, one of those platform shoes. When I turned eight years old, I began studying ballet. It was much harder than it looked and I couldn't do it to save my soul. This made me angry, so I vowed to master the technique whatever the cost. I stayed with my first teacher, Dorothy La Spina, for about a year. When my family moved to the other side of town, I took classes with Stefan Wenta and a gentleman named George Zorich, a former dancer of the Ballet Russes de Monte Carlo. Zorich had been trained by the Imperial School in Russia—the same training that Nijinsky had. I learned *Petroushka* and *Afternoon of a Faun*, two of Nijinsky's most famous dances, directly from George, who learned them from Leonid Massine, who learned them directly from Nijinsky. The famous dancer Anton Dolin, whom I'd met when he was in his eighties, likened me to a young Nijinsky. Dolin had been Diaghilev's lover and knew Nijinsky very well. He had even visited him in the insane asylum. Mysteriously, I have inherited Nijinsky's legacy."

"That's amazing."

"What's also amazing is that Nijinsky and I were the same size, had the same build with virtually the same proportions. I fit perfectly into all his costumes. He was 5'4" and wore 6E size shoes, and so do I. We also had similar facial construction. I am part Sioux Indian, which accounts for

my high cheekbones and slanted eyes. Nijinsky also had high cheekbones and slanted eyes typical of his Tartar ancestry."

"Do you think you were destined to dance?"

"Well, I don't know. I think people make choices in life. But I do believe in following one's instincts. Long ago, I chose to live my life in dance and I can't imagine ever stopping—ever. They say ballet is supposed to end at thirty. Not for me it won't, not unless I suffer some catastrophic illness or accident. But, if I were forced to stop, I'd dance in my mind, like Nijinsky did. After he went insane he danced in his mind the rest of his life—thirty years. Just imagine what he must have envisioned during his years in the asylum."

"Why do you think he went insane?"

"Nobody knows exactly what insanity is, not even doctors. They can't tell you what causes someone to snap, to break. Artists deal with emotions and are sometimes consumed by them. When this happens, their emotions dictate behavior. I think this is what happened to Nijinsky. He became so absorbed in the parts he played, so intently sensitive to the souls of his characters, that he got lost in them and had trouble finding his way back. He might have been okay if he had someone to watch over him. He needed to be taken care of. When his father left him, his mother took care of him. Then the Imperial Theater School took over. When he began performing, he was under the protection of Serge Diaghilev and the Ballet Russes. When Diaghilev abandoned him, his domineering wife Romola Pulsky stepped in. When he cracked, he figured God would rescue him."

"Why does the artist need to be taken care of?"

"Artists who are lucky enough to be taken care of have the ability to focus on their art without fear and concern for their personal and professional survival. Nijinksy was extremely dependent on others. Today's dancers and choreographers are rarely taken care of. They have to struggle to find the money and time to fully develop themselves and their ideas. They have to become their own producers, directors, booking agents, and publicists. How can they devote themselves entirely to their art if they have to manage every aspect of their dancing life?"

"Are artists more emotionally vulnerable than most people?"

"I think artists know in their hearts that they are really just children playing in sandboxes. When I am working well creatively, I feel a childlike openness. I forget about everything and let myself be free to be creative without imposing any restrictions. The real trick is to take responsibility for your own life while maintaining a childlike quality."

"Given the sensitive nature of artists, do you think they are more susceptible to mental instability?"

"If you're not prone to insanity, you're not going to lose reality, especially if you're disciplined. I can tap in and tap out of the characters that I portray. If actors and dancers stay inside their character, they are experiencing neurosis, not art. No matter how brilliant their performances, it's still neurosis. You have to be able to turn it on and turn it off. It's like going into the ocean. If you stay in too long and don't have a life preserver, you're going to drown. So you'd better go for your swim and then get out."

"Do you ever find yourself on the edge—tempted to stay in and not come out?"

"I'm always on the edge—always. I've been teetering on the edge my entire professional life, but I like that place because it's risky and dangerous. It's a real rush—the best rush in the world. I like to sit on the rim of the maelstrom. From that height I have an amazing view—the calm sea and the depths of hell. . . ."

"I suppose Nijinsky was totally on the edge."

"Yes, absolutely. He was on the edge his entire life. In his diaries he called it the precipice. He was maniacal about his art and took up permanent residence on the edge—that is, until he fell overboard. He probably couldn't help himself. Nijinksy was absolutely obsessed with dance. He had blinders on. Everything that crossed his path reminded him of dance. If he heard music, he related it back to dance. If he saw a design on the floor, he saw it as a pattern for choreography. Everything was about the dance."

"Why did you choose to create *Nijinsky Speaks* and not *Fred Astaire Speaks* or *Bill Robinson Speaks*?"

"I chose a show on Nijinsky on the suggestion of Robin Palankar, who is my artistic collaborator and partner in life. I would be lost without her. She keeps me in balance when I'm, you know . . . on the edge. Nijinsky had a Diaghilev. I have a Palankar. She recognized that as an actor and a dancer Vaslav Nijinsky was the perfect character for me to showcase both my talents."

"How did you come to understand this complex man in order to portray him on the stage?"

"First, I read every book I could find on Nijinsky, including his diaries. Then I studied films of people with mental pathologies to get a sense of aberrant movement. I use this information in both the character of Nijinsky and in the choreography to give a heightened sense of Nijinsky's mental disintegration. In order to play Nijinsky, I must be able to combine all

of this information and build consistently throughout the performance. The show begins with Nijinsky in a catatonic state and ends with him in a catatonic state. During the body of the show, the audience learns what has happened to him."

"So what did you learn about him?"

"Nijinsky was the best dance technician of his day. He was a master of high jumps. His father had trained him to jump as high as a ball could bounce and then land as softly as a feather. He was known to take as many as eight classes a day, and continuously explored his body's capabilities. Chief among his skills was his talent to transform himself into a role. They say when he danced the role of Petroushka, the audience thought they were watching a wooden puppet. When he danced *Invitation to a Rose,* they said he was the essence of a rose. How do you play the essence of a rose? It's a flower! Nijinsky was so sensuous in *Afternoon of a Faun* that viewers thought they were looking at an animal. He was so real in all his roles, audiences didn't know that it was him unless they saw his name in the program. He was never a dancer doing steps. Nijinsky clearly became his characters. He was a brilliant actor, and that made him a brilliant dancer. He was simply a genius. All we have are written accounts of his dancing. No films exist. But I'm willing to bet that he danced the essence, the purity of his soul. And that's how I try to portray him."

"How do you prepare yourself physically and psychologically to perform *Nijinsky Speaks*?"

"Well, I'm a puke-atonic. I vomit."

"Before every show?"

"Yes. I get sick before every performance. It's something I began doing like a ritual—or jinx—when I first started performing on Broadway. I'd just get so nervous and frazzled. I was able to overcome it for a while, but when I started performing *Nijinsky Speaks*, it came back twentyfold. I was so sick at the premiere I didn't think I'd make it onto the stage. And every night for the first six months that I performed it you could hear me in the bathroom. But after that, I'm calm. I listen for the overture to begin, and then I know I have about three minutes before my entrance. I'll be on the stage for approximately an hour and twenty minutes. I get in touch with my breathing and make sure I can regulate various rhythms, which I use throughout the show. I look at my notes and implant in my mind some general thoughts. I relax, shake my body out and, depending on how I feel at the moment, either generate energy or contain it. The overture stops. I take my entrance onstage, and the show begins. Every show for me has a personal and sensitive life of its own. I'm in an altered state."

"Do you think it is fear of failure that makes you ill prior to a performance?"

"No, I don't believe it has to do with failure. You never fail if you do it. But if this is your passion, you do have to take the risk of failure every single time. You have to go all the way—and that means being absolutely naked on the stage, totally vulnerable. Every show of *Nijinsky Speaks* I do has to be for the moment. If it isn't, then I'm doing a past performance. It's going to be second best, and not even that. I can never be Nijinsky. I can only strive to portray his essence. It has to be true—100 percent true to that particular audience."

"Why is the life and art of Vaslav Nijinsky relevant to the dancer of the twenty-first century?"

"Nijinksy went insane. Find a way not to."

Encino, California, December 2004

Cynthia Gregory

Cynthia was waiting for me at the Greenwich train station in her candy-apple red BMW.

"You must be Rose," she said as I opened the passenger side door.

Dressed impeccably in a camel-colored wool suit, pearl earrings, and an elegant necklace, the former ballerina looked as regal behind the wheel as she had on the stage.

En route to her house, I asked her if it had been hard to leave the stage after a lifetime in dance—"like you might lose your mind as Nijinsky did?"

"Hardly. You've got the wrong ballerina, Rose," she said, bursting into laughter. "I'm not like that. Let me make you a cup of coffee and I'll tell you all about it." I followed Cynthia from the garage into her kitchen, where we were met by her bouncy chocolate Lab, Fred, who stuck his nose in my bag, grabbed the bagel I had been saving, and ran out of the room. Cynthia took off after the dog. In the meantime, I noticed a wall of framed pictures. Among them was a breathtaking black-and-white photo of Cynthia as the Dying Swan. Another showed her performing a pas de deux with Rudolf Nureyev, another with Bruce Marks. Above them were eight framed *Dance Magazine* covers side by side, each with Cynthia on the cover—the first when she was only seven years old.

"I call that my wall of shame," she said, walking toward me with what remained of my bagel. "Sorry about that, can I make you something to eat?"

"No, no, I'm fine." Cynthia fixed me a double espresso and spooned instant coffee into a mug for herself. Then we sat down in her family room to talk.

"How did your dance life begin?"

"I grew up in Los Angeles and was sort of a sickly kid. Every year I had a cold that lasted from Christmas to Easter. So when the doctor suggested that I get out for some exercise, my mother enrolled me in a ballet class. And from the minute I pointed my toe, it was clear that I had an affinity for it."

"I read that the famous ballerina Carmelita Maracci was one of your first teachers."

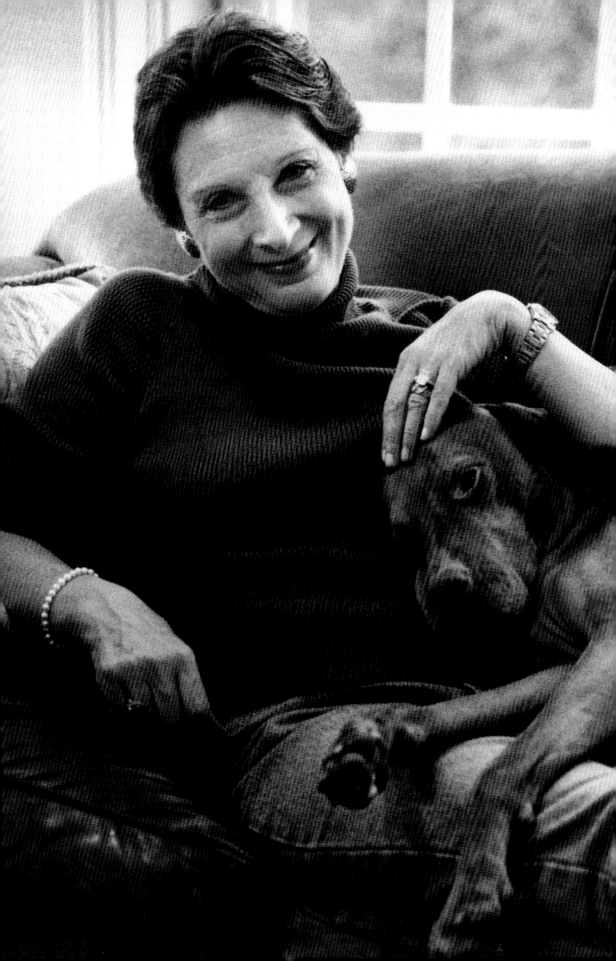

"Yes, I studied with her from the time I was nine until I was fourteen and a half. She was a formidable creature, only about 5'1", but used to scare me to death. She was very intelligent and well educated and always spoke of art and music and its relationship to dance. Her classes were choreographed, so that the exercises didn't feel like exercises. She told us stories and had us imagining all sorts of things. For example, she would liken the *rond de jambe* to an oar in the water.

"I also took classes from two other Los Angeles ballet teachers, Michel Pinaeff and Robaire Rouselott, who is really responsible for giving me my technique. He was a little Swiss man whose classes were very dry and very technical. You had to be very serious to survive his class because it was full of theory and not much fun."

"And you were one of the serious ones."

"Yes, I suppose I was. I didn't fit in that well at school and only had a couple of friends outside of dance. Dance became my whole world. The dance studio became my second home. My social life revolved around ballet."

"When did you start thinking about becoming a professional dancer?"

"I caught the bug when I was around fourteen, after I received a Ford Foundation scholarship to study at the San Francisco Ballet School. I loved being around a major dance company and watching its director, Lew Christiansen, work with the dancers. That's when I began dreaming of becoming a famous ballerina. I wanted to dance in all the great ballets, like *Beauty and the Beast, Swan Lake* and *Giselle*. I became a principal with the company and remained there for four and a half years."

"Why did you leave San Francisco Ballet?"

"Back then if you really wanted to make it big, you made your way to New York City and into one of the premier ballet companies. I had met George Balanchine when I was only thirteen. He said to me, 'Come see me if you want to dance in my company.' My parents thought I was too young and wouldn't let me go. So my plan was to go to New York when I got older and dance in New York City Ballet."

"So how did you end up in American Ballet Theatre?"

"I happened to attend ABT's 25th Anniversary celebration at Lincoln Center and couldn't believe what a fabulous company it was. I loved their repertory, their sense of theater and drama. I loved the dancers. So I never went to see Balanchine."

"How did you know that you were making the right decision?"

"I didn't at first. When I auditioned for ABT, they said they'd have to put me back in the corps de ballet and that there were only a few spots available for principals. If I wanted to get in as a principal, I would have to wait. In the meantime, I auditioned for the Harkness Ballet and they wanted me. I didn't know what to do, so I phoned my mother for advice. She said, 'You've always dreamed about being in a company like ABT. Don't take the first thing that comes along; hold out for that company.' I'm so glad she advised me to do that because a couple of weeks later ABT called and said they'd take me. I ended up dancing with the company for twenty-six years, from 1965 to 1991, with the exception of the ten months I took for my breakdown."

"What breakdown?"

"In 1965, I became a member of ABT's corps de ballet. Nine months later I was a soloist, and nine months after that, a principal. They inundated me with roles—dancing, dancing, dancing, and working with various choreographers and a multitude of partners. I became completely overwhelmed and overworked. It was exciting, but I had no time for a personal life at all. Here I was, a promising principal dancer with a lot of fans, but I was growing more miserable every day. I started hating everything about dance. I didn't believe in myself as an artist because I didn't really know who I was as a person. I became rebellious. I didn't want people telling me what to do. I didn't want to be judged by critics, by audiences, by the director, my teachers, my coaches, my peers. It came to a point where every time I stepped on the stage, I felt like I was going to my own execution. So in 1975, at the age of twenty-nine, I quit. I walked away from it all. I moved back to Los Angeles and got fat. I vowed that if I were ever going to dance again, I would need to discover who I was as a person and integrate that into my dancing."

"So what happened?"

"Lucia Chase, the director of American Ballet Theatre, called me every month and said, 'Don't do this to yourself. Don't abandon your great talent. You haven't yet fulfilled your potential. You'll be so sorry you're doing this.' And so, after nine months, I agreed to come back, but only under certain conditions. I told Lucia that I didn't want to perform eight times a week and be dog-tired all the time. And I didn't want to constantly be changing partners. I wanted each performance to be special. I wanted to do it right."

"Your leaving must have been such a shock to the company, as well as to your fans. Did people understand your motivation for leaving?"

"Everybody thought that I left because I was having a tantrum about the Russians. There was an influx of Russian defectors coming into the company around that time. The press loved to focus on Alexander Godunov, Natalia Makarova, Baryshnikov, and Nureyev. This gave everyone the impression that the Russians were better than everyone else. I believed that we were just as good as the Russians, but we didn't have the built-in publicity that they were getting. I became very outspoken—a champion for the American dancer—so people thought I left in protest. But the truth is that I left for personal reasons."

"Lucky for all of us that you came back. Audiences have always adored you."

"The connection I felt with audiences was very special for me, spiritual in a way, as if we experienced some sort of deep exchange. A psychic once told me that in a previous life I had been a temple dancer—a healer. So when people would come up to me after a performance and tell me that my dancing gave them a spiritual lift and helped them forget their troubles, I felt really great. I always wondered if that psychic was right about me because I really did want to improve people's lives."

"What was your internal process like? How did you prepare for a performance?"

"Music was always the first thing for me. Once I connected with the music, I learned the choreography very quickly. Then once I knew the steps, I'd begin thinking about how to interpret the role. But I was never a finished product. I was a spontaneous dancer. I needed to lose myself in performance, be in front of an audience to fully develop a role. It never happened for me in rehearsals. My partners used to tell me that I was twenty pounds lighter on the stage than in the studio."

"You partnered with some of ballet's greatest male dancers."

"Yes, I had several great partners who, like me, were spontaneous dancers and felt the music the way I did, dancers like Ivan Nagy, Fernando Bujones, Erik Bruhn, and Rudolf Nureyev. Dancing with them I heard the music a little differently, and no matter how I phrased the movement, they'd be with me. Our dancing was of the moment, so we didn't need to plan every fingertip, every eyelash. We had a general idea of the steps and where we wanted to go, but each night it would be a little different. And I loved that. I never danced as well with partners who played it safe. I preferred the risk-takers. If something went wrong during the performance, they would roll with the punches. Nureyev, for example, would flip things around and make the choreography even better. Fernando Bujones had

such incredible technique that if I would do something unexpected, like an extra pirouette, he'd spontaneously do something amazing too. The audience just loved that."

"Do you miss having those moments on the stage?"

"You know, Rose, I honestly don't remember what that feels like any more. I don't know if I miss it. I feel that my dance career was fully realized—from beginning to end. I left no stone unturned. I had a fabulous career. But I also believe that having a family and being a mom are even more wonderful."

"Before we finish, I must ask you about *Swan Lake*."

Cynthia smiled at me, as if she knew this question would be coming.

"What can I say? I just loved dancing *Swan Lake*. It was the first full-length ballet that I danced with ABT, and it was the role that established me as a principal ballerina. I danced it all over the world and with twenty million different partners," she said with a laugh. "It's one of the most important ballets of my career. In 1986, I wrote a children's book called *Cynthia Gregory Dances Swan Lake*. And in the book I write that I thought that Tchaikovsky wrote the music just for me. Aside from the music, what I loved about the ballet was that I got to play dual roles. I could be lyrical and beautiful and then I could be sharp, alluring, and sexy. The choreography felt natural on my body because I was a large ballerina—tall and long-necked like the image of the swan. I felt like it was made for me."

"Do you ever have dreams at night that you're dancing on the stage?"

"Interestingly, I dream that I'm on tour—late for a flight or can't find my shoes. But I don't usually dream that I'm on the stage dancing. The reality is that I'll always be a dancer. You're always a dancer in your mind and in your heart. And I do love that I can still dabble in it, coach, and advise young dancers. But I don't feel that I need to be involved with it on a daily basis. After I returned to ABT after my breakdown, I always made time for a personal life. And this is what I tell dancers: Don't be in that theater or that studio twenty-four hours a day. Don't live with blinders. Open your mind to everything else that's going on around you and then bring your real life into your dancing."

"You're very down to earth, Cynthia. I doubt most people know that about you."

"Yes, I'm very down to earth—I'm really California laid-back. I'm just somebody that had a talent for dance and went with it. I'm really just a regular person that loves family, loves people, and animals. People are

stunned when they hear that I do my own laundry and push my own cart in the supermarket. But I think it's important for people to know that I'm just like them. Some say it ruins the illusion, but I'd like the American public to feel closer to dancers and not regard them as so esoteric and removed from everyday life. I think if artists were more accessible and regarded as real people, then more people would embrace the arts, and we would all have a richer and happier society."

Greenwich, Connecticut, 2004

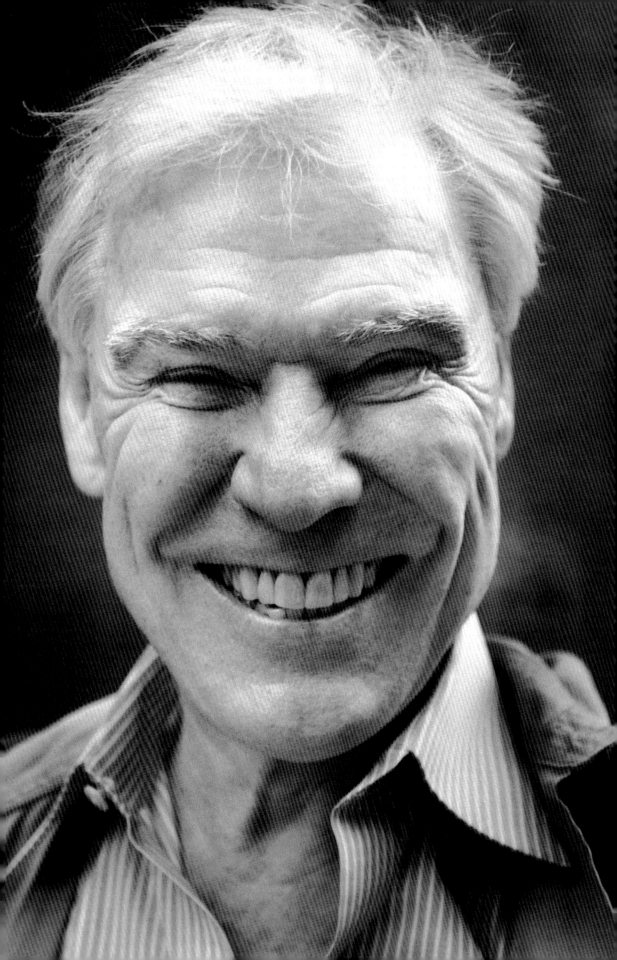

Jacques d'Amboise

Jacques greeted me at the offices of his Manhattan-based National Dance Institute. After showing me around and introducing me to his staff, he donned his backpack and said, "Let's grab some lunch."

"You have an amazing operation," I said as we walked to a nearby deli. "You're really making a difference in the lives of young kids."

"My goal," he said, "is to bring dance to children all over the world, rich and poor—from the highest to the lowest points on earth—Mount Everest to the Dead Sea."

"That's ambitious."

"Yes, it is, but we are doing it. In fact, I only have about an hour for our meeting today. I leave for China at the end of the week with a group of kids. There are still a million details to be worked out."

"What exactly do you need from me," he asked, taking a seat and handing me a menu.

"I'd like to get your take on what it's like to have a career in dance and live the artist's life. You've been doing this since you're what—seven years old?" Before he could answer, a pretty young waitress appeared and asked, "Vhat can I get you?"

"*Govoryte po-russki?* [Do you speak Russian?]" Jacques asked her.

"I'm from Bulgaria," she replied.

"Ah . . . let me see, I think Bulgarian is very similar to Russian, yes?"

"Yes, very close," she said. Relishing the opportunity to practice his Russian, Jacques learned within minutes that the name of our waitress was Sophia and that she'd soon be returning to her native land to finish her university studies.

Jacques nodded his approval and gave Sophia his order in his heavy New York accent.

"Yes, I did start ballet at seven," he said, picking up where we'd had left off. "I attended the School of American Ballet at eight. George Balanchine cast me as Puck in *A Midsummer Night's Dream* before I was nine, and from then on I performed many of the children's roles in Ballet Society, which was the company that preceded New York City Ballet. When Balanchine invited me to join the company, I quit school. That was in the summer of 1949. I was fifteen years old. He gave me a flexible contract, so

I had the freedom to do a variety of things. I went to Hollywood at the age of seventeen to dance in the film *Seven Brides For Seven Brothers*. I turned eighteen on the set. I became a principal with New York City Ballet before I was nineteen and stayed with Balanchine until he died in 1983."

"Did you aspire to be the greatest dancer of all time?"

"Honestly, all I ever wanted to do was play," he said. "I stumbled into the art of play on the highest level—storytelling to music with the physical body in the context of theater. That's dance."

"So games like baseball didn't hold the same interest?"

"Well, picture this," he said setting his sandwich on his plate. "George Balanchine, Frederick Ashton, Jerome Robbins, and Antony Tudor setting work on me, dancing with the greatest ballerinas in the world, Stravinsky conducting, making feature films. Imagine . . . getting paid for all this. Why would I want to do anything else? And you . . . ?"

"Me?"

"Yes, you. When did you do your first plié?"

"Oh . . . in high school. I only discovered dance at the age of sixteen—sort of late. One day after nearly fainting from running a mile in a timed sprint in my P.E. class, I decided that I'd had enough of track and field. I stormed into my guidance counselor's office and demanded to be transferred out of P.E. I didn't care where they put me—swimming, tennis, archery—as long as I didn't have to run the track. My counselor suggested dance class. I agreed without any idea of what that really meant. The next day I entered Rose Gold's modern dance class. And in that very first class, my life changed forever. But this is not about my dance path, Jacques. Tell me more about yours."

"Well, I just always tried to do my best and live in the moment. I danced every performance as if it were my first—and my last. Even if I had performed the same ballet hundreds of times, I viewed it as if it were my last curtain call. I had this ritual I used to do before every performance. In my mind I would dedicate that evening's show to someone special in my life. You know, like when someone writes a book or produces a movie, they say, 'in memory of.' Sometimes it would be to my dance partner, but more often it was to one of my former teachers. I'd think to myself, 'you're going to be proud of me, Mr. so-and-so.' He might be dead, but I'd imagine him out there watching me. Doing this made my performances more meaningful and more joyful."

"Did you know early on that your involvement with dance would be for life?"

"I didn't know that I wanted to dance for the rest of my life until I was about twenty-three. Up until then, I kept thinking I might go back to school, become a doctor or something like that."

"So what made you decide to stay in dance?"

"Balanchine decided to revive *Apollo*. He originally choreographed it in 1928 at the age of twenty-four. It is considered among his most masterful works. It brought him international recognition and was the first ballet he choreographed to the music of Stravinsky. *Apollo* combined a new classicism with a modern age that was reflective of Fokine, Massine, and Nijinsky. He chose me to perform this seminal work—a role of a lifetime! Balanchine envisioned a whole new look for the ballet with new costumes and new scenery. Naturally I agreed to do it. I would perform *Apollo* probably more times than anyone else over the next twenty years. It was extremely challenging, and I don't think I ever reached its core, what's truly inside of it. I don't think there is a dancer who has."

"Why? Is this ballet so deep, so complex?"

"Well, you need so many things in order to really bring it to life. You need the physical body, the stature, the classical technique, and the drama. You need a master like Balanchine to teach you and guide you. You need the orchestra and great ballerinas all dancing on the same high technical level."

"So without Balanchine how is it passed on?"

"Well, it's *not*—not in the way that I learned it."

"Why can't you pass it on?"

"Well, I tried. I don't know how well I succeeded. Twenty years after I last performed, Helgi Tomasson asked me to come to San Francisco to coach his dancers. He has a beautiful company, but I wasn't there every day working with the dancers, coaching them and watching every performance. You have to remember that when I was asked to dance the role of Apollo, I had great resources to draw upon. Balanchine's pianist was on hand as was Nicholas Magallanes, who had danced the role years before in Ballet Caravan. I was able to look to them for advice. 'Watch Balanchine and copy him,' they told me. And so I did. And yet, when people asked, 'Mr. Balanchine, what's going to happen to your ballets? What about the company after you're gone?' he would say, 'After me, I don't care, there will be something else.' He even refused to name anyone as his successor. He didn't care about becoming a museum piece. He hated the idea of it. And he was right in his thinking. Times change, people change. It becomes something else."

"Do you think you had natural talent?"

"No. But I wanted to be perfect. I worked hard to be good and had some tricks up my sleeve. For example, I didn't have a very good turn-out, so I learned how to fake it. I'd show the audience a turned-out front foot and hide my other not-as-turned-out foot directly behind it. I had bad feet, so to give the illusion of high arches I would tape them to make them look better. Another thing I used to do was keep shoe polish in the wings, so if I scuffed my shoes I could immediately clean them to make them look neat before going on again. I always felt that every new performance was another opportunity to do things better. Last night's performance is gone, it's over, and the only thing that matters is what happens tonight. Tonight I'm a new person, and this may be the only chance I ever have to give my best performance. This performance has to be it."

"Did you ever worry about forgetting the choreography or messing up in front of thousands of people?"

"No, I never worried about that because I had a system to reinforce the choreography so that I knew it instinctively. Before a performance, I'd get to the theater before anyone else arrived and I'd sit in the house facing the stage. I would think, okay, we're doing *Raymonda,* the first variation. I would watch myself in my mind's eye doing an entrance and my first steps."

"In other words, you did visualizations?"

"Yes. And then I would go to the rehearsal room, and I'd take that first entrance and go over and over it. I would do it fast and I would do it slow. Sometimes I would do it with my eyes closed. Then I would make myself do it three times in a row so that it was definitely part of me. I'd do the same thing with the first step. Then I would repeat the entire exercise with the second step, and then the third, and so on. It might take me two hours to make it halfway through a variation, sometimes four hours before I owned it. Then, when I came on the stage, I had no fear because I had complete control of the choreography and no tempo change could throw me off. All I needed to do was dance to the music and enjoy myself."

"It's about having control and confidence."

"That's right. I always tell the children I teach, 'When you learn how to control how you move, you're taking steps to control how you live. It's the right foot not the left. It's lifted halfway, not all the way. Does it move fast or slow? And what do you want to convey with that gesture or move-ment?' It's so profound. They are learning how to control the time and the space they inhabit. And the way one moves in time and space defines the life of the dancer."

"It's no wonder you are so successful working with children. You have a deep understanding of what they need to go through. Yours is a noble mission."

"Rose, it's not really a mission. I simply realized what a transforming experience being an artist is. I wanted to share it. There is great joy in being consumed with an art form and making it your life. And it's true of all the arts, whether it's learning to play a musical instrument, drawing or painting, writing, singing or acting. If you are lucky enough to 'play' with tremendously talented people as your teachers, it is a soul-transforming epiphany. At National Dance Institute we take the best professional artists we can find who are interested in conveying to children the joy of dancing. In New York City we teach dance to two thousand children a day."

"They embrace dance willingly?"

"Yes. Nothing engages you like dance because it includes all the arts. You're dancing to music. Music and dance are naturally wedded. Costumes, scenery, and lighting are created by visual artists—so there's your art. Whether it's an abstract dance or one with a story, you are conveying something. There's drama involved. And then there is what I call architecture. By architecture I don't mean in the sense of designing a building, but how you put things together and the order that you put them in. You'll do the same when you listen to the tape of this interview. You'll choose some of the things that I say and leave out other things based on what you think is relevant. Right?"

"Yes, absolutely."

"I call this architecture. So when you introduce dance to children, it's attractive to them because it encompasses all these things. All you need is a dance space. Dance can be practiced in a hallway, on a rooftop, or in someone's backyard. The minute you create a dance space it becomes sacred.

"Listen, I've got to get going. Why don't we talk some more when I get back from China? '*Pozhalysta,* [Please],'" he called out to Sophia, "'I need the check.' Looks like we won't have time for that portrait you wanted."

"Let me just take a few reference photos, if that's okay," I said, pulling a loaded camera from my bag. "We can do a formal session another time." He agreed, so we walked outside. Reminding Jacques to stand up tall and look dancerly, I got off a few shots but felt a little funny about photographing the great Balanchine dancer next to a sign that read Lean Pastrami.

As we approached the institute, Jacques recognized a group of hip-hop dancers standing near the entrance. "Hey, man," he said, giving them a

round of high fives and pats on the back. I thought if I could photograph him with these dancers, I might be able to capture his natural enthusiasm and signature smile. At just the right moment, I called out, "Jacques, look at me."

New York City, April 2004

Dudley Williams

"Now, after forty-one years, your time with the Alvin Ailey American Dance Theater has come to an end. What's it like looking back?"

"Oh, these were the most fabulous years of my life. I only wish that every time I danced *Revelations* I had put twenty dollars in a savings account. I'd be a wealthy man today. We performed *Revelations* in almost every program for over forty years and sometimes twice a day. Honestly, I can't even estimate how many times I danced it. But what a joy it was. What a joy! And the piece is indestructible. I've seen so many casts come and go, and it just continues to shine. It's an absolute masterpiece. In the forty years that I performed it, and I danced almost every single male role, Wading in the Water, Daniel, Cinnaman, you name it, I never, never, never got tired of it. I never once said, 'Oh God . . . we have to do *Revelations*.' I always looked forward to it and found meaning in it. Alvin gave us what I call 'jazz soul meat.' You could dive in whether you were a modern dancer or a jazz dancer. Alvin's choreography allowed you to completely express yourself. I've always been grateful to him for what he gave me and feel really good about the fact that I told him so before he died."

"What prompted you to confess your appreciation?"

"We were in Los Angeles performing at the Wilshire Theater when for some reason he and I started reminiscing about the past. And then he said all of a sudden, 'Dudley, I'm going to die, soon.' 'Oh, Alvin, we're all going to die,' I said jokingly, having no idea that he was delivering me a message. Suddenly, out of the blue, I felt the urge to thank him for everything he had done for me. 'Alvin,' I said. 'I want to thank you from the bottom of my heart for giving me your stage and for the possibility of doing all these wonderful, wonderful ballets.' It meant a great deal to me that he knew that. He was already sick at the time, but none of us knew it. He died shortly thereafter in 1989."

"Will you ever stop dancing?"

"No, that would be like cutting off my air supply. I would just fade away and die. I've only started to feel this way recently—when I turned sixty-five and started getting Social Security. You see, I have no desire or intention of ever stopping."

"What is it about dance that has such a hold on you?"

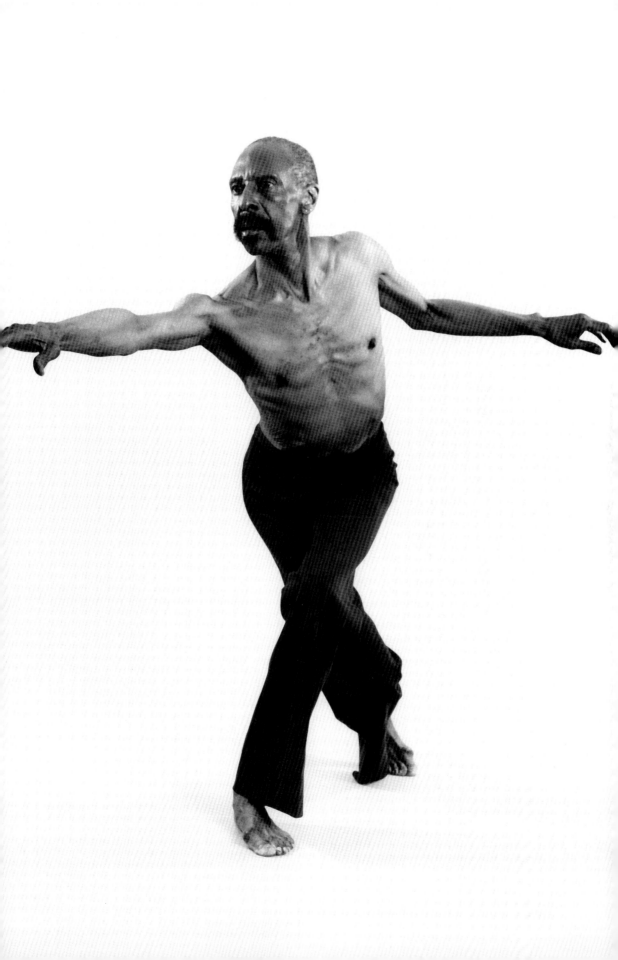

"It's what I've loved all my life, and it's what I do best. I can't think of anything I love more than the challenge of getting inside a choreographer's head and bringing his vision to life and creating a dialogue that can be shared with an audience."

"How do you bring movement to life?"

"Well, that's not something I care to reveal."

"Why not?"

"I don't want to encourage imitators. I don't want others to dance like me."

"Do others try to imitate you?"

"Yes, of course they do. They try, but they can't."

"Why can't they?"

"Because imitators don't know where my movement comes from. They think it's muscular action. Yes, I use my muscles, but my movement originates in my heart. I can't teach others what's in my heart. My heart speaks through interpretation of a beautiful choreographed moment. I have never tried to imitate anyone else's dancing. I found my own way of expressing myself, and that's what I think others should do. Be your own performer."

"I've been told that Alvin always encouraged his dancers to show themselves."

"Yes, he did. He never liked cookie-cutter dancers. When he opened the door for me to interpret his moves, I jumped right in. For example, when he choreographed *Field of Poppies* for me, I decided to hold the *penché arabesque* for as long as I could before moving on to the next part. One day he comes over to me and says, 'Oh, Dudley, don't hold that *penché* in *Field of Poppies*.' 'But Alvin,' I said, 'I've been doing it like this for ten years.' 'I know, I've been meaning to tell you,' he said and walked away. I just had to laugh. He let me get away with that for ten years and then suddenly changed his mind. But Alvin was very sensitive to his dancers. He would ask them if they wanted him to change things based on their individual training. Some had come from studying ballet; others, from Lester Horton. I was schooled in Martha Graham's technique. Alvin took that into consideration when he choreographed on me. In all my years of dancing, I've never worked with another choreographer who so respected the individuality of his dancers."

"Dudley, how important is technique in achieving artistry?"

"Well, I'm still trying to figure out who I am. Every dancer has days when they don't feel like dancing, especially after months and months of touring. I remember Alvin used to tell us, 'If you don't feel like dancing,

then just do the technique. But know that you can't get away with that all the time.' And the truth of the matter is that once you're on the stage and the curtain goes up and you start moving, you realize you can't just run through the steps. Something happens inside of you. You have to put some emotion into it, and as soon as you do that, you forget that you didn't feel like dancing. I can't put into words what takes over. I think part of it is that you don't want to make a fool of yourself on the stage, so you rise to the occasion. I remember this one time when we were performing one of Talley Beatty's pieces in Morocco. I was feeling ill, so I just did the steps, didn't really invest anything of myself, but got through the performance. Afterwards I felt very depressed."

"I think once you stop getting depressed about things like that—you've lost the commitment."

"Yes, I felt bad about that because I didn't put any heart and soul into it. The other side of that is that after forty years of dancing on the stage, I have yet to do a perfect performance. I've never walked off the stage and said, 'that was it.' There was always something in every piece that went wrong for me. But even when I gave an excellent performance and wanted to repeat it the next night, I couldn't. I'd try to do all the same things. I'd eat the same food, go to the bathroom at the same time, do all sorts of crazy things, but as soon as the curtain went up—I'd realize I'm a different person today than I was yesterday. There is no way to duplicate a performance."

"Do you think maybe you're too hard on yourself?"

"If I'm not hard on myself, who will be? I've never thought of myself as a great dancer. I'm an okay dancer. I am an okay dancer. I've been at it for forty years, but I've never, ever, ever, thought of myself as one of the greats."

"Do you think you'll ever achieve perfection?"

"I certainly hope so," he said with a smile. "I think it's that yearning for perfection that keeps me going. And I intend to go all the way until I can't lift a leg or move a muscle. I still want to work with choreographers who give me material I can sink my teeth into. I want to be part of a creative journey. Right now I'm working with Gus Solomons, Jr., and Carmen de Lavallade in a group we formed called Paradigm. The choreography is geared toward the mature dancer and wonderfully challenging."

"I imagine it takes years to understand how to translate what you learn in the studio and give it performance value."

"Well, I think I was pretty lucky having learned how to perform from Martha Graham and her disciples: Yuriko, Mary Hinkson, Ethel Winter,

Helen McGhee, and Bertram Ross. Martha Graham picked me to perform in her company after I graduated from Juilliard in 1959. She was smart as a whip—and, oh, the drama," he said, demonstrating a contraction with his arms turning in over his head. "She had already retired from the stage when I entered the company, but she was still teaching, so I got much of it straight from the horse's mouth. She taught her dancers about imagery—to feel what you're doing. I felt so inspired during class that I made a practice of positioning myself under the studio's recessed lighting. It made me feel as if I were on the stage—under a spotlight. By the time I got to rehearsals I was working at a performance level."

"How did 'A Song for You' become your signature piece? The song's lyrics could be your autobiography."

"I've been performing that dance since 1972. 'I've been so many places in my life and times. . . . With ten thousand people watching. . . .' I discovered this record, *A Song for You* by Donny Hathaway, when I was in Canada. When I got back to New York, I gave Alvin the record and said, 'This music, it's absolutely fabulous.' I then left on tour, and when I got back, Alvin called me into one of the studios. 'Chicken,' he said. He liked to call me Chicken because I was so skinny. 'I have a surprise for you.' He put on the record and said, 'I'm going to do this for you.' I was truly overwhelmed, you know, started crying and carrying on. He choreographed the dance on me in three days and then encouraged me to make it my own."

"How did you feel the first time you performed it?"

"The movement, the lyrics, it was so powerful. But it took some time for me to really dig into it and realize what it meant to me. Gradually I began to play with it on the stage: I'd do two turns instead of one, go deeper into the contraction, extend the amount of time I held my arms in the air, accentuate the use of my hands and fingers."

"As part of the company's repertory, you eventually had to relinquish this work to other dancers. Was it difficult for you to pass it on?"

"Yes, very. I passed it on begrudgingly. I knew I couldn't hog it up, be a pig about it. I taught it to several of the younger male dancers: Matthew Rushing, Amos Mechanic, and others. But I only taught them the steps. I didn't reveal its essence as I understood it. I let them work it out for themselves. I refuse to show others how to become artists. Besides, it's not something you can teach."

"Dudley, what does it feel like for you when you're on the stage?"

"Honestly, it's a very nerve-wracking experience. Before a performance I pray that the theater will burn down. It doesn't matter what piece I'm

dancing—I'm terrified. For me it's like going before a firing squad. A week before I have to perform, I start sweating, stop eating, and stop sleeping. I think that's why I'm so skinny. The energy I use worrying about performances simply devours me. I have something coming up next Thursday and I'm already sweating. And this is a piece I've been dancing for five years. I shouldn't be nervous. But I am."

"So if it's so tormenting, why do it?"

"Why do it? Because I love it, and I want the love of everyone in the audience. I want to hear those bravos and see those standing ovations. When I meet a stranger on the bus who says to me, 'I saw your performance the other day and you were magnificent,' I'm in heaven. But I never let on that it means so much to me. I say 'Thank you' and act a little humble, but inside I'm shouting 'Yes! Yes! Yes!' That's what I do it for, Rose. I can tell you it's definitely not the money!"

About a year later Dudley and I met again for our photo session.

"I brought some music like you suggested," he said, and handed me a stack of CDs. On top was *A Donny Hathaway Collection*. I placed the disc in the CD player as Dudley stepped onto the seamless and began to stretch.

"You ready?" I asked.

"Go ahead."

I walked over to the CD player and pressed play. A chill ran up my spine when I recognized the piano intro to "A Song For You"—Dudley's signature work. Within seconds Hathaway's clear soulful voice filled the studio. Dudley heard his cue in the music, hinged back, and began to carve the space with his long thin arms as he'd done hundreds of times before in concert halls around the world. But on this day, he performed it solely for me. I got down on my knees and began shooting. I tried to catch every move, every gesture and nuance. His eloquent dance left me trembling. After the shoot, Dudley walked up to me, holding the Donny Hathaway CD.

"Rose," he said, "I watched you during the session and could see how this song feeds your soul. I'd like you to have it," and he handed me the disc.

New York 2004, 2005

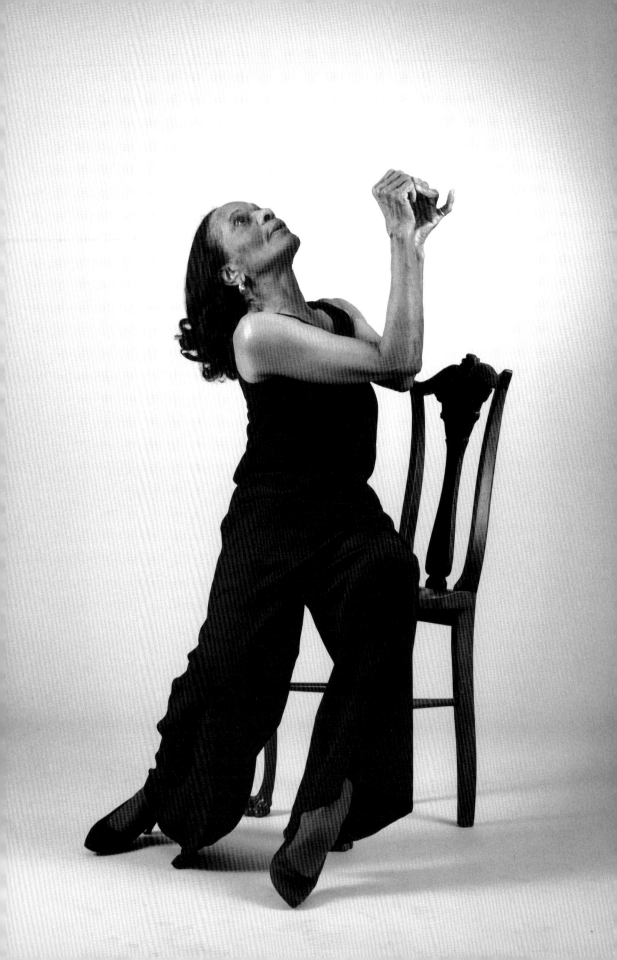

Mary Hinkson

"Here are some mementos of my career," Mary said, pointing to a gallery of framed black-and-white photos in the hallway of her Park Row apartment in lower Manhattan. "I traveled all over the world with the Graham Company. These were taken in Europe."

"What an extraordinary career you've had," I said, studying the photos—a view of the Eiffel Tower, the Colosseum in Rome, the canals in Venice, the streets of Granada, and a stunning window-lit portrait that someone had taken of her in a New York dance studio.

"Where did it all begin for you as a dancer?"

"My dance training began at the University of Wisconsin. I studied under Margaret D'Houbler who created the first university dance department in the United States. My family was dead set against my majoring in dance. 'What are you going to do with that?' they asked. But I was adamant. At the audition I performed the only dance I knew—a Native American Indian dance that I had learned as a kid in summer camp. After the audition Ms. H'Doubler said to me, 'You are not really very prepared, but I sense a real sincerity in you, so I will accept you.'"

"When did you first become aware of Martha Graham?"

"In the late 1940s when Martha and her company performed in Madison, Wisconsin. Ms. H'Doubler required that her dance students attend the concert. Later, after I moved to New York, I took a class she was teaching at NYU. I fell in love with her technique, its intensity and hypnotic quality. In 1951, Martha invited me to perform in *Dark Meadow* with the company as a replacement for one of her dancers. It proved life-changing."

"What was it about Martha that was so. . ."

"Compelling. An aura of drama always surrounded Martha because, well, that was Martha. Her studio on 66th and Fifth Avenue was a magical place. She was all about the physical experience, but you would be mesmerized by her words and imagery. Many times I tried to write down what she said, but her words were so illusive, so poetic, I could never seem to get them down on paper. I was in awe of Martha, but fearful of her too. When she raised her voice, I quaked in my boots. If she yelled at me, 'Don't let me ever see you do that again,' I didn't dare do it again."

"She eventually entrusted you with many of her own dance roles."

"Yes. I danced in *Clytemnestra, Deaths and Entrances, Cave of the Heart, Dark Meadow, Ardent Song, Acrobats of God, Phaedra, Canticle For Innocent Comedians,* and others. She chose me as a soloist based on what she thought I could do. It had nothing to do with whether or not she liked me. She simply thought I was a mature dancer."

"I understand she created *Circe* expressly for you?"

"Yes. After I was married and had a child, I no longer wanted to tour. That's when Martha bribed me. That's the kind of relationship we had. She promised to create a whole new work just for me, if I agreed to go to Europe with the company. So I did. We premiered the piece in London in 1963 to rave reviews. *Circe* was otherworldly and full of mystery. I was the Seductress. Bertram Ross danced the role of Ulysses, and Clive Thompson was the Helmsman; Eugene McDonald, the Goat; Bob Powell, the Serpent; and Dick Gain, the Lion. These people were dancers with a capital *D*."

"Did you have a favorite Graham piece?"

"I loved Martha's *Deaths and Entrances,* originally choreographed in 1943. The first time I performed it was in 1969 for the Blossom Festival in Cleveland, Ohio. But Martha was so disappointed with my performance that she gave me the silent treatment all the way back to New York. She put on her large eyeglasses, took out a book and read—*totally* ignored me. This was during the time that she was drinking heavily and her behavior could be very unpredictable. You see, there's a section in *Deaths and Entrances* that required that I fall back and travel from stage right to stage left. Somehow I could never gain enough ground to make it all the way across the stage on time. After the Cleveland performance Martha decided to rehearse it with me before she'd let me perform it again. This was the first time that she ever worked so closely with me—one-on-one."

"What was that like?"

"That day she pushed me further as a dancer than even I thought I could go. She had a way of driving you with her presence. She leaned over me and roared like the engine of a truck: 'Rrrrrrrrr, Rrrrrrrrrrrr.' But after a while I felt myself wilting under her pressure. To revive me she put her hands on my shoulder, leaned in towards me, and with soft, almost doelike eyes said, 'Maybe I didn't do all these things myself, but I meant to.' This was an incredible confession, an admission that she was not perfect, that even she was human. I never forgot it."

"Martha gave her last performance in 1968 at the age of seventy-two. That's way past when most dancers retire."

"That's right. For her not to dance was painful and tragic. She just could not come to grips with the fact that this was *it*—the end of her

dancing. And I don't think it had anything to do with her age. It had to do with her frame of mind. She had the biggest ego in the world and did not compare herself to anyone. Martha was completely and totally self-involved—an amazing, mysterious, fantastic, creative genius."

"Legend has it that the two of you had a very stormy split."

"Yes, it's true, we did. We had this falling-out in late November 1973. I think it started when I was owed some money. I was advised by some up-scale lawyer to write a letter to Martha demanding payment. Well, if there was one thing you didn't do, it was demand money from Martha Graham—even small amounts. She could be absolutely villainous. After that, Martha set out to destroy me—blacklist me. She even convinced dance reviewers not to write about me. I was pretty disgusted with her at that time. One day I stormed out of the studio and had nothing to do with her again."

"Didn't your contract protect you?"

"What contract?" she said, throwing up her arms. "There were no real contracts in those days, nothing as detailed and thorough as we have today. We were all so in love with the work that we did it virtually for nothing. We barely got paid for rehearsals or performances and received nothing in the off-season. We had to teach or do something else in order to survive."

"What a sad way to end such an extraordinary relationship."

"Yes, very sad. It marked the end of my performance career. I was forty-eight at the time. The breakup was especially sad because I had been part of the Graham Company's golden era—the mid-fifties through the mid-sixties. The things I'm most proud of as a dancer I did during those years when Martha was at her peak, creating many of her signature works: *Clytemnestra, Ardent Song, Seraphic Dialogue, Embattled Garden, Appalachian Spring, Night Journey,* and others. I worked with some of her most legendary dancers: Yuriko, Matt Turney, Donald McKayle, Bertrom Ross, Ethel Winter, Paul Taylor, Glen Tetley, and so many others. She was very hands-on then and we received the full impact of her genius. Those who came later, from the 1970s until her death in 1991, experienced what I call the 'benched Martha.' In those years she taught from a distance sitting on a bench."

"During the years that you were in the Graham Company you also performed the work of other choreographers."

"Oh, yes, we would have long periods off prior to the Broadway season so we could do other things. What immediately comes to mind is the New York City Opera production of *Carmina Burana,* which I performed along with Carmen de Lavallade in 1959. Choreographed by John Butler

and presented with choir and full orchestra, it proved one of the high-lights of my career. John's choreography was minimalist, delicate, and musically driven. I can still feel that solo inside me right now. I interlaced my fingers slowly through the air. The music seeped into my body and then a sweet musical note lifted my arms."

"You also performed with Donald McKayle in what would become his signature work, *Rainbow 'Round My Shoulder*."

"Yes, that's right, and I adored that experience. Donald hadn't yet fully developed his own choreographic style, but his movement was very much his own—not imitative at all. I found his choreography musical, lyrical, playful, and fun to perform. In the final section of *Rainbow* we per-formed a duet—man and woman. I felt he composed it with real matur-ity and drama.

"Over the years I also worked a great deal with Glen Tetley. In 1966, he choreographed a piece for me and Scott Douglas called *Ricercare,* and we performed it at the Metropolitan Opera House. Working with Glen was completely different from working with any of the others. His work was dynamic, intense, and not in the slightest bit sentimental. Typically, his work was very challenging to perform because of its quick and staccato-like changes in the body."

"Do you feel that your collaborations with these great choreographers enhanced your dancing?"

"Oh, absolutely. Every meaningful experience contributes to your be-coming a more complete and versatile dancer—a total dancer. These op-portunities to perform outside the Graham repertory and vocabulary of movement allowed me to experience my body in new and exciting ways. I consider myself very lucky and can say with confidence that I've had a very rich and fulfilled dance life."

"Do you miss the stage—the limelight?"

"No. I'm not one of those who ask, 'Oh God, why can't I?' I know I can't dance the way I once did, and don't want to tarnish my image. I pre-fer to be remembered in my glory. I meet people all the time who tell me that I was fabulous. I'd rather hear this than, 'Oh, is she still trying to do that? She *used to be* a fabulous dancer.' Why get on the stage and just hob-ble around and embarrass yourself? Don't give me some watered-down version of what you used to be. If you can't do it, don't do it. Let's have a cutoff point."

We met again about a year later year later at a photo studio in Manhattan. Mary was noticeably nervous about being photographed.

"Is this outfit all right? I knew I should have worn something else. Should I let my hair down? Do you want me barefoot? You know it's been a long time. Do you really need me to dance?"

I tried to calm Mary and assure her that we would have fun. I suggested that we begin slowly, with her sitting in a chair. Cautiously she stepped out onto the seamless, took a seat, and began to move her long expressive arms and flexible torso.

"Beautiful, beautiful," I called out—*click, click, click.* How about some music?"

"Oh, that would be lovely," Mary said, pushing the chair to the side.

"How does Brazilian music strike you?" I asked, pressing the PLAY button on the CD player.

"Oh, I like this," she said, moving her hips and snapping her fingers to the beat. Soon she was shimmying her shoulders and moving in all directions. I had to remind her to move back onto the seamless and into the light. I continued shooting until I ran out of film. Mary didn't seem to notice. She was too busy dancing.

New York, 2005

Bill Evans

At our very first meeting Bill Evans told me the story of his dramatic entry into the world: "I was actually born on the road in the front seat of a 1939 Ford en route to the hospital. I was six and a half weeks premature and born breech—I came out feet first. When my parents finally made it to our little country hospital some thirty miles from our home in Lehi, Utah, they learned that it was not equipped with an incubator. The nursing staff put me in a small box, opened the kitchen's oven door and set me inside to stay warm. The doctor told my mother, 'He won't make it through the night.' He was wrong."

"Do you think your birth experience has had an influence on your life?"

"Oh, yes. I believe that a traumatic birth has a profound and lasting impact. I don't have any conscious memory of it, of course, but injuries resulted from it."

"What kind of injuries?"

"My developmental movement patterning was affected, along with some other physical deficiencies. To execute complex movement patterns as a professional dancer, I had to compensate for my limitations in coordination and physicality. In my fifties I began movement therapy sessions, which helped correct these deficiencies in my neuromuscular wiring."

"I wonder if your coming in to the world feet first was a sign that you were destined to dance."

"Maybe," he said with a smile. "I was drawn to dance at the age of three, after seeing a man dancing on the movie screen—probably Fred Astaire or Gene Kelly. I started making up my own tap dances wearing my mother's plastic flowerpots on my feet to amplify the sounds when I took steps. I also remember taking my brother's marbles and holding them under my toes so they would click when hitting the floor."

"Were Hollywood musicals your only exposure to dance as a young child?"

"Yes. We lived around the corner from a movie theater. For a nickel I could buy a ticket to see Fred Astaire, Gene Kelly, Mitzi Gaynor, or Vera-Ellen. I liked to imagine myself dancing on the screen with them. But my father, who had been on the Brigham Young University basketball team

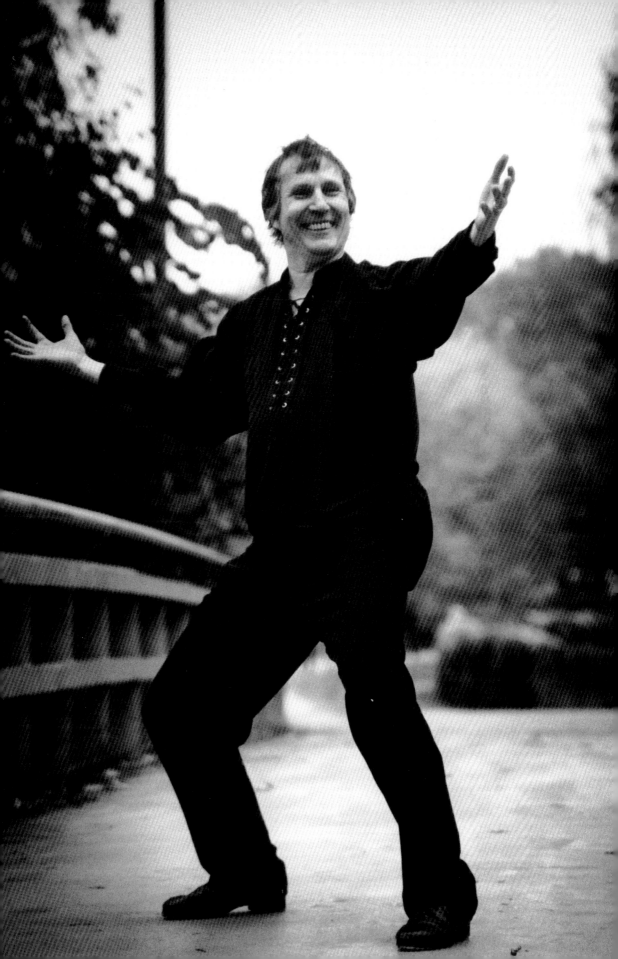

and played professional baseball, dreamed of an athletic career for me. When I told him I wanted to take tap dance lessons, he said, 'Out of the question.' I knew he was thinking, 'How can this boy possibly be mine?' His look of astonishment stayed with me for a long time."

"Did your father eventually support your desire to dance?"

"Well, I continued to pester him, and even though he had a thing about men dancing, he agreed on the condition that I study with a male teacher who had other male students in the class. He found a retired vaudevillian hoofer named Charles Purrington, who had opened a dance academy in Salt Lake City. So at the age of eight, I began taking tap dancing lessons. When my father saw how happy dance made me, he accepted that I was meant to do it and supported me. He even drove me to my tap classes in winter, when the road from Lehi to Salt Lake City was treacherous."

"When did you begin your training in ballet and modern dance?"

"When I was fifteen, my father took me to see my first ballet performance. It was a production of *Coppélia*, choreographed by William Christensen, with the Utah Symphony Orchestra. When I learned that Christensen was teaching classes through a university extension program, I immediately enrolled. Two years later I opened the Bill Evans School of Dance in Lehi and used the income from my school to help finance my college education at the University of Utah. It was during those years that I studied with three remarkable women: Shirley Ririe, Joanne Woodberry, and Virginia Tanner. After graduating from college in 1963, I continued to study dance and performed with a variety of companies, including the Utah Theater Ballet, Ruth Page International Ballet, Oleg Briansky Ballet, and Washington, D.C. Ballet. In 1967 I returned to the University of Utah, enrolled in a Master's of Fine Arts program and became a member of the dance department's performance group. What made that experience so rich was our exposure to many of the era's most distinguished modern dancers, including Anna Sokolow, Donald McKayle, José Limón, John Butler, Glen Tetley, and Viola Faber. In 1967 I watched a rehearsal of the Martha Graham Dance Company, which was doing a residency at the university. Ethel Winter's solo affected me as never before, changing my idea of what a performance could be."

"How so?"

"I realized that dance is not about how high you can lift your leg. It's about what you're expressing. Anna Sokolow reinforced this for me when we performed *Steps of Simon*. After two weeks of rehearsals she came up to me and said, 'Bill, you are a true artist.' I almost fainted. To have Anna Sokolow say those words to me. . . . Oh, my God!"

"What do you think she saw in you?"

"Well, the other dancers in the program had great technique. I didn't. If you can't lift your leg very high, you have to find another way to be expressive. I had to reach into some deep place in order to give 100 percent, and perhaps she saw that. Anna Sokolow believed that artists possessed real power. I was with her when Robert Kennedy was assassinated in 1968. We sat together watching the news on television and she said, 'It's up to the artist to save society.' And she believed it! There was always a social and political purpose behind her work. She taught me to be clear about what I wanted to say, and to strive for truth."

"Who else left their imprint on you?"

"Jack Cole, a genius who could be a tyrant. He taught me about the integrity of the body, the economy of movement, and the importance of exploring every nuance of a movement phrase. Donald McKayle, who brought his West Indian sensibility into the art form, introduced the use of the pelvis and the shoulders accompanied by buoyant rhythms and musical flow. Modern dance up until that time was very earnest. You wouldn't use your pelvis sensually in front of a purist like Anna Sokolow. She'd throw you out of the room. Viola Farber, who had this eccentric style—she had these hyperextended elbows and a very willowy noodlely body—impressed upon me that we can, we can all be different. She would say to me, 'Be yourself.'"

"When did you develop your own dance style?"

"I had been choreographing and evolving my own style since 1968, integrating many of the influences from these great artists I had worked with. When I started the Bill Evans Dance Company in 1974, I revived the tap dancer in me. You see, in my pursuit of physical body strength and athletic skill, as was demanded in modern dance and ballet, I lost touch with the ease, flow, freedom, dynamics, humor, and other qualities that had made me successful as a tap dancer. Now I happily invited these qualities back into my work."

"Describe your state of mind before and during a performance."

"The night before a performance I become acutely aware of my body and my emotions. As the performance draws closer and closer, I often find that I need to calm myself down. Sometimes I'll take a very long shower just so that I can breathe. On stage I experience an altered state; it's a physical high, an adrenaline rush. It's the only time that I feel fully present in my body, fully alive. My emotions and my senses become exquisitely sensitive. And I love sharing these sensations with my audiences and other performers."

"You certainly go all out."

"That's because I don't want to be less than my best. If I let myself down during a performance, it causes me emotional distress and anxiety. It's not that I'm afraid of letting people down. It has more to do with the fact that I feel a sacred trust with the material, and I don't want to violate that trust."

"Tell me about your most memorable dance experience."

"It was in 1978 when I performed with my namesake, jazz pianist Bill Evans at the University of Washington before twelve hundred people in a program called *Double Bill*. As the curtain went up, I felt the power of his music seeping into me, supporting me and animating me so that I was able to go beyond my physical limitations—to cover more space and achieve greater lightness and freedom than I'd ever had on stage. After that experience I understood why some people believe that music and dance have magical powers."

"Following that high point you experienced some tough times."

"That's right. About a year after my performance in *Double Bill*, my dance company folded when funding dried up, my seventeen-year relationship with my life partner Gregg Lizenbery crumbled, and then my father died. These three incidents caused me to spiral down into a profound depression. I was forty-four and in a state of complete hopelessness. It lasted a better part of a year. Finally I came to the realization that I was the one responsible for my own well-being and happiness, and that it was up to me to pull myself together. I began to appreciate relationships and other good things in my life that I had taken for granted. As an affirmation that I'd come through this dark period, I choreographed *Soliloquy* and performed it to music by my good friend Bill Evans. It's a simple piano solo with a structure of chord progressions and melodic embellishments. *Soliloquy* was a dance of healing—a creative movement metaphor that reflected personal memories and the pain and joy I had experienced to that point in my life. It was the first time that dance had became a form of therapy for me."

"How exactly did *Soliloquy* help you?"

"With *Soliloquy* I turned a new corner. In the past I had always looked outside for approval from the outside and depended heavily on good reviews. But starting with *Soliloquy,* I found I no longer *needed* such endorsements. I was now dancing to discover myself."

"What do you think your future holds for you?"

"Honestly, I don't know. And I don't how much longer I can expect to dance. I am focused on the day-to-day, on the joy and stimulation I

experience from teaching my classes and working on performances. I've come to cherish every moment. I do know that dancing and making dances are as necessary for me as breathing and that the most difficult, heart-pounding, muscle-burning day of dancing is better than the most tranquil day without it."

East Lansing, Michigan, 2004

Brenda Bufalino

Gregory Hines hailed Brenda Bufalino as "one of the greatest female tap dancers that ever lived." Her virtuosity took her onto America's most prestigious stages: Carnegie Hall, Avery Fisher Hall, the Apollo Theater, Smithsonian Institution, and the Kennedy Center. But perhaps her greatest achievement was as one of a handful of women who are responsible for reviving tap dance after its demise in the 1950s.

Before asking Brenda how she helped save tap dance from the dustbin of history, I inquired about her earliest dance experience.

"I was sent to dance school at the age of five and began performing in my mother's act when I was eight. My mother and my aunt—The Strickland Sisters—sang medleys, and I danced. By the age of fifteen I was performing in nightclubs in and around Boston in an interracial review where I danced Afro-Cuban and tap and sang torch songs."

"How did your dance path unfold as you grew into an adult?"

"I moved to New York City in 1954 at age seventeen with nothing but a little suitcase and a hundred dollars. But my career was problematic from the start. I was part Italian, English, and Native American Indian, but drawn to black music and dance—Afro-Cuban and American tap. I wasn't black, so I didn't fit into Katherine Dunham's African-American Dance Company or Talley Beatty's group. I tried auditioning for Broadway shows but was told that my style was too individualistic and never got picked. I had no direct dance path, and no one knew where to put me."

"So what did you do?"

"Well, this was a period when calypso music was all the rage. I put together an act comprised of jazz standards and calypso songs. I had never sung calypso in my life but I figured if I danced really well, I wouldn't have to sing that well. It worked for Fred Astaire, so why not for me? I got booked in the Calypso Room, the African Room, the Blue Angel, and even headlined at the Café Society. That lasted for a couple of years, until the calypso fad died out. But the 1950s was a great time for dance—all sorts of styles were thriving in New York. I studied jazz with Matt Mattox, modern-primitive with Syvilla Forte, Talley Beatty and Walter Nix and Afro-Cuban with Chino. It was also around that time that I met and was mentored by

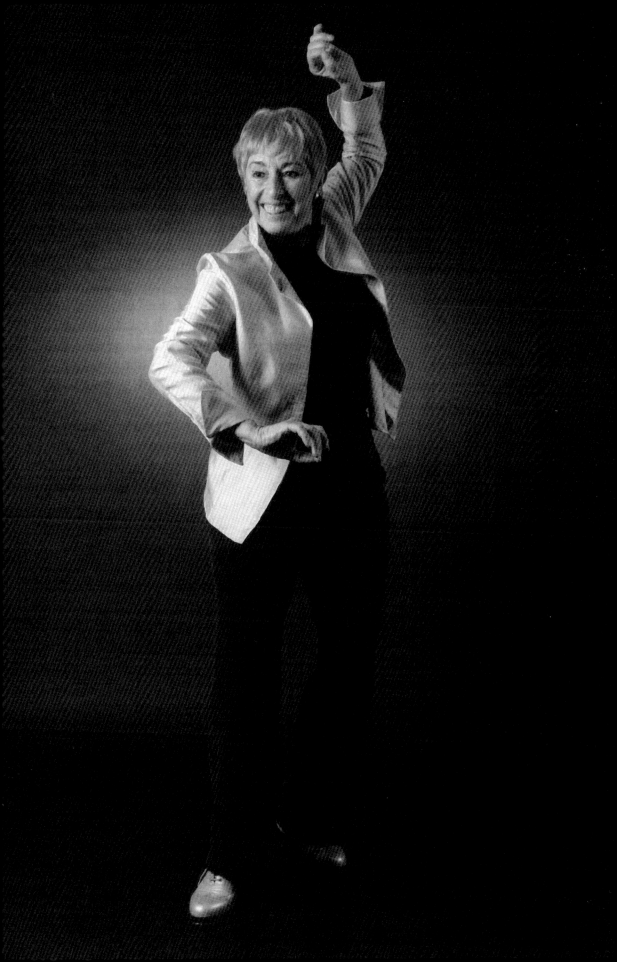

Honi Coles, who was known as having the fastest feet in the business. He, along with Cholly Atkins, had created a very successful tap career during the 1940s. But by the time I met him, tap was on its way out and fewer and fewer dancers were studying it. By 1959 tap dance was dead."

"So again, what did you do?"

"From there, I entered the avant-garde. I worked with a composer named Ed Summerlin, and together we created performance pieces for the National Conference of Churches. During the early 1960s the NCC was one of the biggest supporters of avant-garde jazz and performance art. Our shows included monologues. This was definitely an era of poetry, especially in the dark coffeehouses of New York. I wrote entire jazz librettos for Ed's music, which was often performed within the liturgy of church services."

"Did you see yourself more as an entertainer or an artist?"

"I saw myself as a dancer who was an artist, or rather, as an artist who was also a dancer. I think there's a difference between an entertainer and the artist. I had a broader, more holistic vision than a chorus girl might— not to cast aspersions on chorus girls—but what I'm talking about is living an artistic life of adventure."

"What you're talking about is usually expressed by modern dancers— you know, investigating one's deeper self through movement."

"Well, this was the milieu that I wanted for myself. I wanted to work from a personal vision—write and arrange my own harmonies and dance my own dances. No one could do it for me. Dance was, and is still, the greatest opportunity for me to be fully present in my body, acknowledge my strengths, admit to my weaknesses, and be linked in some way to a universal energy."

"You've been called a trailblazer for tap dance and responsible for its renaissance. What was your strategy to bring it back?"

"Well, when I decided in the late 1960s and early 1970s to bring back tap dance it would have to have a new appeal. You see, traditional tap dancers performed routines, which repeated again and again. And even though their routines originated through improvisation, they performed set pieces on the stage. I wanted to compose dances and incorporate improvisation within them. My compositions were free and unrestricted, so I could play with meter, tempo, and rhythms and move in and out of dance styles like bop or swing—whatever I wanted. My manipulations were highly original and extremely challenging."

"Did your compositions have themes?"

"I combined tap dance with storytelling. My stories were autobio-

graphical and based on what was going on in my life at the time. This had never been done before—to put tap dancing into a narrative context in which you created an atmosphere. One of the first shows I did was called *At the Junction*. I composed it when I was at a major crossroads in my life—one thing ending and another beginning. You know, tap had always been *smiles*—happy, happy, happy, demonstrating no emotional depth. But I was a product of the avant-garde movement of the 1960s. I looked to produce tap pieces that were imaginative and poetic, and performed on the concert stage. This was a major departure for tap dance, which had never been performed or viewed as concert art. It thrived during the vaudeville era and was popular in nightclubs, music halls, Hollywood musicals, and later on television—but, with the exception of Paul Draper, was never performed on the concert stage."

"How did you do it?"

"Initially I incorporated tap dance into the context of my avant-garde performances and the public liked it. That's when I realized, 'They're ready for it.' I followed up by presenting Honi Coles and members of the famed Copasetics in workshops and performances in my studio in New Paltz, New York, from 1973 to '75. In 1975 with the help of a NEA grant, I produced and directed them in a two-hour documentary called *Great Feats of Feet: Portraits of the Jazz Tap Dancer*. I wanted to do more with my company of performers, but no one knew how to tap dance. So I had to teach them. In 1978, along with Honi Coles, we gave our first full-length tap dance concert at New York City's Pilgrim Theater. It received rave reviews. I followed up by presenting Honi Coles and members of the Copasetics in upstate New York where I was teaching. Next, Bufalino and Company embarked on a national tour doing tap dance workshops and performances. Slowly a new tap scene began to emerge. Soon tap dance schools and performance ensembles sprung up all around the country. From the mid-'70s through the '80s, Broadway shows that featured tap dancing, like Tommy Tune's *My One and Only*, Danny Daniels's *The Tap Dance Kid*, Coles and Atkins's *Black and Blue*, Gower Champion's revival of *42nd Street*, and choreographer Henry Le Tang's *Eubie* and *Sophisticated Ladies*. Jazz Tap Ensemble, a West Coast–based performance group, offered guest spots to many of the great tap masters who had long retired, among them Jimmy Slyde, Buster Brown, Bunny Briggs, and the Nicholas Brothers. It was during this time that Gregory Hines discovered a young prodigy, Savion Glover, and brought him along to work with the great veterans of tap. Savion would eventually

take tap in a whole new direction."

"Is this also the period that you created your famous American Tap Dance Orchestra?"

"Yes, my vision for concert tap actualized in 1986 with this company. I danced, choreographed, and served as its conductor. The company consisted of eight dancers, two vocalists, a piano player, a bass player, and myself. We got off to a great start and were very well received by audiences. And when PBS did a TV special, *Great Performances: Tap Dance in America,* with Gregory Hines, it just catapulted us. After that I initiated and collaborated with producers of tap dance festivals internationally, that helped reestablish tap dance."

"What was it like working closely with the legendary Honi Coles?"

"Honi was my mentor, partner, and collaborator. We shared ideas, but our collaborations often grew out of passionate discourse and heated arguments. A lot of the time he didn't understand what I was doing or why. I was always up against his intellectual muscle. His questioning of my ideas forced me to analyze them because I knew I'd have to defend them. But Honi totally supported the mission and the orchestra. He even donated the first five hundred dollars towards costumes of white ties and tails, and through his connections we were able to do a very important benefit concert at the famed Cotton Club."

"As your mentor, what did he leave you with?"

"You remember I had studied with him in 1955. What I learned from him, I got from just listening to him dance. His classes back then were really jam sessions—but with some of the greatest tap dancers who ever lived. I *heard* what he was doing rhythmically and *saw* what he was doing structurally, and without my really being aware of it, absorbed it into my own way of dancing. I only realized this fifteen years later, when we were reunited and appeared on the stage together; our dancing was very similar. Even after his stroke, Honi was still involved in my work, and we remained very close until the day he died."

"How demanding is tap as compared to other dance styles?"

"I've done just about every dance style that there is, and tap is the most complex—intellectually, emotionally, and physically. The number of manipulations you have to create with your feet is extraordinary. It's like your feet are playing a conga drum. You're developing all the parts of your foot to achieve different tone qualities. Then you have to figure out how you're going to shape it. I'm a crawler. That's my style. I look like a centipede crawling along the floor. It took years and years of developing

manipulations to do that. There is a limited set of patterns for tap, so you have to develop your own. Also, the tap dancer will dance differently at different stages of his/her life. In the early stage you're going to do big things that are incredibly demanding. You're going to do wings , over the tops, and very strenuous things. I don't do that any more. What happens when you get to my age is, you switch to the mind, and the mind takes over. Your compositions are more subtle and complex. You no longer have to do five thousand wings and over the tops to get a hand."

"So the tap dancer can maintain a fairly long dancing life."

"You can master a piece when you're fifteen, another piece when you're twenty, and another when you're thirty, and so on. But it takes a lifetime to completely master the art of tap dancing."

"Where are you now in your mastery of tap?"

"Well, I don't know exactly because I don't know how much more invention or development of my physicality I need to do. I think I have as much technique as I need to compose what I'm hearing in my head. I may, however, find out later that I'm wrong about that. The tap dancer is both a composer and a choreographer. We may compose rhythmic patterns, but that's not choreography. Choreography comes when you shape what you've composed. I do feel that the composer in me has a long way to go. There is really no end to that."

"Do you think a time might ever come when you'll no longer want to dance?"

"I don't know. But I can tell you that I will not perform on the stage if my form is not up to par. A lot of tap dancers are so charming; they get up and do a few things, and the audience just howls because they love them so much. That's not me. I don't have to dance if my feet aren't tight. Yet, after a lifetime of performing, choreographing, and teaching, I think giving it up could be very tough. At sixty-seven I'm already one of the oldest women on the circuit. I've lasted in this profession longer than most, and I'm still making a living at it. I've asked my students and the musicians I work with to please tell me when I start to slip. You can fool yourself into thinking that you can still do it. But I don't want to fool myself. I can dance in my living room. I don't have to get up onstage with it."

"If you abandoned dancing, how would you express yourself?"

"Fortunately for me, I write, I compose music, I sing, *and* I dance. So there's a little wheel that I can travel in my life. If I can't do one thing for a while, I turn the wheel to the next. The point is to keep traveling in your art, and in my case, that's not only in my feet."

"Brenda, I have a feeling you'll always dance."

"Maybe you're right," she said, shaking her head. "You know, when my mother came down with Alzheimer's disease and didn't recognize me any more, she was asked by one of the nurses, 'Do you know that woman?' My mother looked at me and said, 'Why, yes, she's the girl who dances.' When I heard her say that, I realized that is who I'll always be—'the girl who dances.'"

New York City, 2004

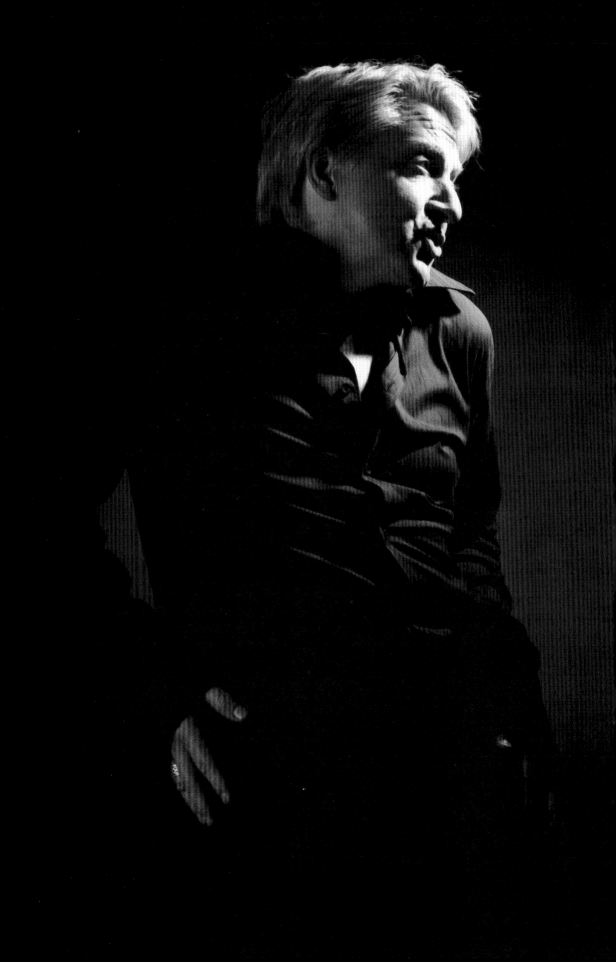

"Ask me anything. I have no secrets," said the former Fosse-style dancer who had performed in more than ten Broadway musicals over his thirty-year performance career.

"Let's start at the beginning then. When did you first feel the urge to dance?"

"I remember it very clearly, even though I was only five. I was at my aunt's house in Memphis, Tennessee. We were having chicken goulash and someone put on an Elvis Presley record—"It's Now or Never." Without thinking, I got up and started to dance. Before I knew what hit me, my mother had enrolled me in dance lessons at Martha Scott's Dance Studio. When my family moved to New Jersey, I continued ballet training with Betty Hocter.

"I was different than most kids. I was severely dyslexic. That you might have a learning disability never occurred to anyone back in the '50s and '60s. You were just considered dumb or retarded. All these labels were put on me. But the only place these labels did not apply was when I was at dance. Dance would soon become my salvation and the studio my safe haven. It was the only place where I felt good about myself, and Betty took me under her wing and protected me. She treated me like a son and did everything in her power to help me. She often took me with her when she attended classes at the Ballet Russes de Monte Carlo School on 57th Street in Manhattan. Even at the age of ten I knew it was pretty extraordinary to take class there with great teachers like Madame Saboda, Madame Perislavic, and Leon Danellian. It was not unusual to find a place at the *barre* right next to Rudolf Nureyev, Margot Fonteyn, or Merle Park. Eventually I became a regular at the Ballet Russes school and continued studying there until it closed in the early 1970s. From there I went to the American Ballet Theatre School."

"So you were set on a ballet career."

"Well, even though I was training in ballet, I had my eyes on Broadway. My parents were Broadway aficionados and took me to see all the great musicals. I was drawn to dancers like Gwen Verdon, Chita Rivera, and Tommy Steele. The emotional impact that these dancers had on me, I wanted to have on others. When I was about seventeen, I spotted an ad in

the paper for auditions for a revival of *On The Town,* Jerome Robbins's *Fancy Free* made into a Broadway show. I went to the audition and got picked! My God, I got picked! I remember breaking the news to my parents—'I'm dropping out of school. I'm not going to college. I'm going to dance on Broadway!"

"When did you begin your relationship with Bob Fosse?"

"Ahhh . . . Mr. Fosse," he said, his eyes lighting up. "I met him in 1972 when I came to an audition for his Broadway show *Liza With a Z.* All I knew was ballet, so I came to the audition dressed in a striped T-shirt, tights, and ballet slippers. Can you imagine? I found myself surrounded by big muscular guys with beards and goatees wearing boots, earrings, and bandannas. And here I looked like Buster Brown. Fosse kept staring at me and finally said, 'What am I going to do with you?' 'Hire me!' I yelled, and just then my voice cracked. Everybody burst into laughter. Talk about being mortified! Fosse stood there appropriately amused, his cigarette hanging from his mouth."

"So, did he hire you?"

"No, not then. I came back later in 1974 to audition for *Pippin.* And you know what, he remembered me. 'I know you,' he said. This time he hired me, and I've never been able to figure out why. I had no real jazz experience. But because he did choose me, I decided to give him whatever he wanted. I gave 110 percent. The experience would change my life."

"What was it like for you to move in the Fosse style after having danced only ballet?"

"It went against everything I had ever been taught. It was dark and decadent. It was sensuous and sexy. It was liberating and therapeutic. It allowed me to feel my body and tap into emotions in ways I never thought possible. I found it comforting just to be around him. I could be myself. He made me feel safe. Every time he looked at me, I felt that he was seeing the real me. There was something about his eyes that was absolutely intriguing. Bob Fosse gave you the feeling that you could trust him. He never made his dancers look bad or ridiculous. Because of that we gave him everything we had."

"As his dance captain you must have learned a great deal about choreography and performance."

"Mr. Fosse taught me indirectly, which was a more powerful approach than if he'd sat me down and explained things step-by-step. If you paid attention you learned a lot, especially if you were on the inside track like I was. When you're a dancer, you're only given what you're supposed to perform. You never experience the dance in its complete vision. As dance

captain, I witnessed the dance emerge and saw how Fosse put it together piece by piece. I learned not only my part, but everyone else's part. His choreography was conceived of imagery and story—not steps. For him, musical theater was storytelling. The dances were like dramatic scenes with a beginning, middle, and end. I wanted to know at any given moment what he was doing, so I kept a written log—my dance captain's book. I recorded what he created and how he changed the choreography for specific dancers. The work was always evolving. This gave me an understanding of Mr. Fosse's process at its core."

"*Dancin'* [1979–1982] was one of Bob Fosse's most successful shows, the first Broadway show to have virtually no dialogue and little singing—an all-dance show. What was that experience like for you?"

"You're right, *Dancin'* was a landmark in musical entertainment and proved a huge financial success. But for me, as the show's steward, it was a painfully difficult time."

"Really? Why's that?"

"The pressure on me was enormous. Mr. Fosse relied on me to keep the show's choreography clean, make the list of who would dance in the different numbers and pick replacements. I had to know the guys' parts and the girls' parts, be on the stage and behind the scenes. We rehearsed seven days a week for what seemed like years. It was a miracle every time the curtain went up and the curtain came down and no one got killed. I was barely able to cope. It was then that I started drinking."

"You became an alcoholic?"

"Yes, big-time—and a drug addict. But I've been clean now for seventeen and a half years."

"Did you perform while intoxicated?"

"Oh yeah. . . . Oh . . . yeah. And I put people's lives in danger. Just imagine all those lifts. I could have dropped someone on her head. It was a horrible thing to do. The pressure of maintaining the show along with everything that was going on in the 1980s, like the plague [the AIDS epidemic], literally drove me to drink. AIDS took the cream of the talent pool, leaving this gaping hole in the dance community with few heroes for the next generation. And many of Broadway's seasoned dancers and choreographers were retiring or dying off. On top of that, I was starting to feel my age. And you know, when you're older and there is a younger group coming up, 'the young shall inherit the earth and the old shall die.' Here were all these young dancers coming in from Nebraska and places like that, who saw the show as nothing more than a job—a gig. They wanted to be *told* what steps to do. 'You're the choreographer, show me

what you want,' they would say. I didn't know how to deal with dancers that had no idea how to work collaboratively with a choreographer to create something special. It was the beginning of a new era that I didn't quite get."

"Was there no one you could turn to for help?"

"I didn't know whom to turn to, and I didn't have the tools to help myself. I knew the choreography so well, and Mr. Fosse had bestowed upon me this huge responsibility to hold things together. I didn't want to let him down or screw things up. I didn't want to give anyone a reason to call me stupid. I'd been through that enough in my life. So I just tried to keep things going. If you ask people about me during that time, they'll tell you I was a tyrant. And I was. I fired people and was pretty coldhearted."

"How did you turn things around?"

"It stopped one day like *that*," he said, with a snap of his fingers. "I made the decision to get sober and write a new chapter."

"I understand you were responsible for creating *Fosse*, which won a Tony for Best Musical."

"Yes, I came to Mr. Fosse with the idea of doing this show in 1986, a year before he died. At first he was reticent, but then he agreed, but with one stipulation: 'I don't want anyone in the show who has ever worked with me before.' When I asked him why, he explained, 'I don't want anyone telling me what I did before.' I loved the idea that he wanted the freedom to infuse new ideas into his earlier works and not have people say, 'No, it's supposed to go like this.' He suggested that if I wanted to go ahead with the show, I should start a company and train the dancers. So I did that for three years with the help of Gwen Verdon. Then we began workshopping it for Broadway. The show *Fosse* was well under way when he died in 1987."

"Where were you when you learned of Fosse's death?"

"I was in Washington, D.C., at the National Theater working on a revival of *Sweet Charity*. Both Bob and Gwen Verdon were overseeing the production. I was working with some of the dancers when I noticed Bob walk out of the theater. That was the last time I ever saw him alive. He died in Gwen's arms moments after leaving the theater. None of the cast knew what had happened until after that night's performance. The stage manager gathered us all around after the bows and broke the news. When I learned of his death, I became enraged—out of control. I put my fist through a wall. Moments later I fainted. I wasn't ready for him to leave us. Selfishly, I wanted more. How could this happen *now*, with our new show, *Fosse*, in the works? I was devastated. Later that night I phoned my

mother and sobbed like a baby. 'Stop crying,' she told me. 'This man has given you so much. Now is your opportunity to give back.' And she was right. I decided to stop performing and dedicate myself to teaching jazz, choreographing my own shows, and restaging Fosse's work all over the world." [Just days after our meeting, Chet traveled to Argentina, Norway, and France to restage *Sweet Charity*.]

"What ever happened to that irrepressible little boy who danced to the Elvis Presley record?"

"He's somewhere inside of me—burning on a low flame, like a pilot light. I no longer have time for dancing. Those of us who performed with Bob Fosse have a responsibility to see to it that jazz is not reduced to trash, that it enjoys the same respect as ballet and modern dance. I'm committed to promoting the history and legacy of jazz."

"Before you arrived for this interview, I really wasn't sure how to photograph you. But I know now."

"Is that right?"

"Yes," I said. I unplugged all the lamps from my power pack except one and elevated it on a stand several feet into the air—pointing down. Chet took a comb out of his pocket and ran it through his fashionably cut blond hair. I motioned for him to stand underneath the lamp. He stepped into place and awaited my instruction.

"This is going to be very bright," I warned, pressing the button on my light meter and blasting him with white light.

"How does that feel?" I asked.

"Intense."

"Exactly. Now just turn up the flame of that dancer inside of you and show me some jazz."

New York City, 2004

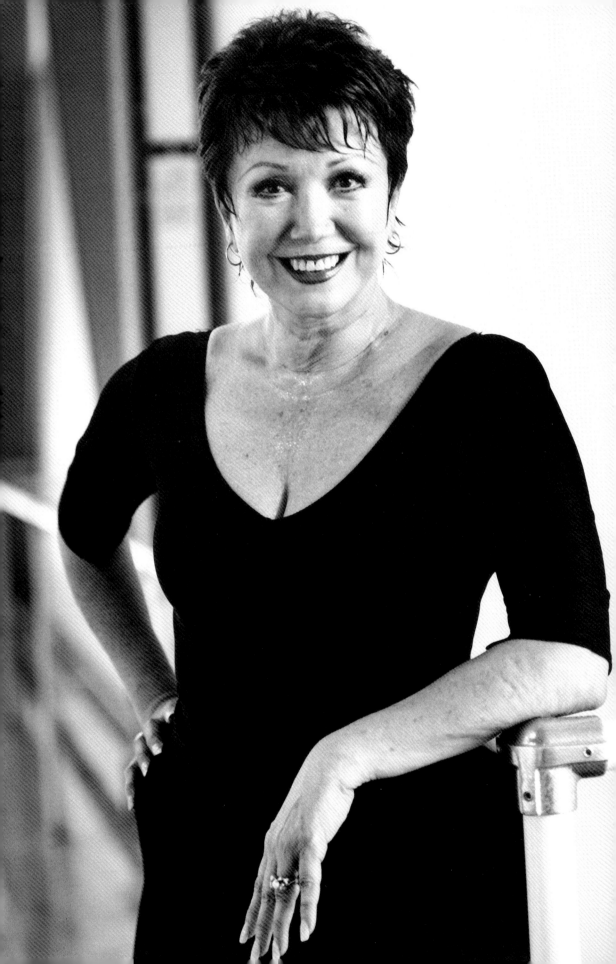

Donna McKechnie

Donna McKechnie, one of Broadway's most famous triple threats, began her professional career with an act of rebellion at the age of fifteen.

"I got a job doing winter stock in Detroit, which enabled me to get an Equity card. Later the director David Tihmar asked me if I thought my parents would let me travel with his touring company. It paid seventy-five dollars a week. We were very poor, so I was thrilled. But my parents said no. They wanted me to finish high school. I remember saying, 'What do you mean, no? This is my big break!' I went anyway. There was really no stopping me. I puffed up the pillows in my bed, covered them with a blanket to make it look like I was sleeping, and I took off with the company. My running away from home brought great pain and shame to my family. With the exception of my mother, my little girl ballet classes were never taken seriously, but as I got older and talked passionately about a career as a dancer, it became a point of contention with my family's puritanical sensibility. I felt terribly guilty afterwards, and it took years of therapy for me to get over it.

"What made you do something so bold?"

"I knew that jobs for dancers didn't come to my hometown very often. This was a chance of a lifetime. It offered me an opportunity to get out of Detroit. At the time, I couldn't think of any other way. I knew that once I got to New York, I could get hired as a ballerina."

"What happened once you got there?"

"I auditioned for American Ballet Theatre, but they didn't pick me. I was told to continue studying and that maybe I'd be picked the following year. Instead of thinking about that as a positive thing, I took it as a total rejection of my ability. I felt desperate. I needed to show my parents that I could survive. My mantra was 'I'll show them.' The need to prove myself powered my drive."

"What did you do next?"

"There weren't a lot of ballet companies around in those days. So I did what most ballet dancers did—I went to Radio City Music Hall and auditioned for the corps de ballet. Back then they had the Rockettes and a corps de ballet. Let me tell you, that was the hardest audition I've ever had in my life—harder than ABT. It was like thirty-two *fouettés* to the right,

thirty-two *fouettés* to the left, and then *relevé arabesque* across the floor, which was the size of a football field. I got the job, but they had me doing things like gracefully picking up baskets of lilies and putting them down. This wasn't dancing. I was crazed. I had to be dancing. I quit. I didn't even give notice. I just didn't show up for work. Up until that time, I looked down at jazz and theater dance, but I could no longer afford to be that cocky. I needed a job."

"So you auditioned for jobs in theater?"

"Yes, and landed a summer stock role in *Carousel,* playing the role of the daughter. John Raitt played my father and Inga Swenson my mother. It was a dancer's part, but within a highly dramatic scene. Working with professionals and moving out of the chorus led to my decision to work towards a career in musical theater."

"Where did you live?"

"Hell's Kitchen—54th and Ninth. It was a pretty raunchy neighborhood back then. I earned enough to pay rent in a shared apartment with a couple of other girls."

"Then came *How to Succeed in Business Without Really Trying* [1961]."

"Yes. This was my first Broadway show. For me it was like going to musical theater university. I took it all in. I was working in a Pulitzer Prize-winning show, produced by Cy Feuer and Ernest Martin. Frank Loesser of *Guys and Dolls* wrote the score and Abe Burrows directed."

"And Bob Fosse was the choreographer."

"Oh, yes. This was a far cry from dancing in white tulle. Bob Fosse's wild style, isolations, energy, and going down instead of up and out created a whole other feeling in the body. The dancing was expressive, but also connected with a story line, music and song. You have to understand that this was Jack Cole's era, and his infatuation with African and Eastern dance was popular in theater and in films. He generated a sensual and seductive, almost forbidden expression with its Latin and Afro-Cuban moves and rhythms. Performing these shapes and dances was very exciting. I realized that in order to have a career in musical theater I'd need to learn how to act, sing, and dance. During those years I could never save any money because I spent it all on acting, singing, and dancing lessons.

"Did it ever occur to you that you might not succeed?"

"No."

"Why are dancers so desperate to dance?"

"Because it's such a short-lived career. You never know if an injury will take you out. And if it doesn't, aging will. The dancer has an intense desire to express herself, but few opportunities in which to do it."

"Tell me about dancing on the television show Hullabaloo in the mid-sixties."

"It was a great variety show on NBC with an award-winning team of producers and directors. It had a wonderful format, featuring all the big pop artists of the day, including the Rolling Stones. I remember the dance number we performed when the Supremes came on. The Hullabaloo Dancers often did their own big dance numbers. It was a great job and paid three times more than Broadway. Members of my family started to see me on television, and this was a big deal because they were basically in the dark about what I did as a dancer."

"This was where you met Michael Bennett?"

"Yes. We were both Hullabaloo Dancers. He knew what he wanted from the very beginning. When I met him he had a core of dancers that he worked with from previous shows. He had people following him around like little ducks. Michael showed real potential as a choreographer, and dancers knew that he was up-and-coming. I started to tag along too, but I was still very independent-minded. My ambition was to become a great singer, a great actress, and a great dancer. I asked Michael, 'What do you want to do when you grow up? You can't dance like this your whole life.' 'I'm going to be a choreographer,' he told me. It was the way he said it, that I knew nothing would stop him. All of the things I wanted to be and do, like incorporate the disciplines of acting, singing, and dancing into musical theater, would come together working with Michael in *A Chorus Line*."

"How did the idea of *A Chorus Line* come about?"

"For a long time Michael had an idea of doing a show for dancers. He invited twenty-four dancers to come together for a weekend to talk about what it meant to be a dancer. We sat around in a circle in front of a reel-to-reel tape recorder. Michael said, 'Just state your name, where you're from, and why you want to dance.' Those are the three questions that start the show. It was amazing to learn about the people you had worked with to hear their secret desires and the things that you had in common with them. Several of the women said that the movie *The Red Shoes* had changed their lives, as it had mine. Lyricist Edward Kleban wanted to get more specific ideas about the dancer, so he interviewed a few of us and used our conversations to write the show's phenomenal songs."

"What was it like talking about these deep feelings?"

"Having never spoken about my relationship to dance, I had difficulty verbalizing my feelings. But Kleban captured what I said in a very poetic, eloquent way, and translated it into language that every dancer could relate to."

"Why is it so hard for dancers to talk about dance?"

"Dance is something that you *do*—not something you talk about. It's abstract and emotional. Art comes from a private, hidden, never fully understood place. You lose yourself in it. You become one with the music; it's godlike; it's spiritual. To talk about it is to trespass in a restricted zone."

"Was your portrayal of the character Cassie in *A Chorus Line*, for which you won a Tony Award, based on your own personal experience?"

"Actually, much of my personal story was written into the characters of Maggie and Judy. Cassie was the most fictionalized because her character needed to feed the dramatic relationship between her and the choreographer. If you recall, in the story Zach asks Cassie, 'What are *you* doing here?' when she arrives for the chorus call. She answers, 'I want a job. Everyone deserves a chance. I'm desperate. I need a job, and I'm asking you to give it to me.' That part of the story is based on something that actually happened to me years earlier. I was desperate to get out of my first marriage and needed a job badly. I went to choreographer Jaime Rodgers, who was choreographing *The Education of Hyman Kaplan.* I begged him for a job. I told him, 'I know it's a show about Jewish immigration and I'm not right for it, but I'll do anything, bring you coffee, be your assistant, anything you want.' He said, 'Let me ask George Abbott how we can give you a part.' I'd never before found myself in that begging place, so vulnerable and desperate. If dance is all you know how to do, you'll beg to survive. I did get a part in the show and this incident became central to Cassie's character."

"I read that Michael Bennett once said, 'Jerry Robbins had Chita Rivera, Bob Fosse had Gwen Verdon, and I can't tell you how happy I am that Donna is mine.'

"You've been called Michael's muse."

"Ours was a real artistic collaboration. I could interpret what he wanted to say in dance. I was able to take his vision to another place, and even go beyond what he could choreograph. He loved my dancing, my line, my dynamic, but more than that, it was the emotional connection and power I could bring to his choreography. I could do a solo number on the stage and stop the show, but I couldn't do it without him. He found in me someone who could take his ideas, bring them to life and make them commercially successful. Artistically, he was always reaching for something new and different, and so was I. We complemented each other."

"Your relationship with him was also a personal one."

"Yes, we loved each other and wanted to be married. It's that simple. Looking back on any given day I can say, 'What a mistake it was to have married him' or 'It was great to have married him.' Marriage seemed logical at the time because our individual dreams converged in what would become our child, *A Chorus Line*. We both came to New York to achieve something, to be part of something. And here it was. *A Chorus Line* would win nine Tony Awards and become the longest-running Broadway show in history—fifteen years. It played in twenty-three countries and in just as many languages. And it changed the landscape of musical theater. To be in that show you had to sing, act, and dance. We put everything we had into that show. But then we divorced, and I left."

"Were you with Michael at the time of his death?"

"No, I hadn't been friendly with Michael for about ten years. I heard on the radio that he had died. At the time, I was opening with Bob Fosse in Toronto, doing *Sweet Charity*. Three months later, Fosse died. That was some year."

"At the height of your dancing career you were hit with rheumatoid arthritis. You must have felt like the painter who loses his eyesight."

"Yes, it just swept over me. It seemed sudden at the time, but it was probably brewing in me for a while. Doctors told me that eventually I would be unable to walk. Fortunately, I found a holistic doctor who was able to turn things around for me. I was one of the lucky ones. Not only was I able to put it in remission, I no longer show any signs of the disease. My recovery was not magic. I had to apply certain behaviors. And If I can do this, anybody can do it. This is why I've written a book, *Time Steps: My Musical Comedy Life*, with Greg Lawrence. I want to tell my story and hopefully give hope to others. I can't tell people how to treat the disease because everyone's chemistry is different. But I turned mine around through a diet change, vitamin therapy, yoga, and psychotherapy. I believe the disease was brought on by stress. There's a saying, 'If you throw your feelings out the window, they'll come in through the back door and kick you in the ass.' This was my kick in the ass. When you go year after year denying your feelings and emotions, you're bound to upset the body-mind balance. I was in complete denial about certain things in my life. Feelings don't just evaporate; they have to go somewhere and if you don't respect them, they'll be pushed into your muscles as you do your daily *tendus*. This is what I was doing. Luckily I was able to get help."

"How fares the dancer within as you contemplate the future?"

"Very healthy, I think. I dance in my shows and take class at STEPS whenever I can. It's funny, every time I'm there I see this old woman who's got to be around ninety, her skin hanging from her bones. She does her pliés very slowly. And I think to myself, 'That's me. That's me at ninety.' If I can still walk when I'm that age, I'll be right there too, working at the barre, doing my pliés and *tendus,* skin hanging from my bones."

Great Barrington, Massachusetts, 2005

Mitzi Gaynor

As I pulled into the driveway of her Beverly Hills home, the tune from her film *South* Pacific kept running through my head: "I'm gonna wash that man right out of my hair. I'm gonna wash that man right out of my hair."

I was greeted at her door by— of all people—her hairdresser! "She'll be right down. Just make yourself comfortable," Tommy said, leading me into her sprawling living room.

Twenty minutes later, Mitzi Gaynor walked into the room wearing white capris, a satin lime-green blouse, and high-heeled sandals. In her mid-seventies, she was still gorgeous.

"Ah, Rosie. Oh, may I call you Rosie?" she asked.

"Sure."

"Come baby, let's sit down over here," she said, pointing to one of the sofas.

"Mitzi," I began, turning on my tape recorder. "I have a feeling that the dancer within you is still as vibrant as ever."

"I've never known a moment in my life when I wasn't dancing or trying to amuse and amaze—and still am. I love to dance and I love to work. When I was under contract with Twentieth Century–Fox they called me Rita Rehearsal. I couldn't wait to get to the next project. 'When do we go again? What time is rehearsal?' I come from a show business family you know. My father was a well-known Hungarian cellist and my mother and her sisters were dancers—exhibition ballroom and ballet."

"How old were you when you began your dance training?"

"My auntie began teaching me the ballet positions when I was just five years old. But the teacher that had the most influence on me was Madame Katherine Etienne back in Detwa," she said, flicking her wrist. "You know, Detroit, where I grew up. She was French-Greek, and in her day had danced all over Europe. God, she inspired me. She was everything I wanted to be and, what's more, she knew what I was all about from observing my imitations of Carmen Miranda and my constant swinging to *Boogie Woogie.* I had only one goal, and that was to be a dancer. 'Mitzi, you are going to be a big star. Dance from the heart. Give.' That was Madame Etienne's favorite word—Give."

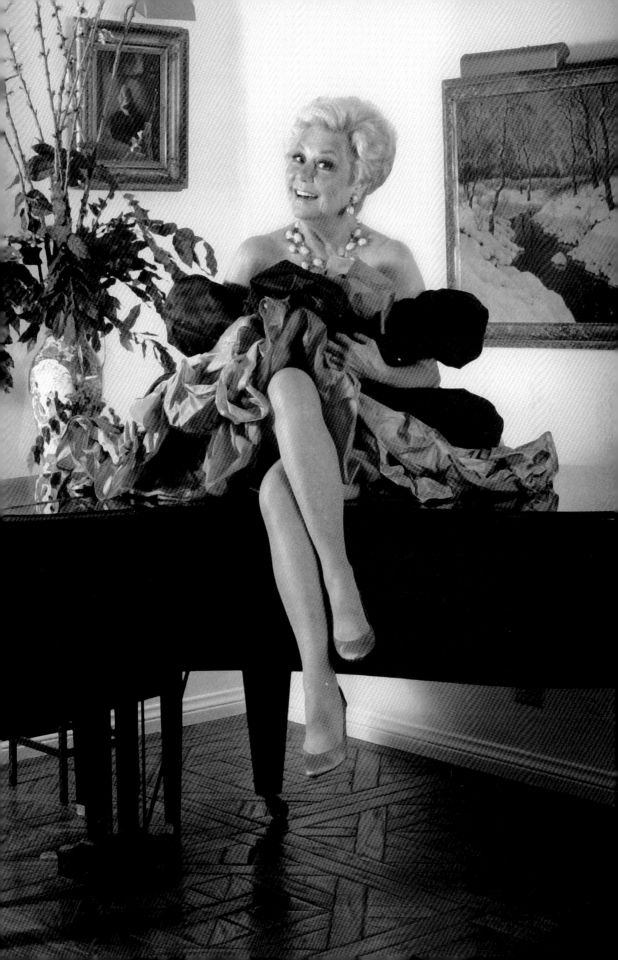

"Did you start your professional career as a chorus dancer, like so many in Hollywood?"

"No, honey. I was a star," she teased, faking a cough. "Yes, I started in the corps de ballet of the Civic Light Opera here in Los Angeles when I was thirteen, learning my craft from its director Aida Bronbadt. When I was sixteen, I was discovered by Hollywood producer Sol Siegel and director Henry Koster. After seeing me perform with famed Russian dancer George Zoritch in *The Great Waltz*, they came backstage and offered to give me a screen test, which of course I accepted."

"What was that like?"

"It's a wonder I got signed. I was asked to do a little ballet number on a black glass floor. Darryl Zanuck, then head of Twentieth Century–Fox didn't want to see any smudges on the glass, so I was not allowed to use rosin on my toe shoes. It was suggested that I attach a piece of rubber to the tip of my shoes to keep me from slipping. I did that, and when I made my entrance, the rubber caught on the floor and I fell flat on my ass."

"No."

"Yes. But I got that contract—a thousand dollars a week. I was just a kid, but I wanted to be a star. I knew that there weren't any ballet dancing stars, so movies would have to be my path. My first film was *My Blue Heaven* [1950] opposite Betty Grable and Dan Dailey. I was just seventeen."

"How difficult was it for you to make the transition to dancing in films?"

"Well, I learned very quickly that dancing for the camera was very different from performing live. It meant that all these technical things had to be in place before you could move from one scene to the next. The director sits back in his chair, puffs on a cigarette and calls 'Action.' The camera starts rolling, and you're working like hell to be with the music and hit your mark on the floor. Then the assistant director says, 'George, I think that light over there was a little crooked. Let's do it again.' And here you are bustin' your chops, repeating your number over and over again and trying to keep it fresh every time. And if you're singing at the same time, it adds a whole other challenge to the performance. Dancing in the movies is very tough, very tough."

"What was the Hollywood movie scene like in those years?"

"Vodka and cigarettes, honey," she said, with a laugh. "That's what it was like. We all smoked so we wouldn't be hungry and gain weight. And if you were a dancer, home was your dressing room with its smell of sweat and cologne mixed with benzene."

"Why benzene?"

"That evil-smelling stuff protects you from scrapes and blisters. And if you didn't have scrapes and blisters, you weren't really dancing. So you slather your feet with the thick brownish stuff and stick lamb's wool in between your toes and try not to bleed into your shoes. I lived with aches and pains all the time. I've sprained my ankles at least eight times and have had many broken toes. Just look at my feet," she said, extending her legs out. "See how crooked they are? Hey, girls," she said, wiggling her toes in her sandals. "We've been through a hell of a lot together, haven't we? You know, Rosie, we'll do whatever it takes to get out there and shake our tails. We'd go in with a headache or the flu, and no one talks about it, but when you have your period—it's a bitch. We used to call it 'the old lady.' Imagine you're doubling over with cramps, you're bloated, irritable, so sick you're throwing up, and terrified that you'll have an accident through your skimpy costume. So you tell the choreographer that you have your period and he says, 'Well, darling, don't strain too much, just do the splits and the pirouettés and maybe the fouettés, but don't strain yourself.' "

"Mitzi, why do dancers do it?"

"It's just something that we have to do. And not everyone can dance—I mean *really* dance. You can take dance lessons all your life, but unless you're born with that unique spark, that gift, that thing that makes others want to watch you—you're simply not going to make it. Dancers are the pylons of theater. The show is built on top of them. When the show needs an opener, a transition, or a closer, you bring on the dancing girls. Chorus dancers are living curtains. We're there to please. It's a pleasing profession."

"Is pleasing others built into the training?"

"It was for me. Madame Etienne drilled it into us: 'Give, Give, Give.' Even today when I rehearse, I give it everything that I've got. If I'm in a performance and the lights go out—I glow in the dark. When you're working before an audience, you have to make them feel like they can touch you. That's the dancer within, reaching out. I'm one of those that gets nourishment from the audience. And I don't have an ego," she said, faking a cough. "No, No, No compliments, please! . . . and how was I?"

"Your ego drives you?"

"My ego is the catalyst that pushes me to be the best I can be. Don't you think we all pee in our pants before we go on? Why do you think we get the heebie-jeebies, the cold hands, the dry mouth? We're afraid of totally embarrassing ourselves. But I want you to think that my show is the best show you've ever seen. I want to go to bed after a performance and know that I gave it everything. And to this day I've never done a perfect show. I've come off the stage and said, 'Close but not perfect.' "

"What was it like to partner with Gene Kelly and Donald O'Conner?"

"The motorcycle ballet in *Les Girls* with Gene Kelly is some of the best work I've ever done. The only reason I took the picture was because I'd be able to dance solo with Gene. He ended up choreographing the number when Jack Cole got sick and had to pull out. Gene came to rehearsal with a photograph of Marlon Brando from the film *The Wild One* and said, 'What do you think if we do a number based on a character like this?'

"What was the rehearsal process like?"

"We were in a rehearsal hall at Metro with a piano and drums. And I loved it. I absolutely adored it. I'm dancing with Gene Kelly, and he's lifting me and throwing me around like a powder puff. I'm so in paradise, and he was so good, and so sweet, and so delicious. He was very, very, *very* attractive and he liked me. There was no romance between us, but he knew how I felt about working with him and that I would do anything to please him."

"It's hard to imagine that you and Donald O'Conner weren't really lovers after watching you dance together in the "De-lovely" number from *Anything Goes.*"

"Donald was terribly attractive, absolutely adorable. You just wanted to take a bite out of him. I brought out his sex appeal. I made him sexy. He was a very masculine dancer with gorgeous lines. He was so clean. God, he was clean and graceful and at the same time he could be so funny. Immediately after that film we worked together again as brother and sister in *There's No Business Like Show Business.* I loved him and we enjoyed working together. I did three of his television specials. He was an extraordinary dancer, and I've always felt that his remarkable talent was not fully recognized."

"What did *South Pacific* mean to your career?"

"If not for that movie, Rosie, you wouldn't be sitting here interviewing me."

"Your character, Nellie Forbush, was different from your other Hollywood roles. How did playing that part make you stretch as an artist?"

Mitzi took a deep breath and sighed. "You know, all my life I'd been kinda jazzy, kinda sassy, kind of leggy—tits and ass in high heels. I was always the cute girl that caught the guy, and then we'd go off and sing and dance together. This had been my onscreen persona. But the role of Nellie Forbush demonstrated that there's a lot more to me than just steps. The role changed my life and my approach to acting. In the past, I'd act out my character. But I *became* Nellie, this nice young woman from Little Rock, Arkansas—a product of her upbringing in the South. I began to

feel like her, think like her, and dance like her—and that meant masking Mitzi Gaynor's dance technique. Nellie only had a little dance training."

"Did the shift away from Hollywood musicals in the late fifties and early sixties make you feel insecure about your career?"

"After I did *South Pacific,* which was a huge success, I did three more pictures that I didn't dance in, and that's when I decided to put an act together and tour. Dance—that's my life and I wanted to do it while I still could. I got together with Bob Sydney, who choreographed a show for me with four guys as chorus dancers, and we opened at the Flamingo Hotel in Las Vegas in 1961. I was the first to do the 'one-woman show' that would become a standard in show business. All the other dancing ladies followed—the Juliet Prowses and so on. I played Las Vegas, Reno, Tahoe, Atlantic City, and theaters."

"You were once again dancing live before an audience."

"Oh, Rosie, there's no feeling like it. Madonna would say, it's like good sex, but it's beyond that. You have this incredible feeling of empowerment and control over your life, and at the same time you're giving. There's that word again—Give! And, as you know, I love to work. I'm a quick study, a serious believer in rehearsing. I always want to be totally prepared, so I repeat things over and over and over until I know it inside out. I was doing a show once in Las Vegas when a man in the audience was having a heart attack right in front of me. But I had rehearsed my show so thoroughly, I didn't miss a beat."

"Mitzi, you've really stayed in great shape."

"My body has served me very well. All the different choreographers I worked with—Jack Cole, Nick Castle, Robert Alton, Tony Charmoli, Bob Sydney—all of them helped shape this body through their choreography. I still have a good back—Thank you, God—and only get occasional aches and pains. Back when I was on contract to Twentieth Century-Fox, my thighs were twenty-two inches around and now they're around eighteen. And I had a big fat ass. Oh yes, I did. It's about four inches smaller now. I was *zaftig.* I was juicy."

"Mitzi, how do you face the next stage of your dancer's life?"

"Well, I want to take my show back on the road—you know, take an orchestra and go out by myself and tell you stories about my life, and sing and do sketches from the things that I've done, change my clothes on the stage behind a screen."

"You're never going to say, 'I'm retired,' I hope."

"I don't think I could. I have such a good time, Rosie. No, I don't think so. Shall I get into drag now for that photo of yours?"

"Yes, Mitzi, let's do it." Mitzi went upstairs to change while I set up my lights in her living room facing her baby grand piano. Thirty minutes later she descended the staircase—perfect hair and makeup and wearing a black gown with red and blue puff sleeves designed by the famous Bob Mackie—a dress she had worn in one of her television specials.

"How's this?" she said, modeling it for me.

"Absolutely gorgeous!"

Tommy brought in a stepladder and helped Mitzi climb atop the piano. She extended her body across the length of the piano and threw me a wink.

"Not bad for an old broad," she said, lifting the dress to expose her famous legs.

"Mitzi, you've still got it," I said and clicked the shutter.

Beverly Hills, California, 2006

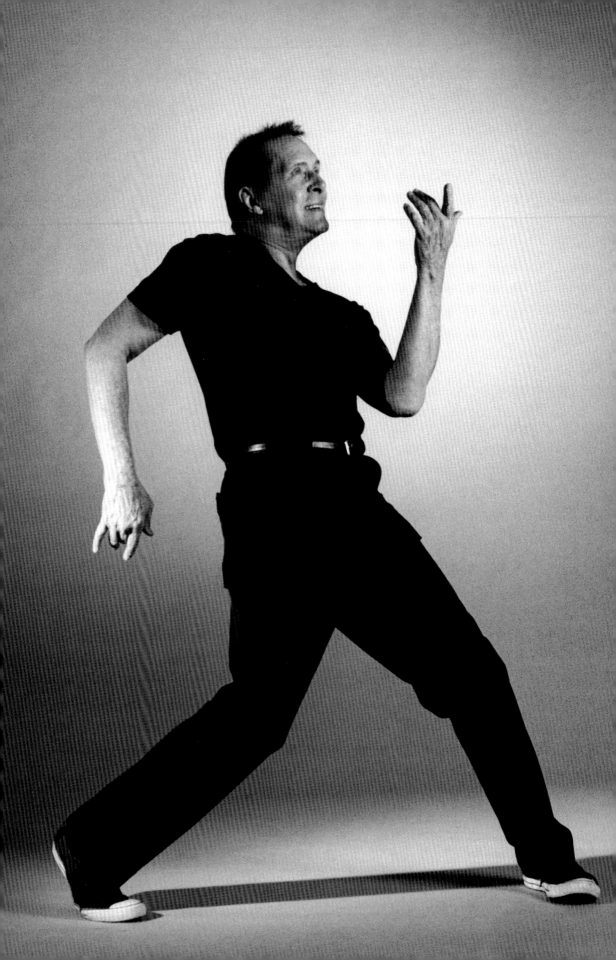

Joe Tremaine

My meeting with Joe Tremaine took place just days after Hurricane Katrina hit the dancer's hometown.

"I'm worried about the devastation, but have no doubt that New Orleans will rise again," he said, in a Southern drawl more pronounced than I had remembered.

"Sounds like your Louisiana roots run very deep."

"Oh, yes, very deep. I grew up just outside New Orleans in Oak Ridge, Louisiana, surrounded by plantations and cotton fields—population 250. My family owned a grocery store and from an early age I liked to hang out in the back room with my dad's African-American workers and plantation field hands. We'd listen to the radio and have dance battles trying to outdance each other. Something innate within me just responded to music. I had to get up and twist and turn and jump and flip."

"When did you begin formal dance training?"

"I stepped into my first pair of tap shoes at the age of six. My mother stole from the grocery money to pay for my classes and costumes, never telling my father. She drove me to dance class thirty miles from home."

"Tap dancing was at its height then."

"Yes, this was the late 1940s, you know. . . . Fred Astaire and Gene Kelly. We called it modern jazz back then. But by the time I was in high school in the 1950s, jazz dance was beginning to find its look. I had a teacher who studied with Gus Giordano in Chicago, and she integrated some of his moves into her classes—head and shoulder isolations. It was very innovative at the time. More and more, I thought about becoming a professional dancer."

"But you decided to attend university first."

"Well, my father decided for me," he said, with a laugh. "I would have jumped on the first bus to New York City. In retrospect, I'm glad I did go to school and I recommend it highly. I graduated from Northeastern Louisiana University with a degree in sociology/ psychology. Once I got involved with the drama department, I hardly ever went to any of my other classes. I found myself appearing in all the shows of the school's wonderful state-of-the-art theater. I was always on the stage."

"So did you hop on that bus to New York City after you graduated?"

"Yes, that's right. The year was 1963. And I was your typical dancer with blinders on—'Just get me on the stage, get me on the stage, get me on the stage in New York, New York, New York.' I'd dance in any show, anytime, for free. It didn't matter, as long as I was dancing."

"How did you support yourself once you got there?"

"I knew my way around a keyboard."

"You played piano?"

"No, the typewriter. I could type really fast—something like a hundred words a minute. So I went to a temp agency, and they sent me to different offices—a few days here, a few days there. As soon as I made a little money and got settled, I started taking dance classes and going to auditions."

"Who were some of your New York teachers?"

"There are several people to whom I owe so much; Matt Mattox, Luigi, Claude Thompson, and Gus Giordano. Each one of them gave me something different. Matt Mattox helped me improve my freestyle ability and improvise with modern jazz; Luigi taught me about body isolation and breath; Claude Thompson, who had been an Alvin Ailey dancer, added more modern dance incorporation into my movement; and Gus encouraged direction and focus. It didn't take long before I got hired to do summer and winter stock, and then June Taylor came along and my world changed."

"Tell me about her."

"June Taylor became the Busby Berkeley of television. She was known for her overhead shots of dancers in interesting configurations. And she used every trick in the book—camera work, props, you name it. Her contribution to television is enormous with her Broadway-like musicals on a small scale. Do you know that there are literally hundreds of former June Taylor dancers? She gave lots of dancers work over the years, both in television and live shows. The *Jackie Gleason Show* is really what made her big. Everybody watched the *Jackie Gleason Show* on Saturday night at 7:00 P.M.: 'Live from Miami Beach.'"

"How did you come to dance for her?"

"I auditioned for June in New York for a Broadway-type show called *Mardi Gras,* scheduled to open at Jones Beach Theater on Long Island with Louis Armstrong, Guy Lombardo, and the not yet famous Joel Grey. It was a two-day audition with hundreds of dancers—something like three or four hundred guys. Everyone wanted to get this job. My friends thought I had a pretty good chance of making the cut. They kept telling me, 'She's watching you. She likes you.' I was working as hard as I knew how. Finally, in the afternoon, she turned to me and said, 'Hey you, Give

me a triple time step.' I performed the step and was told me to come back the next morning at ten. We continued the audition into the afternoon, when I learned that I got the job. I remember running around to the corner Howard Johnson's to call my mother in Louisiana and tell her that I got picked: 'I'm working for June Taylor!' I did *Mardi Gras* for a couple of months, and then June took me and three others down to Miami to work on the *Jackie Gleason Show*."

"Was that your big break?"

"This was a big break, but not my big, big break. Everyone wanted to be on television and would kill for a job like this one. It paid $175.00 a week, which was considered really great money back then. After concluding the *Jackie Gleason Show,* I returned to New York and heard about an audition being given by Hollywood choreographer Nick Castle. I remember I had this really bad cold. I felt awful and I wasn't going to go but everyone kept saying, 'You have to. He's looking for dancers to do a number of television specials in Europe.' "Well, okay,' I said, and went in. They started with a combination, but when they asked us to freestyle—the thing that I was great at—I got the job, hired on the spot. Nick and I clicked like that," he said, snapping his fingers. "Then, while we were in Amsterdam taping the specials, Nick asked to see me. I thought to myself, 'Okay, this was great, but now he's probably going to send me back to America.' But instead, he gave me what I consider my biggest break: he hired me as the lead dancer on the *Jerry Lewis Show* on NBC—a two-year contract. That's when all hell broke loose. Nick introduced me to everyone in Hollywood, including every choreographer in town. When Jerry's show was on hiatus, I'd get hired to dance on other shows, like the *Carol Burnett Show,* the *Smothers Brothers,* the *Jack Benny* specials, *Rowan and Martin's Laugh-In.* There were lots of specials in the late '60s and '70s, and I danced in many of them."

"Sounds like you really had it made."

"Yes, I did, but there was something I was still itching to do. I wanted to do a nightclub act. So I got together with my former dance partner from the June Taylor show, Debbie Mackumber, and hired a fabulous black singer/dancer, Bert Woods. Jerry Lewis offered to finance the act, but I decided to do it myself. We called ourselves the Number Company and premiered on January 24th, 1969, at The Factory, which was a supper club owned by members of the Rat Pack. Bobby Kennedy even owned a share. On opening night Jerry Lewis introduced us, and after that the act just took off. We began performing in hotels and also changed our name to Black, White, and Fourteen Smith. I was white, Bert was black, and

Debbie, who was into numerology, changed her name to Fourteen Smith. We made it really big in Vegas at Caesars Palace. Claude Thompson choreographed the show, country singer Lee Greenwood conducted the ten-piece band, and we had nineteen chorus dancers behind us."

"Did you realize back then that you were developing your own style of dancing—razor-sharp kicks and lightning-fast turns, high-energy moves that would come to be known as West Coast Jazz?"

"Yes, I think it was during those years that a style began to emerge. When I moved to L.A. in the late 1960s I started doing a lot of freestyle dancing, which basically consisted of improvising to music. By day I worked in television, but at night you would find me freestyling in L.A.'s busy dance club scene. I was fascinated by what I saw nonprofessionals doing on the dance floor and started stealing their moves. I'd take their steps and reconstruct them into a jazz form and then perform it as a combination. If I have a discernible style, that's its source."

"Seems natural that you would become a choreographer."

"I never set out to become a choreographer or even approached anyone with that idea. The stars that I had worked with in numbers on the *Jerry Lewis Show* just started calling me. Entertainers like Diana Ross, Barbi Benton, Olivia Newton-John, Carol Burnett, Raquel Welch: 'Would you work with us? Would you choreograph for us?'"

"How did you know you had it in you to do it?"

"I simply knew I could make them look a hell of a lot better than they could on their own. Many of the stars were not dancers—like Raquel Welch, for example. She was at the height of her fame back then. My approach was to give her a combination with as many steps as I could, 'try this, kick here, turn there,' and then I'd start eliminating as much as 98 percent of everything I gave her. It was through the process of elimination that I found the 2 or 3 percent of movement that she could do well—and isn't that the job of the choreographer? We would work for umpteen hours and days just to find the little thing that she could do. It's much more challenging than hiring professional dancers who are capable of realizing your vision. Don't forget, you're dealing with stars like Diana Ross, Barbara Streisand, Debbie Reynolds, Mary Tyler Moore. One of the hardest parts of my job was not allowing them to do moves that they wanted to do but were clearly not capable of. You can't say, 'You're going to make a fool of yourself,' but that's exactly what it was. Connie Stevens, for example, always wanted to go beyond her capabilities, but I wouldn't let her. Instead, I had the backup dancers move her—'bring her over here, turn her, lift her'—fabulous! It looked like a huge production number, yet she had hardly danced any steps at all."

"Would you say that working with the stars was what eventually led to your next reincarnation—dance teacher?"

"Yes, I was getting a reputation as a good teacher. Eugene Loring, one of L.A's top choreographers hired me to teach at his American School of Dance on Hollywood Boulevard. I also taught at Morro Landis Dance Studio before I opened my own school."

"I remember your dance studio in North Hollywood. It was where the professional hopefuls went to take class."

"I opened the Tremaine Dance Center in 1974. Originally I wasn't interested in warm-ups and getting dancers trained. All I wanted to do was see dancers moving. But then I had to develop something that could be adapted to beginners, intermediate, and advanced students, and I taught all levels. I made it a straight-ahead jazz warm-up with ballet basics—good solid stretching to warm up the body and use it properly. At one point we offered 115 classes a week, with thirty of L.A.'s top teachers and choreographers. Casting agents and producers would come looking for talent. West Coast Jazz was happening and the landscape for dance was beginning to shift from New York to L.A."

"How did Joe Tremaine's Dance Conventions come about?"

"That evolved slowly. Dance Educators of America, Dance Masters of America, Danny Hoctor's and other dance organizations started asking me to teach at their conventions. So I'd teach my Saturday afternoon class, jump in my car, drive to LAX and fly to Des Moines or Houston and teach all day, then fly back late Sunday. But I became frustrated with their level of professionalism, so I decided to create my own dance convention enterprise. For a while I was doing it all: choreographing movies and television specials as well as teaching at my school and traveling every weekend to another city with my Joe Tremaine conventions. In time, I did less and less commercial choreography and closed my school to devote my time entirely to the conventions."

"Joe, how did you become such a savvy businessman?"

"Well, when I was working on the *Jerry Lewis Show* I had my eye not just on the choreographer, but also the director, the producer, the scenic designers, the costume designers, the gaffers, the best boy—everyone. This was a fast-paced, weekly TV variety show with live audiences. I began to think from both a production team point of view and a management point of view about how all these pieces fit together. I saw that it took more than just talent to produce a show. One required a business sense. I realized that if you take care of business, then you have the freedom to be an artist."

"Do you still love to perform?"

"Absolutely. My desire to perform has never ever waned. I have to dance and see bodies dancing. I have to have dancers in my face, moving to music all the time. This is probably some sickness, some mental disorder," he said with a laugh. "I'm only happy when I'm on the stage or teaching. If I'm not doing that for more than two weeks I get depressed."

"Do you think that will ever change?"

"No. Never! I'm a dancer-performer and a lifelong student of movement. This is why I've built a thirty to forty minute show into every Tremaine Dance Convention—so I can dance. I'm not interested in just hanging around, doing lunch, talking about the old days. I want to be *doing* it—day in and day out—shut and closed case."

Van Nuys, California, 2006

Chita Rivera

Thirty minutes before my scheduled shoot with Chita, her assistant phoned to let me know that they were in a cab on their way . . . but that Chita was coming against doctor's orders.

"Against doctor's orders?"

"Yes. She should be home in bed. She came down with the flu last night and is running a fever, has body aches, and laryngitis. She won't be able to do the interview but insisted on coming for the shoot. Chita always keeps her word."

Twenty minutes later, Chita entered my rented studio looking gorgeous in a black Anne Klein pantsuit, ruffled silk blouse, and sexy high-heeled boots. She greeted me with a hug and whispered, "Rose, I'm so sorry I can't do the interview today. But you have my word, we'll do it soon."

I told her that I understood and offered her a cup of hot tea. Then we sat down to discuss her portrait.

"Chita, I've had this image of you in my head ever since we met last year in L.A. I'd like to shoot you in silhouette."

"Wonderful," she said. "What a great idea."

"Why don't you change into your skirt and heels," I said, pointing to the dressing room at the other end of the studio. Chita emerged from the dressing room moments later wearing a beaded camisole top, short flare skirt, and stiletto heels that accentuated her famous Broadway legs.

I had her stand in front of a lit white seamless and then unplugged my key light, throwing her into darkness. "Hit your mark on 8," I told her, bringing the camera to my eye and counting: 5, 6, 7, 8. On "8," Chita threw a hip up and flung her head back.

"Perfect!" I said hitting the shutter.

Two months later, we met for our interview at the West Bank Café on 42nd Street, Chita's favorite Manhattan restaurant.

"Chita," I began, "I have a feeling dance is in your DNA."

"Yes, it probably is," she said with a laugh. "When I was a kid, I always loved to run, climb trees and walk on fences. I'd ride bicycles like a stunt performer, standing on the seat with one leg and doing all kinds of acrobatics. Then one day I jumped from the sofa to a chair and broke the cocktail table. 'That's it.' my mother said. 'I'm not going to have you

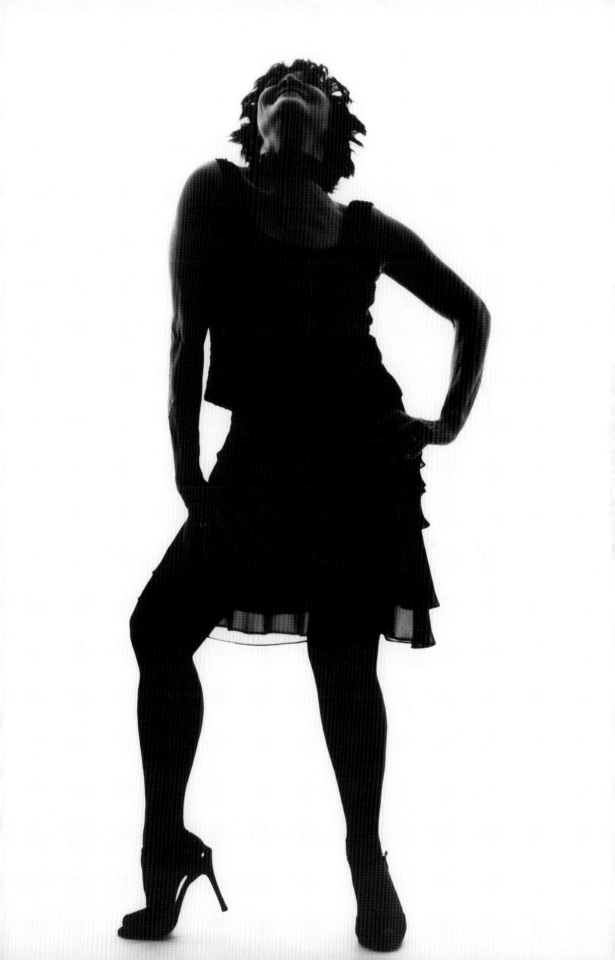

breaking all the furniture in the house.' And she put me in Doris Jones's Ballet School in Washington, D.C. Ballet helped contain my energy, even though I really wanted to run wild. By the time I was fourteen, I wanted to be a ballerina and won a scholarship to the School of American Ballet in New York City. While a student there, I went with a friend to an audition for the Broadway show *Call Me Madam,* choreographed by Jerome Robbins, and I got picked. From that point on everything changed. I was seventeen, standing face-to-face with my first professional job and earning $250 a week as a principal dancer. That's what started it all. I immediately fell in love with musical theater. I just adored it: the excitement, the costumes, the lights, the music. I was in heaven."

"What do you think Jerome Robbins saw in you at the age of seventeen?"

"Probably that I was really gung-ho. I wanted to please, and I was never complacent about any of it. I wanted it, and I wanted it bad. Plus, I had great technique courtesy of Ms. Jones and Balanchine's hand-picked teachers, Muriel Stuart, Oboukhoff, Doubrovska, and Vladimirov."

"When you got the part in *Call Me Madam,* you must have had to leave SAB?"

"Yes, that's right. I never did complete my ballet training at SAB. Telling them that I was leaving was one of the hardest things I've ever had to do. I beat myself up over this for years. It was like an open wound. My dream had always been to dance with New York City Ballet. In my head, *that* was the true measure of success. But all that anxiety lifted after opening night for *The Rink* (1984). After the show opened, I received a congratulatory card from my former SAB teacher Muriel Stuart and New York City Ballet's Lincoln Kirsten. It read, 'We are so proud of you.' I totally broke down. It meant I had made it."

"You've been on the stage for close to five decades?"

"Unbelievable, isn't it?" she said, throwing her hands in the air.

"Was it tough to balance such an enormous professional career with a private life?"

"There is no line between the professional and the personal life," she said, her emerald-green eyes turning serious. "Just because you perform on the stage doesn't mean that you should stand apart from the rest of society or lose reality about who you really are. Entertainers want to live a full life and experience all the things that most people experience. When you perform you share energy, spirit, and a real dedication to life. Dance teaches you what it means to be human. I married and had a wonderful daughter, Lisa. Unfortunately, my marriage ended in divorce, but this too is just part of living a life."

"You learned about the power of dance from some of the best in the business."

"Yes, I did. I inherited something from everyone I worked with."

"What did Jerome Robbins leave you with?"

"Jerry taught me how to think like a dancer. In his directing of *West Side Story,* he made us aware that the steps come from the mind-set of the character. It's very basic and very important. When you know who you are, you know how to move."

"Michael Kidd."

"Michael Kidd taught me to have a sense of humor. He was very comical and playful, but, at the same time, courageous and daring—always teetering on the edge of danger. He'd toss your body into the air and he knew exactly how you were going to land. But you didn't. So if you wanted to land on your feet, you really had to trust him."

"Jack Cole."

"Jack was an encyclopedia of dance. He was Isadora Duncan, Martha Graham, and Katherine Dunham rolled into one. He fused all these influences together in his own style of jazz. People thought he was mean, but he demanded that you work. Dance is hard. If we could, we'd all cut corners, but he wouldn't let you. He taught me to be serious."

"And there was Gower Champion."

"Gower was as smooth as they come. He was Hollywood. He turned Dick Van Dyke and me into Fred Astaire and Ginger Rogers when he choreographed us in *Bye Bye Birdie.* From Gower I learned how to be graceful."

"Peter Gennaro."

"Peter taught me how to understand my own body—every muscle. He choreographed the body as if it were a musical instrument—like a trumpet doing scats. He taught me how to make my body speak through undulations and contractions, how to be tight and how to be loose."

"So by the time you got to Bob Fosse you really knew how to move."

"Absolutely. Fosse added something else. He taught me to be a little dark, a little cynical, and very sensuous. He had an unbelievable understanding of the restricted use of the body. But when he wanted to open up his movement, he was wide open—like in *Sweet Charity,* with his wonderful leaps he could be very Agnes de Mille. Most people only see his tight, precise, minuscule, almost breathless movement style. But his movement vocabulary was huge."

"You've created some of musical theater's most iconic characters . . . Anita, from *West Side Story;* Velma Kelly, from *Chicago;* and Spider

Woman, *Kiss of the Spider Woman,* just to name a few. Anyone who came after you was measured against the standard of performance that you set."

"Yes, that's true. It's a great feeling to know that I breathed life into these characters."

"What was it like to play such extraordinary women?"

"Interestingly, all the women I have played have been survivors—from Anita to Charity. Anita was WOMAN in the truest sense of the word. She is faithful, passionate, elegant, and aristocratic—a lioness. She is like a mother figure to Maria, a lover to Bernardo. Had Bernardo lived, she would have had many children. And she would have been a fabulous mother. I felt her true power when she sings 'A Boy Like That' and when she comes to the candy store to deliver a message for Maria. When the Jets taunt her, anger is turned on: 'You've just murdered the one person that I loved, and you can't recognize humanity in my coming here. I'll get you.' She was trying to save Tony and Maria, but she can't help herself and so she lies—payback time."

"Velma Kelly is a bad girl—a bad, bad girl," she said, shaking her head. "She's spunky. She's razzmatazz. She's a killer! When Roxy comes into the picture, Velma is smart enough to know that she's on the losing end. She sees the cards and says, 'I'll play the game. I'll go from here to whatever the next step is. I will not fall. I will survive.' In the end, Roxy and Velma end up working together. I learned from playing Velma that you don't know what you'll do until you're faced with a particular predicament.

"Spider Woman is glamorous, a desirable seductress. I never thought of myself this way, but her character allowed me to say, 'Hey, I've got some power here.' And it came at a very good time in my career, when I had maturity to bring to it. I'd often played the seductress—you know, in the red dress with the split up the side— but Spider Woman represents an entirely different kind of seduction. When I got a chance to play *death* in a loving and comforting way, I embraced it. We'd all love to not be afraid when death comes. This role helped me believe."

"I see that timing is extremely important—when certain roles come to a performer."

"Yes, absolutely. At the time that I appeared in the original production of *Chicago,* I didn't think I was big enough for my entrance on such a massive stage. Picture this. I make my entrance by coming up from the floor on a platform with my back to the audience. First you see my hand, then the feathers, and then my whole body. When I turn around wearing this slender little thing, I'm hit by shafts of light, and then you hear, *boom, boom, boom.* I have everything working for me, you see. I walk all

the way down to the point of the stage, sit there, cruise the audience with my eyes, wink. This is Bob Fosse at his best. Well, at the time I didn't think I had the stature needed for that entrance. So just before the elevator would bring me up, I'd say to myself, 'Who am I tonight?' Tonight I'm Sophia Loren or I'm Gina Lollobrigida. I needed a famous character to help me project this larger-than-myself image. But by the time I got to Spider Woman, I didn't need an image in my head. I was ready for the role."

"At the height of your incredible career you were in a horrible automobile accident. What was going through your mind at the scene, your leg obviously very hurt?"

"You don't think about things like 'my leg is shattered, my career is over.' I didn't feel anything—any pain. My mind locked into what had just happened: *Bam*! The sound of crushing metal, shattering glass. You're in shock. All you know is that something really bad has just happened. Then I heard something at the window and looked up. There was this Oriental man saying, 'I'm sorry, I'm sorry.' It was the taxi driver who hit us. His ranting seemed to make no sense to me. I do remember being cut out of the car, but not the ride in the ambulance. Once I was in the ER I could see members of my family outside the examining room, pacing and frantic. I felt torment that they were so worried about me. Then the radiologist came in all excited and happy: 'Miss Rivera, I'm so glad to meet you. I'm a big fan.' I began to feel more relaxed, but then she came back with the results from my X-rays. 'You really did a good job on yourself,' she told me. That's when I knew I had to shift gears. It was a very clear moment. I didn't panic or slip into 'Oh my God, Oh my God! This is it. Woe is me.' When you have years and years and years of dance training under your belt, you know what you have to do. You fix it. So I said to the doctor, 'Whatever we need to do, let's do it.' Eleven months later, after surgery and intensive physical therapy, I was back doing my club act and then moved right into my next big show, *Can Can.* I figured the greater the challenge the stronger I'd get."

"And now at the age of seventy-two, how does the dancer within you face her future?"

"I realize that people have an image of me from *West Side Story, Sweet Charity, Chicago*, etc. But the scale is different now. I'm older and the body doesn't do what it once did. I need to adjust to who I am now and keep pushing the bar like I did when I was younger. You never know what great challenge might be around the corner. And I feel very lucky to have the ability to work with great choreographers like Graciela Daniele, Rob Marshall, and Alan Johnson, who know me and know what I can do. Even when you get older, Rose, you want to be elegant and work with pride."

"So what's your next project, Chita?"

"I start working again in a couple of months on my one-woman show, *The Dancer's Life.* I was approached about the show over a year ago. I agreed to do several interviews to see if we could come up with some material. Three hundred pages of transcripts later, we had the makings of a show. The book was written by Terence McNally *(Kiss of The Spider Woman, Ragtime)* and choreographed by Graciela Daniele *(The Rink, Ragtime).*"

The show proved a personal triumph for Chita, with a four-month run on Broadway, a Tony nomination for best actress, and a road show scheduled for the future. I met with Chita after the New York run closed to get her personal impressions of the experience. When she and I sat down together again at the West Bank Café, we were alone except for waiters setting tables and preparing for the dinner rush.

"Chita, you look radiant. *The Dancer's Life* must have been a wonderful experience."

"Yes, it was. I loved it. I got to know myself a bit more and worked with amazing artists. We became one big family."

"What was it like to play yourself?"

"The first time we performed the show it was very emotional for me. How often does one get to revisit the best times of her life? I love telling these stories and talking about Charity, and Rosie, and working with Gwen Verdon, and reliving my childhood."

"Did you see clearly your life's path?"

"I have this notion in my head of a big book up in the sky with everyone's path already written—like storyboard images. I feel that our decisions are made for us long before we face them. Did I expect a *West Side Story,* and after that a *Bye Bye Birdie?* I look back at my forty-plus years on stage and say, 'Damn! That was good—a great run.' Could I have preplanned such a life? I don't think so. All I did was play it out as written."

"And what did you hope to achieve?"

"It never mattered to me how many people were in the audience. All I've ever wanted was to touch that one person out there in the dark. That's what the theater does."

"Chita, what did you mean when you told me in our first interview that *The Dancer's Life* is for every dancer who ever set foot on a stage?"

"It's a reminder that if you really want to dance, you can do it, and do it for a long time. If you work hard and never give up, you'll have it. I think we all need a mirror to reflect what we're capable of. You see me on

the stage at my age and you say, 'Damn! . . . why can't I? She's seventy-three and has fifteen screws in her leg and she's up there doing it.' We have to challenge ourselves, adopt a spirit of competitiveness, and fight for it. I don't expect to win a Tony this year, but why the hell not?"

New York City, 2005 and 2006

Russ Tamblyn

Driving to Russ Tamblyn's Venice Beach apartment, I contemplated the fact that he was about to turn seventy and my only mental image of him was that of the young leader of the Jets in *West Side Story*, filmed in 1960. That was forty-five years ago. So when he opened his front door, I was absolutely stunned. It was Riff—only older. Bernardo hadn't killed him in the rumble after all.

"Come on in, Rose," he said, shaking my hand.

"You look almost exactly as you did in *West Side Story*."

"Minus the gray hair and wrinkles," he said with a laugh. "Please come in, have a seat." The apartment Russ shared with his wife reminded me of my old college days: an array of mixed and matched but comfortable furniture, vintage lamps with beads and fringes, books of poetry and art, jazz records, and knickknacks from India. I sat down on a green leather recliner and pulled out my tape recorder. Russ took a seat across from me on the sofa.

"Rose, I thought you might get a kick out of this," he said, lifting a photo album from the coffee table. "I created this scrapbook for my daughter, Amber Rose, who's an actress. I thought she would enjoy learning about her grandfather."

I opened the book to an old, worn, black-and-white photograph of a man in a tuxedo and tails, posing with a woman in a ballroom gown in front of a stage curtain.

"Your father was a dancer?"

"Yes, that's him and his dance partner, Mary Sheffield. His name was Eddie Tamblyn. He danced in vaudeville in the 1920s and did a few Broadway musicals before moving out to Hollywood. He made a bunch of films during the 1930s as a featured actor. When his movie, *Sweetheart of Sigma Chi,* came to a theater in our neighborhood, our whole family went to see it. I remember it to this day, seeing my father on the screen—his image so big . . . bigger than life. For me, it was like seeing God."

"So showbiz is part of the Tamblyn legacy."

"Yes, handed down from my father. After seeing him on the big screen, I wanted to be just like him. I was only nine when I did my first off-the-cuff performance. I grew up in Inglewood, California. My mother used to

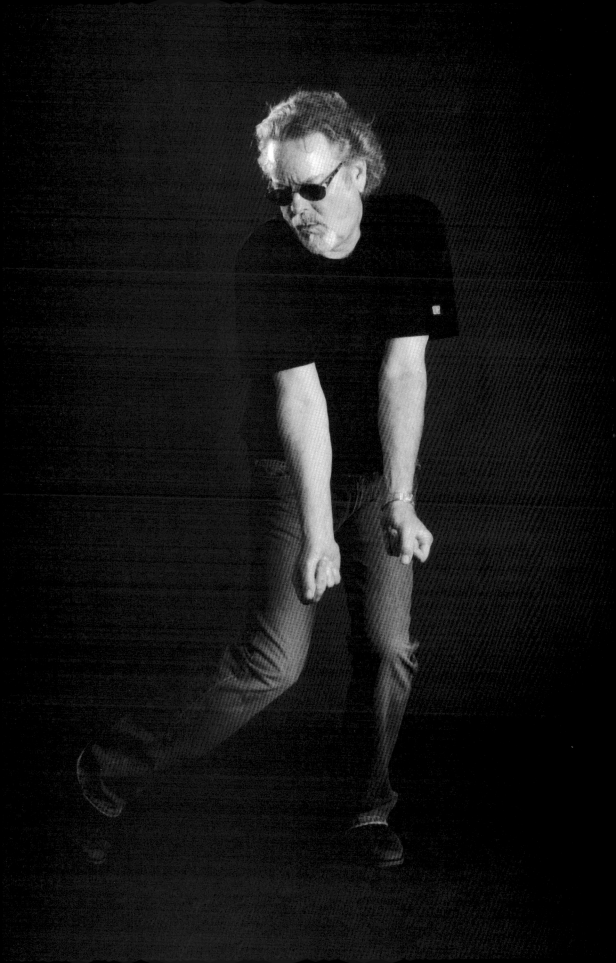

drop me off at the Granada Theater every Saturday afternoon to watch cartoons and kids' shows. One day during intermission I ran up on the stage and did this spontaneous dance routine. The kids in the audience loved it and started screaming and carrying on. So I did it again the next Saturday. This time the theater manager didn't think it was so cute. He ran down the aisle screaming, bent on pulling me off the stage. But I was too quick for him. I jumped down and hid under the seats. So now I'm doing this every Saturday—six weeks in a row. But the next Saturday he decided to hide behind the movie screen, and when I ran up to give my little performance, he grabbed me. He made me wait with him in his office until my mother came to pick me up. Then he told her I'd better stay off the stage, or else. My mother figured if I wanted attention that bad, she might as well sign me up for tap dance lessons."

"You were one precocious kid."

"Oh yeah—and fearless."

"One time my friends bet me I couldn't do a handstand on top of a telephone pole. I crawled up in between the high-voltage wires and did it easily. My mother came out and saw all these kids looking up, and there I was. I had no fear of heights—absolutely no fear."

"This explains your also becoming a gymnast. Where did you learn gymnastics?"

"At the neighborhood park. Soon I started incorporating backflips, front-flips, and handsprings into my tap dancing. When I got a little older I took tap dance lessons from specialty dancer Willie Covan, who taught Shirley Temple and Bojangles. Willie taught a kind of low-to-the-floor, heel-and-toe–style of tapping. Gradually I got involved in acting and joined the Screen Children's Guild. It wasn't long before I started getting parts in movies. My first featured role with an introducing film credit was *The Kid From Cleveland* [1949]. I went under the name Rusty Tamblyn. I didn't dance in films until I was under contract at MGM. They originally signed me as a dramatic actor, not a dancer."

"Didn't you also win some major gymnastic competitions?"

"Yes, I loved acrobatics and tumbling. In high school I won the Los Angeles City championship. I took third in the state, and sixth in the invitational nationals.

"What about formal dance training?"

"Other than those tap dancing lessons when I was a kid, I just did popular dancing. I was really a street dancer. I liked the creativity of making things up, being inventive. I liked climbing, jumping—anything that involved body movement. I was inspired by acrobatic dancers that I saw

in films, like Fred Astaire, who danced on furniture and with brooms or coatracks. The Nicholas Brothers blew me away with their amazing jumps and splits, and I loved seeing Gene Kelly climb up walls and swing from ropes."

"So that's really the extent of your dance training?"

"Yeah. I never took a ballet class in my life. I was really lazy when it came to going to dance classes. I never wanted to work that hard. I learned that I could get by if I just did what I knew best. I guess you can say I learned on the job from working with great choreographers like Michael Kidd, Hermes Pan, Alex Romero, Jerome Robbins, and others."

"It's remarkable, considering you became famous for your dancing."

"Yes, it is. *Seven Brides for Seven Brothers* [1954] put me on the map, and after the film came out, *Dance Magazine* put me on their cover. And it was interesting to me because I really thought of myself more as a dramatic actor than a dancer."

"How did you get the part of Gideon in *Seven Brides for Seven Brothers*?"

"Michael Kidd, the film's choreographer, wanted to cast seven great dancers to play the brothers. The studio said that Howard Keel, who plays the oldest of the brothers, didn't have to be a great dancer because he was a great singer. They also insisted on using at least two actors they already had on contract. They let Kidd cast the last four, whomever he wanted."

"Let me guess. You were one of the MGM actors."

"Yes, I was. Michael Kidd came up to me and said, 'Someone told me you do tumbling—backflips.' 'Yes, I do,' and turned a backflip right in front of him. 'That's fantastic, we'll use it in one of the numbers,' he said. 'Hey, wait a minute,' I told him. 'You want me to dance with Jacques d'Amboise, Tommy Rall, Matt Mattox, and guys like that? I don't think I can do that.' 'No, no, no,' he said, 'don't worry, they'll be playing woodsmen and doing square dancing.' I think I was the only one of the brothers who didn't have formal dance training. But this actually worked in my favor and got me one of the solos in the movie. There was a number called 'Going Courtin'' where Jane Powell has to teach the brothers how to dance. Well, it's very hard to teach classically trained dancers to look like they don't know how to dance. And since I really didn't know how to dance, I made it look real. It wasn't until *Seven Brides* that my career took a quantum leap—and it was because of the dancing. After that film, more dance parts came my way, like *Hit The Deck* [1955], choreographed by Hermes Pan, in which I danced opposite Debbie Reynolds, and *The Fastest Gun Alive* [1956], choreographed by Alex Romero. Alex had me swinging from rafters, doing acrobatics and dancing on top of a shovel. He was

great with people who didn't know how to dance—like Elvis Presley in *Jailhouse Rock*. Elvis was really uncomfortable with choreography, but Alex got him to do all sorts of things. Alex would find out what you could do, and then he'd choreograph to your capability. I was a lot like Ray Bolger. Ray wasn't great at ballet, but if you got him to do some eccentric loose dancing, he was terrific."

"Did you say you danced on a shovel?"

"Yeah. Alex and I fastened a boot to the top of a shovel and I jumped around in this crazy routine. I have that film on video. I can show it to you."

"I'd love to see it." Russ found the videocassette, slipped it into the player and fast-forwarded it to the number. The scene took place in a barn. Russ looked like a teenager. He jumped down from a loft, then swung on a rope from one end of the barn to the other, climbed back up, and then down a wall, and then grabbed a shovel. Balancing on top of the shovel's straightedge blade, he jumped around the barn as if on a pogo stick.

"I imagine your acrobatics helped you in a lot of the roles you played?"

"Oh, definitely. I made several westerns and combat films like *Take the High Ground* [1953] and *How the West Was Won* [1962] and could leap onto horses and use my acrobatics in fight scenes. I made comedies and could do pratfalls and things like that. I did lots of acrobatic dancing if a musical number was called for. This was what I excelled at. But there was a drawback. It prevented me from getting serious dramatic roles. Once you did a successful musical you were automatically labeled a dancer. Dancers like Donald O'Conner and Dan Dailey, who were also very fine actors, could never break out beyond the Hollywood musical."

"You're saying there was a common perception that dancers can't act?"

"Yes. I did a film for Twentieth Century–Fox in 1957 called *Peyton Place* and was nominated for an Academy Award. And it was like this huge surprise to everyone that 'Russ Tamblyn who started out as a dancer' can act. None of them realized that the reason I got signed at MGM was for my acting ability."

"Did it bother you that you were viewed more as a dancer than an actor?"

"Yes, but only because I thought of myself as a performer in all manner of ways: acting, dancing, singing. Is he an actor that dances, or a dancer that acts? It's that need to categorize people that bothers me."

"*West Side Story* gave you celluloid immortality."

"Yes, I suppose it did. But, interestingly, I almost wasn't in the film. You see, I was under contract at MGM, and *West Side Story* was a United Artists picture. But I had an inside track to the film's casting because I had

the same agent as Robert Wise, the film's producer. MGM allowed me to test for the role of Tony. It never occurred to me to do the part of Riff. But then my agent phoned and said, 'Richard Beymer just got signed to play Tony. They've offered you the part of Riff—the leader of the Jets.' 'No,' I said. 'I can't play Riff. He's got to do all that incredible dancing, and I'm not that good of a dancer. I can't dance the *"Cool"* number with all those trained dancers.' 'Don't worry, they've switched things around,' he said. 'You just need to do the "Officer Krupke" number.' But then word came down that MGM had turned down the offer because they wanted me to play the role of Tony. Well, now I'm thinking, I'll do anything to be in *West Side Story.* I'd seen it on Broadway and knew that this was the part of a lifetime. So I went in to meet Bennie Thaw, the head of MGM, to see if I could change his mind. Sitting in this huge chair across his desk, he says to me, 'Russ, I know you want to do this movie, but let me read you some of the lyrics you would need to sing: "my brother wears a dress, my grandma pushes tea." You have a very good reputation at this studio and this film will not be good for you. We turned it down and booked you into another film that would be much better. It's called *Where the Boys Are,* with Connie Frances.' I told him I'd be crushed if I wasn't in *West Side Story.* I literally begged him to let me do it. Finally, he said, 'Let me think about.' He made me sweat it out for several days. I couldn't sleep or eat. And then he finally called and said, 'Okay, you can do the part of Riff.' "

"Since you were not as trained as the other dancers, did Jerome Robbins give you specific direction?"

"Jerry told me right up front: 'Riff is not a tumbler. I know you've done acrobatics in many of your films. But for *West Side Story,* you're going to have to do straight dancing.' 'I'll do my best,' I told him. 'I'll work on it.' And that's the way it was up until Jerry was fired."

"Wait, stop! Jerome Robbins was fired from *West Side Story?*"

"Yes. He was fired as codirector, not choreographer. Jerry, a perfectionist, took too long with some of the New York scenes. By the time we got to the shooting in L.A., we were way off schedule. We had already shot the Prologue and the 'Cool' numbers when he and his first assistant, Howard Jeffrey, left. Tony Mordente, who played the role of Action, stepped in as choreographer. On the day we were to shoot the dance in the gym number, Tony said to me, 'Let's put some tumbling into this number.' 'But Jerry told me that he doesn't want any tumbling in the film.' 'Jerry's gone,' he said, 'Do some tumbling.' So I added a round-off backflip with a full twist."

"Russ, do you have a copy of the film?"

"Yeah, sure."

"Could we watch that scene? I'd love to see that again and have you talk me through it."

"Russ went into another room and came back moments later with a recently released collector's-edition DVD of the film. He ripped off the plastic, removed the disc from its case and inserted it into the player. The Prologue—the Jets versus the Sharks—came up on the screen.

"Ah! This is a good example, Rose, of how Jerry worked around the fact that I was not a trained dancer. Notice, as we're all walking down the street, the Jets are dancing and doing turns and things—and I'm just doing this stylized walk. He came up with something for me to do that would blend in."

"My God, I've seen this movie a thousand times and I never realized that you were actually doing something very different from the other dancers."

"Yeah, I'm just walkin'. That was the genius of Jerome Robbins. This scene right here is shot in New York in the space that is now Lincoln Center. At the time they were renovating that whole area, so the producers had them save a couple of the demolished streets to be used in the film."

"*West Side Story* with its huge box office success and racked-up multiple Academy Awards—it's a wonder that you would choose to drop out of the business. Why did you? You were only in your mid-twenties."

"You know that old cliché—don't kick a gift horse in the mouth. Well, that's exactly what I did. I knew that I was blessed with a gift, but it was around that time that I got turned on to fine art and poetry. I discovered a kind of creativity that I had never experienced before. You see, an actor, singer, or dancer has one main objective—to make the audience's head spin and knock them out. That's the job of the performing artist-entertainer. But the objective of the fine artist is to make one's own head spin—to knock one*self* out. I discovered that I liked the freedom to explore my own inner creativity, and wanted to see if I could go to a deeper artistic level."

"Your creative output then was solely for yourself?"

"Yes. The fine artist doesn't have to please anyone but himself. It doesn't matter if people don't like your work because you're not doing it for them. It's not necessarily meant to be communicative. In the long run, I found it's not a bad place to be."

"So you regarded the work you did in films as nothing more than a vehicle for the artistic expression of others?"

"Yes, I think that's true, but it's not like 'Oh, for so many years I did other people's art and now I want to do my own.' It's just that once you start doing your own work, you discover a new freedom of expression and a new independence. You become your own director, photographer, editor—creator. What interests me now is work that emerges as a spontaneous artistic expression. I don't think most people really know what an artist is. You only know when you become one—when you find your voice and see the world differently."

Venice, California, 2005

Rita Moreno

Rita and I sat down with a bottle of wine in her dressing room at the Berkeley Repertory Theater. She had just completed her evening's performance as Amanda Wingfield, the lead in Tennessee Williams's *The Glass Menagerie*. I was curious to know how the seventy-four-year-old dancer/actress had risen from poverty to stardom, having won an Oscar for her role as Anita in *West Side Story*.

"You were born Rosa Delores Alverio in a poor farming village in Puerto Rico. Is that little girl still living inside of you?"

"Oh, that little girl is not only present, she's active. In fact, she can make me feel really bad and insecure at times. You know, children are very suggestible; if they hear often enough that they have no value, they believe it. I grew up trying to please everyone and prove that I'm really a worthy person. And I was Puerto Rican in New York City at a time when it was not good to be a Latina."

"But look what you have accomplished in your life."

"I was lucky. I grew up in an era when you could still earn a living by performing in nightclubs and little joints."

"How old were you when you discovered that you liked to perform?"

"I was very young. My earliest memory is dancing for my grandfather. My Mamma put on a record and would say, 'dance for *Abuelito.*' I'd shake my booty around the living room. Really, that's how it all started. And I loved doing it. When I was five, we moved to New York. I began taking dance lessons after my mother's friend, Irene Lopez, saw me dancing around in our apartment and said, 'Rosita really ought to see a dance teacher. I think she's a natural.' My mother took me to Paco Cansino, the uncle of Margarita Cansino. Margarita would later change her name to Rita Hayworth. So I became a Spanish dancer. My very first engagement was in a Greenwich Village nightclub. I was six years old. Paco and I performed together in a very well known dance from Seville called the 'Simiamas.' A little later, a talent scout discovered me at my dance school. He found me some acting jobs. Acting seemed to me the most natural thing in the world. Acting parts began to come my way. I played on radio and did some early television."

"But you had dreams of Hollywood."

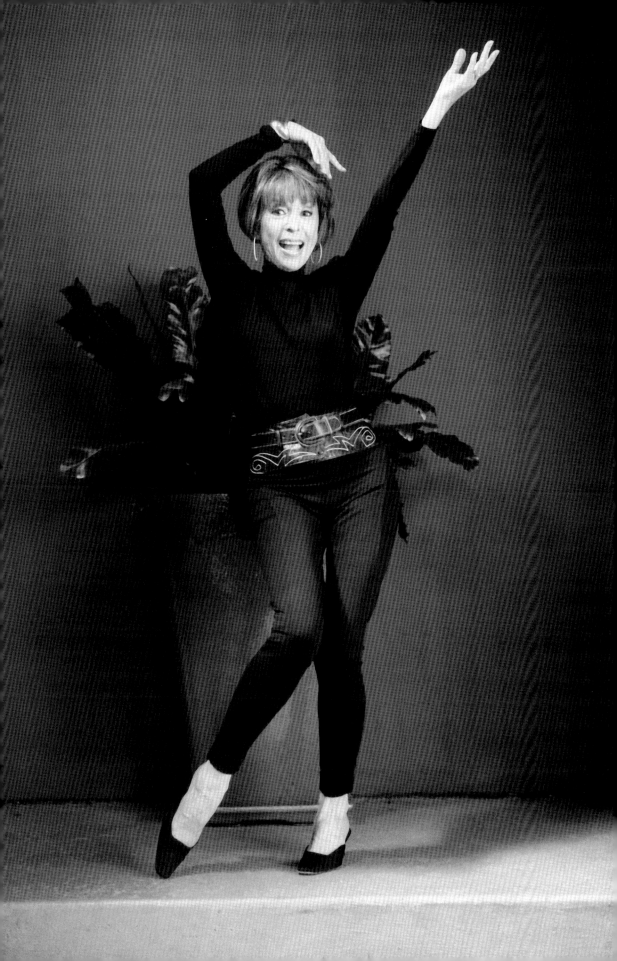

"Oh, I wanted to be Lana Turner," she said with a laugh. "Boy, was I in for a big disappointment. Turner was the one of the most glamorous stars in Hollywood. There were no Latina role models back then, so who was I going to model myself after? In the 1950s I fashioned myself after Elizabeth Taylor. I even combed my hair like hers and wore thick eyebrows. When I met Louis B. Mayer, who signed me at MGM, he said, 'She reminds me of a Spanish Liz Taylor.' I thought I had it made."

"You hoped to dance on the silver screen?"

"I loved to dance, and it was a wonderful vehicle to express my feelings, but the motivation behind it all was to be world-famous, loved by all, and not to be specifically identified as Puerto Rican or Caribbean."

"Why did you say you were in for a big disappointment? What went wrong?"

"Well, I did three musicals at MGM: *The Toast of New Orleans, Pagan Love Song,* and *Singin' in the Rain,* the first time I played a non-Hispanic, thanks to Gene Kelly who cast me in the role of Zelda Zanders. Then the world crashed down on me when Louis B. Mayer decided he had no more use for me and traded my contract to another studio. After that, I was cast in westerns as either a little Indian maiden or some Mexican chick. Most of my roles were what I call 'Conchita, Lolita' characters—stereotyped Latina girls. For years my characters spoke with an accent. It was the bane of my existence."

"Did you fear that your dreams of glamour and fame would never be realized?"

"Yes, and I became extremely neurotic and depressed during that period. I felt as if I were still six years old and trying to please everybody. My depression drove me into therapy, which was the best thing that happened to me and lasted for about eight years."

"You would go on to be the only woman in history to win an Oscar, Tony, Emmy, and Grammy Award. What a triumph!"

"Once in a while I stop and look at those awards that I keep in the living room, and I'm just amazed. I say to myself, 'Oh my goodness, isn't this astonishing?' Recently I was also awarded the Presidential Medal of Freedom."

"You must have done something right, listening to your inner wisdom while navigating your career."

"'Navigate' implies that you're doing something to control your future. I don't think I had a lot of choice about where I went. I took whatever was offered to me. What was there to navigate? I turned nothing down, which was why I would get so bloody depressed. When I was out of a job, I'd be

miserable and when I got a job, I'd be elated for twenty-four hours and then realize that I had to speak with that damned accent again. I was playing the same role again and again only in a different costume, either buckskins or an off-the-shoulder blouse and large hoop earrings. I was in a constant state of frustration and feeling oppressed by my situation. I had nowhere to turn. I had to take what was offered to me, but deep down I knew I had this untapped talent. I've always had that juice, and I knew if someone just gave me the chance to show it, they'd get an incredible performance out of me. I hope this doesn't sound arrogant, Rose. But it took me years of therapy to be able to say, 'I'm good.' Years of therapy to say, 'I have value.' And so I say it now without hesitation."

"You first met Jerome Robbins when you costarred in the 1956 film *The King and I* with Deborah Kerr and Yul Brenner."

"Yes, and after we finished shooting *The King and I,* Robbins told me that he was working on a new musical for Broadway called *West Side Story.* 'It's a modern-day Romeo and Juliet,' he said. 'Would you be interested in trying out for the part of Maria?' 'Oh, yes,' I said, with confidence. But when the time came, more than a year later, I got cold feet. Why did I get such cold feet? Well, I had been in the movies in which you could do things over and over again and there was always someone there to pull you up if you fell. I just wasn't brave enough to be a lead in a Broadway show. Later, when I went to see *West Side Story,* I regretted not having accepted the role."

"How did you land the part of Anita in the film version?"

"Well, by the time the film was being cast I was twenty-seven and no longer looked like a Maria. I looked more like an Anita. I auditioned for the part—acting and singing. Jerry and the film's producer, Robert Wise, really wanted me. Then Jerry said, 'I have to tell you, Rita, that if you can't cut the dancing, you don't get the part. You'll have to audition for that too.' I gulped really hard. I hadn't really danced since I was seventeen. All I really knew how to do was Spanish dance. I was a great skirt dancer and could do footwork and play the castanets."

"What did you do?"

"I immediately ran to Eugene Loring's dance school in Hollywood and threw myself into classes from morning till night. I was taking ballet class and jazz, which I had never done in my life. I worked so hard that one of my teachers kicked me out of her class. She said, 'Honey, you're turning a funny shade of purple. You're working too hard and I'm afraid you're going to collapse.' I think the only thing that saved me from getting a heart attack was that I was extremely strong and had tremendous stamina. I was

working my butt off, but my jazz dancing was really not improving. The audition was just a couple of weeks away and I was becoming desperate. I had to get this part, and I knew that I didn't have the proper dance technique. So I phoned someone I knew who had played the role of Anita on the road and asked her if she could teach me some of the choreography. She taught me a section from 'America' that she said was frequently, but not always, used in auditions and a section from the mambo in the gym— but again, not always the one they used. Learning the choreography was like learning Greek. I went to the audition with my heart in my throat. Jerry's assistant, Howard Jeffrey, auditioned me. He took my hand and said, 'I'd like to teach you a piece from "America."' It was the same section that I had just learned. I said, 'Okay,' as if I had never seen it before. Then he asked for the mambo number—also the same one that my friend had taught me. And I got the part! I got the part! I was out of my mind with happiness. Someone was looking out for me."

"What was it like for you to play Anita?"

"Oh, I *was* Anita. I was Anita with my eyes closed. The side of me that had been squashed for years under those roles, 'why you no love me no more' or 'I'm going to show you where da gold is hidden,' had been set free. Anita was a vibrant and fully developed person. I can't tell you how many Latina girls and young men said to me that it was so thrilling and inspiring for them to see a Latina playing a strong Latina in a film."

"How cathartic this must have been for you."

"Oh, it was. In fact, it was during the scene in the candy store that some very deep wounds opened up inside of me. In that scene, the Jets shout insults at me—spic, garlic mouth, and gold tooth—and they rough me up. On the shooting break I sat down at the candy store counter, put my head in my hands, and started to cry—and I could not stop. I was sobbing so deeply that I couldn't speak. I couldn't even tell anyone what was wrong with me. Some wounds have very thin scabs and if you poke them, they'll bleed again."

"Rita, your performance in the film is extremely powerful—your dancing, brilliant."

"I have Jerry Robbins to thank for that. This was the first time in my life that I really, really felt like a dancer. Jerry and Howard Jeffrey showed me where the impulse of a step comes from. Do you know what a gift that is? Very few dancers—even some choreographers—don't know from whence comes that impulse."

"Jerome Robbins had a reputation for being cruel at times. Was he ever hard on you?"

"No, never, and I never understood why. People like Jerry could smell a victim a mile away, and I was a made-to-order victim. I don't know why he didn't smell it in me. I saw him tear others to shreds. I think ultimately he was very proud of my work. *Life* magazine did a story about the making of the film and sent a photographer. I have this wonderful picture of Jerry watching me in rehearsal during the 'America' number. He's leaning against a wall, with this approving grin on his face—and it says it all."

"*West Side Story* finally put you on the map."

"Actually, it put me on the unemployment line for about seven years."

"What?"

"I can't really explain it except that there were very few musicals being done during those years. And now, once and for all, my persona was firmly imprinted on the minds of those who could employ me as a Latina. How many Latinas do you remember seeing in Hollywood musicals in the 1960s? None, right? When the Academy Awards show came around, I was working on a crappy World War II movie in the Philippines playing— guess what?—a Philippine guerrilla girl. I flew from Manila to Hollywood, collected my Oscar and flew back to finish that crappy movie. After that I was offered very few movie roles. Producers and directors said, 'I have nothing for her.' It wasn't that they didn't like me. They thought I was marvelous, but there just weren't any parts for me. You know you really have to be made of something very special to endure those blows. And I'm surely not alone here. So for the next few years I did television and live theater: road tours of *Damn Yankees, Bells are Ringing,* and *Gypsy.*"

"Years after *West Side Story* you won a Tony for your role as Googie Gomez in *The Ritz.*"

"Yes, Googie was my invention. During the making of *West Side Story,* members of the cast and I used to hang around and do bits, you know, crazy shtick. And one day I burped up this wacky Puerto Rican girl. She's auditioning for the lead in *Gypsy,* 'I had a dring, I had a dring about you baby.' Playwright Terence McNally saw me performing Googie at a party and laughed so hard he nearly fell off his chair. He came up to me and said, 'I am going to write a part for this character of yours.' Pah, I never have this kind of luck, but he did it. *The Ritz* opened on Broadway in January of 1975. A year later it was made into a film. What I love about Googie is that she can't sing and she can't dance, but she's a singer-dancer."

"Rita, you have remarkable resilience."

"Oh, am I stubborn! And I don't know anyone who is more terrified of going before an audience than I am. Moments before a live performance my hands turn to ice and my knees literally knock. If I have to sing, I

know I'm in real trouble because my voice trembles. That's how terrified I get. Seconds before I go on I ask myself, 'Why are you doing this? Why are you torturing yourself?' The answer is that I have to do it. I simply have to do it. And the terror that I feel comes from wanting to be perfect. I know I can fool the audience, but I can't fool myself. And the one person I don't want to disappoint in this world is *me*. That's the real credo of a perfectionist. I know it's ridiculous and absurd, but there you are."

"And yet you crave new challenges and dive right in."

"It's true. I don't pick easy characters to play—take Maria Callas in *Master Class* or Serafina Delle Rose in *The Rose Tattoo,* or this one, Amanda Wingfield, in *The Glass Menagerie.*"

"Or your character Sister Peter Marie Reimondo—the Catholic nun turned psychiatrist to murderers and child molesters in Ozwald Prison on the HBO series *Oz.*"

"Oh, yes, she was truly a challenge to play, since I didn't know how to be that real, that natural playing a nun. I looked to the directors to guide me."

"What's your next big challenge?"

"What we're thinking about here at the Berkeley Repertory Theater is a one-woman show about my life. I've been putting this off for a long time. I want to be careful that it doesn't turn sentimental—see how much this poor little Latina girl suffered.' But the truth is that my life has been really interesting. I dated Elvis Presley, for chrissakes, and went out with Howard Hughes. I was with Marlon Brando for a bunch of years."

"Really? What were these men like?"

"Well, Elvis liked brunettes, which was the reason he got in touch with me and asked me out. But whenever we went out we were bombarded by his fans. He was gorgeous but I didn't find him very interesting. Howard Hughes, on the other hand, took me to dinner and tried to explain to me how radar works. He was a real gentleman, actually very sweet, but I was not happy when he said that I was a lovely child. I wanted to be viewed as a woman, not a child. And Brando, he was fascinating and had a great sense of humor. He was really the funniest man I'd ever met. But at the same time, he was also troubled."

"Tell me, Rita, what is the most important lesson you learned in your life?"

"It's very simple, Rose. You don't die from bad things. You don't die from not being liked or from making a mistake. You may think it's the end of the world, but you learn to live with things. Death is the only thing that will kill you," she said, with a laugh.

Berkeley, California, 2006

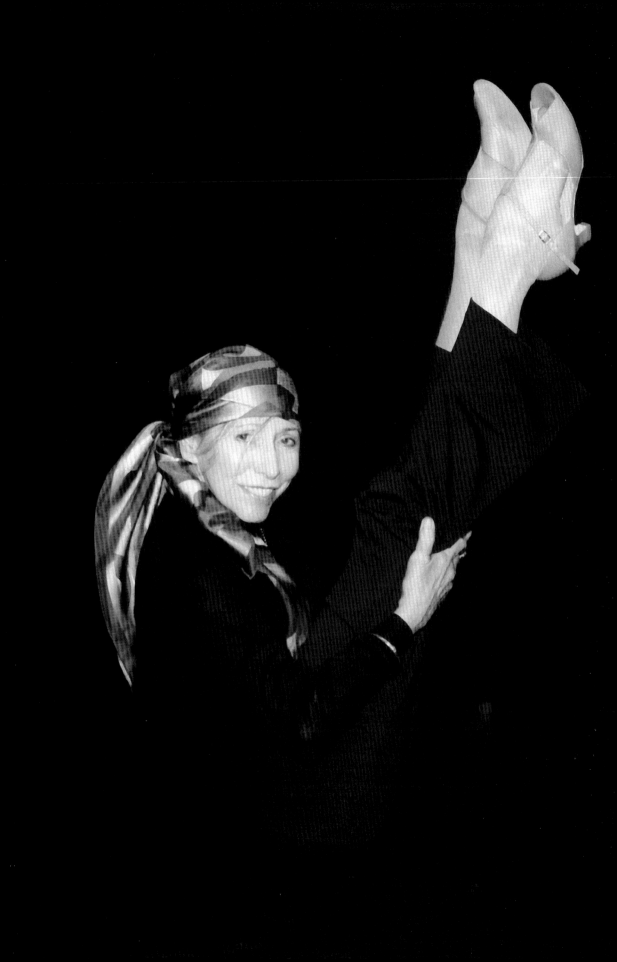

Natalia Makarova

Natalia Makarova's 1970 defection to the West in pursuit of artistic freedom made international headlines and set off a wave of defections from the Soviet Union to the United States, bringing over some of the Kirov Ballet's finest stars, including Mikhail Baryshnikov. The technical virtuosity and dramatic expressiveness of the Russian dancers brought the popularity of ballet in America to new heights.

Today Makarova lives in San Francisco, California, and remains an international presence through her choreographing and coaching of major European ballet companies. My meeting with the legendary ballerina coincided with her staging of *Swan Lake* for the Perm Ballet of Russia's production at the University of California, Berkeley. I waited for her outside her dressing room, under a handwritten sign inscribed with her name in both Russian and English.

She walked in about ten minutes later, dressed in a fur coat and a kerchief wrapped around her head—her signature look. I shook her hand, surprised at how petite she was—around my height, 5'2".

"Hello Natalia, I'm Rose." I said. Her deep blue eyes studied me.

"Come," she said, opening her dressing room door and leading me inside. "Sit. I'm ready for you." She pulled several typed pages from her handbag, responses to the questions she had insisted I send her in advance of our meeting.

Natalia took a seat across from me on the sofa, removed her fur coat and pulled the scarf from her head, revealing short wispy blond hair that fell into her eyes.

"My life is very complex—not one-dimensional," she said, her Russian accent now clearly discernible.

"Yes. I am aware that you've had a most extraordinary life."

"I have much luggage from my past. I was born during World War II and lost my father in the first years of the war. He disappeared without a trace. My mother survived the siege of Leningrad—one of the bloodiest in the city's history. I was spared the horrible images of war: the frozen bodies in the streets, the starvation, and bomb shelters. I was sent to live with my grandmother in the Russian forest, spending the first five years of my life surrounded by nature. To this day, I love the forest. It instilled

in me a great love of beauty. I remember the joy of picking wild mush-rooms and berries surrounded by tall trees."

"How did you come to discover ballet?"

"I came to dance quite by chance, even though I was always very physi-cal. I liked gymnastics and to climb trees, but these have nothing to do with dancing ballet. My friends and I belonged to a group, like you have here—Girl Scouts, yes? We did folk dancing and other activities. The leader of the Scouts thought I was slower than the others. I was like so many Russian children born during the war who had suffered from mal-nutrition, and it probably affected my stamina and physical strength. My Scout leader directed me to Rossi Street—to the Vaganova School, which used ballet technique to build muscle strength. I went there and saw on the door an advertisement for an experimental ballet class for children ages 9 to 13. I was twelve. For the first time in their history they offered a course that condensed nine years of training into six. After the war, the school's enrollment was very low, so when I walked in, they put my leg in the air and signed me up. You see, it was just an accident that I came to dance ballet."

"Was destiny calling, perhaps?"

"Only if you want to be very mystical about it—then okay. Do you want me to say that each individual has their life already written?"

"Well, I think we are all chosen for some purpose."

"Yes, I do believe in destiny. But I also believe that there are many fac-tors that go into what makes a dancer: environment, family, exposure to music, literature, art, and the right physique and proportions," she said, extending her arm. "I was always very flexible—double-jointed is called, yes? But then there is something else, something that is God-given—spirit. How spirit is formed I don't know. No one can explain this."

"In your autobiography, you said the source of your power came from a natural curiosity."

"Curiosity killed the cat, no?" she said with a smile. "I would say I was adventurous. The Vaganova School prided itself on bringing out students' creative potential and talent. Once you immersed yourself in this artistic environment you never wanted to leave it. The walls of the Vaganova School emanated with artistic tradition as it funneled its stu-dents into the Kirov Theater. When I arrived in 1951, the school still re-tained remnants of its former glory from the days of the Maryinsky The-ater and the Imperial Ballet. Each of our legendary teachers had a history. They taught us the roles that they had danced. The Vaganova children

were taught to breathe expression into their movement and give spiritual meaning to their steps. Like a singer who sustains a note to give song more power, we learned to sustain arabesque. Yes?"

I nodded.

"The training," she continued, "was also very well rounded, with classes in the history of art and music." Natalia looked down at her notes and asked herself, "What else do I want to say?"

"Did you recognize that you had talent?"

"As a child I didn't really understand my gift, but I had within me the desire to express myself. Had I not seen that sign for ballet classes on Rossi Street, I might have become a painter or an artist of some kind. If you have depth and something to say, it will find a way to surface."

"What defines a true artist?"

"Artists are attuned to and trust their instincts. Decisions that I made in my life may have looked random to others, but I was listening to the voice inside my body. For me, timing has been everything. My mother was against my becoming a ballerina, but my entering the Vaganova School became for me an obsession. I screamed and cried until she gave in. I defected to the West in 1970, while on tour with the Kirov Ballet. If I had defected earlier, I would not have survived physically or emotionally. My decision was entirely spontaneous and of the moment. I even had my son, Andrew, at just the right time in my life. Few ballerinas have children because they are afraid of losing their careers. But for me the timing was right."

"You worked with many great teachers and choreographers in Russia. Who most influenced your dancing?"

"Once I became a dancer with the Kirov I was very lucky to fall under the wing of Leonid Yacobson—a very innovative and romantic choreographer with a rebellious spirit who defied the basic tenets of classical ballet. He created works in which the dancer's feet turned in. He developed characters with distorted bodies and ballets with erotic overtones. He sought to bring out the utmost expressiveness of the dancer's body. I became his muse. He created many original works on me, based on my personality. Yacobson recognized that I had the ability to express feelings through movement and drew them out of me. It became clear to me that you are who you are on that stage. The body doesn't lie. Dancing his experimental ballets taught me that I was capable of doing things I never dreamed possible. As a result, I became much freer in a tutu when dancing classical works. Sounds paradoxical, but is true."

"You once said that you defected because you didn't want to die a slow death in the Kirov Ballet. What did you mean by that?"

"Had I stayed in Russia it would not have been very good for me. I don't think the artist in me would have survived. I was becoming artistically very hungry. I'd already performed the entire Kirov repertoire many times over. Yacobson wasn't enough for me. When we toured outside Russia, I was exposed to different choreographers and dance styles, including modern dance. I saw that dancers on the outside had many more artistic opportunities. Don't forget, we were still behind the Iron Curtain in the 1960s. Choreographers from the outside did not come to the Soviet Union. I felt very limited. My appetite for artistic exploration continued to grow and I was becoming increasingly more frustrated. I could see that a larger repertoire was not in my future."

"How was your adjustment to life in the West?"

"It was not easy to start a new life, how you say, on the ground floor. I had left my family and everything I owned in Russia. I didn't know the English language. Most difficult for me was being without a teacher. I had only myself and my years in the theater to rely on." Natalia began to check her notes again.

"Can I see that?" I asked.

"No," she said, moving them out of my reach, hiding a devilish smile.

"I imagine it was a shock when the Royal Ballet in London didn't invite you to join their company."

"Ya, Ya, was disappointing at the time. But I was fortunate to dance with the Royal Ballet many times later, as guest artist. American Ballet Theatre sent me a telegram inviting me to come to America and dance with them. I embraced their repertoire with great enthusiasm, not having danced a new work since 1968."

"How did the ABT repertoire affect your dancing—and your technique?"

"Within a short time I became very strong—and my technique, very versatile. I was learning many new roles and performing my signature ballets, *Giselle* and *Swan Lake*. For me it was like a superhuman schedule—a big change from performing only three or four times a month as I did with the Kirov. I couldn't very well complain. After all, I defected because I wanted to dance more."

"Were you able to choose which choreographer's works you wanted to dance and who you would partner with?"

"Yes, from beginning, I had a name and a position in ABT. In addition to the works that I was known for, I could choose ballets of many great choreographers: *Pillar of Fire,* Antony Tudor; *Apollo,*

George Balanchine; *Other Dances,* Jerry Robbins; *Voluntaries,* Glen Tetley; *The River,* Alvin Ailey; as well as popular classic works that were new to me—*Les Sylphides, Coppélia,* and *La Fille mal Gardée.* I partnered with Ivan Nagy, Eric Bruhn, Fernando Bujones, Baryshnikov, and many others."

"Did you feel any pressure to have to prove yourself?"

"Ah, of course! Every performance I have to prove! You know the public never forgives you the bad performance; they forget the good ones and remember the bad one. I struggle each time to find a new level of artistry. You see, you are always looking for perfection, which, of course, you never achieve. But striving for it propels you to a greater level. I never danced the same way twice. For me, each time is like the first. Even if I dance ten *Swan Lake*s, each *Swan Lake* will be different—and original. This is my nature. I can't repeat myself. I need to renew myself constantly."

"When you're on the stage are you thinking about the audience?"

"I perform at my best when I forget about the audience, when I become my character. I don't act, I don't play—I just am. I become involved with the music completely. It's like a personal conversation. And then—suddenly—I hear the silence. Total incredible silence—*Ringing silence!* People in the audience are not even breathing. They are completely with me; we are like one. This is magical moment. This is when I am most inspired."

"Is there a way to prepare for this kind of intense experience?"

"You must be an original every time to create this kind of atmosphere. You must prepare physically, of course—warm up each muscle to its fullest extent—but you must also prepare yourself spiritually. It requires great concentration. This is why before a performance I don't want to talk to anyone. While I put on my makeup, I must be alone in my dressing room. I sometimes play a Bach concerto. The music is so sublime it fills me up, and then I have something to give. It's very bad when you dance on empty. Before dancing *Giselle,* I would listen to Bach because his music is so transcendental. Before performing *Romeo and Juliet,* I would read passages from Shakespeare aloud, which helped me get into the spirit of Juliet."

"I've heard that some artists say a prayer or mantra before going on."

"Yes, I too say something. But this is mine—mine alone. I'm not going to tell you what I say."

"Do you have a ritual that you do following a performance?"

"No. Is finished. I drink glass champagne."

"How can dancers increase their emotional and spiritual range?"

"To be a great artist you must have an internal vision. From which source you take it, doesn't matter: art, literature, music. For me, it has always been painting—art. Art gives me nourishment—depth and spirituality. If you have nothing inside, how can you touch people's hearts? And if you dance with muscles alone, then you are not an artist."

"For most, just mastering the physical body is an overwhelming challenge."

"One must work the body like a racehorse. Rein her in and bring her under your control. When she rebels, you must conquer her, become her master to bring body and mind into harmony. But, at the same time, you must listen to her when she tells you that she can't go on. If you don't, the result will be injury."

"How is the dancer inside of you doing these days?"

"I killed her."

"You what?"

"I killed the dancer inside of me."

"Are you saying that dancers should retire when they get to a certain age?"

"Yes, of course. Ballet has an aesthetic. Ballet is beauty, no? I no longer wanted to dance on the stage, so I ended my dancing life and put my creativity into different areas, like coaching and choreographing."

"You don't miss performing?"

"I try not to think about that. I still train my body two hours everyday for my health and to stay in shape. I work and move my joints."

Natalia stood up and began to stretch. Her lean body looked as supple as any of the dancers I had seen wandering around backstage. She placed her feet into an amazing turned-out first position and began performing demi-pliés. She then extended one leg back and lengthened out in a prolonged arabesque. Her arches were like no one else's I had ever seen—perfectly curved and as pliable as rubber.

Gathering up my things, I said, "Natalia, how about I take a few pictures?"

"Not now," she said warily.

I had been warned that Natalia was terribly camera-shy. I thanked her for the interview and contemplated how I might photograph her later that afternoon.

I returned during rehearsal to find Natalia on the stage demonstrating to a group of corps ballerinas how to extend the arms gracefully across the body. Standing in the wings with my camera I hoped to capture the scene. Before I could shoot, Natalia spotted me and motioned for me to approach. She dismissed the girls and instructed: "We take photo now,

quickly." She sat down on the floor and shot her thin muscular legs into the air. "Ah! Wait! It's too dark here. My flash! Please, wait. I'll be right back." I took off through a maze of sets, props, stagehands, and dancers to Natalia's dressing room. I grabbed the flash from my bag, slid it onto the hot shoe of my camera, and raced back to the stage. Natalia saw me coming and hit her mark.

Berkeley, California, April 2007

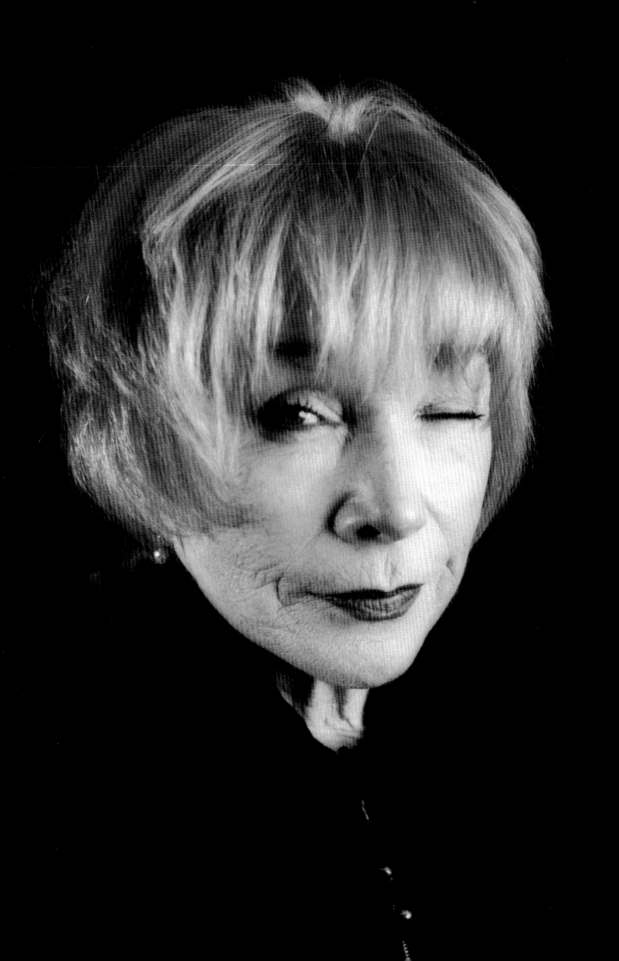

"When Shirley MacLaine's rented coupe pulled into my driveway, I walked out to greet the famous movie star, but she remained in the car, looking down and mumbling something.

"Shirley, do you need help?" I inquired.

"I've lost my ruby. It fell out of my ring and dropped under the seat."

She got out of the car, moved the seat back and began feeling around for the precious stone. "It's got to be here," she said. "I'll just be a minute. Oh, and this is Terry." On cue, her spunky little terrier jumped from the back seat and ran cheerfully toward me.

"The next person who rents this car is going to be pretty happy when they find my ruby," Shirley said, as she made her way through the front door and straight into my kitchen.

"Do you have the bananas and skim milk I asked for in my phone message?"

"Yes, of course. I went out and bought them this morning."

"Okay, where's your blender?"

"I don't have a blender."

"You don't have a blender? Who doesn't have a blender?"

"I use a food processor. It does the same thing."

"All right, let's try it." I added the banana, milk, ice cubes, and sweetener, and switched on the machine. There I was, making a banana smoothie with one of Hollywood's most celebrated stars. It felt surreal.

"It looks ready," I said, handing her a glass.

"Hmm, this is very good. The food processor fills it with air and that makes it very creamy."

"How about doing the interview now, Shirley."

"Yeah, yeah, we'll get to it. Who are they?" she asked, pointing to a large framed photograph in my hallway.

"Those are my three kids. They're away at college."

"Aha! And who are the dancers you have on your studio wall? How did you shoot that one? Oh, and I like that Southwest design on your sofa."

I finally coaxed her into the family room and clipped a microphone to her shirt. As I glanced at my notes, she said, "Rose, why do you need all this? Let's just talk. You can lighten up now."

"I use notes so I can focus on the things I want to talk to you about, to get to know you so that my portrait reflects who you are."

"You think you're going to get to know me in an afternoon? No way. Besides, photographers never get an honest picture of their subjects because people only give them what they want them to see."

"Perhaps, but I think they are more inclined to present themselves generously if they're comfortable with their photographer."

"So this is really about you?"

"Well, yes, of course it is. What I report will reflect my experience: what I see, hear, feel—and learn."

"Whatever. Do your thing," she said, slipping off her shoes and stretching out on the sofa.

"First, I'd like to tell you a story that happened to me over thirty years ago. It involves you."

"Really?"

"Yes. When I was eighteen, I went to study dance in Jerusalem. It was a tough year for me—first time away from home, first time living in a foreign country, not knowing the language. I was very lonely and questioned whether or not I had what it takes to be a dancer. One day I discovered a bookstore near the school and went in hoping to find something that might lift my spirits. But they seemed to carry only Hebrew books. As I turned to leave, I noticed a book in a cardboard box near the door with your picture on the cover. Your autobiography, *Don't Fall Off The Mountain,* was the only English book in the store, so I bought it. That's when I learned that you began your career as a dancer. You told the story of how as a teenager you danced the role of the Fairy Godmother in *Cinderella* with a broken ankle. I thought to myself, now *that's* what it takes to be a dancer. If Shirley MacLaine can dance with a broken ankle, then I can survive these dark days of self-doubt and loneliness. Your book was a great comfort to me. I never expected to meet you, but vowed that if I ever did, I would thank you and share this story with you."

Unfazed, she said, "Why would you go to study dance in Israel and not New York?" I told her that it seemed like a good idea at the time and launched into the interview.

"Shirley, when did you first feel the impulse to dance?"

"I think I had a dancer's mentality when I was born. I believe we all come in knowing what we want to do—what we *have* to do. I knew I had that physical task when I was three. So during *Cinderella* it never occurred to me that I shouldn't dance just because my ankle was broken. The audience was out there, the overture was playing, and I was part of a collective

of people who believed that the production was the thing—to express the dance. You have to go on, and this was my work ethic. It still is. If I promise to do something, I do it. Plus, I loved the music, the freedom of expression, and the discipline that is dance. All my teachers told me that I shouldn't try to be a dancer because I was too much of an individual, that I thought too much. Every single one of them told me that. And I knew it, but I didn't have a way of doing something else that would be as fulfilling. Up until I moved to New York City, my life revolved around dance—what I call the discipline of the physical."

"Did your parents inspire that in you?"

"My father was a musician who wanted to run away and join the circus. My mother was a poetess who loved to act. Both gave it all up when they got married and had children. I think my need for self-expression was to compensate for how they subdued and suppressed their own—to do what they didn't."

"Dance led you to other forms of self-expression."

"Dance led me to Broadway. There I learned that wonderful things were happening on the stage, like singing and acting and comedy. So yes, I went from this impulse to move to all the rest of it: singing, acting, and writing."

"Your story actually plays out like a Hollywood fable. You were discovered when you stepped in for Carol Haney after she broke her ankle during the production of Bob Fosse's *Pajama Game*."

"Yes. Hal Wallis and Alfred Hitchcock were in the audience that night, and after the show I was offered both a studio contract and a movie deal. Hal Prince, the show's producer, told me not to take either. He said, 'Don't go. Stay in the chorus a little longer and get more experience.' Don't you think it's crazy to ask someone to stay in the chorus? I never really understood that. I wanted to move on, and here was my chance."

"Did you continue your ballet training?"

"When I came to New York City, I studied at the American Ballet Theatre School. But every ballerina I met cared only about her toe shoes and what part she might get once she advanced out of the corps de ballet. She couldn't tell you who was president. Most ballet dancers have tunnel vision. So when I was invited to join the company and go on tour, I declined. I was adventurous and wanted to experience life. I didn't think I could find adventure inside a ballet company."

"Sounds like you had more the spirit of a jazz dancer?"

"Yes, absolutely, and Bob Fosse would be the one to teach me about jazz. He was brilliant."

"What was it like dancing for him in *Pajama Game*?"

"Rehearsing in the basement at three or four in the morning, everyone falling down dead with exhaustion. Somehow between the cigarette smoke and the apology, he would say, 'Could we just do it again?' I understood that he was just being eccentric. It didn't matter to him that he was driving everyone to utter exhaustion. He seemed to think it was okay with an apology. Choreographers are sadistic and have damaging power over their dancers. They want to see form happen in the air according to their vision, and they don't care what it takes. And dancers will do anything they're asked. Dancers are artistic soldiers."

"I always thought that Bob Fosse was simply possessed by the dance—but perhaps he was, as you say, an eccentric."

"Yes, he was. I'm an eccentric now. I didn't used to be. And the older I get, the more curmudgeonlike I become. The way I see the world, everyone is fronting, most everybody—except older people. Older people know they don't need to give a shit any more, so they stop fronting, which means they drop the masks. That's what I'm doing. I know that at times I'm shocking and harsh, mean and even hurtful. But I can't stop myself. I can't bring myself to be polite if I don't feel like it. I say things with more force than I need to. Maybe that's because with age you become more and more invisible, and you don't want to be invisible. I've been thinking about that a lot lately. If someone wants to know who I am, Rose, tell them I have the mentality of the dancer edging toward being a pain-in-the-butt choreographer."

"I will. I promise. Do you have any interest in performing again as a dancer?"

"Recently I've thought a lot about going back on the stage and doing something with a stool, black dress, spotlight, and talking-singing-acting with a little bit of movement—not a big boom-boom dance number but something appropriate. You know I've worked with so many incredible choreographers."

"How has your dance background influenced your acting?"

"If you want to act, the first thing you have to get rid of is moving like a dancer. But there is no doubt it has helped me. When I take on a new role, I immediately set out to determine how a character moves, carries herself: how she sits, walks across a room, how she runs. When I know that, then I understand her overall body behavior."

"One of my favorite movies is *The Apartment,* and there is one scene that has always stayed with me. It's when your character, Miss Kubelik, is in the bathroom and about to put on lipstick but decides to take an overdose of sleeping pills instead. It's a short scene but pivotal."

"Yes, she decides to kill herself instead of continuing as the other woman. I get great pleasure from becoming my characters at the time that I'm involved with it. Afterwards I don't remember the characters that I've played. Give me the name of the movie, and still I haven't got a clue. Isn't that fascinating? But if you give me specifics, like that scene in *The Apartment,* I can remember shooting that. In fact, I remember that particular day. I had a cut on my finger, and if you watch that scene carefully, you'll see that I'm choosing the pills in the medicine cabinet in a way so that my cut doesn't show on camera. My short-term memory is going because of age, but my long-term memory needs to be corralled into specifics. Maybe that's why they say God is in the details. I find myself living in the now and for the moment. It's just wonderful, by the way. That's why when you said, 'Sit down, we have work to do,' well, I wanted to look at your geisha doll over there or at those photos on the wall. That's what old people come to. That's their big wisdom—the now."

"Through your films and stage shows you've entertained millions of people. That must give you great satisfaction."

"Well, that's *their* problem. It's not important to me. That's another thing that happens to you when you become cognizant of what your life has been. You did it all for yourself. And to say you didn't, makes you a liar. So tell me, Rose . . ."

For the next forty-five minutes, Shirley became the interviewer, digging into my family history and previous lives. Finally I demanded, "How did we make this interview about me?"

"Because that's what this is all about," she whispered. "You said so yourself. You know, I can use another smoothie. Have you got any vanilla?" In the kitchen Shirley put me back on the witness stand for another round of questioning.

"Rose, have you ever had an affair?"

"Uhh . . . no, Shirley, I haven't."

"How long have you been married?"

"Thirty years."

"But you've had opportunities?"

"Yes."

"And?"

"And I didn't act on them."

"I see. What about your husband?"

"What about him?"

"Has he had affairs?"

"I don't think so. But I don't know for sure."

"Hmmm, that's very interesting! I guess you're those *type* of people."
I desperately needed to change the subject.

"Let's prepare to take your picture now," I said, pointing to the powder room. She returned twenty minutes later having left her in-your-face testiness behind. Standing before the lens, Shirley summoned up her carefully crafted public persona—fifty years in the making—funny, playful, wacky, adventurous. The real Shirley reappeared after she'd had her fill of photos. Her camera smile began to wear thin, her jaw locked, and she winked at me as if to say, okay, enough already. I pressed my shutter and ended the shoot.

Walking Shirley and Terry to the car I felt a little queasy—the way you feel when you get off a roller coaster. Shirley's probing into my life had forced me to take a good hard look at myself. This work REALLY is about me. Sure, I wanted answers about the fusion of life and art—not as an academic exercise, but as a way to understand the dancer submerged within me, which for decades has been struggling to find expression.

Shirley once again had come to my rescue.

Encino, California, March 2005

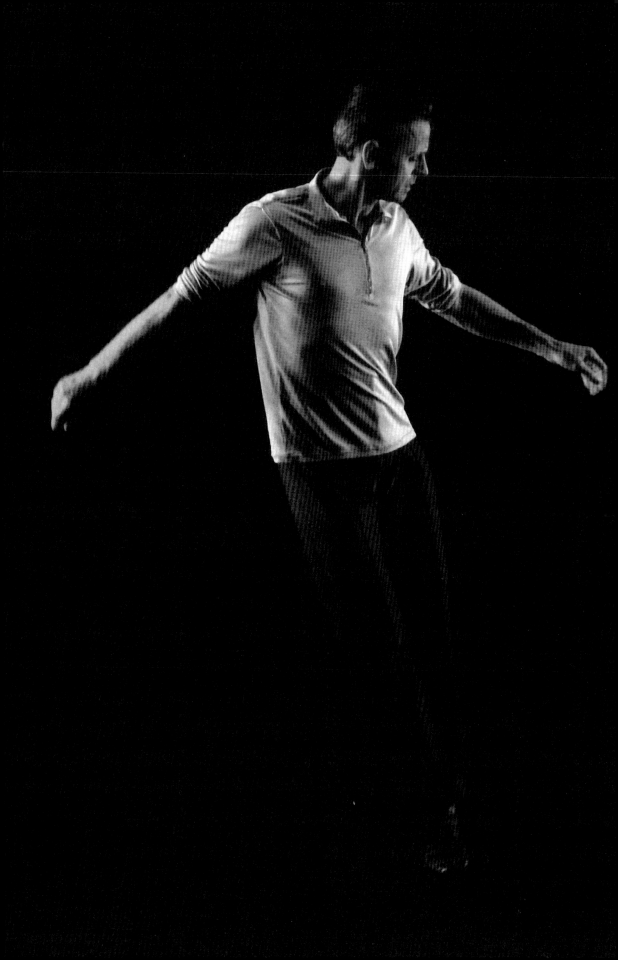

 Mikhail Baryshnikov

Mikhail Baryshnikov rarely consents to being photographed, but I was determined to include him in this book. In June 2006, I learned that Baryshnikov's *Hell's Kitchen Dance* was booked to perform at Zellerbach Hall on the University of California, Berkeley campus—the same day as my scheduled interview and photo session with Rita Moreno, also in Berkeley. I took this as a sign that it was time for me to make my move. I contacted Baryshnikov's Dance Foundation in New York to request a meeting with the world-renowned dancer and ask permission to photograph his Berkeley engagement. I was told that my request had been forwarded to Misha on the road and that his assistant would get back to me. He didn't. So the morning of my Berkeley trip I phoned his executive director, Christina, and reiterated my request.

"All I ask is to speak with him," I told her.

"The only thing I can tell you, Rose, is that Misha is staying at the Hotel Durant."

"That's where I'm staying!" I said. Another sign.

"In that case," she said, "if you want to leave some materials for him through his assistant, Travis, maybe he'll take a look. I can't promise anything."

I had a toe in the door. Once I'd checked into the hotel, I phoned Travis's room, only to learn that he had never heard of me and knew nothing about my request.

"Misha doesn't participate in people's books," Travis told me, "and almost never allows photography during performance."

I persisted. "I have a gift for him—a signed copy of my book *Masters of Movement*. All I ask is that he take a look at my work. If he doesn't like it, then I won't bother him again. If he agrees to let me photograph tonight's performance, I would make the photos available to his foundation."

Travis agreed to present my book and portfolio of dance images to his boss. I told him that I'd leave the materials at the front desk for him to pick up.

I waited all evening and the following morning for a call from Travis. No messages. At noon I paid my bill and checked out of the hotel, resigned to the fact that my request had been denied. As I

stood waiting outside the hotel for a taxi to take me to the airport, my cell phone rang.

"Rose, this is Travis. Misha and I reviewed your materials very carefully and he has agreed to let you photograph the show tonight—but only under the condition that your camera is silent and that it does not disturb the audience. You will have to shoot from the back of the theater. Do you have a silencer for your shutter?"

"Well, no," I said nervously. "But my digital camera is fairly quiet. I will not disturb the audience."

"If Misha hears your shutter click, you will have to stop immediately. Is this clear?"

"Yes."

I arrived at the Zellerbach Playhouse an hour before curtain and met Travis, who told me that I would be able to shoot from the soundbooth through an open window. He then led me up a flight of stairs at the back of the theater and asked me to wait for him in the soundbooth. I placed my gear on the floor and noticed Baryshnikov alone on a darkened stage. I pulled a telephoto lens from my bag, attached it to my camera body, and focused in on him. He looked handsome and trim—in perfect form. I wondered how many warm-ups like this he'd done in his life. Studying him as he performed *ronds de jambe* at a portable ballet barre, I recalled hearing him once say, 'I hate to explain what I do because dance is about philosophy and action.' I was tempted to snap a picture but something told me to hold back. Travis returned moments later and handed me a piece of paper.

"What's this?"

"It's for you from the New York office. Read it:"

Baryshnikov would have to approve any images before they could appear in *The Dancer Within*. The camera equipment used must be silent and not disturb the performance. If there is noise emanating from the device, this agreement is terminated.

"I'll need you to sign this," he said, offering me a pen.

I signed the agreement confident that no one would hear me all the way at the back of the theater in a soundbooth.

Then Travis issued a warning: "Baryshnikov has impeccable hearing and even though you're all the way up here in the booth, he may still hear your shutter from the stage. If he does, he'll signal the stage manager, who

will send a message to the soundman here in the booth, and you'll be asked to stop immediately. Is this clear?"

"Yes," I said, feeling a wave of heat washing over me.

"Let me give you a little tip," he said in a whisper. "Misha doesn't dance in the first act so, if I were you, I wouldn't take any photos until he's on the stage. Once he starts dancing you might get a few frames in before he stops you. By the way, much of his piece is performed in silence or accompanied with very soft music. Good luck."

I studied the program that Travis had given me and noted that Misha would be performing *Years Later*, choreographed by Benjamin Millepied, after the first intermission. I tried to shake off a sudden feeling of doom, as Travis's words echoed in my head: *Baryshnikov has impeccable hearing. . . . He may still hear you . . . and you'll be asked to stop.*

I paced nervously inside the small booth all through act 1. After the intermission, I prepared to photograph Baryshnikov as he made his entrance. I expected the audience to burst into loud applause at the first sight of him. But they didn't. They remained silent. Misha exited stage right before I could even focus on him. Then a film came on showing him on a beach dancing to music by Philip Glass and Meredith Monk. Moments later the footage shifted to a never-before-seen, grainy, super-8 film of Baryshnikov at age seventeen, performing jumps and multiple pirouettes back in Russia, most likely at the Vaganova School. Misha reappeared on the stage. He seemed to glide above the floor with the grace of Fred Astaire. His body cast a large black shadow against the screen, creating a collage of dancing Mishas: himself as a young man, himself today, and in silhouette. It was a powerful visual—a powerful statement. Shoot now, I told myself. But the theater was *silent.* I could hear my own heart pounding a drum solo. I feared that my first picture would be my last. Where was the music? Why was the audience so quiet? How much longer could I wait? It's now or never. I aimed; the sound of my shutter went off like a gunshot in my ears. I looked over at the soundman, expecting him to motion me to stop. He didn't even look in my direction. Was I in the clear? I aimed again and fired—another blast. I waited . . . nothing. Where was his signal for me to stop? Still nothing. By the time we got to the bows I had managed thirty-five exposures.

Mission accomplished.

Berkeley, California, 90026, June 2006

Liza Minnelli

"Let's take it with the music," Luigi instructed, as he wrapped up his morning jazz class. "One last time, 5, 6, 7, 8, *and* . . ." Group 1 launched into the combination: jazz walk, kickball-change, *pas de bourée, chassé*—and there, front and center, was Liza. Thirty-four years since she dazzled Hollywood and Broadway with her talent in *Cabaret* and *Liza With a Z*, she was still moving—still dancing.

I greeted her as she came walking out of Luigi's studio. Wet with perspiration and slightly short of breath, she shook my hand and asked that I wait while she changed out of her dance clothes. Ten minutes later we were sitting in her SUV, driven by her manager, Ira, and heading toward her East Side apartment.

"Ever miss L.A.?" I asked Liza from the back seat.

"Never!" she said. "I positively loathe it. I came to New York when I was fifteen, got a job and never moved back. I adore Manhattan—just look at it," she said, pointing out to the bustling city street. "This is a fabulous city."

Ira dropped us off at her apartment building and then Liza led the way to the elevator and up to the twenty-first floor and into her spacious apartment with its magnificent views of the city. Liza offered me a cold drink and then we sat down together at her dining room table.

"You were literally born into show business."

"That's right. My family on both sides can be traced back to the stage in one form or another. My grandmother on my father's side had an act in the Paris circus. And my father's father and his brother ran a tent show. My mother's parents were vaudevillians and she and her sisters performed as the Gumm Sisters. So, yes, show business is in my breeding."

"And very much part of your upbringing too."

"Absolutely. I was a studio brat. I rode my bike to MGM studios every day after school and spent most of my time in the rehearsal halls, watching the likes of Cyd Charisse, Gene Kelly, and Fred Astaire. I wanted to do what they were doing. I wanted to express myself the way they were—dancing. I remember Gene saying, 'She's gonna be a dancer!' And Fred thought I was smart—'she counts.' MGM dancers counted."

"You mean to learn the steps?"

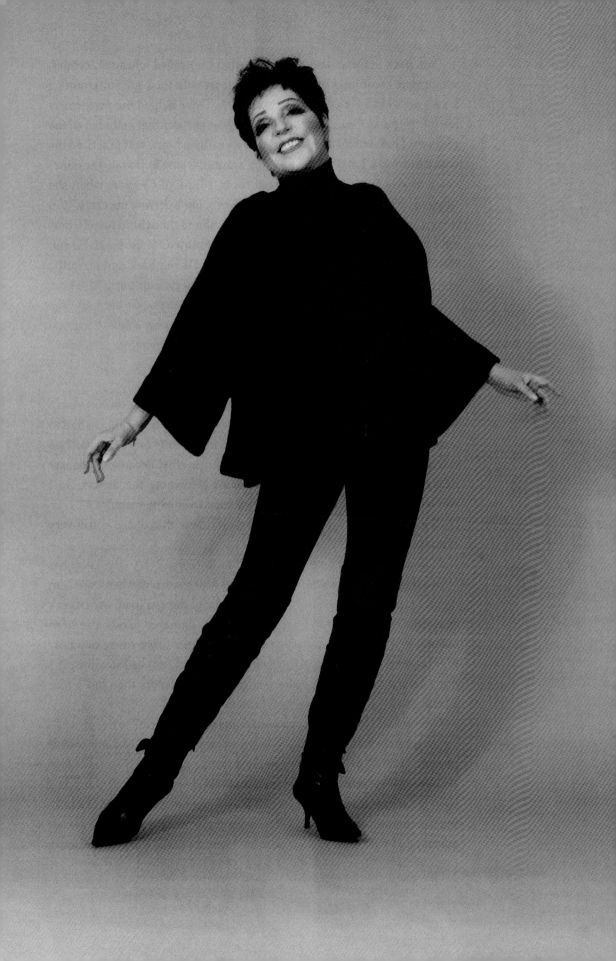

"Yes. Back in those days they made what they called rehearsal acetates, which were recordings of the dance numbers with their specific counts: 1 2 3 4 5 6 7 8—2 2 3 4 5 6 7 8—3 2 3 4 5 6 7 8. These helped the performers learn their parts. One day I got a pile of these acetates that included all the numbers I had watched in rehearsals. I took them home and practiced the dance numbers. I was always hanging around, trying to imitate the dancers. One day I was in the rehearsal room with Cyd Charisse when she stopped cold and yelled, 'She has to sit down. She's driving me crazy.' 'I'm sorry Cyd,' I said, and sat down quietly. But then I thought to myself, how am I going to learn this? I watched her and counted. At the break I'd run into another other room and practice. Then I'd run back and learn the rest of it. So I learned at a very young age how to pick up steps. This gave me a great advantage later on. I could learn choreography very quickly. And I did something else. I'd watch the choreographer's face. I realized that if you watched his face, you got the reason, the intention, the answer to why he was doing the steps."

"Your dancing came first? Then your singing and acting?"

"Well, I saw *Bye Bye Birdie* and I knew I wanted to dance on Broadway. But I realized that if you wanted to be in a Broadway musical, you had to also sing and act. So yes, the dancer came first, but I consider myself an actress first, a dancer second, and a singer third. Why? Because the dancer needs a reason to move—that's the actor informing the dancer. So I worked on my acting and gradually developed a singing voice."

"I loved watching you in class today. It's clear that dance is still very much part of your life."

"I dance with Luigi every day that I'm in town. Every day. Luigi has been a huge influence in my life since I was four years old, when I saw him dance on the set of *An American in Paris*. Luigi danced in all my father's musicals. He continues to train me, and I am damaged goods. I've been beating this body up for sixty years. I have three fused discs, two false hips, a wired-up kneecap, arthritis in my feet, and very bad scoliosis. If I don't keep moving, I lock. "Never stop moving" is more than just a nice phrase. It's my life. If I go to class, I can do anything."

"Are you still learning more about yourself as a dancer?"

"Absolutely. Oh, God, yes. When I'm dancing I feel like my soul is present. When I had brain encephalitis from a mosquito bite, I was told I'd never move again, let alone walk and talk. I blew up to 180 pounds. I went to Luigi and asked, 'You think I'll dance again?' Remember, I'm talking to a man who brought himself back after he was paralyzed in a car accident and in a coma for four months. 'Sure,' he said. 'You'll dance better

than ever.' I went to class the next day, and I never stopped. That was six years ago. In six months I was rehabilitated. I'm able to speak today because of dance. I'm living because of dance. There's nothing more important in the world to me."

"Your mother, Judy Garland, was one of the greatest entertainers of all time and your father, Vincent Minnelli, was a celebrated director. Did your parents give you professional advice?"

"When I was thirteen, Mama gave me one very important acting lesson that I've never forgotten. It was for an audition I had coming up for some television show. She said, 'The inner dialogue is more important than the outer dialogue.' I said, 'Huh?' I didn't know what she meant. 'Look,' she said, 'let's say your line is "Hi. How are you?" I don't want you to say what's on the paper. Think about the intent. What are you really saying? Hi . . . How are you? So with that pause, what you're really saying is, Why haven't I heard from you? Why haven't you called? You son of a bitch, you nearly broke my heart.' This was an invaluable lesson, particularly when I did the film *New York, New York,* because the dialogue with Robert De Niro was entirely improvised. Intention was everything.

"My father also taught me a great deal. I must have been around ten or eleven when I asked him what acting was. He had to think about it and said, 'Acting is like hearing something for the first time and saying something for the first time.'"

"I know you attribute so much of your success to Fred Ebb and John Kander, who wrote the music and lyrics for *Cabaret* and *Liza With a Z.* Is it fair to say that Fred Ebb gave you your artist's voice?"

"Oh, he invented me," she said, taking a long drag off her cigarette. "He helped me become my own person. I never had to sing my mother's songs. *Liza With a Z* had people saying, 'Hey, she's an original.' My greatest talent has always been knowing who's more talented than I am, and going to them. I want to be around people I can learn from and show me what I can do next. I've never needed people to tell me I'm perfect as I am.

"Freddy taught me to sing from character. When I sing a song, even today, I have the lyrics here and a piece of paper with the character's personal characteristics here," she said, pretending to hold two pieces of paper. "What color is her hair? Where does she live? What does she see when she looks out the window? What magnets does she have on her refrigerator? What happened last night to make her sing instead of dance?"

"If Fred Ebb was responsible for giving you your voice, who gave you your moves?"

"That would be Ron Lewis. I was never more comfortable than when he set choreography on me. He'd ask, 'Does that feel good?' And I'd say yes. And he'd say, 'Then it's right.' With Fosse, if it *hurt*, it was right," she said, bursting into laugher. "You know he was pigeon-toed and that's why all of the choreography is turned in—which accounts for my hip replacements. But what a dancer! My God. What a great man. His technique is inside of me—still. I can pull it up anytime. I think *Liza With a Z* was his best stage work, which was created as a concert for television. It premiered on September 10th, 1972, and would win four Emmys and a Peabody Award. It reran twice and then sort of disappeared. But then a friend of mine, Michael Arick, asked if he could restore it. He worked on it for six years and it has just been released on DVD. Promise me, Rose, you won't write anything about me until you see *Liza With a Z*."

"I promise, Liza." I said. "What did Fosse leave you with?"

"He really showed me how to get inside the body. He taught me to slow down and focus. Sometimes we'd practice the simplest move over and over, sometimes for days: 'elbow, wrist, hand, elbow, wrist, hand again and again,'" she said, showing me the arm gesture.

"How did you know when you'd fully mastered his technique and choreography?"

"Remember, I always looked at the choreographer's face. I could see Fosse's intention in his eyes. I understood that it was never just about the steps. But rather, why am I doing the steps? How do they make me feel? How do they bring me to the next place? Fosse had a great sense of humor, so when he giggled, I knew I was doing it right."

"You also brought your own individuality to the choreography?"

"I was actually limited by my own body. There are moves I've never been able to do. I have scoliosis, which is a curvature of the spine. I can turn like a bat out of hell to my left. I can't turn to my right. My rib cage is so crooked that I can't open my chest all the way or it cuts off my air supply. It's funny to me that everyone thought I had this great style of moving—but no, I couldn't do it any other way.

"Let me show you something," Liza said, standing up. "Now look carefully. I can't jump anymore, but I've learned how to make it look like I can." And with that she performed an upbeat tap dance. "If you look closely, you can see that I'm not really leaving the floor. I can make it look like I'm a great dancer, even though I'm not. This is called acting," she said with a smile.

"Liza, *Cabaret* was an incredible vehicle for your talents. What was that experience like?"

"The film's producers sent us to Germany to work on the film. Fosse was able to get away with all kinds of things he never would have gotten away with in Hollywood—like the *Two Ladies* number. Every time the studio executives saw the dailies, they'd send him a memo: 'The dance numbers are too risqué' or 'there's too much smoke in the scene.' He'd just tear up the memo and keep doing what he wanted according to his own vision. The result was a masterpiece."

"Do you feel that your performance in the film was a real turning point for you as an artist?"

"I think I've had several roles that allowed me to do good work and experience complete characters—like Pookie Adams in *The Sterile Cookoo* and Francine Evans in *New York, New York*. The only difference is that Sally Bowles made me a superstar. I won an Oscar and it opened many doors for me."

"Did you identify with her character?"

"Playing Sally was hard for me because I'm shy. I'm really shy. I'm basically Pookie Adams, the girl in *The Sterile Cookoo*. Sally's character needed to be sexy, and I really didn't know how to be that sexy. I watched Fosse's face. If he giggled, then I knew I was being sexy. Fosse taught me how she walked, how she moved. But I was responsible for creating her look. I asked my father for his help, because I didn't really know how women in the 1930s looked, except for Marlene Dietrich. But Daddy said no, not Dietrich. He sent me pictures of Louise Brooks and other dark-haired sirens from whom to draw upon. Right before shooting, I cut my hair like this," she said using her finger to show me the hairstyle. "I wore these way-out eyelashes that I had found in a little shop on La Cienega Boulevard. in Hollywood, put on dark lipstick, and knocked on the door of Fosse's apartment. 'What do you think,' I asked. 'It's great,' he said. 'But what if I hadn't liked it?' 'But you do, don't you?' I said. 'Yes, it's wonderful.'"

"Divine Decadence, you called it in the film."

"Yes, that's right. Daddy said, '"*Mein Herr*" has been choreographed on three other women before you, so you have to find a way to make it your own. You want to be strange and extraordinary.' We filmed all the musical numbers first, which really influenced how I would play Sally. The dance numbers gave me clues into Sally's personality and character. Why is she working in this dark seedy nightclub instead of in theaters as did Josephine Baker? Maybe she wants to be there."

"Years later you made a film called *Stepping Out*, choreographed by the great Danny Daniels. You play Mavis, a one-time understudy who's still

trying to make it as a dancer on Broadway. One day she lets loose in her empty studio and dances her heart out. It's a very powerful scene."

"You learn more about her from that one scene than you do from watching the entire film. You see her passion, her sense of humor, her talent, her drive, her sensuality. She dances to express what she's feeling in her heart. It was interesting filming that scene, because it was around that time that my hip was really beginning to give me trouble. Danny gave me some steps to perform, but I couldn't do them. 'Put on some music and let me do what I can,' I told him, and I pretty much improvised the entire scene."

"Whether you're playing Sally Bowles in *Cabaret* or Linda in the film *Arthur,* you bring something intrinsically human to all your characters."

"Thank you. This is the nicest compliment I've ever received. Ever. I love characters that we all have inside of us. We've all known a Pookie Adams or been Pookie Adams—shy and desperate to be loved. Sally Bowles is the same way."

"Liza, *is* life a cabaret? What does that mean, anyway?"

"Well, let's look at the song's lyrics, Rose," and began to recite them:

> "Life is a Cabaret, ole chum,
> Come to the Cabaret."

"So what does it mean, Rose? It's all going to be over much too soon. So live your life. Live it all the way and make the best of it."

New York City, 2006

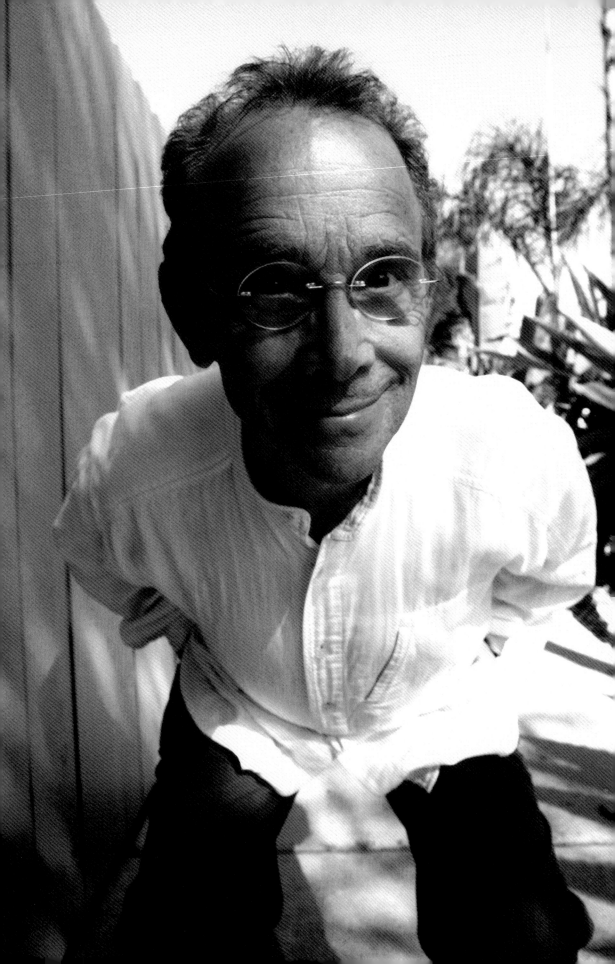

"When I learned that the Professional Dancers Society wanted to honor me, I couldn't believe it," Joel confessed during his acceptance speech. "I've never considered myself a dancer. I was always an actor who moved. I couldn't understand how I belonged at this occasion. And that night I started to think of all the dancers who had inspired me: Donald O'Connor, Dan Dailey, Mickey Rooney, Fred Astaire, and of course the unbelievable Gene Kelly. I also remembered all the choreographers who struggled with me, suffered with me, and perhaps gave me my career. Sit back, the list is long." By the time Joel had finished reading names, including Michael Bennett, Nick Castle, Bob Fosse, Peter Gennaro, Rob Marshall, Ann Reinking, June Taylor, Tommy Tune, Charles Weidman, and Onna White, he was fighting back tears: "To all of them, and to all of you. . . ." He then stepped away from the microphone, paraphrasing the words of George M. Cohan. "My mother thanks you, my father thanks you, and my daughter thanks you, and as for myself, that goes without saying."

As the event's photographer I zoomed in on an emotional Joel Grey holding his Gypsy Award before six hundred professional dancers, and I wondered if he finally felt like he belonged.

Six months later, when I entered his cozy Venice Beach bungalow for our interview, he said, "Well, we meet again."

"Yes," I said, "and there's one thing I've been wanting to ask you since the PDS luncheon. By the end of the awards show did you feel . . ."

"Like a dancer?" he said, completing my sentence. "I did, actually. You know, looking at the film clips of my dancing over the years, I was really all right. It amazed me."

"Oh, it was more than just all right. It was phenomenal."

"Well, I think that a lot of people who haven't studied, feel that they aren't entitled to call themselves whatever it is that they haven't studied. Like they haven't earned the right. I suppose I fall into that category."

"I think you've earned the right to call yourself dancer. And that's why I'm here. So tell me, how did it all begin?"

"I came from a family of musicians and performers. My father was a clarinetist, my uncle Al played the violin, my aunt Jean played piano, and

Aunt Estelle did ballet and tap. I was around nine when I began studying ballet in Cleveland, Ohio. Ballet excited me and I loved expressing myself through dance, but there was a bias against boys doing ballet in those years. But then I fell in love with the theater and knew that that's where I belonged. I became a kid actor and appeared regularly at the Cleveland Playhouse. I was pretty successful too and was even reviewed. I thought I was going to be the next Laurence Olivier. The Playhouse's director, K. Elmo Lowe, became my mentor. He thought I had something. I learned early on that if I knew my lines, if I was on time, and I had proper stage etiquette — the way you behaved in serious theater—I would be taken seriously both as a person and as an actor. It was intoxicating. But when I was twelve we moved to Los Angeles and suddenly I found myself doing nothing but high school plays. It was depressing to have found something that I loved doing, but no place outside of school to do it. By the time I was sixteen, my father—Mickey Katz, a klezmer clarinetist with the Spike Jones Band who had become famous for his Yiddish parodies of hit songs—was performing in a traveling vaudeville-type show called the Borscht Capades. Eager to get back on the stage, I asked him if I could be in the show. He gave me this very popular Yiddish song to sing called 'Romania, Romania.' I worked in the show for about two years, which gave me experience singing and dancing in front of an audience. Then Eddie Cantor saw me, and that's when my career took a right turn. He put me on television in the *Colgate Comedy Hour*, which was a variety show with sketches. I appeared about three or four times and it made me a huge success."

"Did you learn much from that experience?"

"Oh, no. I wasn't learning anything. Success at the age of eighteen catapulted me into a very pressured world. I was just living through it and trying to keep up. My next ten years were spent trying to reestablish myself as a serious actor. I never wanted to sing or dance or be in anything musical, but by that time everyone knew I could sing and dance. Producers saw something in me that they liked. And because I needed the work and was ambitious, I accepted roles in theater like *Come Blow Your Horn*. I got hired even though I was totally untrained as a singer or dancer. And it was hard because I didn't have technical training to back me up. I didn't know that one was supposed to warm up their muscles before doing dance steps. I just threw myself into the numbers and got pretty injured along the way. Oddly enough, I would later use all that early stuff, the singing and the dancing, in the character I play in *Cabaret*."

"You were born to play that role."

"Well, so it seems. I didn't think so at the time. I didn't want to take it. I didn't know what I could do with it."

"And yet you turned the emcee character into gold. How did you create him?"

"Well, how do you do anything? You reach, you fail, you succeed, you find something, and then you don't find something, then you do. It's like putting a puzzle together. He was just an idea, from a single line—'There was an emcee'—in Christopher Isherwood's short story, 'Goodbye to Berlin,' from which *Cabaret* was inspired. The emcee is also referred to in *I am a Camera,* a play by John Van Druten that was also inspired by the Isherwood short story."

"The film opens with your image—a blurry mirror reflection of your face. The setting is Berlin, 1931. Your character invites us in with 'Willkomen'; 'Leave your troubles outside! We have no trouble here! Here, life is beautiful.' You draw us in. You're mesmerizing—sort of like Hitler was with the German people. Did he come to mind when you were creating the character?"

"I did think of him, often. Hitler manipulated the people and the emcee does the same thing. Hitler promised bread on every German table, and the people believed him. They lost their sense of humanity when they gave into this vicious man. The emcee in *Cabaret* manipulates the audience with amusement and titillation. You think you're being entertained and then by the end of the film you come to discover that you've been fooled. And that's what Hitler did. He fooled the people and they allowed themselves to be fooled."

"Yes, I see that in the film when you sing *'If You Could See Her.'* It starts out so, with your singing a love song to a gorilla, and then your true colors come out when you say, 'But if you could see her through my eyes / She wouldn't look Jewish at all.'"

"That's my favorite song. It starts out as entertainment, people are having a good time and finding me amusing, and then I hit them right between the eyes. That's when it all catches up with you. It's the most evil moment in the story. I felt this tremendous responsibility to make the emcee character a nightmare—frightening and dangerous."

"What was it like working with Liza Minnelli on *Cabaret*?"

"Liza was magical. It was one of her greatest moments. Everything she did came together beautifully. We became very close during the making of *Cabaret.* We bonded because the experience of making the film was so stressful. The general feeling in the industry was that it was not going to be a success. It didn't follow the typical "musical formula." It was a dark

film about something very controversial. Some thought that it might have a special audience but never be a hit."

"How did playing the emcee role affect you?"

"The history of the Holocaust absolutely became more real to me—more frightening and more fascinating. When we finished shooting I visited Dachau concentration camp. I knew I wouldn't be able to handle going there while I was still in character."

"Later in your career you played a Holocaust survivor."

"Yes, I did—and I also played a Nazi, Joseph Goebbels, Hitler's propaganda minister. Now *that* was disturbing."

"In what way?"

"It wasn't like playing the emcee, a fictional character. Goebbels was really a terrible man. And every day I had to be him. I try to respect the characters that I play, but it was hard to respect Joseph Goebbels. I had to look for what might have been his best qualities. What I found was that he was extremely accomplished and had tremendous drive. I didn't end up loving him, but I had to admit, he was a power, and look what horrors he wrought."

"Why did you choose to play him?"

"I'm an actor."

"Well, yes, but you turn down roles all the time."

"I thought it was going to be an interesting film. I'm always drawn to things that are going to make some kind of art. That's my job. One of the by-products of my profession is to change people through the work. Actors are there to enlighten, to make you question things and to clarify ideas about life. They are there to inform like literature does."

"Joel, I'm still a little baffled as to how without formal training you were able to perform your dance numbers so convincingly?"

"Rose, it's called acting. The dancing comes from the same place as the acting. I'm always looking for the character's motivation. What does he look like and what's he trying to say? I'm always looking for truth. Why does this character dance? Most choreographers say, 'Forget all that, just do the steps.' Remember, the choreographer is usually telling someone with training, 'Do this, do that, 5, 6 7, 8.' That's what he's trained to do. It's the rare choreographer who welcomes the actor with that other sensibility of character and motivation. Bob Fosse was just such a director. He was familiar with my work and understood my limitations. When I made things my own and they worked, he accepted them."

"But even when you understand a character's reason for dancing, there's still the issue of dance technique."

"I guess you could say that it's innate in me, but untrained. Performing some of those numbers was extremely difficult and stressful. I had to keep up with trained dancers and look exactly like them. All I could think of is, why did I say yes? They must have been crazy to think I could do this."

"Another one of the characters that you brought to life is Amos Hart in *Chicago*."

"Amos Hart was originally written as a big dumb mechanic. Why they asked *me* to do it I'll never know. The only way I could play him and have respect for myself, and his character, was to convince myself that he loved Roxie blindly. He was so lovesick that anything she did didn't matter."

"I saw you perform this role on Broadway. When you sang 'Mr. Cellophane': ''Cause you could look right through me / and never know I'm there,' you positively brought us to our knees. You were so convincing in the part, even though you don't resemble a big dumb mechanic."

"You have to find the truth within yourself so that you can tell that story."

"How did you find truth in the seventy-five-year-old Korean martial-artist character that you played in the film Remo Williams?"

"I thought the producers were insane when they sent me that script and said they were interested in my doing the part. I agreed only under the condition that he not be a caricature, that he be believable. Also I needed to know for myself if I could physically resemble a Korean martial artist, if *I* could believe it? So we brought in a makeup man, a genius, and ran a test. And I did believe it. This was where all that previous dancing came in handy because I understood that he had to move with a unique quality."

"I saw that film and found it very interesting that he really did have an Asian quality about him."

"How is that possible?" he asked.

"I don't know. You tell me."

"It's acting," he whispered.

"Yes, Joel," I said. "I get it now. Tell me, is there a particular philosophy that you live by?"

"Don't take anything for granted," he said without hesitation. "Let love infuse everything you do as much as you can, and have integrity. Take care that you don't do things that you don't really believe in. That's my deal."

"Are you still driven the way you were when you were starting out?"

"No, I'm not driven any more. I'm curious, I'm interested, but I'm not driven. I'm much more choosy now about what I will spend my time

doing. I've done six or seven Broadway shows—sometimes eight times a week for long periods of time. So I think that's it—for that. I might do something short like an ensemble piece at the Roundabout, but only if I love the director, love the piece, and love the part. That's the only thing that's going to bring me back; otherwise I'm going to spend my time taking pictures."

"Speaking of pictures, why don't we take that portrait of you now." We stepped out into his freshly landscaped backyard. I decided to just start shooting and see where it would lead. Joel's body language sent the message—'don't ask me to mug for the camera. I'm only interested in being myself.' After shooting a couple of rolls I suggested we move to the street.

"Sure," he said, leading me out through his front gate and onto the sidewalk.

"How about you walk down the street towards me."

Joel took off down the street about fifty yards then turned around and waited for my cue. "Okay," I yelled, and he began walking slowly towards me. "Keep coming, keep coming," I instructed until he was only inches from me. Then he bent down and peered straight inside my lens and smiled. His distorted image bore a familiar resemblance to the emcee character in the opening scene of *Cabaret*. I had my portrait.

Venice, California, 2006

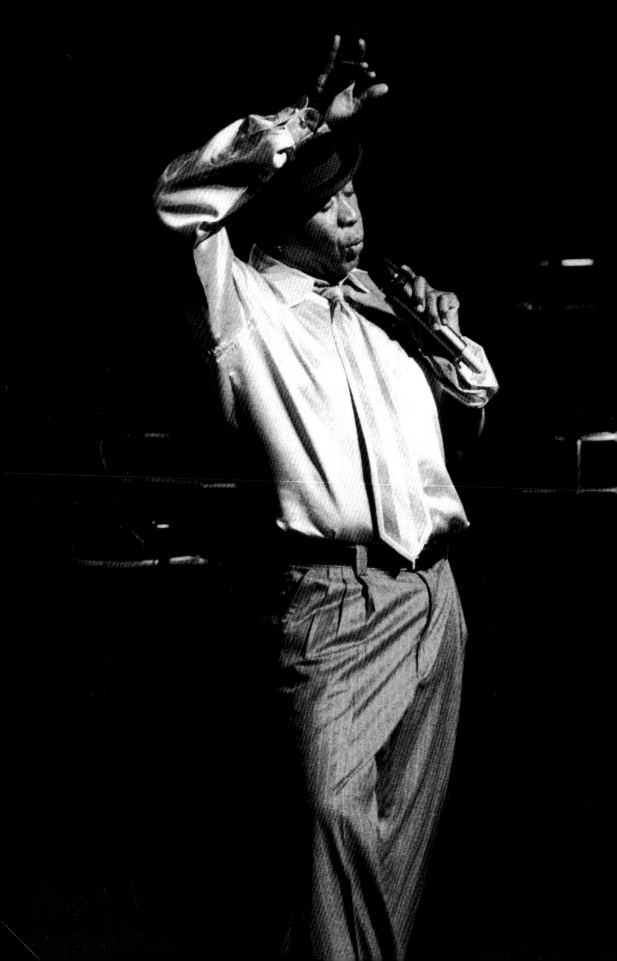

Ben Vereen

Ben Vereen's touring schedule is mind-boggling. He performs his one-man show year-round, crisscrossing the country and the globe. I caught up with him in Morristown, New Jersey, on an early April morning. When I arrived at his hotel, I asked a receptionist to ring his room and was informed that he was still asleep and would meet me in the lobby soon. I took a seat facing the elevators and waited. An hour later, he appeared, looking tired and stiff. I approached and introduced myself. As we were getting acquainted, the hotel services director appeared and asked if Mr. Vereen required any assistance.

"Yes," he told the manager. "This young woman and I are going to do an interview. Is there someplace private where we can sit?" "Yes, of course," he said. "Please follow me." He escorted us to the elevators and up to the hotel's penthouse. Ben slipped off his loafers and crossed his knees in a comfortable yoga-like position on the sofa. I took a seat to his left, pulled out my tape recorder and notes.

"Ben, you're considered the consummate showman, but I have a feeling that if you were stripped down to the bone, what we would find is the essential dancer."

"If I was stripping down, I'd go beyond the bone," he said. "I'd strip down to the spirit. The impulse to move comes from the spirit. My dancing is merely a manifestation of my need to express spirit. I'm not a religious man in the conventional sense, but I believe in a divine energy that exists in all of us. Some call it Buddha or Allah or Elohim, but *I* call it divine spirit. I've come to understand this after having my body badly broken. I believe that there was something within me that was stronger than myself. This is what allowed me to recover." [In 1992 Vereen had suffered a near-fatal stroke following an automobile accident.]

"What were you like as a child?"

"I was a wild kid who would rather spend time in front of a record player and make up dances than throw a baseball or shoot hoops. I was attracted to dance parties and movie musicals and constantly imitated what I saw on the screen. Then someone told my mother, 'He's trying to dance!' So she said, 'Well, if that's what he's doing, then let's put him in dancing

school.' So I was placed in a school that nurtured people like me. It was called New York's High School for the Performing Arts."

"What was that experience like?"

"I had some wonderful dedicated teachers: David Wood, Norman Walker, May O'Donnell, Gertrude Schurr, and many others who really taught me a great deal. But I must single out one woman who was not a dancer, Dr. Rachel Yocum, director of the dance department. She was like a mother to us. She encouraged us, stood up for us, and fought for the dance. At my entrance audition she knelt down next to me and asked, 'Would you like to go to this school?' She saw something in me, this wild kid from Brooklyn who liked to sing in church and run with gangs. Even when my grades were unacceptable, she said, 'No! We're going to keep him.' If not for Dr. Rachel Yocum, I would not be sitting here talking to you right now."

"That environment was just what you needed."

"Yes it was, but I always felt sort of like an outcast. I didn't have the typical dancer's body. I just wanted to dance for the enjoyment of it. I had no other reason to be doing it. Whenever I could, I'd find an empty studio with a record player, put on some music, and make up dances. Then one day this kid, Tony Catanzaro, who would later become the artistic director of the Ballet Academy of Miami, took an interest in me. He was just one of the other kids, but he'd stay after school and teach me and dance with me. You need people like that to take you along with them. And there were teachers like Bernice Johnson, who invited me to take Chief Bey's classes and Lester Wilson's African dance class. A bunch of us—Jerry Grimes, Winston Hemsley, Michele Simmons, and I—would head out to Long Island on a school night and dance till eleven. Then, totally exhausted, we'd take the train back to Manhattan. Those are the people who taught me about dance."

"Martha Graham would have said, 'You were doomed to dance.' "

"Yes, I was. Yes, I was." he said with a laugh.

"What happened next? After you graduated from the School for the Performing Arts?"

"I got my first professional job right out of high school with the help of my former drama teacher, Vinnette Carroll, who was the first African American to direct on Broadway. She was doing a show called *The Prodigal,* written by Langston Hughes. Helen Tamiris also helped me get started. I met her when she choreographed our high school graduation show. She later saw to it that I received an award for dance that year. After *The Prodigal,* I didn't know what I wanted to do or where to go. I landed a summer stock job, but when that ended, I was unemployed and homeless."

Ben took a deep breath and paused. "Then I met a gentlemen by the name of Bob Fosse. He was doing a show called *Sweet Charity* in Las Vegas with Juliet Prowse, Paula Kelly, and Elaine Dunn. We opened at Caesars Palace. After that I was hired to do the road show of *Sweet Charity* with Chita Rivera. While we were on the road, we got a telegram to come to Hollywood, where Bob was doing the film version starring Shirley MacLaine [1969]. While there, I met Sammy Davis, Jr., who invited me to come to London to dance in *Golden Boy*. So the career just started to go by itself. I eventually starred in *Hair, Jesus Christ Superstar, Pippin,* TV shows, and films.

"How did Bob Fosse influence your dancing?"

"Bob Fosse had a style. I had movement. Before I met him my movement was wild and all over the place. What Bob Fosse did was contain it. He gave it focus. He taught me about strictness, discipline, and seriousness. He was strict and very hard on his dancers, but I loved him for it. He made you pay attention—really, really pay attention."

"Is his style fully ingrained in you?"

"Yes, completely. And at this point in my life, I'm not trying to develop any new techniques. I'm just grateful to be able to move at all. After all I've been through, you know, having to rebuild my body."

"You had a horrible accident a few years ago?"

"Yes, some call it an accident. I call it an experience. I was just about dead. I had been in an automobile accident and bumped my head very badly. Later that evening I was walking in Malibu when I had a stroke and was hit by a car. I suffered internal injuries and broken bones."

"Looking at you today, one would never know what you've been through."

"Well, it's been a long hard road. During my recovery I met some amazing stroke victims who filled me with inspiration. They demonstrated what we talked about earlier—spirit. Unable to use their limbs, they would draw portraits with just a pencil in the mouth or paint landscapes with a paintbrush held between their toes. I tried to keep them in mind every time I remembered the dancer that I once was. Desperate, I turned to my dear friend Chita Rivera for support. Chita knew what I was going through, having herself recovered from a serious automobile accident that left her leg shattered. 'Will I ever dance again?' I asked her. 'You'll dance again, Ben, but you'll dance differently,' she told me. And she was right. I don't worry about my dancing any more: kicking up my legs, doing cartwheels and splits the way I used to. I'm alive. I'm above ground. That's really what matters."

"How did you overcome your paralysis and begin dancing again?"

"Well, as a dancer, I had a vision of movement and the drive to do it. But that wasn't enough. I had the help of another good friend, Gregory Hines. While I was recuperating at Kessler Memorial Hospital in New Jersey, I was asked how I wanted to celebrate my birthday. I told them, 'I want to see what I used to do. I want to go see *Jelly's Last Jam* on Broadway.' So my friends got together and drove me to New York City. I had a tracheotomy tube in me and had just had an operation on my neck. I was wearing a neck brace and walked with canes. The show was amazing. Savion Glover, Gregory, and the cast were phenomenal, totally phenomenal. I sat there in the audience with tears running down my face, wondering if I would ever . . . ever . . . ever . . . ever. . . ." Ben stopped, unable to finish the sentence. Overcome with emotion, he excused himself and told me he needed a minute. I waited in silence.

"I'm sorry," he said and continued. "After the bows, Gregory walked out and quieted the audience. 'Ladies and gentlemen,' he said. 'There is a man here tonight who is responsible for our being on the stage with you. His name is Ben Vereen and we love him.' The house exploded in cheers and applause. And now I'm really an emotional wreck—really a wreck. The tears are just streaming down my face. And then later on, backstage, the producer of the show says, 'Gregory wants to know when Ben will be ready.' The actor who plays the Chimney Man is leaving the show, and if Ben is ready in April he's got the role.' This was October. So I went back to the hospital and told the doctor, 'I want to do this show.' She immediately bought a ticket to *Jelly's Last Jam* to see what the role entailed. She came back and said, 'We can do this.' I started an extensive physical therapy program that involved step classes and a treadmill and sessions with both a dance therapist and vocal therapist. We worked every day and ten months later, on the third of April 1993, I walked onstage in *Jelly's Last Jam*. Gregory, the gracious gentleman that he was said, 'Ben, come this way, you can do this.' He showed me the road back. And I heard him. I heard him. And each night onstage with Gregory Hines was a celebration of life. God was using this man. Every time Gregory's foot touched the ground, that was God walking on the earth. I miss him greatly. I miss them all: Sammy Davis, Jr., Michael Peters, and Lester Wilson. Oh . . . ," he said, wiping his tears.

After sitting in silence for a couple of minutes, I asked Ben what it felt like to communicate with an audience. He took a deep long breath and exhaled slowly.

"First there is fear—this nervousness in the stomach. But something inside says, embrace the fear, for inside your fear is your courage. Soon

there is no me, no them—only us. We become one. You see, the stage is just another platform to express and receive spirit."

"Short of being hit by a truck, how does one find enlightenment?"

"The Native American Indian used to do a thing," he said, sitting up and leaning forward. "If they wanted to know what was coming, they would put their ear to the ground and listen. What I'm saying, Rose, is, listen to your heart. Listen to your own ground. Be observant, be receptive, and be open."

A little more than a year later I caught Ben's show at the Orange County Performing Arts Center in California. For more than an hour, Ben thrilled a capacity crowd of two thousand with popular songs, jazzy dance moves, and messages of hope, good health, peace, and love. His words echoed in my mind as I leaned against the back wall of the theater with a telephoto lens: "The stage is just another platform to express and receive spirit."

Morristown, New Jersey, April 2004
Costa Mesa, California, May 2005

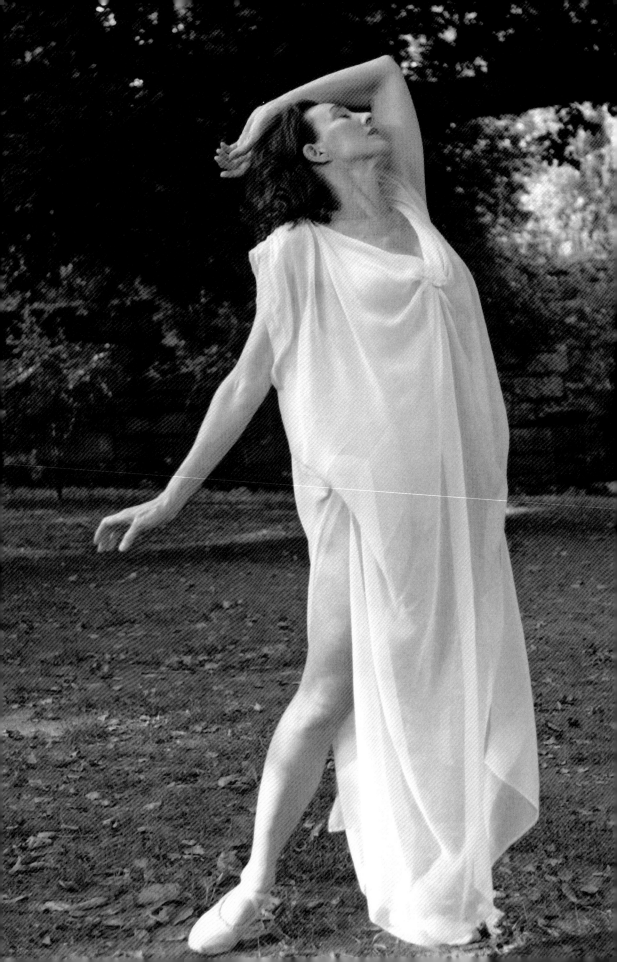

Lori Belilove

The first time I saw Lori Belilove dance, I wept. I'd never before seen Isadora Duncan's original dances performed. Lori's dramatic and impassioned performance at City Center in New York made me feel as if I were looking into a mirror and seeing what might have been my own dance path.

I had first learned of Isadora Duncan in high school when my dance teacher handed me a copy of the dancer's autobiography, *My Life*. Isadora was to become my idol and led me to choose a career in dance. So when I met with one of the foremost interpreters of the Duncan dances at her studio, I couldn't resist confessing that seeing her perform so gloriously had brought with it a flood of emotions.

"Rose, you are one of the lost Isadorables!" she declared. "If you felt so strongly about Isadora, why didn't you study her technique and perform her dances?"

"Isadora died in 1927 and I just assumed that her dances died with her. How did you unearth them?"

"It's a long story. When I was thirteen, my family and I embarked on a cultural tour of Europe. We drove from country to country in a VW bus. 'To enrich the hell out of us,' as my mother liked to say, we visited art museums and cathedrals. In Greece, at the advice of our piano teacher back home in Berkeley, we looked up Vassos Kanellos. Years earlier she had danced in a show produced by Kanellos in the States. He greeted us warmly and invited us to stay as his houseguests. In one of our conversations he recalled that in 1902, when he was sixteen, he had befriended the Duncans in Athens while they were immersing themselves in the aesthetics of ancient Greece. Kanellos traveled with them through village after village, dancing in the town squares while paying homage to the Greek gods and drawing inspiration amidst the ruins of the Parthenon and other ancient sites. The Duncans abandoned their Western clothing for Greek robes and sandals and camped out in the hills of Athens like pilgrims. 'Return to your ancient Greek roots,' Isadora told Kanellos. And he did. Adopting their mission, he began to study ancient rituals, read the Greek tragedies and plays, and embrace Isadora's concept of movement inspired from figures of Greek sculpture, bas-reliefs, and vases. Years later, Kanellos would produce Greek pageants in the United States.

"One day during our visit, he turned to me and said, 'You, my dear, are the next Isadora Duncan! Would you like to stay here in Greece and study dance with me?' He showed me a photograph of himself with Isadora as well as a lock of her hair he had saved. I was flattered by the invitation, but I was only thirteen and not prepared to leave my family. When I returned to Berkeley, I read Isadora's autobiography, *My Life,* which had a profound effect on me, probably because we had so much in common. Like Isadora, I was born and raised in Northern California to freethinking, artistic parents who encouraged me to follow my dreams wherever they might lead me. She lived at a time of transition from the Victorian era to the modern age. I grew up in Berkeley during the 1960s, a time when free love, political radicalism, and feminism reigned. The Berkeley scene made it easy to embrace Isadora's notion of uniting mind, body, and spirit in the quest for self-expression and self-actualization.

"Did reading Isadora's memoir convince you to take up Kanellos's offer?"

"Yes. At the age of seventeen, after graduating from high school, I moved to Athens and spent the next two and a half years steeped in Greek mythology and dance. When I returned to Berkeley, a local newspaper story on my Greek experience caught the attention of a group of former Duncan dancers who considered themselves Isadora's artistic daughters and had been preserving and practicing her dances. I would later study with two of the six original Isadorables: Irma and Anna. Both accused Kanellos of being a fraud, insisting that Isadora had never had male students. I realized that Kanellos had not taught me Isadora's choreographed dances, but he did give me something invaluable—a deep understanding of her artistic and aesthetic vision. I also studied with Mignon Garlin, who in 1927 devoted her life to dance after attending a performance of Isadora's disciples. Mignon went on to be trained in the Duncan technique and performed with Irma Duncan, Isadora's adopted daughter, who had accompanied Isadora to Russia and later toured there in the 1930s and 1940s. We worked together privately for about a year, but she did not offer Isadora's dances freely. I had to earn the right to learn them, and she raked me over the coals constantly, testing my sincerity and fiber as a dancer. Eventually I left Mignon and moved to Santa Barbara to study with Irma Duncan, who by that time was in her eighties and suffering from arteriosclerosis. I was only nineteen, but I knew that she was the real thing.

"Though she could no longer dance, Irma felt it was her responsibility to keep Isadora's technique alive and generously offered me guidance. I also learned from her book *The Technique of Isadora,* which included

beautiful photographs showing the progression of Duncan leaps, walks, skips, and movement vocabulary. Because of her infirmity, Irma could coach me for only brief periods before needing to break for a cup of tea. Fortunately, by this time not only did I have a good understanding of Isadora's technique, but I knew much of her repertory. After a few months, Irma recommended that I study with Hortense Kooluris, who had been the youngest person in her dance troupe. Hortense, she said, could show me how to flesh out a skip or a jump or a leap."

"Were there many other dancers interested in the Duncan method?"

"Oh no. Duncan dancers were really not around in the 1970s. You had to be really strange and different to want this at that time."

"How did Isadora affect dance in her own day?"

"At the turn of the century most staged dances emphasized frivolity in the form of vaudeville-styled vignettes, often with pantomime. Fairy-tale ballets like *Swan Lake* and *The Sleeping Beauty* were popular, as were the ballets presented by Diaghilev's Ballet Russes in Europe, the United States, and Latin America. Isadora took dance in a more serious direction. She told stories that dealt with issues like the burgeoning of womanhood and the overcoming of personal obstacles. She danced to classical music but used the body in new and expressive ways, emphasizing the upper torso and including runs and skips. She brought with her a sense of modernity, stripping the stage of flowery sets and heavy costumes that hid the body. She also infused into her dances aspects of modern poetry, sculpture, architecture, and painting. Isadora was part of a new movement that saw dance as a sister art to the fine arts, and she did in fact help elevate dance as an art form."

"How did Isadora convince skeptics and detractors of the validity of her approach to concert dance?"

"In addition to her dance performances, Isadora gave postconcert speeches, wrote articles, and made herself available for press interviews. People looking for new and radical ideas found in her a kindred spirit. Going beyond the suffragette movement of the period, she pursed life with revolutionary fervor, having love affairs, children out of wedlock, building a stage career and a school, touring the world and championing the Russian Revolution. She was an inspirational revolutionary figure who changed the way we looked at women and dance."

"Like her affect on woman's clothing and the aesthetic of the female form?"

"Exactly. Just think about the clothing women were wearing at the turn of the twentieth century—the female body covered in yards of fabric and

restricted by corsets. Isadora came out wearing streamlined tunics revealing the soft feminine curves of the female body. She adapted to her own needs the fashions she saw in the artwork of the antiquity, particularly the Greek and Roman tunics. Her loose garments, for example, enabled her to move her limbs and torso with absolute freedom. Isadora didn't think of herself as reviving ancient Greek dance. She saw herself as an American dancer of the future—a modern dancer."

"I read that you and your company performed Isadora's original dances in Russia– the country that embraced her more than any other. What was that experience like?"

"Oh, my goodness. My company and I were treated like rock stars from the minute we arrived. The press was everywhere, taking pictures and following us around. I couldn't brush my teeth without being photographed. We performed a two-and-a-half-hour concert at the beautiful Tchaikovsky Hall in Moscow before an audience of three thousand people. I opened the program with a solo of three pieces: *Waltz Brillante, The Mother,* and *The Revolutionary*. The audience just went wild. This was the performance of my life. My technique that night was flawless, and I could feel that the audience was totally with me. I felt like every cell in my body was giving, giving, giving—and they in turn were giving back to me. I remember thinking—if this is my last performance, than so shall it be. I had reached the pinnacle of my career."

"Have people ever accused you of being an Isadora Duncan imitator or trying to be her?"

"Yes, but I've never wanted to *be* Isadora or to relive her life. I just feel comfortable in her dances. I've always had my own life, my own lovers, my own drama. I am a conduit for her ideas. I have come to realize that this is my calling and my destiny. I am a repository of some seventy-five to eighty-five Duncan dances and their various versions. For example, when I perform *Waltz Brillante*, I do these chest ripples forward and back towards the audience, which is reminiscent of ocean waves splashing on the shore and receding. Though I feel her spirit passing through me, I am fully present in the flow of the movement—it's no one else but me. I remain ever mindful of Isadora's dictum: 'Don't imitate your teacher. Find your own soulful essence, inhale it and throw it back out again.'"

New York, 2004 and 2007

Rasta Thomas

I was introduced to Rasta Thomas at a rehearsal of *La Bayadère* for Orlando Ballet's thirtieth-anniversary gala. The twenty-two-year-old star gallantly kissed my hand. I responded by offering to take his portrait the following morning in his hotel room at nine. I knocked and waited. After several minutes, he appeared at the door wearing nothing but a bedsheet draped around his waist.

"Did I wake you?"

"That's okay," he said with a yawn. "Come in."

"It'll take me a little while to get set up, so if you want, you could rest a little longer."

"Cool," he said, and dropped back into bed, pulled the covers up to his neck and closed his eyes. I loaded my cameras, checked the lighting, composed my shot, and was ready in about fifteen minutes. When I looked back at him he was sound asleep. I watched him for a while thinking how far this young man had already come in his career. He had already won the gold medal at the International Ballet Competition in Varna, Bulgaria, guest-starred with many of the world's greatest ballet companies, and performed a solo on national television on the Academy Awards. And here he was, sleeping as sweetly as a little boy. I brought the camera to my eye and clicked the shutter once. He awoke with a start.

"Sorry," I said. "I couldn't resist."

Rasta sat up, rubbed his eyes, and stretched his arms over his head. "I guess I fell back to sleep. So what would you like me to do?" he asked, leaning back against the headboard.

"I'm looking for something natural—you look perfect just like that."

"Okay, but wait, I have an idea," he said. "Could you hand me one of those flowers from the vase behind you on the dresser?"

I put my camera down, carefully pulled a stem of pale yellow orchids from the arrangement, and handed it to him. Holding it in his left hand, he bent his elbow over his head and dangled the string of blossoms along the right side of his face.

"Why do you want flowers in your portrait?" I asked, focusing my lens.

"Dancers have always been infatuated with beauty," he said. "The dancer's life is like that of a flower—it blossoms and then it dies."

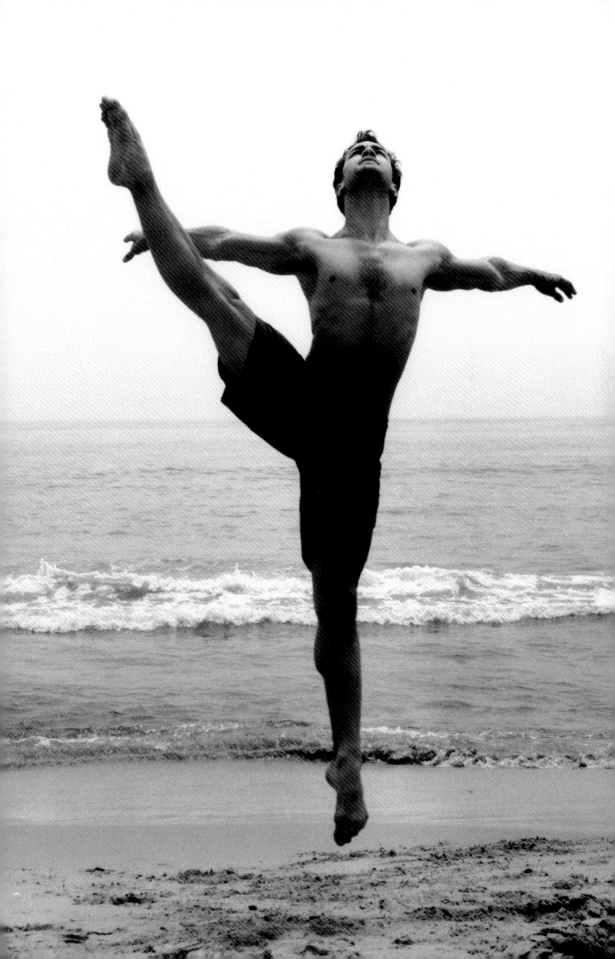

I grabbed my pen and quickly jotted down his words. I knew at that moment that I'd be tracking this young artist's career for years to come. My first opportunity to interview him in depth came a couple of years later in Seattle.

"Rasta," I began. "There's so much I don't know about you. Let's start with your unusual name."

"My full name is Rasta Kuzma Ramacandra (pronounced *Rama-chandra*) Thomas," he said proudly. "Rasta means prince or head of the family, Kuzma refers to the Persian story of the boy who was orphaned in the jungle and tamed by the animals—like Mowgli in *The Jungle Book*—and Ramacandra is the reincarnation of Krishna—one of the three Indian gods in his most warlike form. I am part Jamaican, Native American, Arab, and Irish-English."

"Where did you grow up, and how did you come to dance?"

"I grew up in Washington, D.C. As a child I had so much energy my parents signed me up for just about every sport you can think of: karate, gymnastics, swimming, hockey, baseball, basketball. I was like a chameleon and could adapt myself to whatever I was doing at the time. My father wanted me to be strong and masculine, but at the same time graceful and suave, so I was also enrolled in ballet classes. I excelled quickly and entered the commercial dance competition circuit, winning Showbiz, Star Quest, and Star Power dance contests. By twelve, I was on scholarship with the Kirov Academy of Ballet in Washington, D.C. My father made sure that I was taken to see all the great dance companies that performed at Kennedy Center and then asked if I could take classes with the touring dancers. Most of them agreed, so I stood at the barre with world-class dancers from American Ballet Theatre, Joffrey Ballet, Dance Theater of Harlem, and many other companies. In time, I developed relationships with artistic directors Gerald Arpino of the Joffrey Ballet, Arthur Mitchell of Dance Theater of Harlem, and dancer/choreographer Debbie Allen. They all grew very fond of me, and so when I decided I wanted to compete at the 1996 International Ballet Competition in Varna, Bulgaria, they agreed to sponsor me and did so at the cost of thirty thousand dollars. I would win the gold medal in the junior category."

"When you were sixteen, you competed in the senior category—ages 19 to 26 at the 1998 U.S. International Competition in Jackson, Mississippi, and came away with the gold."

"Yes."

"I imagine lots of doors opened for you after that?"

"Yes, they did. I danced in Russia for six months with the Kirov Ballet and then I went to Los Angeles for a bit of the Hollywood thing: got an agent, headshots, joined SAG—all of it. I performed a solo on the 1999 Academy Awards Show, did a Gap commercial, but the experience put me off course for a while. I found myself drawn to commercialism and the dangling carrot—the allure of money and being in the spotlight. When I checked in with Arthur Mitchell, as I did periodically, he said to me, 'Go be a star, go be a star. When you want to be a classic artist, a timeless artist, call me.' That's when I realized I was getting off track and needed to get back on the artist's path."

"Sounds like you hit sort of a fork in the road."

"I did, and I was scared to grow up. When you're a technical virtuoso as a child, you can get by on your cuteness, but as an adult you need consistency and a mature presence. I knew that I needed to make a serious career decision."

"So what did you do?"

"I flew to New York to work closely with Arthur Mitchell. He had been a great artist with the New York City Ballet under George Balanchine, and I knew he could teach me what I needed to know. I joined Dance Theater of Harlem, but unfortunately it would be its last season."

"What specifically did Arthur Mitchell teach you?"

"He gave me what he calls the *za*—the spirit. It's a word used in the martial art of kung fu, meaning flavor and spice. He warned me against becoming a trickster and explained that everyone can do steps, but it's the interpretation of those steps that is the key to making magic. 'Every action has a reaction,' he told me. 'If you can control and master the action, the reaction will be a standing ovation.' Mitchell also talked to me about the still moments, the transitional moments between steps, and made me aware of the dancer's stage presence. He'd say, 'Let the light hit your cheek bones, always look at your partner with your downstage eye so you can feel the audience.'"

"I imagine that the roles you've performed have also contributed to your development as an artist."

"Yes, absolutely. I view certain roles as markers in my growth as an artist. *Prodigal Son* forced me to become a storyteller and challenged my bravura. *Le Jeune Homme et la Mort* made me a better actor and helped me excel technically. *Apollo* taught me to be artistically vulnerable and helped me understand that less is more. Twyla Tharp's *Movin' Out* made me aware of the value of consistency and how to remain fully present on the stage. Jerome Robbins's *Fancy Free* taught me how to be

comedic. Lar Lubovitch's *Othello* made me aware of just how much the body can handle."

"Most successful dancers end their careers as guest artists. You began yours this way. Why?"

"I always feel that you know what's best for you. I'm opposed to someone else telling me the career that I should have. I'm one of those reaching for the stars, but most artistic directors are not concerned with individual dancers' dreams. Being a freelance dancer and booking roles in different companies allows me to have a bigger piece of the pie. Just think about it. Every soloist wants to be a principal, every principal wants to do opening night, and you probably have ten principals in a company. In order to feed everyone, the pie must get sliced thinner and thinner."

"And you want a big slice."

"That's right, and I also like to have some say about what I perform. What I like to do is go through the repertoire of different companies and see what they're going to be doing that season. I'll contact the artistic director and try to sell myself to them for a particular role. Some dance companies resist because it affects morale with their established dancers—why not use one of their own? But I'm only interested in perhaps one or two of the ballets they're presenting. I have to use a sales pitch to convince them that I'm worth it. If they don't want to bring me in for one show, we negotiate for a certain number of shows. I'm aware that it's important not to upset the balance of an existing company and not to give the impression that I am irresponsible or a drifter."

"Do you aspire to have a signature work? Something that is totally associated with you like Jacques d'Amboise and *Apollo*?"

"I believe a dancer is only as good as the choreography he's performing. That's why I'm drawn to master choreographers like Lar Lubovitch, Jiri Kylian, and William Forsythe, who might one day create something unique for me that will challenge me and push me to my limit."

"Are you driven towards fame?"

"Oh, absolutely. In this country you need fame to achieve your career goals. I associate fame with artistic freedom. Think of it this way. If you want to work with choreographers at the highest level of the profession, you need to be known—known for your talent. Along with fame often comes money and power, and that enables you to bring your artistic vision to life. The career is too short not to reach for these heights. The bigger my fame grows, the more people I will be able to reach in order to sell my ideas and raise funds to develop projects and create great art."

"What sort of projects are you considering?"

"One of the things I'd like to do is create a show based on the three dance artists who have most inspired me: Vaslav Nijinsky, Rudolf Nureyev, and Mikhail Baryshnikov. I've always been fascinated by the mystery surrounding Nijinsky—his dream of perfection and his pioneering spirit. In collaboration with Sergey Diaghilev he revolutionized dance with cutting-edge ballets like *Afternoon of a Faun, Petroshka,* and *Spectre de la Rose.* His ballets are still being performed a hundred years after they first premiered. There is no actual footage of Nijinsky dancing, but his power comes through in photographs. I'd love to be the Nijinsky of my day, to leave an imprint on the art form like he did."

"And Nureyev?"

"I never met Nureyev or saw him dance live, but his performances have been recorded on film. He was beyond belief—like a myth, so sensual and godlike. He had such confidence and strength of conviction in his dancing. In his prime, the ferociousness he possessed was magical. Whatever role he danced, whether it was Siegfried in *Swan Lake* or Albrecht in *Giselle*, you always saw *him.* Nureyev simply shined through his characters."

"And Baryshnikov?"

"I think because of the evolution of dance, Baryshnikov was able to train in many styles and achieve a technical range and artistry that was off the charts. With his superb understanding of the physical body, he was able to absolutely captivate audiences. This is what all dancers dream of."

"What's it like for you, Rasta, when you're on the stage with hundreds of pairs of eyes on you?"

"I used to look at the people in the audience and try to make a connection with them, but it would break my concentration. There are so many distractions that can throw you off in a performance: the light blinds you, you notice the tape on the floor, someone in the audience coughs. I found it's better when I *don't* see the audience and let the music guide me. What I'm always aiming for is to get into that zone, where you feel as if you're dancing for the gods. It comes to you fleetingly in the form of seconds— incredible seconds. You train years and years, hours and hours, for those few precious seconds. One of my great challenges is to link those seconds into moments."

"You're a highly gifted performer. Do you also have the talent to make dances—to choreograph?"

"I can arrange a room if you give me a lamp, a sofa, a table. I can place them aesthetically, but I need the furniture. In other words, I have the ability when I'm given something to make the best out of it, but I don't have the ignition to start from nothing. I need a blueprint, a vision of

how things should be built, and then I can build on them, at least at this point in time."

"Don't you find it odd that wonderful movers such as yourself often are not able to create their own dances?"

"I do, but a violin can't play itself."

"How do you envision yourself at the end of your dance career?"

"I'd like to be able to say that I have no regrets and have been artistically fulfilled. I feel so many dancers are miserable after a lifetime of service to the dance; so many are simply discarded, forgotten and flat broke. Perhaps that's why I'm so proactive and discriminating about where I dance, what I dance, and with whom. I'd like to look back at my career and say—like Frank—'I did it my way.'"

Orlando, Florida, 2004
Newport Beach, California, 2005
Seattle, Washington, 2006

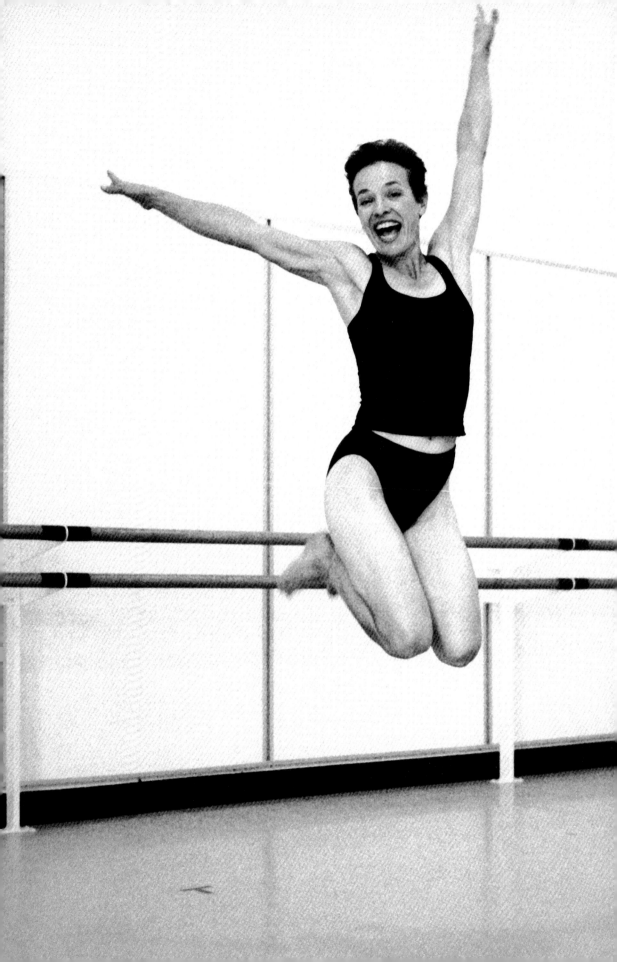

Marine Jahan

The 1983 film *Flashdance* became a huge box office hit, making head-bands, leg warmers, and off-the-shoulder sweatshirts fashionable. The film's break-dancing sequences catapulted hip-hop dance from the inner city to Main Street, and the name of its star, Jennifer Beals, became syn-onymous with dance. But *Flashdance* is also remembered as one of Hollywood's most embarrassing faux pas.

Beals's character, Alex Owen, worked as a Pittsburgh steel-mill welder by day and as an exotic dancer by night. She dreams of becoming a balle-rina, despite having no formal dance training. Encouraged by both an elderly former ballet dancer and her new boyfriend, she auditions for the Pittsburgh Ballet Conservatory and by the film's end is accepted.

Beals, who is not a dancer, required a body double to perform her character's hot and gritty dance scenes. But when *Flashdance* premiered, there was no screen credit for the real dancer—French-born Marine Jahan—allowing the public to think that Beals had performed her own dance numbers.

Now in her late forties and retired from show business, Marine lives with her husband in Sequim, Washington, on the northern Olympic Pe-ninsula. The once-famous dancer agreed to drive two-and-a-half hours from her home to meet me at my hotel in downtown Seattle.

"Marine," I asked, "how did you become a dancer and how did you end up in Hollywood?"

"I was born and raised in France," she began, revealing a slight accent. "My mother loved musicals, and when I was a child she took me to see a Fred Astaire–Ginger Rogers film festival in a theater along the Champs-Élysées. We watched a different film every day for two weeks. I found that even though Fred Astaire was speaking in English, I needed no translation. His dancing spoke to me. Afterwards I asked to take tap dancing lessons. It was difficult to find a teacher in France who could teach tap. I finally found a woman who had trained in the States. One day at her studio I met Al Gil-bert, a longtime friend of hers who had a tap dance school for kids in Hol-lywood. I took a few workshops from him and decided to go to Hollywood with the dream of dancing on the stage. My plan was to come for three or four months and study with Mr. Gilbert at his studio on La Cienega

Boulevard. But after I arrived, I realized that the city was full of professional dance studios that offered not just tap but a variety of dance styles. I could take ballet on Mondays, tap on Tuesdays, jazz on Wednesdays, and so on. My parents thought that I should investigate which studios offered scholarships. I discovered the Dupree Dance Academy on 3rd Street in Hollywood. I auditioned in December of 1976 and was accepted into the scholarship program. Now I could dance for eight hours a day, all styles."

"Did your parents come to L.A. with you?"

"Yes, but they returned to France after a few weeks. Before leaving, they rented an apartment for me and bought me a bicycle so that I could ride to and from the studio. It was terrifying at the age of eighteen to be in a strange city without my family. I remember crying to my mother, 'How can you leave me here all alone?'"

"How did you do at the Dupree Dance Academy?"

"Well, I thought I was a pretty good dancer until I saw all these kids younger than me performing multiple pirouettes, high leg kicks, and tremendous leaps through the air. 'I'm never going to be that good,' I remember thinking. In the beginning there were many discouraging days. When I performed poorly in class, I'd go to the back of the room and cry. I thought about giving it all up, but I had nothing to go back to in France, so I stayed. In time I made friends, and the studio became like a second home. I only went to my apartment to sleep and wash out my dance clothes. I remained on scholarship at Dupree for two years."

"Did you favor any particular dance style at Dupree?"

"I was particularly drawn to jazz and popular dance, but my teachers pushed me to take ballet and modern dance. Ballet in particular left me feeling naked and self-conscious, maybe because I began studying it so late in life. It was jazz dance that really spoke to me, and once I began performing it professionally, my movement vocabulary and capability really developed."

"What was the L.A. dance scene like back in the 1970s?"

"All of the dancers that I knew were trying to get jobs on television variety shows for the major three networks. There was little work in feature films, and it was before the age of music videos and MTV. Dance agents hadn't yet been invented, so there was no one to help struggling dancers find jobs, negotiate contracts, and protect them from hazardous jobs. Dancers in my time really had to hustle because the job market was extremely narrow and highly competitive. And if you didn't sing and act, you were even more limited. I remember going to auditions where you had to fight your way to the front of the room just so you could see the

combination in order to learn it. And then, you had to learn it very quickly and perform it better than everyone else. Breaking into the Hollywood dance scene was very, very tough. But I did it."

"What was your first big break?"

"I got picked to dance on the 59th annual Academy Awards show. This was still back in the days when they put on big flashy dance numbers. That year they did a Busby Berkeley–type number choreographed by Walter Painter and starring Donald O'Connor. After that I had regular work: the *Donny and Marie* show, TV commercials, and variety specials. It was also around then that music videos came on the scene. I had steady work for the next three years, and then I got a call for an audition that would change everything."

"*Flashdance.*"

"Yes. This is a story of a girl who dreams of becoming a dancer but has had little formal training. She rides her bicycle everywhere and befriends this older woman—a former ballerina—who advises her to follow her dreams."

"Sounds a little like you."

"Yes, it was very much like me. I even had an older woman in my life back then. Her name was Jo. She had been a singer and knew her way around Hollywood. She helped guide me and became my true confidante. I wanted the *Flashdance* job very badly. Originally the producers wanted someone who could act and dance, but they couldn't find anyone that could do both. Jennifer Beals did a screen test and was picked for the lead role, but they needed a body double to play her in the dance scenes."

"What was that audition like?"

"It was me and about six other girls in the old commissary at Paramount Studios with the film's choreographer, Jeffrey Hornaday. We had been told in advance to show lots of tits and legs and have big frizzy hair. I came in wearing a sexy outfit with six-inch heels and a wig meant to look like Jennifer's hair. We auditioned on a hard cement floor for three hours—one at a time and in small groups. It was utterly exhausting. Then the producers and director came in to watch us. They asked us to line up, facing away. 'Lift up your dress,' one of them instructed. They can't be serious, I thought. My minidress was so short you could practically see my entire butt. Exhausted, I complied. After the audition I crawled back to Jo's tiny apartment in Hollywood and crashed. While sitting on the sofa like a zombie, watching TV, and soaking my feet in a tub of hot water with Epsom salt—the phone rang. It was the choreographer, 'Guess what,

Marine, you were the producers' first choice. The director will be phoning you in five minutes to tell you himself.' "

"What went through your mind at that moment?"

"A mix of excitement and determination to make this character in the film look amazing. A couple days later I was on a flight to Pittsburgh to begin shooting scenes for the Jennifer Beals character. They had hired a girl to do the bicycle riding scenes, but she kept falling off the bike. It was challenging to ride a racer's bike with its thin tires down wet cobblestone streets and hills while wearing heavy boots and welder's gear. I was an experienced rider, and so when they asked me to step in, I did. The film opens with me (as Alex) riding the bike to Irene Cara's famous song, "What a Feeling."

"Did you know in advance that you would not be credited in the film?"

"No, no, no, absolutely not. My contract read 'credit at the producer's discretion.' I didn't really understand what that meant and, at the time, I didn't feel it was so important. I was thinking more about the fact that this was such a great opportunity for me to show people what I could do. I thought everyone would know that it was me. But as the filming progressed and I saw the dailies, I began to worry about my technique and if I might embarrass myself. You know, dancers are extremely judgmental about their dancing. Plus, early previews indicated that it would be a B movie and a failure at the box office. So I started to think, well, maybe it's a good thing not to be credited. But then I changed my mind and asked about it. I was told that they'd come up with a way to include me but that they couldn't credit me as "body double" because that would reveal that Jennifer hadn't done her own dancing. That's when I was sworn to secrecy by the film's producers."

"When did you discover that you received no credit for your part in the film?"

"It was at the movie's premier in a theater in Westwood, California. I waited to see my name come up on the screen, but it never appeared. And when I saw that the dog in the film got credit and not me, I was heartbroken. Afterwards in the lobby I could hear people saying, 'Boy, that Jennifer Beals sure can dance!' And I couldn't say a word. I'm sure it was also uncomfortable for Jennifer, who had to answer all sorts of questions about her dancing during her media tour. My friends were after me to sue Paramount Pictures. But that's not my style."

"What effect did all this have on you?"

"Working on the film left me physically injured and totally exhausted. I don't think I ever fully recovered from the burnout of *Flashdance*. I began to contemplate giving up dancing and doing something else."

"Wasn't the charade exposed shortly after the film's release?"

"Yes, of course. It was stupid of Paramount to think that they could keep such a thing secret. All of the cast and crew knew, and my friends and family knew. A few days after the premiere, someone leaked the story to the press and a photograph of me alongside Jennifer's appeared on the cover of the *Los Angeles Times*'s Calendar section published with the headline, "This is the girl who did the dancing." In the end, all the controversy surrounding the film helped it at the box office; people wanted to see how it had been done. I received more publicity from *not* having had a credit than if I had had one. I was bombarded with job offers and requests for interviews. It really propelled my career."

"In the end, were you happy with your performance in the film?"

"I didn't feel that my dancing was that amazing. But I loved the sense of empowerment that I felt from dancing alone before the camera; it was liberating for me. Until then, I had only danced in the chorus. I also loved having the ability to collaborate with the choreographer and the freedom to explore movement and break boundaries, which is what I think we did in *Flashdance*. Once I had done the film, I couldn't go back to being a chorus dancer. All the attention demanded that I push forward as a soloist, but there were few exciting opportunities for dancers back then. I did perform in Italy and Japan and had guest spots on television, including a reprise of my *Flashdance* performance on the Emmy Awards telecast and at the People's Choice Awards. My Hollywood dance career lasted for about ten years, and then I looked to theater and acting. I appeared on Broadway as Madame St. Cyr in *The Scarlet Pimpernel* and Off-Broadway in several shows. I also became the national spokesperson for Reebok, Crystal Light, and Nine West Shoes."

"So what became of the dancer that you worked so hard to develop?"

Marine sat up straight and pointed to her chest. "Oh, she's still in here. I keep her very much alive. I dance for myself in my living room whenever the mood strikes—which is pretty much whenever I hear music. I look to dance when I have difficulty with words and when I want to release emotions that grow inside of my body. I intend to dance till the end of my life. I don't need an audience to want to dance."

Seattle, Washington, 2006

Robert La Fosse

The famed ballet star looked pale and thin, his hair cut short and uneven as if self-clipped without a mirror.

"It's good to see you again," I said, initiating a hug.

"Yeah," he said, returning the hug but showing little emotion. He led me into his Manhattan apartment, walking slowly, favoring one hip, hardly saying a word. This was not the same playful Robby La Fosse I had met eleven months earlier. His black Lab, Isadora, likewise seemed a mere shadow of herself. Last time she leapt with excitement, nearly knocking me down; this time she sniffed my leg and walked away.

"Robert, where's all your furniture, all your stuff?"

"Most of my things have been packed. I'm moving, selling this place. I've lived here for eighteen years. I think I need a change," he said dropping his body onto the sofa—the only piece of furniture in the room except for the coffee table.

Sitting down next to him, I said, "Thought you might like to see some of the photos I took of you last summer when we had our shoot in that vacant lot on 58th and West End Highway."

Robert and I had squeezed through a narrow opening in the fence; amidst slabs of old concrete, broken glass and rods of twisted iron, we spent a full hour composing and shooting photographs. His energy seemed without limit as he bounced across the debris, inventing outlandish characters for the lens.

Robert studied the photographs in silence, nodded his approval, and then handed them back to me.

"Robert, I read your autobiography, *Nothing to Hide*. It revealed much about your life up until 1986. What's been going on since then?"

"Most of the people I wrote about in the book are dead. The AIDS epidemic wiped out a lot of the people that I had worked with and many of my closest friends. I myself have been HIV for more than twenty years. When I first came to New York in 1977 at the age of fifteen, it was a very sexually free time and I was very promiscuous. I was diagnosed in 1983. Back then, it was like being handed a death sentence. Strangely enough, I'm one of the few who lived long enough to see new drugs come on the market. I was one of the first to go on AZT."

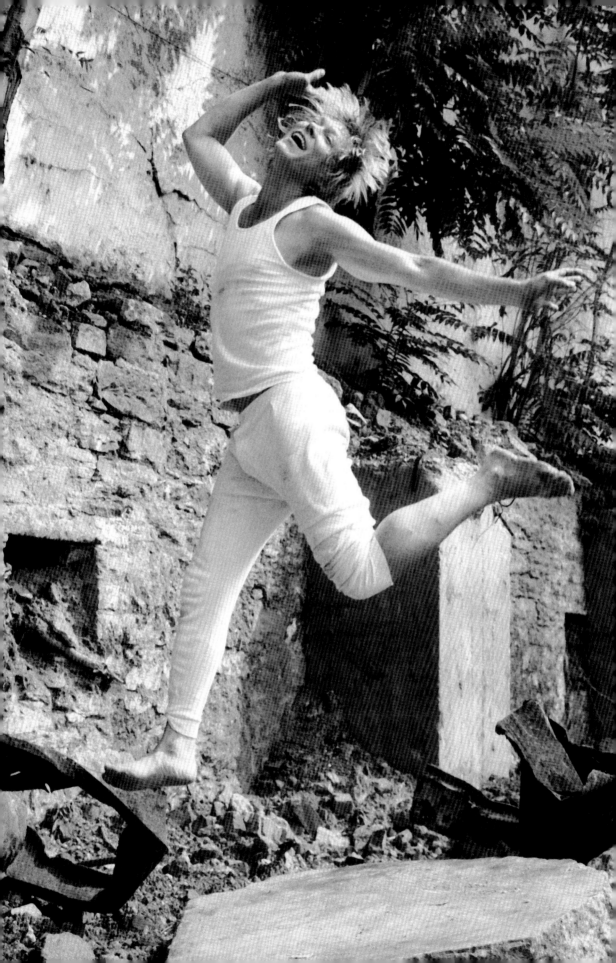

"Do you have close friends now to help you through this rough time?"

"It's been hard to make new friends. I get gun-shy."

"Why, you're afraid they might die on you?"

"Yeah, and I know it's weird. It's not logical. I know I shouldn't live in this paranoid state. But I have good days too—the days that I'm connected to my dancing. When I'm not dancing, rehearsing, taking class, or doing something that has to do with dance, I feel disconnected, alone, lost, and purposeless."

"Balancing one's personal life with one's professional life can be tough."

"I've always put my dancing first and relationships second. It's not that I didn't love my partners, but dance is an obsession. You know it's a short career, so you pack in all you can in a short amount of time. You're always facing the end of your career. Most dancers are completely focused on themselves and their careers Dance was the constant in my life. It was the thing that I trusted the most. I could rely on it for love—unconditional love. But when I went into semiretirement a few years ago, I didn't have that any more. And I realized something very important about myself, and that was that in my relationships I was extremely passive. I think it's an inbred character trait with most dancers. Maybe it comes from constantly being told what to do—from your first dance class to your last performance on the stage, you're being directed. For most of my life I've been taken care of, first by my parents and then by my artistic directors: Mikhail Baryshnikov and Jerome Robbins. When I was a kid, my mother was very protective of me. She did everything for me, even the things I should have done for myself, like make my bed. There were a lot of things I didn't learn to do on my own."

"But you did make some very wise decisions in your life."

"Yes, I did. I came to New York, was in the right place to get into Ballet Theatre, and I bought this apartment. But when it came to relationships, I was passive and submissive. Now that I've come to a point where I want to have a relationship, I can't help but think maybe it's too late. I'm HIV. Will I be able to find someone? I'm making changes like moving to a new apartment. I'm trying to find myself, but it's hard when you're not sure why you should get up in the morning."

"You're mourning the loss of your dancing?"

"Yeah, absolutely. It's very hard to let go. The problem is that once you stop dancing you have to find a new way of functioning. You're like a stranger in a strange land. You have to learn to cohabitate with non-dancers."

"Eventually, dancers transition and come to terms with a new life."

"Do they ever really? It's not the glory we miss. It's the daily routine: the repetition, the constant striving for perfection. And when you finally figure how to do all these things, you're actually too old to do them."

"Still, you've had a phenomenal career: worked with some of the greatest artists of your generation, received wonderful praise for your talent and skill, danced almost every major male role, and became a choreographer. When you came to New York, did you have any idea what was in store for you?"

"To be honest with you, I never expected to be in a ballet company. I first came to New York on a scholarship to study with the respected teacher David Howard at the Harkness House. I loved musical theater and was thinking about a career on Broadway. But when I was seventeen, I was invited to audition for ABT and was admitted into the company. Lucia Chase was artistic director back then. When Baryshnikov took over the company in 1980, I really began to grow as a ballet dancer."

"You witnessed the changing of the guard and the beginning of a new era for American Ballet Theatre."

"Yes, Baryshnikov was responsible for making big changes in the company. Instead of continuing ABT's tradition of bringing in guest artists from abroad, Misha developed talent from within the company. His dancers—American dancers—would represent him at the highest level. If he had not become director, I would not have had the kind of career I had."

"What do you think he saw in you?"

"I think he recognized my ability to take a character and develop it dramatically. He liked my dancing and promoted me to principal in 1983. I was given almost all the principal roles in the Ballet Theatre repertory—*Giselle, Les Sylphides, Swan Lake, La Bayadère, Billy The Kid, Jardin aux Lilas, Push Comes to Shove*, and many many more—and partnered with almost every major ballerina in ABT from Natalia Makarova to Cynthia Gregory to Gelsey Kirkland to Susan Jaffe. But Misha was very hard on me, pushed me. One day I skipped class. He noticed that I was missing and came looking for me. When he found me, he yelled, 'Get your butt into class.' He didn't allow people to slack off. He never missed class and expected everyone to maintain the kind of discipline he had. He was raised in a country where the training was highly formalized and disciplined. To this day I marvel at how he never missed class."

"What a role model he must have been."

"We were all in awe of his talent and his technique. I think what impressed me most was that he constantly challenged himself technically

and artistically. Misha displayed an unbelievable love and respect for the theater and the people in it."

"I remember being so shocked when I read in your book that you elected to leave ABT after nine years and move to New York City Ballet."

"Yes, everyone was shocked at the time. I showed no signs of discontent. I loved the company, I loved the people, but my dream was to become a choreographer. So when Jerome Robbins invited me to join New York City Ballet, I thought it would help take me in this new direction."

"Did Jerome Robbins work closely with you?"

"When I came to City Ballet I was twenty-eight years old and at a major crossroads. I would continue to dance for fifteen more years, and during that time Jerry helped me hone my creative instincts both as a dancer and choreographer. He taught me a great deal about the mechanics of ballet, but made me realize that what choreographers do regardless of their style is essentially put their own lives on the stage. I doubt very much that they are aware of this while they're creating. Jerry Robbins's ballets were very much about *him*, his beliefs, his struggles. The same is true of George Balanchine and Antony Tudor."

"Are you expressing your own personal struggles through your choreography?"

"The last piece I did was about pulling oneself up and relying on others for support in order to carry on. And this is basically what's going on in my life—feeling a little lost and unfocused. This year I plan on gathering up my chutzpah and working on creating new work and making my own choreographic imprint. But no matter what I do as a choreographer, I think I'll always be known as a dancer. I do believe that in order to be a great choreographer you have to have been a great dancer. One's choreography is a reflection of one's own dancing, personality, and soul. Even though I have choreographed around fifty dances, I think I have to accept the fact that my identity is more about who I was on the stage."

"Who were you on the stage?"

"I was an exposed human being—an open book. I had a spirit onstage that transcended technique. I was not a "technical dancer" but one with a chameleonlike range to bring my characters to life. I was the kind of performer who could make people laugh and cry. I was never afraid to be foolish or put myself on the line. In fact, I can remember a time when I fell down on the stage. I was performing an Antony Tudor ballet that had a staged fall in it. But I fell down just before the staged fall. So it looked like—fall–fall. But this is the thrill, the beauty of live theater—it keeps the dancers on their toes and the audience on the edge of their seats.

"I was a character dancer who could do romantic roles like *Giselle* and *Romeo and Juliet*. I did perform *La Bayadère*, but never did a full-length *Swan Lake* and the high classical roles. I think in the end, because I loved the stage so much, people loved me. And I had such a good time," he said, looking out into space, his eyes shining for the first time since I arrived. "I had a good time even when it was painful. I might have been portraying characters, but in the end I was letting people see the real me."

"Do you think this is what draws the dancer to the dance—allowing one's true identity to emerge?"

"I think ultimately it's that you are able to feel so many things. You feel pain, defeat, inadequacy, insecurity. But you also feel joyful, triumphant, powerful. It's not just what you feel, but that you feel intensely. This, I think, is what keeps the dancer in dance."

"And when you're on the stage?"

"Your soul is soaring. It feels like anything you care to imagine. Time does not exist. Centuries could be passing or just a second. It feels like there is no war in the world, no hate, no disease. I wouldn't trade what I've had for anything else in the world. Dance is all I know how to do. It's all I've ever wanted to do. And . . . still want to do."

New York, 2004 and 2005

Gemze de Lappe

Dressed in a blue, floor-length dress, Gemze moved with such intensity and passion one would have thought she was performing for a full house in one of the great concert halls of Europe. But it was just the two of us in a rented studio at the Isadora Duncan Dance Foundation. In a rare solo performance specifically for my lens, the eighty-four-year-old former de Mille dancer, her brow creased and her eyes blazing, reached, stretched, clutched her heart, and dropped to the floor as she captured moments from one of Duncan's most famous creations—*Dance of the Furies*. Drawn from Greek mythology, the dance is set in the fiery underworld, where female creatures seek vengeance for the sins of man.

"Your performance held me spellbound," I said, applauding. Gemze bowed shyly.

"The dancer in you is so vibrant, so strong."

"Once a dancer always a dancer. I was always very serious about my craft. What you implant in your body remains forever," she said, folding her costume and placing it in her tote bag. "That's why you can always recognize a dancer; it shows in the way she moves and holds herself."

"You studied dance and music from a very early age."

"I attended the Peabody Conservatory in Baltimore," she said, taking a seat and picking up a cup of tea I had prepared for her. "By seven, I was studying piano and violin. My first dance teacher was Gertrude Coburn. She taught *plastique* ballet, which was based on Checcetti ballet but much freer. Then we moved to New York and at the age of eight I began studying with Irma Duncan, the adopted daughter of Isadora Duncan, who had achieved a large measure of success in Europe, Russia, and China. In the U.S. she taught dance in the ballroom of the Broadway Hotel and then later at the Pan Hellenic—now it's the Beekman Hotel. Irma was very precise in her instruction. You always knew exactly what you were doing. Nothing was ever improvised. When you heard the music to a Chopin waltz, you knew exactly what foot you were on and where you were in the music."

"You also studied with the Russian choreographer Michel Fokine."

"Yes, that's right. He invited me to audition for him after seeing me perform in one of Irma's recitals. He asked me to improvise to the 'Waltz of the Flowers' from *The Nutcracker*. The audition was very difficult because

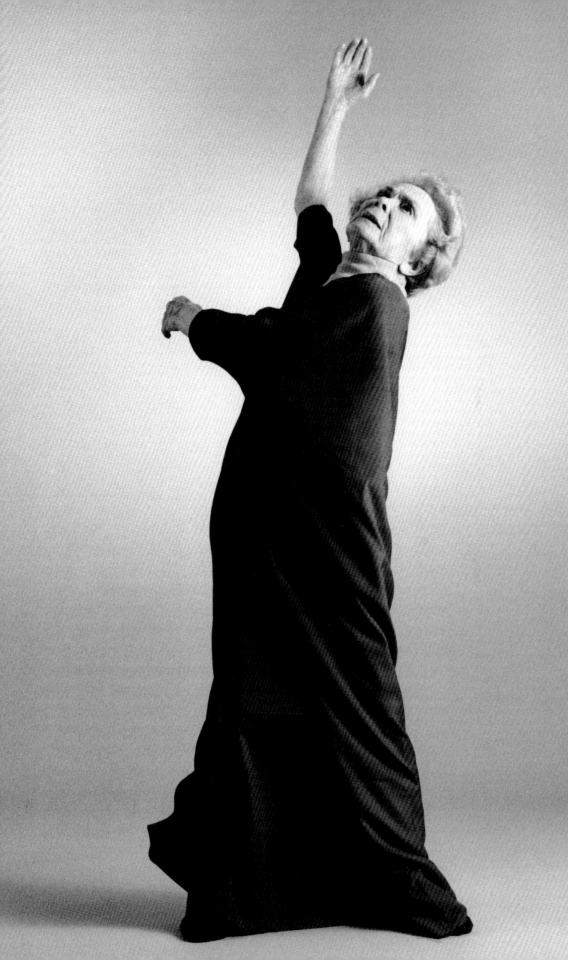

I was only eight years old, very shy, and not accustomed to improvising. But he liked me and offered me a scholarship. I studied with him and performed in his summer programs at Lewisohn Stadium until I was fifteen."

"Did you continue your studies with Irma Duncan?"

"Yes, but I did not tell Fokine that I was still one of her students. But Fokine respected Isadora's style. He knew her back in Russia when he was in the Imperial Ballet at the Maryinsky Theater and during his time with Diaghilev and the Ballet russes. Fokine had attended Isadora's concerts in Saint Petersburg. In fact, some say that her dancing hugely influenced his choreography."

"What was Fokine like?"

"He was a gracious man, charming and patient, a real gentleman. When he entered the studio, he would bow to us students and we would bow back. It was all very respectful and quite serious. By the time I met him he was well past his glory years. It was during the Depression, but he did very well for himself. He bought a huge mansion on 73rd and Riverside with the money he had made from his dance extravaganzas in New York City. In 1939 he restaged *Les Sylphides*, his most famous work, for Ballet Theatre and then after the war he created several more successful new ballets for the company. But what I remember most about him was that he didn't teach just classical technique. He taught us about the meaning behind the steps, characterization, and, most importantly, how to breathe."

"Did Isadora Duncan's technique complement Fokine's?"

"Well, Fokine was all about expressiveness, and this is certainly what Isadora Duncan's dancing was about—feeling an emotion or expressing a message. Irma taught us to use our imagination and express what we were seeing in our mind's eye: to look through walls or ceilings and see trees and clouds and mountains. This was the most important lesson I ever learned as a dancer. It taught me about acting, and I used this throughout my career."

"You are most known for your work with Agnes de Mille. How did you come to work with her?"

"Yes, Agnes," she said with a smile. "I first met Agnes in class at Ballet Arts, which was the premier dance school in New York City in the forties. Everyone took class there, and different-level students were all mixed together. You could stand at the barre with famous ballet stars like Freddie Franklin on one side of you and Alexandra Danilova on the other. Agnes had already made a big name for herself with the Broadway hit *Rodeo*. But it wasn't until I got cast in *Oklahoma!* a year later, that I would work with her."

"How did that come about?"

"Jerry Whyte, who had been the dance captain for the Randall Island shows where I had performed in Fokine's productions, was now production manager for the Guild Theater, where auditions for Agnes's new show were being held. He saw me on the street and said, 'Why aren't you at the audition?' 'What audition?' I asked. I didn't see myself as a Broadway dancer at all. I wasn't tall and long-legged, I could tap some, but I wasn't a tap dancer. He encouraged me to go, so I did, and the producers cast me as the Child with Pigtails, a role originally performed by Bambi Linn. I was seventeen; the year was 1943."

"I thought you played the role of Laurey in *Oklahoma!*"

"Yes, I did, but later, in the national company. *Oklahoma!* was the first Broadway show to go on a national tour, setting a precedent for future shows. And it was the first time that the term musical theater was used to describe a musical. I played the part of the Child with Pigtails, but I was also the understudy for the Laurey role. Tania Krapska had been cast as Laurey, but when she left the show in Chicago, I stepped in. We played Chicago for a year and three months before heading out to California, and then in 1947 we began a long run in London."

"What was that like, to bring a Broadway show to London just after WWII?"

"Oh . . . you could still see the devastation everywhere—the damaged buildings from the bombing of London and the shock of war on people's faces. They were still reeling from it all, living on food rations, and without heat in the winter. People brought blankets and hot water bottles to the theater to stay warm during the performance. Thank goodness that we had hot water. I used to soak my feet to thaw them out before every performance."

"How were you received?"

"For the Londoners we were like a ray of sunlight, a breath of fresh air—all the things they hadn't had for so long. We really didn't expect such an outpouring of joy and love—the electricity that came back at us across the footlights. It was palpable and we had this night after night, nine shows a week for eighteen months. I remember them so well. All of Europe was so brave. They had suffered so," she said, turning away, her voice breaking. "I'm sorry. I need a minute," she said, hiding her face from me as she wept quietly into her hands.

"Forgive me," she said, turning her gaze back toward me. "Sometimes I can't help but get emotional when I talk about those days. They meant so much to me. Let's proceed."

"You've really had such an amazing career, Gemze, and to have played one of the most important characters in musical theater history. What was it like to be Laurey on the stage?"

"Agnes's choreography for Laurey was originally full of Grahamesque-type gestures. I didn't feel comfortable doing them. I interpreted the role of Laurey differently. I tried to imagine what Laurey would be feeling in her relationship with Curly and Judd. I saw movement as telling a story and approached the role from a more Method-acting type of dancing. Agnes saw what I was doing, and she liked it."

"Agnes eventually choreographed many roles on you as she developed her Broadway shows and ballets. I read that she described you as a combination of Indian rubber and gunpowder."

Gemze smiled: "Yes. When I returned from London, Agnes sent for me to work on her next show, *Paint Your Wagon*. She created a series of dances for Jimmy Mitchell and me. Jim and I had instant chemistry—like breathing together. We danced together in several of Agnes's shows, including *Brigadoon* and several of the ballets that she created for Ballet Theatre. But I was always very proud of *Paint Your Wagon*, especially in the *pas de deux* and the rope dance. Agnes saw that I had all the qualities that she wanted. You see, choreographers have an image in their heads, an ideal image, and if you come close to that image they love you. After we completed the work, she sent me a note that read, 'You danced the way I would have liked to have danced.' It overwhelmed me."

"What was her choreographic process like?"

"Agnes, like so many choreographers had a stable of core dancers that she liked to use in the early stages of a work, but it was usually Agnes, me, Jimmy, and her composer, Trudi Rittman, who would be on the piano making musical sketches and notes. Agnes always did her homework and came in with a lot of ideas, and then she'd work them out on us. It was a total collaboration, a team effort. I loved when Agnes choreographed on me and improvised with the music. She could never do things the same way twice, so we always had to remember what she was doing and play it back to her. And it was never on the obvious beat."

"I imagine that you also wanted to contribute to her choreographic vision."

"Yes, that's right. You don't just want to be someone's tool. Dancers need to bring something of themselves to the work that goes beyond mere technique. After *Paint Your Wagon,* Agnes set many roles on me that were later transferred to other dancers, like Nora Kaye, Lupe Sorrano, and Carmen de Lavallade."

"I've heard that Agnes was very secretive about her choreographic process."

"Agnes was a little insecure about her process. She hated to have people watch rehearsals. In fact, she wouldn't let anyone come in. It was only after she'd suffered a stroke that she opened her doors. She said, 'Once you face death, you stop worrying about things like that.'"

"Any career regrets or things you would have done differently?"

"I have only two regrets. The first was that I didn't remain a member of Ballet Theatre. I loved the company and performed in Jerry Robbins's *Fancy Free*, Agnes's *Fall River Legend,* and ballets by Herbert Ross. But Agnes had asked me to go on her concert tour, and I had given her my word that I would. I realized later that I was a fool, because the tour lasted only a year, and once it was over, it was too late to go back to Ballet Theatre. I loved dancing the repertoire and, had I stayed, I would have had a future with the company, coaching new dancers for years to come. My second career blunder was not trying to get into Paul Taylor's company. I could do his work when I was young and I was ready for him. But I didn't act on it."

"When did you stop dancing?"

"I've never stopped dancing," she protested. "I just perform less and less. What's hard, is knowing that I can outdance all these young people in terms of knowledge and experience, but I can't pass for a young maiden. I dance when I stage works and when I teach. In order to show your dancers and students what to do, you have to get up on your feet and do it. You have to dance it. Sometimes I need help getting up off the floor, but that doesn't bother me."

"Gemze, how would you like to be remembered?"

"As one of the really good dramatic dancers of my era."

"What is the secret to a successful dance career?"

"I think it has to do with focus—maintaining a clear place in your brain that is immune from distraction and self-doubt. Any good professional never falls below a certain level, even on a so-called bad day. When there is a veil between you and your audience, it's usually your own fault. When I was on the stage, my focus was so solid I could never tell you who was standing in the wings. I always knew exactly what I needed to do, and I did it. And I didn't take silly chances. When you feel your audience is with you it's like an electric current that travels from you to them and back. It's like giving birth. You're creating a living, breathing entity."

New York City, 2005

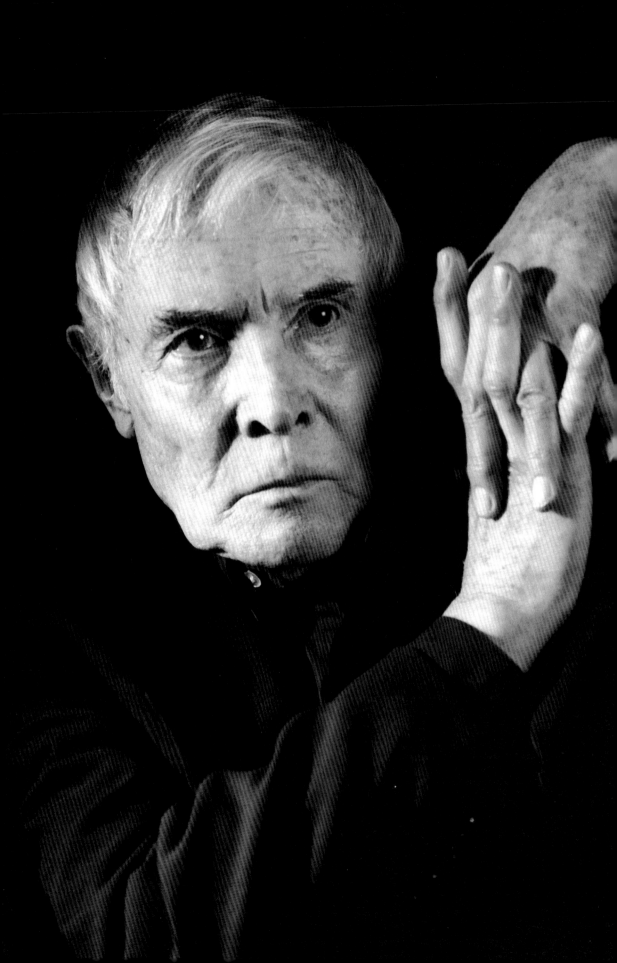

James Mitchell

James Mitchell was considered one of the most handsome and captivating dancers of the 1940s and 1950s. Now at the age of eighty-five he continues to impress audiences as a soap star.

Over breakfast at my Manhattan hotel, I asked him if he still identifies as a dancer.

"When I go to the theater to watch dance, my muscles twitch. I can't help but respond physically to music and the choreography. It simply moves me. There's no doubt that the dancer is still present inside."

"Ever feel the impulse to move the coffee table and dance again?"

"At my age I'm afraid I'll fall down and break something."

"How did you come to dance?"

"When I was nineteen, I attended Los Angeles City College with the hopes of becoming an actor. I had a teacher that insisted that if I wanted to be an actor, I had to know something about dancing. Back in the late 1930s, dance classes were not offered in colleges and universities, so he took me to Lester Horton's studio. I had never really seen dancing or knew what it was. And, I was totally nonathletic. In fact, I was kind of fat. But I was quickly drawn to the movement and appeared to have a talent for it. Lester was very kind and invited me to become an apprentice. I became a part of his amazing company, which for a while would become my family. You see, I had come from a shattered home with no real core and no one to guide me. Suddenly I had people who cared about me. Lester took me under his wing and taught me many things—practical things, like how to relish life. I'll never forget the time he took me out for a steak dinner, but only under the condition that I eat it rare. 'That's the way you're going to get the most value out of it,' he said."

"Did Lester teach you his technique?"

"No. Lester was more the choreographer and director of the company. I learned how to move by watching his lead dancer, Bella Lewitzky. It was she who taught me the meaning of dance and how to communicate with the body. She was only twenty-two, but a fantastic dancer, just unbelievable. You looked at her move and you understood the relationship of the hand up here to the foot down there. Bella taught me about character and how abstract movement—not pantomime—could be used dramatically

and literally. This of course really appealed to me because I aspired to be an actor. She showed me that I could communicate thoughts and ideas without words, that simple movement could be more powerful than pages of dialogue. Bella was my first partner, the first woman whose waist I put my hands around and lifted. We would remain lifelong friends."

"You know, she was one of the first artists I photographed for my book, *Masters of Movement*. I have her picture with me." I pulled my portfolio from my bag and opened it to Bella's portrait. James took one look at the photo and gasped. He looked shaken, stricken. He stared at her photograph for what felt like a couple of minutes, placed his hand on her picture and then closed his eyes as if he were touching her for the last time. Word of her death had been broadcast on the news just days before. Finally, he looked up at me and said, "I'd really love to have a copy of this photograph."

"I'd be happy to send you one as soon as I return to L.A," I told him.

"I really loved and admired this woman," he said trying to pull himself together. "It's hard for me to imagine that she's gone. Bella had an integrity that was like steel. Her ethics were of the highest level. And she was a real educator and not just in a classroom. When she was artistic director of her own company, she gave long speeches to her board of directors about what art meant to her and why she was doing what she was doing. She had to educate them. She didn't just say, 'Go out and get money, get money, get money.' She tried to tell them why—*her* why. And she influenced so many of us. Bella invented Carmen de Lavallade, gave her that beautiful back and elegant torso, taught her what it meant to be expressive on the stage. Carmen went on to be one of the most beautiful dancers of this generation."

"Sounds like Bella and Lester really put you on path."

"Well, I always wondered what would have been had I taken the other path."

"What other path?"

"Well, here's what happened. Lester and I went to New York in 1944 to start an East Coast–based dance company. But we didn't have the money, and it never really got off the ground. So here I was alone in the city with no job. Lester heard that Agnes de Mille was holding an audition for a new Broadway show and encouraged me to go to it. So I went."

"I heard that she hired you on the spot."

"Yes, she did. She asked me where I'd had my training, and when I dropped the names Lester Horton and Bella Lewitzky, she said, 'Okay, that's good enough for me.' I told her that I'd never seen a Broadway show, so she took me to the St. James Theater in the middle of a performance of

Oklahoma! We stood at the back of the house and watched for a while. Then we walked across the street where her other show, *One Touch of Venus,* was running. We watched a portion of that from the wings. Later that day I went to another audition for a road show being cast by the famous actress Helen Hayes. I read for the part and was immediately offered the role and the job of assistant stage manager. Agnes de Mille and Helen Hayes: two incredible women, two different paths—one huge dilemma. I didn't know what to do. I was completely torn. I phoned Miss de Mille and said 'Helen Hayes just offered me an acting job in her new show, and you hired me for your show. I really don't know what to do.' 'Make up your mind, young man,' she told me very matter-of-factly. And so I did, right then. I chose her. I chose dance. But I've often wondered how my life would have been had I gone with Helen Hayes."

"Any regrets?"

"Oh, no, none at all, none whatsoever. I remained with Agnes for twenty-five years. I became her assistant and danced in her Broadway shows and ballets: *Bloomer Girl, Rodeo, Fall River Legend, Paint Your Wagon, Brigadoon, Carousel.* I appeared in *Oklahoma!* on television and in the film, and in some of her earlier, lesser known works."

"After twenty-five years I imagine you knew her very well."

"Yes, we grew to be intimate friends. She gave me jobs, good jobs, but I repaid her with my performances. It was an even exchange. She had an unusual way of working. Most choreographers had these big ideas floating around inside their heads, but Agnes had everything written down on paper. She always came in with very complete notes. It was all right in front of her. She'd tell you what to do, and you'd do it. 'Run over there and catch her,' she'd say to me. Abstract things didn't work too well for her. And she had a limited dance vocabulary, so she borrowed and stole from everybody—Antony Tudor, Martha Graham, whomever. But I will say that she could really structure a story extremely well and that she was highly theatrical. She liked to hire dancing actors, which is what appealed to me. I could act and dance at the same time."

"During your career you partnered with some of the most extraordinary women in dance."

"That's right. Nora Kaye, Joan McKracken, Alicia Alonzo, Gemze de Lappe, Bambi Linn, Cyd Charisse, and Rita Moreno, just to name a few. And they were extraordinary. Old dance films and photographs don't do them justice. Nora Kaye, in particular, was one of a kind. There isn't anyone going to come around like her again, ever. She was a real actress. A good dancer has to be a good actor. Nora had that projection, the ability

to throw it all the way out there past the apron, past the orchestra pit, to the last row in the house. Without that reach you really don't achieve much. When Lester had us working at the ballet barre he'd say, 'Do that barre as if you're performing for the Queen of England or the President of the United States. Your dancing must mean something. It has to say something. If you're simply doing technical moves as though you're in class, how is that going to affect an audience?"

"You are reputed to have been a great dance partner."

"Well, I knew my way around a stage and was strong, so I could lift my partners up and put them down softly. And the other thing that I understood was the importance of eye contact. It's essential when you're performing to remain connected with the person you're dancing with. I see it on the stage all the time when the dancers drop out of character and go for the 'look at me thing.' They break that famous fourth wall and let the audience in on the dancer's private thinking, not the character's thinking. That will destroy a performance."

"Were some partners easier to handle than others?"

"Oh, yes, absolutely. When I performed in *Fall River Legend* for Ballet Theatre, I danced the role of the minister with Nora Kaye and Alicia Alonzo—two different bodies. Agnes once asked me what's the difference between these two women. I told her, Nora is steel and Alonzo is like a down cushion—absolutely luscious, no more difficult to work with, but a whole different feeling."

"I believe you were also known for catching your partners in the air."

"Yes," he said, breaking into a laugh. "I was always catching women. And interestingly enough, they trusted me even when I wasn't 100 percent sure of the choreography. I had a terrible experience the first time I performed Antony Tudor's *Pillar of Fire*. Agnes convinced Lucia Chase, Ballet Theatre's artistic director to let me dance the part of the Man across the Street. Hugh Laing originally danced the part. But Laing refused to teach me the choreography. He disliked me because Agnes and I were very close, and he and Tudor had a strained relationship with her. The two of them took their animosity out on me. I think it was pure meanness. Pure meanness. Tudor and Hugh Laing—they were a pair!" he said, shaking his head. "So I performed it from memory, filling in the blanks as best I could. Nora taught me the section where we dance together. She said, 'Just be over there. I'm gonna run and you're gonna catch me.' Fortunately, I got help from a couple of dancers in the wings who pushed me out onto the stage when it was time for me to make my entrance. In spite of everything, Nora knew I'd be there to catch her."

"You mentioned Cyd Charisse. Did you also catch her in the air?"

"Yes, as a matter of fact I did. In 1954 we worked on a film for MGM called *Deep in My Heart.* It was one of those Hollywood extravaganzas choreographed by Eugene Loring. I'll never forget the first time I saw Cyd Charisse. I was warming up at the ballet barre in one of the rehearsal halls and the outside door was open. It was a very sunny morning and from a distance I saw this gorgeous female figure walking down the studio street, backlit by the sun. All in black and wearing high heels—breathtaking, simply breathtaking. She came in and we were introduced: 'How do you do?' 'How do you do?' My God, she was stunning! Rehearsal began and Eugene Loring gave us our directions.

"'Now, Cyd,' he said. "You go over there and run towards Jimmy, leap into his arms, and then wrap your legs around his body.' He didn't bother to demonstrate. She just took off like a jet and flew into my waiting arms. We had only just met, but she was one of those absolutely fearless dancers. We would work together again a number of times, but after I moved back to New York we lost touch."

"What did you do after you retired from dancing?"

"Well, let's see, from the age of forty to sixty I acted. Did lots of summer stock, a few off-Broadway plays, and one on-Broadway show. I had small parts on some television episodes. And then at the age of sixty, I landed a role on the soap opera *All My Children,* for which I am most known. I just celebrated my twenty-fifth year on the show a couple of days ago. For a quarter of a century I've played a man named Palmer Cortland. He's a snake," James said with a laugh. "He's the patriarch of the family and as mean as can be."

James agreed to meet with me on my next New York trip for our photo session. I had converted one of the rooms of my sublet into a studio with a black backdrop and strobes. When James arrived all he needed to do was step into my setup.

"Careful," I cautioned, as he stepped over cords and lighting equipment.

"Don't worry, Rose, I'm quite accustomed to maneuvering through sound stages."

"Yes, that's right, of course."

"I don't think I can dance for you. But I find that gesture can be very powerful," he said, interlacing his fingers and holding them up near his face.

"Yes, let's play with gesture."

James sat back on the stool I had prepared for him and in silence began to transform himself into different characters, using only his hands,

arms, and face. One minute he was dark and sinister, the next playful and tender, the next seductive and alluring. I followed him closely through the lens as if shooting a choreographed performance. Afterward, he admitted to having had a workout. But I knew that the dancer within him had a hell of a good time.

<div style="text-align: right;">New York, 2004</div>

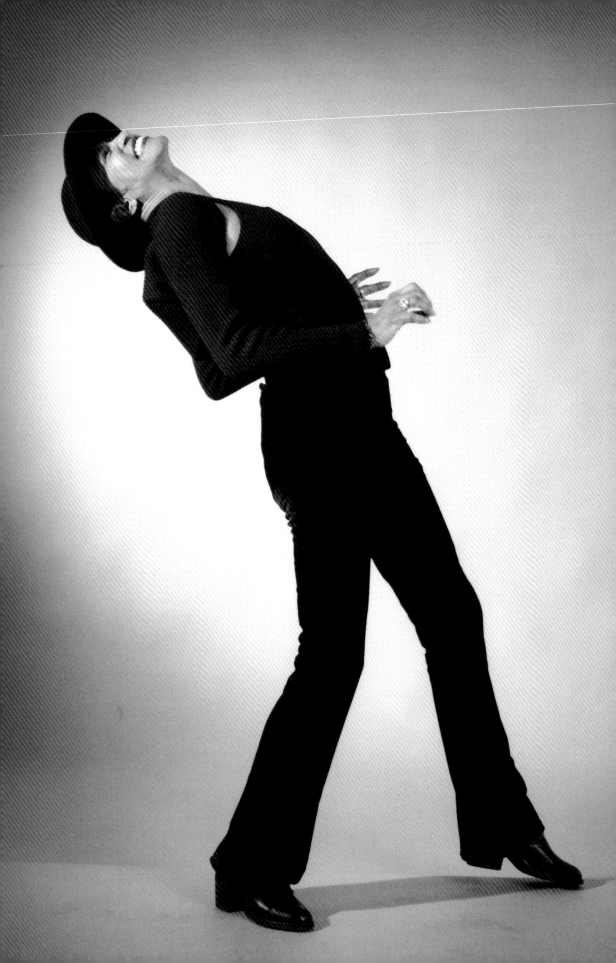

Paula Kelly

Bob Fosse once referred to Paula Kelly as "the best dancer I've ever seen." So when the veteran stage and screen dancer sat down with me at my studio, I was curious to know when she discovered the dancer within.

"My mother said that I danced before I walked. And music was the thing that always brought me to my feet. Music and dance were indigenous to my Harlem habitat in the 1950s and 1960s. The rhythms of Duke Ellington, Count Basie, Little Richard, the Dells, and Wilson Pickett flowed into the streets from open windows. And, oh, how my friends and relatives could dance! At parties or even out on the sidewalk: jitterbug, swing, ballroom."

"You were a natural-born dancer?"

"I could leap and jump and carry on, but I didn't know what a *plié* was until I was seventeen. I didn't know that I wanted to be a dancer until just before I graduated from high school."

"What happened that inspired you to become a professional dancer?"

"When I was sixteen, my father gave me money to see a Broadway show. My friend Roselyn and I took the A train to 42nd Street in the theater district. It was only fifteen minutes away and yet I'd never been there. We got out of the subway and just stood there dumbfounded. We asked one of the ticket sellers which show had the most dancing, *Redhead*, *Damn Yankees*, or *West Side Story*. He said, *West Side Story*. Our seats were in the nosebleed section of the Winter Garden, but the moment the houselights went down and the show started, I sensed that my life would change forever. The show opened with a spotlight on a red curtain. Then came the music: *dab dab—dan dan dan dan dan dan dan*. And I was just gone! The prologue captivated me and this was before I'd even seen a single dance step. Leonard Bernstein's score! My whole body went limp. This was bigger than life. By the end of the show, I felt intoxicated. I was shaking as we left the theater and walked, or shall I say floated, four blocks in the wrong direction. I decided right then, *that's* what I've got to do: music, dance, theater."

"When did you begin taking dance classes?"

"In my last year of high school I enrolled in a Humphrey-Weidman technique class. The teacher was amazed that I'd never had any formal

training and told me that I was crazy if I didn't pursue dance. She encouraged me to attend auditions at the Young Women's Hebrew Association. There I met Muriel Manning and began studying with her—Graham technique. Muriel recommended that after I graduate from high school that I audition for Julliard. 'The worst thing that can happen is that they'll say no,' she told me. So I went for it."

"What was the audition like?"

"I was terrified, especially after I learned that I'd have to choreograph something and perform it for the faculty judges: Louis Horst, Martha Graham, Alfredo Corvino, Antony Tudor, José Limón, Margaret Craske, Martha Hill, and others."

"Did you realize that these people were among the greatest dance artists of the day?"

"Not really. I knew very little about the dance world. The faculty sat in a darkened theater, and we performed for them, four at a time. For my choreographed piece I performed an interpretive dance—a leaf in the wind. It was crude and uneven. I was just a street kid who knew how to do the hootchie-kootchie and the jitterbug. I knew I was out of my league among all these girls in pink tights and leotards. When I came out I heard someone out in the house say, 'She's only been studying for four months.' What had I gotten myself into? I thought. Even by some miracle if I were accepted, how would my parents ever afford to send me to such a school? After the audition, I called my mother on a pay phone, and when she asked how it went, I broke down sobbing. I didn't think I was good enough, at least not yet. A few weeks later, I was walking home from school and saw my father on the street. 'We heard from those people at Juilliard,' he said. 'They told us that they don't ever want to see your face around there again.' He liked to joke around, but what he meant was—I got in!"

"Who were some of your teachers at Juilliard?"

"For modern dance I studied with Martha Graham, Louis Horst, Pearl Lang, Anna Sokolow, Helen McGhee, Mary Hinkson, Ethel Winter, Bertram Ross, Donald McKayle, and José Limón. My ballet teachers were Alfredo Corvino, Margaret Crask, and Antony Tudor. Martha Hill taught dance history and Labanotation."

"Which of these teachers had the greatest influence on you?"

"I've always felt it was a blessing to have studied under Louis Horst, who by the way, was a rather strange man: eyes half closed, with a cigarette always hanging out of his mouth, ashes falling everywhere. But he was extremely knowledgeable about all kinds of music and very precise in

his instruction. He explained how music composition and dance were related. I learned how to listen to music and create parallels in motion. Just as you use a theme in a symphony and you hear repeated *aba* forms, the same thing applies in movement construction. Your interpretation of movement language corresponds to musical forms. Those lessons were invaluable to me, particularly because music has always been the impetus for me to dance."

"So you were beginning to learn a dance vocabulary and the ability to execute choreography."

"Yes, that's right. I remember the first time I performed a true *passé* and leg extension. I was standing in my room on 150th Street, looking at myself in the mirror on my bedroom door, when I saw the beauty and the excellence. And then it hit me. 'I can get there. I'm going to be a dancer. I'm going to be a dancer! Wow!'"

"Did Martha Graham leave her imprint on you?"

"Martha's influence is in my bones till this day. She gave me technique, but more importantly, an awareness to be true to myself, believe in myself. This new awareness instilled confidence, faith, and courage."

"When did you begin to perform professionally?"

"I was coming along pretty rapidly. People took notice of me. Mary Hinkson helped me get my first professional job, a part on a TV show called *Lamp Unto My Feet.* In 1962, I got hired as soloist in a road show with Harry Belafonte and Miriam Makeba, which toured for six months throughout the United States and Canada. After that, I performed in the modern dance companies of Pearl Lang and Helen McGhee. In those years I was also involved with the New Dance Group, which was sort of like a modern dance collective. That's where I met Donald McKayle, who became another one of my teachers and hired me to dance in his commercial shows."

"So were you primarily a modern dancer?"

"Yes, but something was missing for me in modern dance scene. It was clannish and incestuous and didn't reach out to people enough. The jazz and Latin music I had grown up listening to were absent in classic modern dance. Most modern dancers I knew didn't know how to move their hips, even thought they lived in New York in the 1960s, which was brimming with jazz expression and Afro-Cuban rhythms. Nightclubs like the African Room were places where you could see people dancing to bongos and maracas. Jazz dance could be seen regularly on TV variety shows and specials. People like Luigi and Lester Wilson were teaching jazz technique classes. I was growing restless and began venturing out."

"Did you consider contacting Alvin Ailey?"

"Actually, my good friend Claude Thompson took me over to see him. He said, 'Alvin, you've got to see this girl dance.' Not well known at the time, Alvin was struggling to make a name for himself. He wanted to form a company and was looking for dancers. He hadn't yet met Judy Jamison. He put me through some moves to see what I could do. He didn't like to use counts, so he just went 'bada dada dada, dada dada' and had me throwing my body all over the place, in this direction, that direction, doing slides and splits across the floor." Paula demonstrated by flinging herself all around. "I could do it, but it felt pretty foreign to my body. Alvin stood over me, all excited, 'Yeah, yeah, now try this, do that. Bada dada dada dada dada.' It was dizzying," she said, her eyes crossing. "He worked me so hard I was crippled for a week. My Achilles tendons were so shortened from those few hours that I couldn't bend my metatarsals to walk down the stairs. I didn't know how I was going to make it to my classes at Juilliard the next day. After that audition he invited me to become a soloist in his new company along with Jimmy Truitte, Minnie Marshall, and Claude Thompson."

"What did you say?"

"I turned him down. I had sprained my ankle very badly during the audition."

"Yeah, but after your ankle healed you could have . . ."

"Well, I was in school," she said, cutting me off. Paula shifted in her seat and grew quiet.

"And then you worked with Bob Fosse."

"Yes, I met Bob Fosse while I was doing a show with Claude Thompson in Las Vegas called *Rome Swings.* It was for the opening of the new Caesars Palace in 1966. I danced the role of Cleopatra, coming out of a barge *ta da!*" she said, posing Egyptian style. "We were the opening act for Andy Williams. It was also around that time that Broadway shows were beginning to appear in Vegas hotels. So when I heard that Fosse was holding auditions for *Sweet Charity* at Caesars Palace, I took the red-eye to New York and performed some number from *Porgy and Bess,* and he hired me. Later I performed in the film version along with Shirley MacLaine, Chita Rivera, Ben Vereen, and Sammy Davis, Jr."

"Wasn't Juliet Prowse also in that Vegas show?"

"Yes, Juliet was set to star in the show even before I auditioned. She was a big headliner in Vegas. Juliet Prowse was a dancer in the truest sense of the word. She was ballet-trained, and when she danced you couldn't take your eyes off of her. I would say that technically she was probably the best

Charity that Fosse ever had. Dancing at her side was wonderful because we matched energies and moved as one with the same body type: broad shoulders, no hips, and long back. We also had a very similar dancer's mentality and shared a respect and a reverence for Fosse's choreography. I'm definitely better for having known and worked with her."

"What was Vegas like for dancers back in the 1960s?"

"It was a really good life. We lived in our own apartments and got together Friday nights for card games. We were one big family. Vegas was a very lucrative venue for dancers—really good dancers, swift, sharp dancers—and we came from all over the country to cash in. With shows upon shows upon shows, there was steady work, and *gooooood* money. And we worked with choreographers in big extravagant shows."

"After starring in the screen version of the film *Sweet Charity*, you appeared in more than twenty feature films and numerous television and stage shows—an eclectic career path."

"Rose, I've always been sort of an enigma. I've never been a true fit anywhere. Maybe I think too much, and when you do that it stops you."

"Why didn't you join Alvin Ailey's company?"

"Jesus Christ," she said, mumbling under her breath, avoiding my eyes.

"It's okay. Tell me. All dancers have fears."

"He was going to make me a soloist. A soloist. This was too big a thing. I was scared," she whispered. "You see, I was humbled by the power of dance and scared to death of it at the same time. It was life and death—superhuman or nothing. There's fear when you challenge yourself. And the most humiliating thing you can think of is not cutting it. I was afraid that people would find out I wasn't as good as they thought. Choreographers that I worked with over the years had unreal expectations of me. They thought I could do anything, and the fact is, that their choreography nearly killed me. I tried to do whatever they asked, and I did get hurt. I got hurt a lot. All I ever wanted was to give myself to the dance, to dance my heart out, to become the movement. But you're always, *always* in competition with yourself to be better, and if you're a perfectionist like I am, you're afraid you'll never measure up or surpass yourself. This can be paralyzing. At one point, I didn't dance for seven years."

"How did you overcome the paralysis?"

"Like a horse kicking the side of the stall, you have to get angry enough to break through and find your place. Once you get over the insecurity and competitiveness that plagues this art form, your individuality will shine through. Understand that every time you dance, you engage in a silent, internal dialogue between you and yourself, and between you and

your body. You face your own truth, your ethics, your morals. Dance helps you not to lie."

"Do you still dance?"

"People are always asking me that. And the truth is, I don't want to—but I do. My greatest fear now is that I'm afraid I'll fall out of love with it, that the courtship will be over. I don't think I've ever said these things out loud."

"Paula, let me take your picture now," I said standing up and heading toward my photo setup. Paula followed and took a few minutes to shake out her muscles. Then, standing before a large orange backdrop she occupied the open space with the natural comfort of a seasoned dancer. And as soon as I turned on the jazz, I knew that Paula Kelly could never, ever, fall out of love with dance. The dancer within her would never allow it.

Encino, California, March 2005

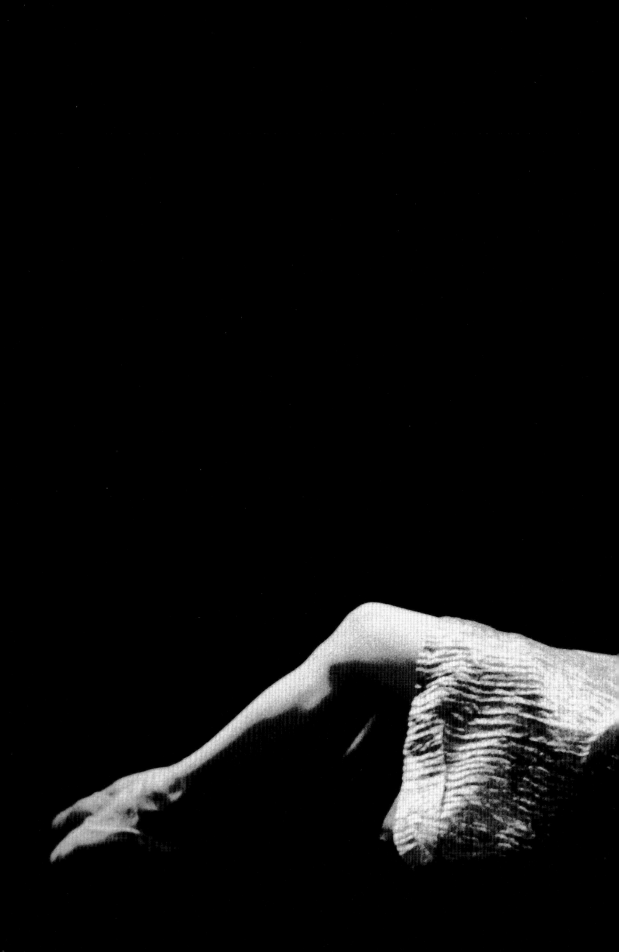

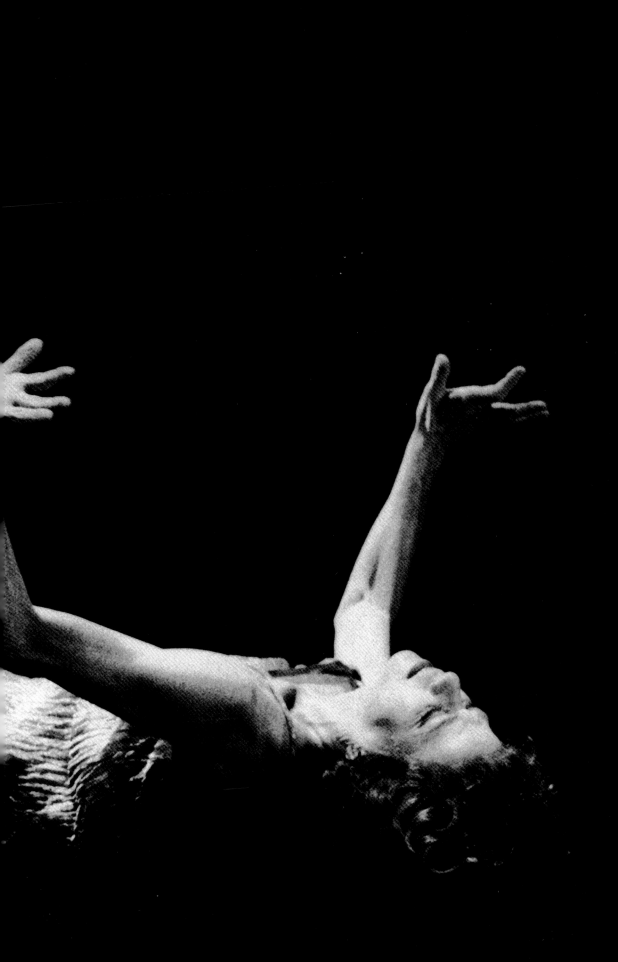

Martine van Hamel

Watching Martine van Hamel perform a short improvised dance at Jacob's Pillow Dance Festival, I wondered how she had transcended her classical ballet training to move so spontaneously. I approached her later that day and asked if we could talk sometime. A few months later we met in Manhattan at my rented sublet. I prepared a pot of tea and invited her to join me at the dining room table.

"Tell me your story," I asked, pouring her a cup.

"My mother tells me that when I was little I was like a tank in a china shop. She didn't know what to do with me—my constant jumping on the furniture and pounding down the stairs, 'impossible to live with.' So she put me in ballet class and almost instantaneously, I found my focus. My very first teacher must have given me a great love of dance, because as far back as I can remember, I wanted to be a ballerina. My father was a Dutch diplomat, and so we traveled a great deal. I was two when we arrived in Copenhagen and that's where I took my first ballet class. From Copenhagen we moved to Indonesia. I tried learning Javanese dance, but I was too young and it didn't quite work for me. Next, we moved to Holland, where I studied with a number of different ballet teachers. When I was around ten, my mother took me to Paris and enrolled me in a class taught by Olga Preobrajenska, a former ballerina with the Ballet Russes. She was a tiny woman—the same size as me—and came in wearing a number of scarves, which she would shed one by one as the class progressed. Preobrajenska confirmed that I had talent, so my parents continued to nurture my dancing by finding ballet teachers for me wherever we traveled."

"What was it about ballet that so appealed to you?"

"I simply felt at home in it. It was something that just suited me and gave me direction. No one in my family had ever danced, so it was really sort of unusual, this pull to perform. I studied ballet at such a young age that I don't remember learning the positions, or steps—how to do a *glissade, ensemble* or *jeté*. It's always been second nature for me, like learning your first language. You don't remember the process."

"Where else did you study?"

"We next moved to Caracas, Venezuela. There I found a teacher named

Henry Danton, who taught for the Ballet nacional de Venezuela. I began to perform in his company and was given solos in *The Sleeping Beauty* and *Swan Lake*. Danton had connections with both the School of American Ballet and American Ballet Theatre School and got me scholarships. But I was unable to accept them because next my family moved to Toronto, and I was too young to go to New York alone."

"So you had to find a new school in Toronto?"

"Yes, but that same year, the National Ballet School in Canada opened, and I was one of its first pupils. At seventeen I became a soloist with their company. It was a very good experience because I learned to dance many of the ballets in the ABT repertoire, including the works of George Balanchine and Antony Tudor. When I was twenty, the company sent me to Varna, Bulgaria, to compete in the 1966 International Ballet Competition. Both Baryshnikov and I won gold medals that year. I also came home with the Prix de Varna, which is an additional prize for my interpretation of MacMillian's *Solitare*. When I returned to Canada with two gold medals, I was given a ticker-tape parade."

"What a great way to launch a career."

"Well, yes and no. I learned that once you're successful, people want to control you and become involved in your process. The National Ballet of Canada had two opposing views about my win. The first was, 'Let's not let Martine think she's so great. Let's keep her humble.' That attitude resulted in my not getting roles or being featured very much. The second view was, 'Let's capitalize on this. She came back from Varna with the gold. Let's milk this.' It was hard to maintain any sense of self with everyone dictating what I should or shouldn't do."

"Does the dancer ever have control over his or her dancing life?"

"I think there is a small window in your career when you have some control. For example, very early in my career I was slightly overweight—about three pounds too heavy. I used weight as a control mechanism, a way of rebelling against all the forces that controlled my life. But it really is the artistic director who controls your career. He casts you or doesn't cast you. And if you're lucky, a visiting choreographer might pick you to perform his or her work, and this gives you added opportunities. But for the most part, you rarely call the shots."

"Describe what the ballet dancer goes through to transform her body into an artistic instrument."

"The ultimate goal of the ballet dancer is to perfect her body's lines. It's as if she sentences herself to a very, very small prison. Confined

within this narrow space she labors to refine and beautify the body's line. Once this is achieved, she is set free to perform, but only within the boundaries of her confinement."

"Sounds like the ballerina is a prisoner of her art."

"Yes, she is in a way. And at the same time she is possessed by wants. She wants to dance this role, have that partner, get this review. But once you've been performing for a long time, it hits you. You have this revelation. Dancing on the stage is *really* the only thing you want. All those other "wants" become unimportant. But it takes maturity to say—just dance!

"How would you characterize your dancing?"

"I danced big and liked to use a lot of space. I'd see ballerinas perform *Swan Lake* and think to myself, 'the swan is a big bird, so why are they dancing this like a canary?' Music was always the thing that guided me and lifted my dancing soul. And as I got a little older and had a little more life experience, I was able to use my character's emotional content and physicality, how she walked and acted to communicate with the audience. I wasn't really a natural actress at the beginning. I was more into abstract movement, but then it gradually infiltrated my roles. I attribute this to maturity."

"How does maturity help you dance better?"

"I think when you get a little older you are better equipped to tap into your emotions and draw from your history. Both sad and happy experiences are stored inside of you. When I was young, I was not a very open person. I was very sheltered. Consequently I didn't experience things very deeply. This sort of upbringing does not serve you well when you need to portray a variety of characters. You need rich emotions to feed your characterizations, like what you feel when you fall in love."

"I imagine there were many roles that educated and enlightened you."

"Yes, there were. When I was twenty-five and had just come to ABT, I was asked to dance the role of the Nurse in Antony Tudor's *Romeo and Juliet*. I was shocked to be cast as a matronly woman who wears this big fat costume and performs simple steps. Tudor cast me in what I thought was an inappropriate role, but it taught me how to embrace characters that are very unlike me."

"It seems that when the dancer achieves artistic maturity, the career is winding down."

"Not always. I performed my last *Swan Lake* when I was forty-five. I stayed at the top of my game for a long time without deteriorating. In fact, I began to think that maybe there was nothing left for me in ballet. I had danced all the great roles. And then it occurred to me that maybe I should do a different kind of dancing."

"Did you accept that reality because you had to, or did you really want to experience a different way of moving?"

"I think it's probably a bit of both. After I left ABT, I found myself asking, 'Okay, what do I do now?' I stayed in shape as best I could, but I started having pains here and muscle spasms there. Your body also asks, 'What do I do now?'"

"What did you do?"

"I went to Holland and worked with Jiří Kylián and his Nederlands Dans Theater III. Dancing with NDT III extended my life as a performer. It felt like the dessert to my career. While I could no longer dance the classical repertoire, I was shown a way to use my dance knowledge in a new dimension. Works involving improvisation were created for me and the other dancers in the company. This opened up a whole new direction for me. Improvisation was something that I hadn't done since I was very young. But now I found it inspired me, gave me a new freedom of expression, and extended my dance life. But that was then," she said shifting gears. "Today, I find myself—my dance life—in a sad and pathetic place."

"What do you mean?"

"I can't figure out how to keep my body healthy. When you're performing regularly your body gets flushed out. It experiences an adrenaline rush that cleanses you and opens you up physically and emotionally. But when you don't dance, you get really plugged up and creaky. Your joints don't want to move, and you feel your feet and knees. I can't dance in this physical state, but if I danced, my body wouldn't be in this state. Do you know what I mean?"

"Yes."

"When I performed that solo that you saw at Jacob's Pillow, I hadn't danced in a long time. I had to break through a physical wall in order to perform on the stage. But once I did, I felt healthier than I had in a long time."

"You must use your body when you teach. Doesn't that keep you loose and free-moving?"

"I taught a class today, but I don't enjoy teaching. People keep telling me, 'You have all this knowledge. You should pass it on.' But teaching is not a natural direction for me. I was a spontaneous dancer, and teaching requires a more analytical approach to movement and the body."

"You're very in touch with your feelings."

"Well, ballet dancers are not blind and stupid about life just because they have this narrow dance focus. In order to reach the top, you have to be fairly smart. You have to understand what life's about and how to deal

with it. But at the same time, the dancer has an obsessive nature. You can look back at your career once it's over and paint it all roses, but I remember lots of frustration, anxiety, and competition. And I remember all the waiting, waiting for more. All dancers want more: more attention, more roles, more everything. Even when you're at the top, you want more. I suppose it's human nature to want what you don't have."

"It's a cruel reality that every dancer faces the day when their body betrays them."

"Every dancer has to learn to live with their own demise. I'm not dealing well with mine. I didn't go to college, you know, so I don't have a lot of intellectual knowledge to fall back on. I'm limited in what I know how to do. People are always proposing solutions for me, like being part of a festival or performance project, but all I really want to do is dance on the stage. That's all I ever wanted: to dance on the stage, to music, in front of an audience. Performing is the old dancer's tonic. But how do you keep dancing when you don't have a stage or an orchestra or an audience? When I hear people say, 'Martine is a great dancer,' I correct them. I say, 'Martine *was* a great dancer.' I don't feel any more like I'm a dancer, and yet, I'm nothing but. Am I doomed to be in this limbo the rest of my life?"

I didn't know how to respond to Martine's question. We sat in silence for a minute.

"Martine, your name means something. You've left your mark in the ballet world. That's not an easy thing to do."

"That's nice, Rose," she said. "But what do I do now?"

New York, 2004

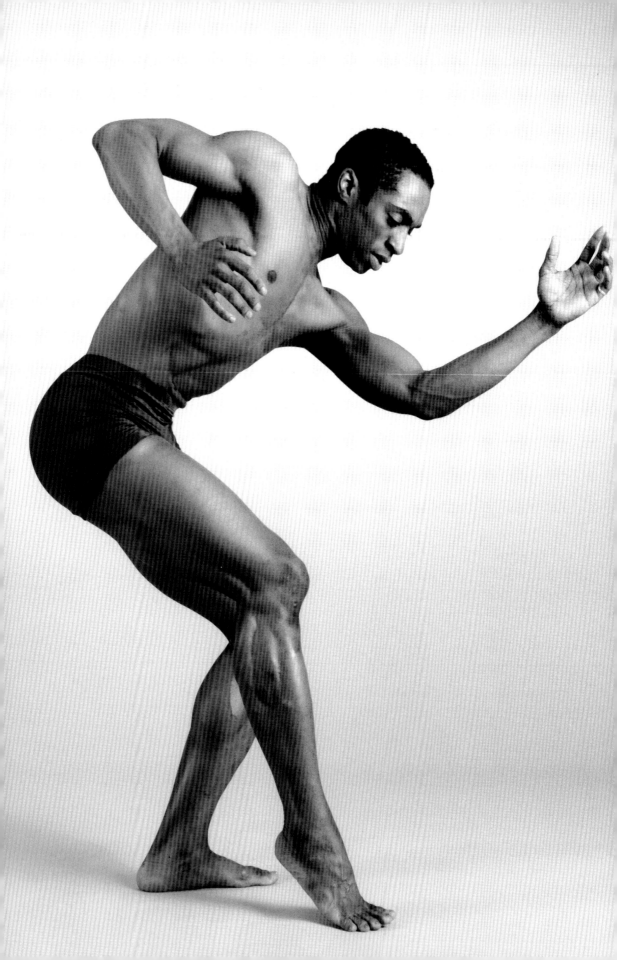

Desmond Richardson

"You're right on time," I said, standing on my tiptoes to kiss him on the cheek.

"Got to be on time—always," he said, stepping through the door of my rented Manhattan studio. "Listen, I've only got about an hour. Complexions is leaving on tour for Greece at one this afternoon, so I'm a bit rushed for time."

"Then why don't we start with the photos," I said and pointed Desmond to the dressing room. A few minutes later he reappeared wearing a pair of raspberry-colored shorts and thermal slippers. Taking a small plastic bottle from his bag, he poured a bit of body oil into his palm and rubbed it onto his arms, legs, and chest.

"I'm sorry I don't have any music for you Desmond."

"Oh, I don't need music. I like the quiet," he said softly, his muscles glistening under my modeling lights.

"I'm ready when you are," I said, picking up my camera.

Desmond shook out his arms and legs, removed his slippers, and tossed them to the side. Stepping onto the lavender-colored seamless he looked more like an Olympic athlete than a dancer—muscled, chiseled. Without a word he began to move, slowly, as if guided by some internal light. Poised to catch the subtlest gesture, I followed his rhythmic dance, his shape filling the frame of my viewfinder. Mesmerizing. Only ten minutes earlier he had walked in a mere mortal, dressed in jeans, a leather jacket, knit cap, and holding a cup of hot coffee. Now, in movement, he was a divine spirit. The camera felt weightless in my hand, as if I were capturing his image with my eyes alone. Our shoot moved along effortlessly, seamlessly. "We're done," I said after twenty minutes. What a gift you've given me here today." Desmond came over and gave me a hug, careful not to stain my clothes with his oily body. After he changed back into his street clothes, we sat down together for the interview.

"Desmond, are you now at the height of your power?"

"I'm in my mid-thirties now, just over the cusp of naïveté and perpetual yearning. My life has found balance. I'm able to listen better and investigate more maturely the work that I do. As my artistry advances, I have found a sense of calm."

"Does this inner balance, this calm, allow you to communicate more freely with your audiences?"

"Yes. I'm much less distracted by external stimuli, all that noise going on in my head, like 'oh my God, there are so many people out there.' Now I find I get in a zone where I'm extremely focused about what it is that I'm doing, and what the choreography is saying. The experience has become a more internal one. I hear my own inner voice. It's always been there, but I wasn't listening—not until now."

"You've come a long way since your days at the High School for the Performing Arts to walk onto the stage and simply . . ."

"Be," Desmond said, completing my sentence.

"Yes. Be," I repeated.

"One of the things I learned working with Alvin Ailey, Ulysses Dove, John Butler, William Forsythe, and other brilliant choreographers is that you must bring yourself completely to the work. When I was young, I didn't really understand what they were talking about. Alvin used to say, 'Your life experience goes hand in hand with your performance.' I know now that it's only when you're willing to show yourself openly as an artist that you begin to truly share with others. You don't need to give it all up—expose yourself entirely—but it's the realism that makes your work accessible. The audience sees a real gesture, not a danced gesture—a real look, not a danced look. Those are the things that I'm concentrating on now, turning real moments into dance moments. This is where Isadora Duncan, Martha Graham, Alvin Ailey, and others were coming from. For them dance was based on real life."

"Can abstract movement mirror real life?"

"Yes, even when audiences don't recognize specifically what they are seeing, they can respond to it humanly if it comes from a real place, an honest place."

"How do you define dance?"

"I define dance as life—using your life experiences to express yourself through your art. It takes a very open artist to be comfortable in that exposed place. It's imperative for an artist to give. Dance is a visual art form performed before an audience. The audience wants to receive. They want to be transported. That's why they're there. I often think back to when I was a kid and saw the film *The Little Prince* at Radio City Music Hall. I watched the audience and saw how everyone was so engaged looking at Bob Fosse slither around as the Snakeman. I learned then the potential to move an audience."

"Desmond, what does it feel like to be on the stage and have hundreds of eyes fixed on you?"

"It can be positively daunting. There are times when I feel like I'm in some deep abyss. I can't see anything; the lights are hitting me from the side or from the front. Sometimes the floor is black, the background is dark, and all I own is the choreography. The music comes on and I go. Over the years I've developed a sort of ritual where I speak to the audience in my mind. I say to them, 'I have something to tell you. I have a story to tell.' I don't know where that came from or even when I started doing it, but it's what propels me. I'm going to go to the edge and I want to take them along with me. I feel that it's up to me as the artist to connect with them immediately."

"Your role as muse is well known, especially in your work with Dwight Rhoden. What's it like working with him?"

"As one who interprets choreography, it's very challenging. I always need to shift the work in my direction, and Dwight likes for me to do that, not just perform it verbatim. It becomes essential for me to discover what the material means to me. Then, like a linguist, I try to make it speak."

"Has his choreography made you dance better?"

"Yes, absolutely because his choreographic range and movement vocabulary is so broad. He might have me dancing a classical piece and then later doing contemporary or popular movement, like what you might see in a nightclub. He works at an extremely high level choreographically, and he is creatively diverse. This is what the artist needs, someone who can challenge and invigorate you to go beyond what you think you can do. Sometimes I look back at what I've done and I say, 'Wow, did I just do that?' That's what Dwight does for me."

"What is the responsibility of the muse to the choreographer?"

"He should have integrity and humility. It's incumbent upon him to be true to the material and not alter the intention of the work. We always have to remember that we are the instrument—to be of service to the dance and not ourselves."

"I've always felt that dancers rarely get the appreciation they deserve. The dancers may get the applause, but the choreographer gets the glory."

"That's often the case and I was aware of this very early on in my career. I never wanted to get lost. I felt strongly about having a presence and holding onto my individuality. Alvin Ailey told me when I was seventeen not to worry about that. He said, 'No matter where you are on stage, you will be seen if you give. The eye will automatically go to you.'"

"So you really have to have faith that what you do in service of the dance will not go unnoticed?"

"Well, the first thing the artist has to do is lose the ego. That's one of the things we tell the artists in our company. 'Drop your ego at the door,

come in, and let's get to work.' Everybody's trying to do the best that they can, and if they come in with, 'Oh no, am I going to be here in the back?'—that kind of behavior can't exist when you're in service of the dance. I've seen this sort of thing on Broadway. Some people make a scene if they're not crazy about the song they've been asked to sing. No, that's not the right attitude. You have to come in with the purest of intentions and believe that if you give it your best you will be seen, respected, and appreciated. Stop wishing and waiting for it because you think you should have it."

"Many professions have a code of ethics. The dance profession should have a code, don't you think?"

"Yes, absolutely. I feel very strongly about certain dos and don'ts—etiquette. For example, the dance studio is our sanctuary; behave appropriately when you're there. We're here to work. Keep your focus. Don't come in chewing gum or talking on your cell phone. This is simply disrespectful to everyone around you."

"You're talking about professionalism."

"Yes, exactly. I believe in maintaining the art form at its highest level. That means working with artists who know and respect their craft, are easy to get along with, and are encompassing of others. Anything less would dishonor the art form and all the great artists who have come before. There is no room for mediocrity, or narcissism."

"Do you intend to dance for the rest of your life?"

"I'll have to transition at some point. I know the body can't sustain itself at this physical level. It's impossible. I'm calm with that. Whenever it happens, I will accept it. Maybe I'll be in my late thirties or early forties. I don't view it as a decline but as a transition from this space into something else. Teaching and choreographing, perhaps. I'll take with me all that I've learned and carry it with me to the next place. It's food I can use to feed others."

Desmond looked at his watch and said, "You know, I'd better get going."

"Yes, of course. Let me walk you out." I grabbed a coat and accompanied Desmond down to the street. Back on my tiptoes I bid him a safe journey and watched him hurry away into a rush of bustling New Yorkers—unaware of Terpsichore in their midst.

New York City, March 2005

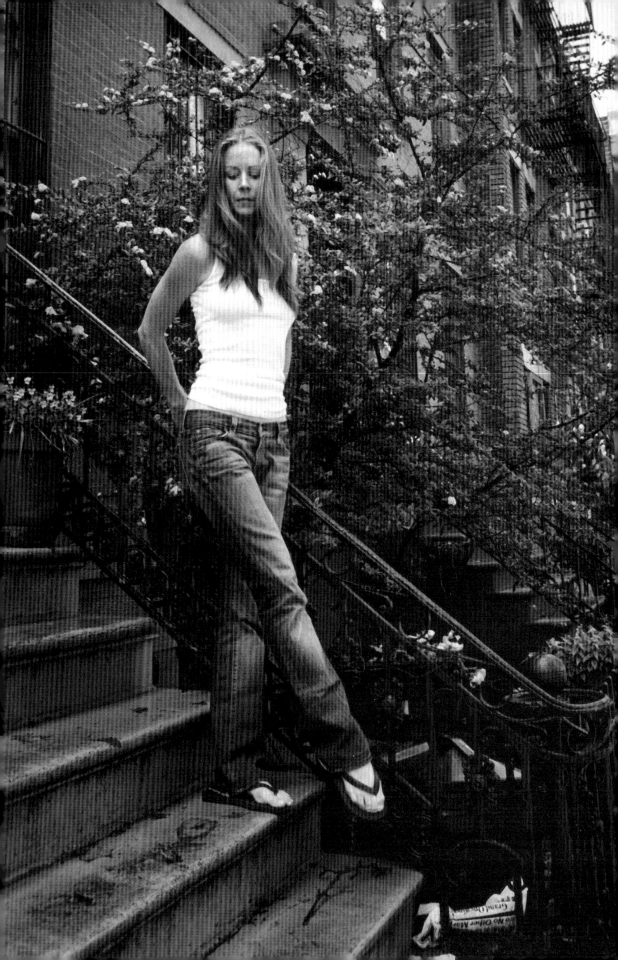

Jean Butler

When *Riverdance* burst onto the scene just over a decade ago, Irish dance champion Jean Butler displayed a level of technical precision in her lighter-than-air toe dancing that mesmerized audiences. But after three years of touring, the tall redheaded beauty decided she'd had enough of *Riverdance* and carved a new path—taking a huge artistic risk. I sat with her in her small Brooklyn brownstone apartment on a cloudy spring morning, eager to learn more about how a girl from Long Island, New York, became an icon of Irish dance.

"Jean, when did you begin to dance?"

"When I was four, Mom enrolled me in tap and ballet classes, which I took for two years. But I never quite fit in there. I was this tall, lanky, freckly, redheaded thing amidst a sea of pink-leotarded blond girls. Mom didn't know any better and always dressed me in a green bathing suit with Snoopy appliquéd on the front. Then she started me in Irish dance classes, which was an extension of her culture. She was born in Ireland and came to America when she was eighteen. I immediately felt a strong bond with Irish dancing and my new teacher, Donny Golden, a very well known Irish dancer both in America and Ireland."

"Did the dance instill in you a sense of pride for your Irish heritage?"

"I felt an Irish identity only as it related to winning competitions. Irish dancing is a competitive sport. It's not about learning the history of Ireland or its traditions. It's about winning trophies."

"Did you sense from an early age that you were especially gifted?"

"Not to sound arrogant, I knew I had the physical intelligence: the body-mind connection, coordination, and ability to move in a certain way. I loved the dance and the challenges that were constantly presenting themselves, like mastering new steps or performing in new ways."

"Did you view yourself essentially as a dancer or as a sports competitor?"

"During my early years, I considered myself an Irish dance competitor—never a dancer in the classic sense. Irish dance is both an international competitive sport and a community cultural activity. And while Irish dancing is part of a huge international network, it's also been a fairly closeted activity. Irish dancing was not widely known before *Riverdance*. Those who did know about Irish dancing thought of it as this hokey folk

dance that people did in green dresses to funky music. Irish dancers weren't ashamed of doing it, but didn't really want to talk about it."

"How many awards did you win during your years of competition?"

"I couldn't even begin to tell you. That would be a question for my mother, who has my trophies in the basement of her home on Long Island. I did get third place in the world championships when I was around fifteen, which was the highest ranking of any North American woman. The world championship is set up like the Olympics, with qualifying rounds and heats. Winning this is what everyone strives for."

"When did your identity begin to shift from competitor to dancer—to artist?"

"Things changed for me around the age of fifteen when Donny invited me to partner with him in his shows with The Greenfields of America. He performed regularly with several other Irish-American bands, like Cherish the Ladies and The Chieftains, which would bring dancers onstage to enhance their shows. Being an entertainer rather than a competitor was positively liberating for me. Competitions were so highly controlled by rules and regulations, like, 'Do not turn your back on the adjudicators.' As an entertainer, I could face wherever I wanted and do any number of steps, not just the required ones. I could dance to music I liked, move my arms, and vary my clothes. Suddenly I was free to explore new ways of moving and interpreting the music. And there was something else—the adrenaline rush that performers get when they're in front of an audience, which is very different from dancing in front of people who are there to judge you and tell you what you're doing wrong. For the first time in my life I was dancing for appreciative people who wanted to reward me with applause and I became aware of my ability to command an audience, to make an audience take notice of me as I walked onto the stage—even before I started dancing. Once I started performing, I grew impatient with competitions and fed up with the politics that surrounded them."

"Sounds like this was when the dancer within you was born."

"Yes, I think so. Donny taught me that it's never about the win; it's about dancing well, performing well, and challenging oneself. And that would become the foundation of my dancing."

"Performing with The Chieftains must have been a big boost to your budding career!"

"Yes. I had just turned seventeen when I began performing with The Chieftains. They saw me dance at Carnegie Hall on Saint Patrick's Day and offered me a job touring with them. Michael Flatley had been their soloist for many years before me. They hired me to sex up the show a little—bring

in a piece of skirt, as it were. This meant more to me than getting third place at the world championships. I would be associated with one of the greatest Irish exports in the world."

"What was that experience like?"

"We literally toured the globe. The band members were much older than me—in their mid-forties, and so I longed to be with people my own age. Fortunately, I had friends all over the world whom I'd met while competing internationally. They eased some of my loneliness. I loved what I was doing and was very serious about the work. I choreographed all my own dances and performed whatever I wanted. I did this for about seven years, and then came *Riverdance.*"

"Sounds like these were extremely important years in your development."

"I wasn't really conscious of it at the time, but I was honing my craft and learning the art of performance. Dancing on stage took on a religious quality for me—like I was in church. I'd experience an elevated sense of self, of otherworldliness. I didn't know then that it was endorphins being released. All I knew was that I could become the music and the movement, and this was when I was happiest."

"*Riverdance* came next and became an enormous global phenomenon. In fact, it's still being performed all over the world. How did the show come about?"

"*Riverdance* grew out of a performance that Michael Flatley and I put together in 1994 for the Eurovision Song Contest, an annual televised program watched by millions. The producer, who was looking for an interval act for its telecast from Ireland, asked us (Michael Flatley and I were considered two of the world's best Irish dancers) to create a seven-minute piece. I did a solo, Michael did a solo, we danced together, and added an ensemble piece composed of world champions. It was really very exciting. All of Europe was watching."

"How did the audience respond to your live performance?"

"Three thousand people seated in Dublin's Point Theater jumped to their feet simultaneously as soon as we finished dancing. It felt as if all the energy and power that came from the dance was answered with an equal amount of energy resounding from the audience. It was like being struck by lightning. The Eurovision Song producers realized that they were onto something and came up with the idea to create a full-blown Irish dance show: *Riverdance.* While the producers were raising the money, Michael went to Los Angeles and I moved to Ireland to pursue an acting career. A year later the money was in place and we began work on the show. Michael and I were the show's choreographers, but Michael took charge of the large company numbers."

"There must have been enormous pressure on you, but at the same time, what an opportunity."

"Yes, this was the first time in my life that I really felt like a professional dancer. With The Chieftains, I was a side act. This was dance—center stage. During my time with *Riverdance,* I attained the highest technical proficiency of my career. I was at my peak. I was so fine-tuned technically and physically that I almost always entered a euphoric state as soon as I got onstage. Like *that*" (snapping her fingers) "I became one with the music and the moment. Technique was just a vehicle for me to tap into that dancer's high. I never wanted just to dance technically, so I prepared my mind prior to each performance. I'd try to get centered by listening to music and by staying present, not allowing myself to get distracted by things going on all around me."

"I imagine you feel pretty good about taking Irish dance to a whole new level."

"I'm not sure that I can take responsibility for the greater cause. *Riverdance* provided a platform for the art of Irish dance and the professional outlet that was to follow. It was a pioneering work. Irish dance most certainly would not be where it is today had it not been for *Riverdance.* You have to remember that the repressed psyche of the Irish dancers who had been told their entire lives that what they were doing was 'hokey' now found themselves desperately trying to keep up with the global appetite for Irish dance."

"In creating the choreography for *Riverdance* did you have to try to introduce innovative elements to Irish dance?"

"*Riverdance* as a showcase for Irish dance was founded on proven theatrical principles: dancing in unison, reaching a theatrical climax, and utilizing elements of rhythm with percussion and call-and-response— one half of the stage dancing and then the other half answering. All the group pieces feature these elements, and the audience is gradually led into that moment of 'Ha! It's amazing!' *Riverdance* did not complicate or artificially decorate the art form, even though the costumes and music were nontraditional. It allowed for the dance to be brought to another level and it took on a contemporary look and feel. The women wore short black skirts, the men wore black trousers, the music was composed of traditional tunes mixed with Eastern European time signatures, and the performances were held in theaters with proper dance floors. All this allowed Irish dance to breeze into the twenty-first century."

"It was a big story in the British media when Michael Flatley pulled out of the show just two days before opening in London."

"Yes. It was our second time in the West End with a sold-out run. This small Irish dance show, not expected to make it outside of Ireland, was now a huge success in the country we had fought with for centuries. And one of our stars was threatening to leave. The whole time we kept rehearsing, just getting on with it, not thinking of what might happen. No one thought he would actually leave—least of all, me. But when he finally did leave, we just had to keep going. There was little time to think. In hindsight, it forced the company to stand on its own feet. Michael was the show's anchor and represented that "American Dream" of believing in success and following it. He inspired the company to believe in that too. And I guess he did a good job at it. Damned if we were going to let his departure destroy all our hard work."

"What happened after he left?"

"Some people questioned whether *Riverdance* would work without Flatley. But when Colin Dunn, a champion in his own right, stepped in as Michael's replacement, I knew we'd be fine, even though he had to learn the entire choreography in just two days."

"You made history. What does that mean to you?"

"It's wonderful to be attached to a milestone in Irish dancing, but *Riverdance* doesn't define me. I would hate it if that's all there is. I've always felt a responsibility to myself to grow artistically—and still do. Yes, I have a history with the show, which sometimes helps to opens doors, but it also closes them."

"In what way?"

"Well, people know me from *Riverdance* and everything is compared to that. They are reluctant to accept anything else I might do. In 2000, I created a show with Colin Dunn called *Dancing on Dangerous Ground*. The production played in New York's West End and at Radio City Music Hall. It was a narrative work, very much like an Irish ballad. We wanted to create a work that showed that Irish dance could be emotive and not just demonstrate the technical virtuosity of the dancers. We wanted people to be moved, not just awed. It was an enormously difficult undertaking with all kinds of stumbling blocks, including competing with *Riverdance* and *Lord of The Dance*—the McDonalds and Burger King of Irish dance. We were trying to do something different, innovative, and unique. New York loved it, and we got a great review in the *New York Times*. *Dancing on Dangerous Ground* was an artistic success but a commercial failure because people weren't willing to accept anything that wasn't *Riverdance*."

"It must have been a terrible disappointment when *Dancing on Dangerous Ground* closed after only ten days."

"I invested everything I had into the show—a three-year commitment. I felt very much that I needed to prove my worth and artistry without the vehicle of *Riverdance*. This was my motivation for creating the show. It never occurred to me that it might fail. And when it did, it was earth-shattering. I didn't dance for two years after that. I was just physically and emotionally exhausted. I didn't know what to do or where to go next. So I did nothing."

"So how's the dancer within you today?"

"She's frustrated. I still have this drive to keep going, but what I do is very specific. I'm not a ballet dancer or contemporary dancer that I can just join an existing company or start my own. I know I don't want to be the driving force behind another big show, but I need to dance. I need to perform. I need to collaborate with people that can take advantage of what I know how to do. Use me, abuse me, deconstruct me, tear me apart, and put me back together again. I know I haven't reached my full potential yet. The thought of not being involved or giving it up is not really a possibility. If I don't continue as a dancer, who am I as a person? The two are totally integrated. At the end of the day, I just want to dance. I just want to dance."

Brooklyn, 2006

Peter Boal

Peter Boal is one of the most elegant and poetic dancers ever produced by the New York Ballet. Entering the company in 1983, the year of George Balanchine's death, he would become one of the premier interpreters of Balanchine's neoclassic style as well as an effective role model for aspiring male ballet dancers. So it didn't surprise me when I arrived for our session to find him teaching a men's class in one of the School of American Ballet studios.

I entered quietly and took a seat. Peter waved a hello and continued his lesson on *jetés* with about ten students, all in their teens. I marveled at how his teaching style mirrored his dancing: clean, precise, humble. After class, each of his students came up and shook his hand—a gesture of mutual respect that has become a tradition at SAB.

When all the students had left, Peter joined me and took a seat.

"What a wonderful group of young men." I said.

"Yes, they are very good."

"You really have a gentle touch with them and they're very responsive."

"Well, I really love teaching. I think it's something that I'll always be doing."

"May I?" I asked, clipping my tape recorder's microphone to his T-shirt. "How old were you when you first experienced ballet?"

"I was nine when I saw my first ballet performance: *Coppélia*. It hooked me. All the dancers looked like they were having such fun on the stage, wearing these wonderful costumes and moving around to beautiful music. The audience was so upbeat. It all simply captivated me. I said to myself, 'I'd like to try that.' So my mother contacted New York City Ballet and said, 'My boy wants to dance.' I began taking classes here at SAB, but I also loved horseback riding, gymnastics, and diving. After my second year of commuting three times a week to ballet class—forty miles from Bedford in Westchester County—I decided I'd let it go, focus on activities closer to home. But the ballet school phoned my parents and said, 'He cannot quit!' It was like an ultimatum. So my mother talked me into staying for a little while longer. Then I got a terrific new teacher, Jean-Pierre Bonnefous, who specialized in teaching young boys. His classes really heightened my appreciation for dance. He took a great interest in me,

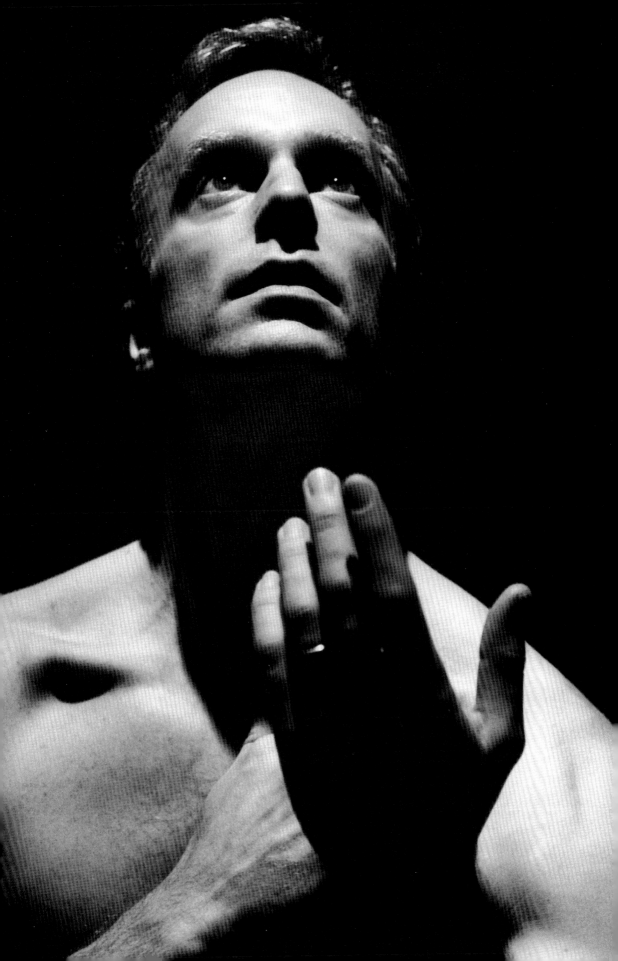

said that I had an opportunity to be exceptional in this profession. But I also excelled in a variety of sports. My diving coach phoned my parents and said, 'I think we have a shot at the Olympics. We need to take Peter's talent very seriously.' My gymnastics teacher did the same thing."

"So how did ballet win out over sports?"

"When I was twelve, Bonnefous choreographed a work for the school's annual performance. He created a solo specifically for me, and when I saw the audience's response to my dancing, it was a life-changing moment. I chose dance."

"As a teen were you the male equivalent of a 'bun-head?'"

"Yeah, I was," he said with a laugh. "By the age of thirteen or fourteen I only wanted friends that danced, and to take as many classes as I could. I wanted to see ballet performances every night."

"The list on your résumé of ballets you've performed is so enormous that you've been called New York City Ballet's superman. I understand that you've performed just about every Balanchine ballet from *Apollo* to *Prodigal Son,* not to mention the works of many other choreographers."

"Well. I've been with City Ballet for twenty-one years. I think initially the roles that attracted me were the technical ones, like *Valse-Fantaisie,* Tchaikovsky's *Pas de deux,* and *Symphony in C.* But I didn't want to be pegged as only one type of dancer. I wanted to be technically brilliant, but as I got older, I looked for roles that involved acting, humor, and aspects of performance that could expand my understanding of ballet. Each time you master another element you open up the possibility of including another ten or more roles that you can perform. In other words, you want to be all things—soft and lyrical, powerful and dynamic."

"How do highly technical roles help the dancer develop artistry?"

"The excitement over accomplishing difficult steps is one of the things that helps dancers transcend technique. The audience is looking for technical purity and precise execution of steps and positions. So there is a euphoria that bounces from the dancer to the audience, and both recognize it's because the dancer executed four flawless pirouettes and double tours."

"The dancer gives so freely to the choreographer: his body, his spirit, and sometimes even his soul. What does the dancer get from the dancer-choreographer relationship?"

"I can only answer that by telling you a story. Many years ago I was scheduled to dance Jerome Robbins's *Opus 19/The Dreamer.* I spent a couple of weeks learning it with the ballet master, and then Jerry came in to see it. I demonstrated the first five minutes and he stopped me. 'It's not

enough,' he said. 'I thought you could put more into this role. I can't let you perform it. You're just not ready.' I remember feeling in my heart that I had connected deeply with the role and had so much to give to it, but he couldn't see it. He turned to leave. The studio door was propped open with a trashcan, and as he stepped over the can, I called out in a voice louder than I needed to, 'Jerry, can you come back? I want to do it again. I know I can do it.' People didn't talk to Jerome Robbins like that, but I couldn't let him step over that trashcan. I knew if I did, I'd never become the artist I hoped to be."

"Why?"

"I've always been quiet, polite, and rather humble. Dance is a culture where you're really the paint on the canvas or clay in the potter's hands. You're not supposed to speak up, especially at the beginning of the career. But later, it's important to speak, sometimes very loudly. This was one of those times that being quiet and polite was not going to serve me well. I knew it was a turning point in my life, the time for me to stand up, grab the moment, and let my inner voice roar, 'I can do this like nobody else.'"

"So what happened?"

"Jerry came back into the studio and I performed it for him again. This time he said, 'That's it! That's it! Next week you'll dance it.' Sometimes you feel that you're executing all the lines and steps and you're on top of the music, but it just doesn't come across. I think Jerry always thought that his choreography was worthless unless the dancer elevated it in performance. He pushed me harder than any other choreographer I'd ever worked with. He watched me perform it over a period of fifteen years, and yet in our last conversation before he died, he said, 'You need to do more in *Opus*.' So to answer your question, What does the dancer get? The opportunity to become a better dancer and realize his full potential."

"When you called Jerry back into the studio, you were taking charge of your future."

"Yes. There are times when you know what you need to go after it. For example, I insisted that I get a shot at *Prodigal Son*. I was asked to learn it when I was around twenty, so it wasn't an absurd request when I approached New York City Ballet's artistic director, Peter Martins, and asked to perform it. 'I'm ready,' I told him. 'You've got to let me out there. I want to show that there is another dimension to what I can do on the stage.' Martins agreed. Later I found out that he was waiting for me to step up and ask for the role."

"Did performing Balanchine's masterpiece bring you to another level in your dancing?"

"Yes. It gave me a more profound understanding of myself. *Prodigal Son* gave me the tools to truly express myself and explore my relationship with my father. Some ballets allow dancers to experience the truest points of living and check in with their deeper selves. It's like entering a zone that you can't access any other way. It doesn't exist in everyday life. Many dance just to get to that place where they feel truly alive and complete."

"Peter, how do you hold onto the euphoria that comes with a great dance performance?"

He took a deep breath and sighed. "The reality is that you're always yearning to get back on the stage to that euphoric place. When the applause stops, you go to your dressing room, remove your makeup, take a shower, and go home. Then the loneliness sets in. Even when you come home to someone that you love and they ask, 'How'd it go?' You tell them, 'It was great.' But the feeling is already evaporating. The whole thing is so fleeting, so totally temporary. All you're left with is a trail of memorabilia, like a photograph, perhaps, or a video that doesn't capture at all what it felt like. You might clip a nice review out of the newspaper and keep these things in a pile, but they don't revive the performance. You want that euphoria again and again, so you find yourself looking to the next performance. But you know in the back of your mind that one day there won't be that next time. The day will come when you'll have to retire. All you'll have left of your career are the memories."

"Is it no consolation that you leave an imprint on the minds of those who have seen you dance?"

"Over time, fewer and fewer people remember you," he lamented. "Balanchine had that fantastic quote, 'Ballets are like butterflies—beautiful while they last, and one day they're gone.' The same is true of the dancer's life. You had your moment, it was extraordinary, but it slowly disappears."

"Once you've been anointed with the power of movement, doesn't it stay with you on some level?"

"Jerome Robbins comes to mind again. At the end of his life he had problems with his balance, but even so, he was still able to demonstrate a dance moment far better than any healthy young dancer in the room. He wasn't jumping or doing physically difficult steps, but just his movement of the head, or a held arm in its stillness. He was actually getting better with age."

"Where should dancers look for inspiration in order to be more expressive?"

"Dancers use the steps and positions that they perform every day in class as the underlying vehicle for expression. On top of that comes everything you've ever done and learned from the moment you're born."

"Life experience?"

"Yes. If you've never had a major heart-pounding crush on somebody, you're not going to dance a very convincing *Swan Lake* or *Romeo and Juliet*. You have to recall that girl in seventh grade that you were nuts about and tap into that. Much of what you do on the stage has to do with real emotion—romantic love and loss, or chemistry that you feel with another person, like a friend or parent. All that goes into the performance.

"Inspiration for movement expression also comes from music. I encourage my students to be musically intelligent, to play with the music and take chances with it. Being *on* the music is the least musical thing that you can do. Daring the music, being behind it or a little ahead of it and then revealing that you hear the music perfectly in meter, can be very exciting to the viewer. You're manipulating the music, which brings the audience to the edge of their seats."

"You're an example of one—at least on the surface—who doesn't seem to have a dark side. Why do so many believe that you have to suffer and be plagued with angst to be a great artist?"

"I actually did experience a death in my family that had a profound effect on my life. I didn't talk about it, but I did draw upon it in my dancing. I was twenty when my father died, and it was just at the time when I was to perform *Prodigal Son*. To come to a ballet like this after having lost a father was extremely emotional. I could relate to the story on a very deep level—the prodigal son comes home and wishes to have his father back. But I don't think you have to wear your tragedies on your sleeve. Can you be that great artist without all the angst and personal drama? I think you can. You just have to be an intelligent and sensitive artist."

Peter gave his farewell performance with New York City Ballet about a year after our interview and accepted an offer to become artistic director of the highly respected Pacific Northwest Ballet in Seattle. I wondered how he had adjusted to his new life behind a desk.

"Peter," I asked by phone, "what's it like running a dance company?"

"It's been an adjustment, Rose, but a great one. The first thing that I staged here in Seattle was *Red Angels*. To watch this cast discover the power of the choreography and see their moments of euphoria in the midst of a performance was probably as rewarding as if I had danced it myself. And to witness the audience erupt in applause was enormously

gratifying. There is something very nice about the giving and passing on of something that you love and understand."

"And in your solitary moments, Peter, how is the dancer within you holding up?"

"If I had a solitary moment, I could tell you," he said with a laugh. "I just dove into this very demanding job without really acknowledging my retirement. I didn't give myself time to mourn the end of my performance career. I miss the movement and the music. Forgive me for being egotistical, but I miss that side of me that was extraordinary," he said. "I don't necessarily feel extraordinary when I'm sitting in a board meeting or running a rehearsal. That extraordinary being that I once was ceased to exist when I stepped off the stage."

"What about taking class just to keep the dancer within you physically active?"

"I'd like to take class. But to take class right now would be selfish of me. Am I going to take several hours a week away from the company for my own vanity? No. I have to consider my priorities. If I were unemployed, I'd definitely be taking ballet class. But there's another side of me that asks, 'Do you really want to?' Do I really want to watch the slow disintegration of the dancer that I once was? I think I've chosen a cleaner break."

New York City and Seattle, Washington, 2004 and 2006

Marge Champion

The dance team of Marge and Gower Champion created some of the most memorable dance sequences ever recorded on film, immortalized in *Showboat* and *Lovely to Look At* as the Fred Astaire and Ginger Rogers of the 1950s. Gower went on to become one of the most successful director/choreographers on Broadway. He died on August 25, 1980, on the day his revival of *42nd Street* premiered. Marge continued her dance career as a teacher/choreographer and patron of the arts, conducting master classes at Jacob's Pillow Dance Festival and serving on the nominating committee of the Tony Awards and on the advisory board of Berkshire Theater Festival.

Marge was in her late eighties when we met at her son's home in Brentwood, California. I asked about the main influences in her career. She began with her famous father.

"My father, Ernest Belcher was one of the first, if not *the* first, Hollywood choreographers. They were called dance directors in those days. He left England in 1911 and settled in Los Angeles just in time to witness the birth of the silent movie era. Charlie Chaplin, Mack Sennett, Cecil B. de Mille and D. W. Griffith all came to him to stage dance scenes in their movies. In 1931 Cecil B. de Mille built for him the University of the Dance, a beautiful three-story building on Western Avenue near 6th Street. It would become one of the largest and most distinguished dance schools in Los Angeles. Vilma Banky, Loretta Young, Betty Grable, Gwen Verdon, Maria Tallchief, Cyd Charisse, and Shirley Temple all received training at my father's school."

"What an amazing environment to grow up in. It's been said that you were born wearing a tutu."

"As a child I don't recall ever *not* wearing one, though my dance training didn't begin until I was five or six. My father, who had studied with a relative of the great ballet teacher Enrico Cecchetti, was very strict in training me as a dancer. And in those days if your father was a tailor you were expected to become a tailor. It never occurred to me that I was going to do anything but dance and teach dance. By the time I was twelve, I'd graduated from my father's advanced classes and was teaching on my own at the school. During the Depression he couldn't afford to pay teachers, so I assisted him."

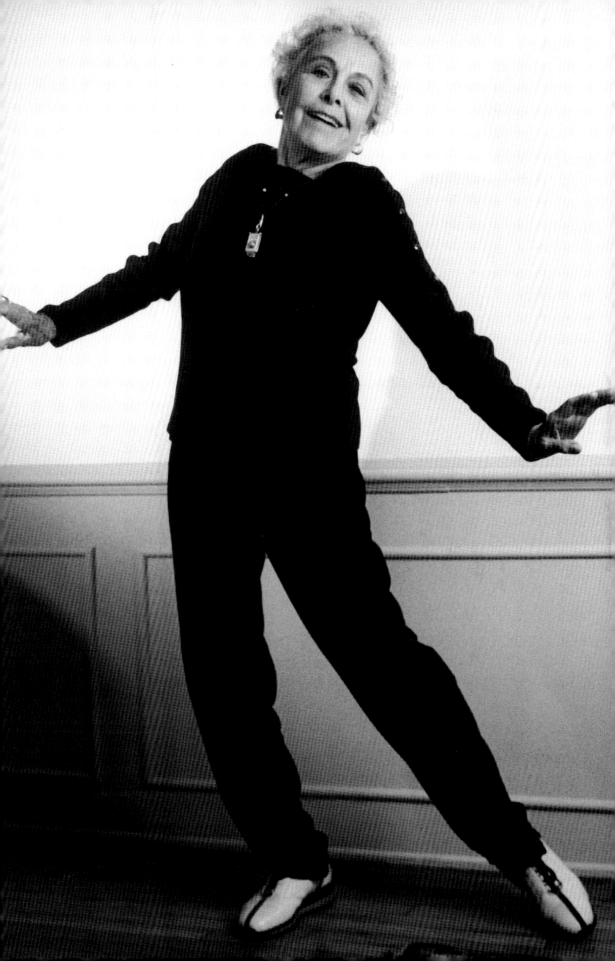

"You were the live-action model for Snow White in Walt Disney's first full-length animated film, *Snow White and the Seven Dwarfs*? How old were you at the time?"

"I was thirteen. A talent scout from the Disney studio came to my father's school looking to cast someone for the part, and I was chosen."

"What did they ask you to do?"

"They showed me storyboards and had me moving and posing. Then my actions were drawn. Snow White's movements and gestures are entirely mine. Snow White was originally drawn as a cartoon character with big *Betty Boop* eyes and a tiny waist. But once they started working with me, they gave her a girlish figure and almond-shaped eyes, like mine. I also appeared as the model for the Blue Fairy in *Pinocchio*, as well as the stork and the dancing hippopotamus in the 'Dance of the Hours' for *Fantasia*."

"Where did your career go after that?"

"In 1940, at the age of twenty, I got a job performing in a vaudeville-type show on the same bill as The Three Stooges. I wore my Snow White costume and did a little dance. I like to say that I went from the Seven Dwarfs to the Three Stooges, and that's what got me to New York. Once there, I began auditioning for Broadway shows and immediately got picked. My first Broadway show was *The Little Dog Laughed*. Several more followed: *Straight Play, What's Up?* (choreographed by George Balanchine), and *Dark of the Moon*."

"How did you and Gower Champion meet and become dance partners?"

"Gower and I knew each other from the time we were twelve years old. Gower sat behind me in history class at Bancroft Junior High School in Los Angeles. We were seated in alphabetical order; I was Belcher and he was Champion. We flirted from the start. At the age of sixteen Gower was an expert ballroom dancer who partnered with Jeanne Tyler. Together they won the 1936 dance contest at the Ambassador Hotel's Coconut Grove. Their win led to appearances around the country and a seven-year dancing partnership. But when Gower returned from serving in the Coast Guard in 1945, he found that Jeanne had married and was no longer interested in continuing their act. By that time I was in New York performing in *Dark of the Moon* under the stage name Marjorie Bell. He came to visit me in New York and we started dating. Soon after, he moved back to L.A. to dance and act in movies for MGM Studios. But Gower saw no future for himself at MGM at the time. Fred Astaire was already one of their big stars, and Gene Kelly would be coming back from the war soon. So Gower bought out his contract.

"When he returned to New York we began a professional partnership with a nightclub act called Gower and Bell. From the very beginning Gower wanted to direct his own work and envisioned numbers that were narratives—dance stories in which the characters expressed their inner thoughts through the dance. Our act had romantic overtones, and audiences really appreciated it. This was a new era in live entertainment. Prior to this time, story line was not important and musical revues like the *Ziegfeld Follies* were popular. But the forties saw a change when Agnes de Mille opened the door for story dances with *Rodeo*. Our timing was right on. We had bookings in some of the finest nightclubs in America. We renamed the act Marge and Gower Champion. I got top billing, which was highly unusual in those days. Gower was trying to cultivate name recognition as a director-choreographer and wanted to keep his name intact. This was very carefully thought out."

"You also got a lot of work in early television."

"Yes. We appeared on the *Admiral Broadway Revue,* which was later renamed *Your Show of Shows,* and had featured spots on *The Ed Sullivan, Perry Como, Dinah Shore,* and *Jack Benny* shows."

"And then Hollywood came calling?"

"Yes. MGM offered us a two-picture-a-year deal for the next five years, from 1950 to 1955. We couldn't fulfill the contract. The era of the Hollywood musical had run its course. MGM just let everyone go—even Fred Astaire. I knew when I saw Elvis Presley on *The Ed Sullivan Show* that we were done. Our time was over. We moved back into live shows, including a 57-city tour with Harry Belafonte and back into television."

"Your Hollywood years may have been short-lived, but you left us with some great dance footage from that period."

"Yes, *Showboat* really introduced us to the world. George Sydney directed that picture and Bob Alton was the choreographer. The choreography for *I Might Fall Back on You* called for 57 hitch kicks that start small and get higher and higher. Gower and I performed it seven times in a row so that the cameraman could film it from various camera angles. *Lovely to Look At* and *Give a Girl a Break* were among our other popular films."

"Why do you think the public so embraced you during the late '40s and '50s?"

"We were married and very much in love. I think this translated on the screen. Gower was six feet tall and I was 5'2", but everybody thought that I was much taller, and that's because he worked low and presented me. I know that if it had been any other time in history we would not have been so successful. We were the clean young married couple next door in the

era of the light-hearted romantic comedy, with films featuring people like Doris Day and Rock Hudson."

"The 1960s brought big changes for you and Gower."

"Yes, Gower was asked both to direct and choreograph *Let's Go Steady,* which eventually became *Bye Bye Birdie.* This was really significant because back in those days directors and choreographers were usually in very adversarial position. If the choreographer got better reviews than the director—which often happened—then you'd really have a mess."

"Is this when you and Gower broke up the act?"

"That's right. We stopped dancing professionally in 1960 when *Bye Bye Birdie* opened. Gower was becoming known in his own right as director-choreographer, and I was now a mother. I had my first child in 1956 at thirty-seven and my second at forty-two. If I had continued to dance at performance level, I would have had to turn my kids over to nannies and babysitters, and I didn't want to do that. But I never totally stopped dancing and taking classes. I found other outlets for my creative pursuits: doing volunteer work, directing plays."

"You and Gower had this amazing onscreen chemistry—the perfect American couple—yet your marriage ended in divorce."

"You know, we had a wonderful marriage up until the last couple of years. Fortunately, ours was not an angry separation. We had two children, Greg and Blake, whom we both adored, and we remained in touch until his death in 1980."

"You had remarried by then."

"My second husband, Boris, was killed in a helicopter accident in 1981. The eighties were a tough decade for me—I lost two husbands and a son. Blake died in an automobile accident exactly six years to the day that Boris died. Like Gower, Blake was handsome and a dancer. He had been performing in a show up in the Berkshires. On the way home he lost control of his car and hit a tree. To have Blake die threw me into a depression. I could hardly function. Couldn't even decide what to have for breakfast: cornflakes or Cheerios? That's how bad it was."

"How did you overcome your depression?"

"I had sessions with a psychotherapist and took antidepression drugs for a short while. I don't recall a specific time when the clouds lifted. It was gradual and not without setbacks. Leaving the city and moving closer to nature helped a great deal. And I resumed movement classes. Dancing and yoga became vital to my recovery, helping me to find my inner spirit."

"Marge, what's it like for you to see yourself on the screen today?"

"Everyone asks this question. And I know the subtext—how does it feel to see yourself when you were young and beautiful? I have a stock answer: 'It's like looking at another person—another person in time and history. I think I'm far enough away from it now that I can stop criticizing the few things that I could have done better.' But honestly, Rose, I'm not so sure this is really true. There are times when I see footage from *Smoke Gets in Your Eyes* and I'll get a lump in my throat. I still have a relationship to that person dancing in the blue dress, filmed by Hermes Pan before a backdrop of flickering stars. I'm still very moved by it. And it's not because I was young then. It's because of *who* I was then. That person on the screen was a diva. I was probably very demanding and selfish in those days and thinking only about myself: whether I was thin enough or pretty enough, if Gower liked what I was wearing, and if he would approve of my dancing. So it's not quite truthful to say that I'm looking at another person. I'm not. It's me. And when I see that footage I'm reminded of how much I've changed and how much I've grown as a human being."

Brentwood, California, 2007

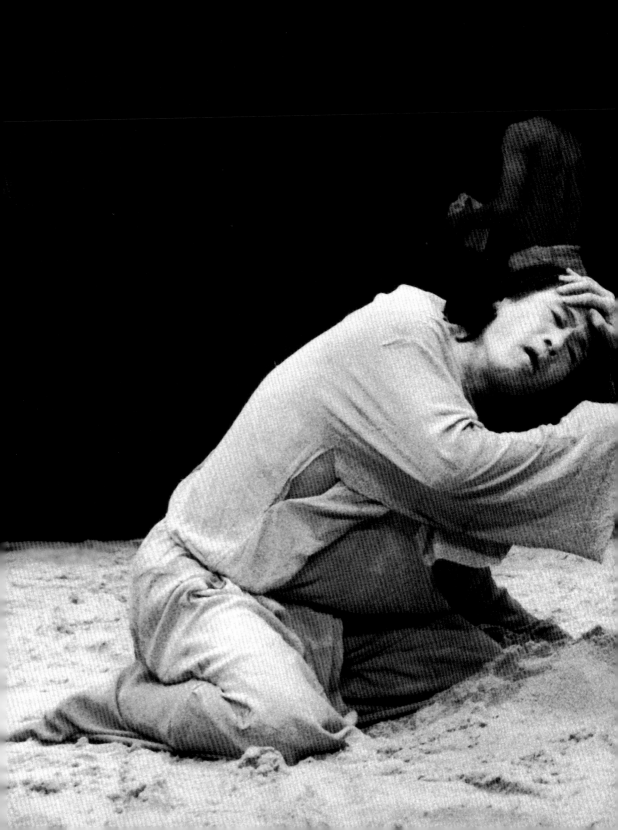

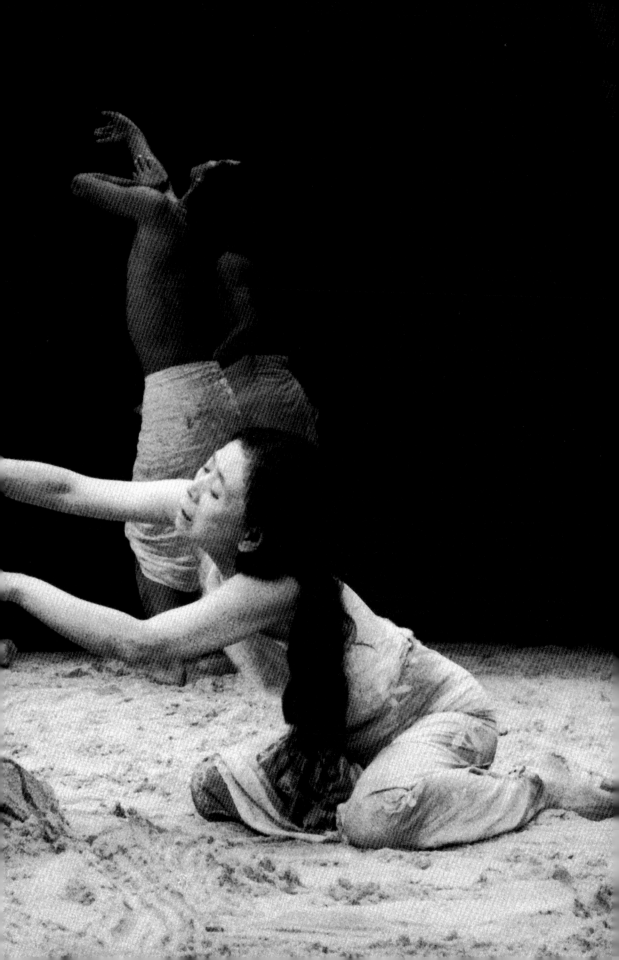

Eiko and Koma

Dressed in a pale brown kimono robe, his face and arms covered in white powder, Koma lowers himself ever so slowly into the outdoor fountain at the Skirball Center in Los Angeles. He is followed into the cold water by Eiko, and then by ten Cambodian art students—young men wearing yellow waistcloths, and a teenage girl in a shimmering white gown. The dancers move in slow motion. Eiko and Koma ascend a platform at the center of the fountain. Koma lights a series of candles, as if ritually honoring the memory of loved ones. Eiko scratches at the air, her fingers like claws, her face anguished and hollow. Koma drops back into the water as if pulled from below. The flames cast eerie shadows onto the white-powdered faces of Eiko and Koma; the pool shimmers with their reflections. The Cambodians, who have been standing in the water, trancelike and somber, begin to weave in and around each other, their arms outstretched until they end up in two parallel lines. Eiko and Koma now drift from the platform and file in among the Cambodians. The fountain and surrounding area has been transformed into a shrine of glistening bodies and light. Eiko gestures to the dancers to take their bows. I lower my lens and exhale.

It was not until I met Eiko a month later in the lobby of the Asia Society on Park Avenue—the next venue for *Cambodian Stories: An Offering of Painting and Dance*—that I would learn what led Eiko and Koma on their unique dance path. Their haunting, hypnotic dreamlike theater pieces that are heavily inspired by the Japanese art of Butoh—also called the "dance of darkness"—emerged during the postwar era in Japan as an avant-garde performance style combining dance, theater, improvisation, and Japanese art influences. Its use of nudity, postures, and gestures that distort the body challenged conventional norms and traditions.

"Eiko," I asked, the two of us taking a seat in a quiet corner. "What prompted you and Koma to adopt this particular art expression more than thirty years ago?"

"Koma and I attended different Tokyo universities—both political science majors in the law departments of our schools. Separately we were drawn to the student activism movement of the late 1960s and early 1970s. Philosophically we opposed the industrialization of education,

Japan's corporate structure, and its support of the U.S. in the Vietnam War. But by 1971, we found ourselves disillusioned with the movement. It began breaking up into factions and the infighting became fierce and violent. We knew if we stayed in school and got law degrees, we'd only be placing ourselves inside the system that we fundamentally opposed—a system that was linked to the forgetfulness of the crimes of the Second World War and a work ethic obsessed with making Japan a success story. We needed our own structure of thinking, our own voice, so we left school in search of another path. Koma and I met at the studio of Butoh innovator, Tatsumi Hijikata in 1971."

"How did you envision your future?"

"I don't know if Koma and I had the same vision for the future, but we had the same sense of desperation. We both felt the need for drastic change—in ourselves as individuals and in society as a whole. It was not a good time."

"Out of desperation comes empowerment."

"Yes, this is very true. We wanted something radically different that would take us to a new place. We had just been through a barrage of ideological isms: Marxism, Trotskyism, etc. We didn't need another ism. Tatsumi Hijikata and Butoh cofounder Kazuo Ohno offered us a way out of our dead-end politics and a new way to exist, to stand and be vital."

"How did they influence your thinking?"

"What we learned from Hijikata and Ohno, both very sensual beings and highly talented artists, was not the secrets of Butoh tradition. What we got from them was passion—especially from Kazuo Ohno. Souls that want to feel passion become attracted to those who are passionate. Passion is contagious. Yes?"

"Yes."

"Both Hijikata and Ohno gave us the awareness and permission, if you will, to be passionate and experimental and unusual. Our teachers encouraged us to believe that extraordinary lives and bodies exist, and we were looking for something like this."

"But you didn't stay with them for very long?"

"We never stay long with any of our teachers or enter into their inner circle to become their disciples. This has never been our mentality. We are looking to be inspired, not to be taught this technique or that technique. There are those who seek to adopt other people's visions, but we were both very impatient and rebellious. We needed to move on. And we understood that sometimes a very big tree makes it difficult for something else to grow in its shadow. Koma said, 'Let's just leave here—start

new.' Traveling seemed to fit in with our newfound sense of romantic idealism and adventure. But to where? We were both anti-American—opposed to the Vietnam War—and did not want to go to the United States. We agreed upon Europe and set out by boat to Siberia. From there we took trains through Russia to Vienna and finally to Munich. When we arrived we learned that Manja Chimiel, a former assistant to German dance pioneer Mary Wigman was teaching in Hannover. Manja was really Czech, a beautiful dancer who could hold an audience for three hours in a solo performance. We decided to study with Manja, who would become like a mother to us. She was the first to see something in 'Eiko and Koma' and encouraged us to work as a team, sensing that neither I nor Koma alone on the stage could hold an audience for two hours. But together, she said, we created a reciprocal relationship of femaleness and maleness. You see, if I'm working alone, then all I have to draw upon is my female body, but if I'm working with Koma, I gain his maleness and he gains my femaleness. During a performance we can work solo, duet, solo, duet. I can carry Koma's shadow. When he enters, part of me enters. When I depart, I leave my shadow for him. On the stage we explore the power of the duet. It's almost like a cell dividing and becoming whole again. This is something that people can relate to, and it's very simple—one male and one female. We realized it's not about the dancer within me or the dancer within him. It's about what we create together."

"Can you define what it is that you create together?"

"Our movement sensibility comes from our being Japanese—the body's relationship to the earth, not the sky. And we take our time. We move slowly. Our performing became a way for us to see ourselves—and for the audience to see themselves in our reflection—like a mirror of a flower floating in a river. We found that audiences viewed our work from the perspective of their own lives and experiences. Our performances—often outdoors and in unconventional settings—offered a new idea of what art could be and engaged us in a dialogue with our audiences."

"You and Koma could have chosen any number of ways to express your political and social views, and yet you chose the body and movement. Why?"

"Well, I aspired to be a writer. Koma aspired to be a revolutionary," she said with a laugh. "But at that time I felt that I had nothing to write. The generation just before ours had lived through WWII, survived life-and-death experiences, whether they were the perpetrators or the victims. They had something to say and were writing about it. We were reading their books. But I didn't feel that I had a voice—or a body for that matter.

I needed something to believe in. Many of us from the student activist movement were lost, drinking too much, smoking too much, even turning violent. I needed to get away from this. I needed to save myself. Koma and I decided that we should reside in the body for a while. I never expected we would stay here for thirty-five years. But the truth is that dance, in a way, saved me."

"And you have many teachers to thank."

"Yes, Koma and I found passion inside the relationships with our teachers and mentors. We stayed in close contact with many of them who, despite our aesthetic differences, became our artistic family."

"Like Kazao Ohno and Anna Halprin?"

"Koma and I are most fortunate because not only did we study under Kazao Ohno. When we see him dance, it's not Butoh or a particular movement style. What we see is the dancer within this mysterious and gentle man, and this fuels the passion within us. Anna Halprin's pioneering spirit inspires and propels us."

"You are on tour right now with a group of young Cambodian art students from the Reyum Painting Collective in Phnom Penh. What are you trying to convey in this work?"

"I was astounded to learn that young people in America know very little about what happened in Cambodia in 1975. How the Khmer Rouge, a Communist guerrilla group, took over the capital Phnom Penh, and forced its people into labor camps and a life of starvation. Over two million people died. Yet I had to ask myself, should *Cambodian Stories* be about the killing fields? I decided no, we should not be the ones telling this story. I do not want my art to be didactic. Knowing often does not change things. It's passion, emotion, and action that move people.

"Koma and I chose instead to create a dance that speaks about the beauty and survival of Cambodian culture and about a generation born into a traumatized society that is willful and driven to grow and live full lives, like a flower that blooms in rock-hard soil with scant water or sunlight."

"Is it important to you that those who see your work become more politically or socially active?"

"I am not so naive to think that people will walk out of my concerts and be changed. Yet I think our performances *can* enhance people's lives. Almost all our audiences are very liberal and highly educated and want to be connected to performances that are as sincere and committed as they are politically and socially."

"How did you end up living in New York City?"

"When we were traveling through Amsterdam during the Vietnam War years, we met many young people escaping the U.S. draft. They explained to us that Americans as individuals are not the same as the American government. It's very hard to know this when you're on the outside. Once you know America, you realize that there are incredible individuals here. We moved here, raised our children here, and developed a career over three decades. This is a country that has let us do what we want, where we have had artistic freedom. It's not easy to give this up once you've found it."

"How do you train your body?"

"I don't. I've never wanted to have a dancer's body, one that audiences see as unique or different. I wanted to have everywoman's body. I'd rather they identify with me, feel more connected then impressed. This is not to say I should be lazy and not keep my body in balance."

"You also choreograph the dances that you perform."

"I am a choreographer only because I am a dancer, and for no other reason. I love to perform and have found that choreography is the shortcut to the dancer within. And the impulse to dance comes from the desire to learn more about something or someone. It's this that inspired our work with the Cambodians. We've created works about Native American people and aspects of nature and 9/11. For us, it's never about expression. It's about exploration. Making a work feeds our curiosity. People in the West are beginning to realize that everything is moving too fast and they need to slow down. This is to some degree why they come to see our work. They need an alternative to TV. They need an antidote for life in the West. We offer it."

When I returned the next day with my camera, Eiko, Koma, and their nine Cambodian art students were about to begin rehearsal. I positioned myself a few rows back from the stage. Eiko spotted me and waved. Watching the piece unfold, I understood why the duo had become famous on five continents. They remind us of our primordial selves—who we are at the core of our being. They bridge the ancient with the modern by awakening our senses and prompting us to ask ourselves: Who are we? And how do we live?

Los Angeles, California, and New York, 2006

Julio Bocca

The son of a ballet teacher in his native Buenos Aires, Julio Bocca began dancing at the age of four. At eighteen, he won the gold medal at the International Ballet Competition in Moscow, followed by an invitation to join American Ballet Theatre by then artistic director Mikhail Baryshnikov. As a principal dancer with ABT, Bocca mastered some of ballet's most challenging roles including Balanchine's *Apollo*, Basilio in *Don Quixote*, and Solor in *La Bayadère*. He is also one of the world's most famous tango dancers in his native Argentina. He fills stadiums like a rock star—an estimated eighty thousand at his last concert.

So when I learned that the ballet/tango star was bringing his company, Ballet Argentino, to UCLA's Royce Hall to perform BOCCATANGO, I requested and received permission to photograph the performance from the wings. But when I arrived at the theater the stage manager informed me that I would need Julio's okay and would have to wait until he had finished his session with his physical therapist. To save time, I pulled a camera from my bag and made my way onto the stage to explore the wings. The stage was alive with cast and crew preparing for that evening's performance. Octango, the company's musical ensemble—composed of piano, violin, guitar, saxophone, flute, bass, and bandoneón (an accordion-like instrument known in Argentina as the heart of tango) was tuning up. Vocalists Noelia Monacada and Estaban Riera were rehearsing one of their songs. Julio's six classically trained dancers—four men and two women—were warming up their muscles. I found a spot up against the second curtained wing where I knew I could crouch down and still angle my camera center stage. I checked my camera's focal length and then headed back to Julio's dressing room. The door was still closed. Moments later a man wearing a BOCCATANGO T-shirt with a towel around his neck and smelling of liniment, walked out. The Argentinean dance star followed.

"Julio," I called out. "I'm Rose. I'm looking forward to shooting the show tonight."

"Yes, we've been expecting you."

"I understand that there are concerns about the wings."

"Wherever you want to be is fine," he said.

"I assure you I won't be in anyone's way."

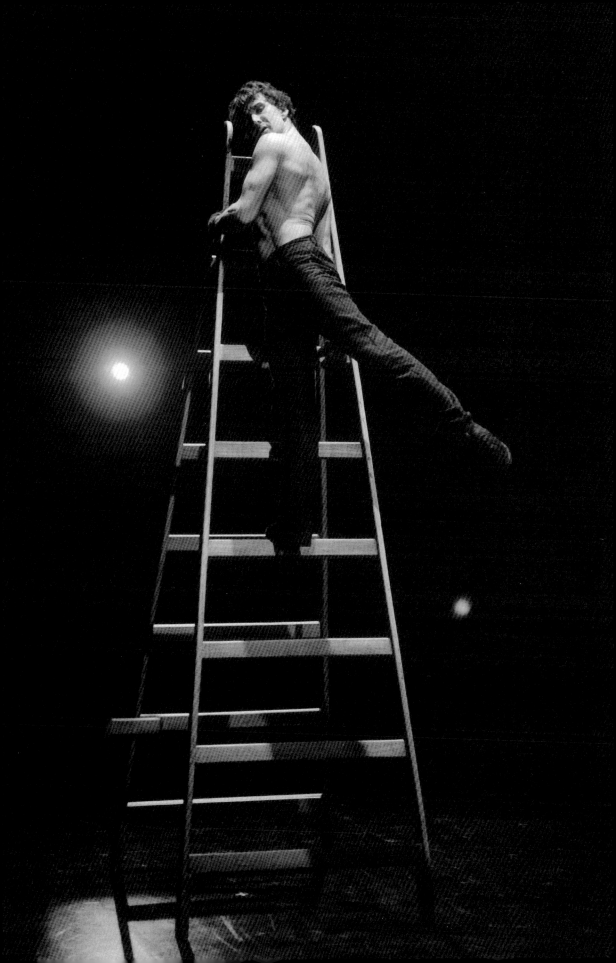

"No, no, it's fine. You are an artist and you need to do what you need to do. I am not at all concerned about it."

I thanked him and asked if he might have time for an interview while in Los Angeles.

"I'm sorry. We've been on the road for three months—nineteen cities—through Europe, the U.S. and next, South America. I need to get some rest, so I don't want to schedule anything beyond the performances. But come to my dressing room during intermission. We can talk a little then."

"That's very kind. I'll see you later then," I said, and grabbed the rest of my gear, gave the stage manager a thumbs up and headed for the wings, stage left. In the meantime ballet barres had been placed on the stage for company class. Julio joined his dancers and took a place at the barre. Class lasted about forty minutes—the usual *pliés, tendus, ronds de jambe, ports de bras, battements*—and concluded with a floor combination and *changements*. Afterward the dancers rushed out to change into their costumes.

Minutes to curtain, I stood waiting alone in the dark, listening to the sounds of concertgoers taking their seats. A tune played backstage on the bandoneón brought to mind lovers strolling down a narrow Buenos Aires street in the moonlight.

Finally it was show time. As Royce Hall's announcer introduced BOCCATANGO, the curtain rose and a blue light hit the stage floor. Esteban Riera strolled out onto the stage, microphone in hand, and began to sing "Mi Buenos Aires querido." Just then I realized that I was not alone. Julio was standing at my side. I sensed his heart beating. He was silent, focused, staring at the stage. I tried not to move or even breathe. Hearing his cue, he bolted out to meet his dance partner Lucas Oliva, who had entered from the opposite wing. The two men, dressed in tuxedos hit their opening pose, shifted into an embrace, and glided downstage. Julio performed the woman's part with searing masculinity. Oliva lifted him throughout the dance as he would a female partner. The men presented an elegant stage version of the dance that had originated with the Argentinean gauchos in crowded cafés in the late nineteenth century.

For his next dance, "Invierno porteño," Julio entered from the opposite wing pulling his next partner—a heavy table. Drenched in white light that accentuated his muscles, he demonstrated an array of quick staccato moves, gymnastic balances, and dramatic gestures. Tracking his every move through the lens, I marveled not only at Julio's technical precision but his ability to temper machismo with tenderness. In the final dance of the first act I felt the full force of his power. He partnered with principal

dancer Cecilia Figaredo, both partially nude in a rough-and-tumble display of sexual tension entitled "Romance del Diablo."

At intermission, I gave Julio a few minutes to recover before knocking on his dressing room door.

"Come in," he said and gestured with his chin for me to sit down. Though his face and hair dripped with perspiration, he was already dressed for his next number. He grabbed a towel and dried his face and hair and then sat down in front of the mirrored lights to apply fresh makeup.

"We can talk while I get ready. What would you like to know?" he asked.

"How is it going for you tonight?"

"It's good. Very nice audience, very nice. You know it's hard sometimes when you've been on the road for a long time and you're performing the same show over and over. It can be difficult to get in the mood and keep it fresh. So when you have a nice audience like this one that responds to what you're doing, you dance much better. You really want it to be exciting every time you go on the stage."

"How can you tell when it's a good audience?"

"Oh, you know in the first few minutes how the audience is going to be. Sometimes you feel like there is big wall between you and them—a distance, a coldness. When that happens, you feel like you're dancing like a machine. But, that's not happening tonight. Tonight I feel the audience is with me."

"Your dancing has a deeply masculine feel to it. Is this something you're conscious of?"

"Well, I don't try to be manly. I am a man and the roles that I dance are men's roles. Even when I partner with another man, as I did in the tango this evening, I am still dancing as a man. When I dance ballet, which can sometimes look effeminate, I never want the audience to ask who is the woman and who is the man. So when I'm on the stage I am only aware that I am a man."

"Are you also conscious of being an Argentinean man?"

"I am born in Buenos Aires. We have a particular way of moving, a Latin-ness that affects us in body and mind. And, like the tango, it lives inside of me. So how I walk, how I carry myself, and how I move, comes from my culture. And this distinctive quality is something that I can always recognize in others. I spend a great deal of time in airports and I can spot Argentineans anywhere in the world just by the way they carry themselves. I can recognize tango dancers by the way they wear their hats."

"I read that your mother had greatly influenced you to become a dancer."

"Yes, my mother encouraged me. She gave me the tools and the knowledge to dance, but she is not *why* I became a dancer. I was a born dancer. It came from within me, the desire to dance. I heard music and I felt rhythm in my body."

"When we stood together in the wings you were in a deep state of concentration. What were you thinking about?"

"Before I go onstage I am connecting with my character—the role I am dancing, and with my partner. I experience a special sensation, a natural adrenaline. Once it takes a hold of me, I can only describe it as spiritual. And this is when the movement comes and I begin the interpretation of my character."

"Is this feeling the same whether you're dancing classical ballet or tango?"

"Yes. Tango or ballet, it makes no difference. The only thing that is different is the character I am dancing."

"I understand in act 2 you will be dancing with a ten-foot ladder."

"That's right. I encouraged my choreographer, Ana Maria Stekelman, to come up with ideas that will challenge me physically and creatively. These pieces—using a table and a ladder—remind me of my childhood. When I was a kid, I loved to play in the park on the jungle gym and climb on tall structures and be high off the ground. And that has not changed."

"Julio, cinco minutos, cinco minutos," rang out from the intercom.

"Julio, I'd better go now, I feel like I'm keeping you from getting ready."

"No, it's okay. I want to finish, sit, sit," he said, gesturing for me to stay. "I've been dancing on the stage for many years. I don't need much time to prepare myself. What else do you want to know?"

"Does your fame and the demands of your career make it hard to have a personal life?"

"I used to say dance is my life. But now, I say dance is a part of my life. The discipline of dance pushes you to focus solely on yourself and your career. You can be consumed by your career or you can plant your feet on the ground and know where you stand. I try to make sure that I know who I am as a person—and then I am able to integrate my real life into my art. For example, when I dance the role of Romeo, I draw from my own personal experiences to express what I know about love. If I had never experienced love, how could I demonstrate it in my dancing? If I am secure in myself as a real person it benefits my art."

We were again interrupted by the intercom: "Julio, por favor . . ."

"Julio, I'd really better go now," I said, thanking him and quickly returning to my spot in the wings.

The high point of the second half was Julio's dance on the ladder. Wearing leather gloves to protect his hands from wood burn, he weaved in and out of the rungs from the bottom to the top—a feat that required extraordinary physical strength. From my vantage point in the wings, I could see his muscles flexing and releasing. At the very top, he balanced precariously for several seconds—fearless in his defiance of gravity. Gasps could be heard from the audience.

After the show, I returned to Julio's dressing room to say a final goodbye. He had already showered and was wearing a towel around his waist.

"Come in, Rose. I hope you got what you needed."

"Yes. You are very generous to open yourself to me this way."

"I believe that if you want people to come and see you dance—you must be accessible to them. It doesn't serve you to hide from the public. I know that sometimes the people that handle my schedule try to protect me, but I'm not like that. I want to know the people. Come visit me in Buenos Aires. You're welcome to shoot my performances from the wings anytime," he said, and gave me a hug.

"I'll look forward to that day."

Los Angeles, California, 2006

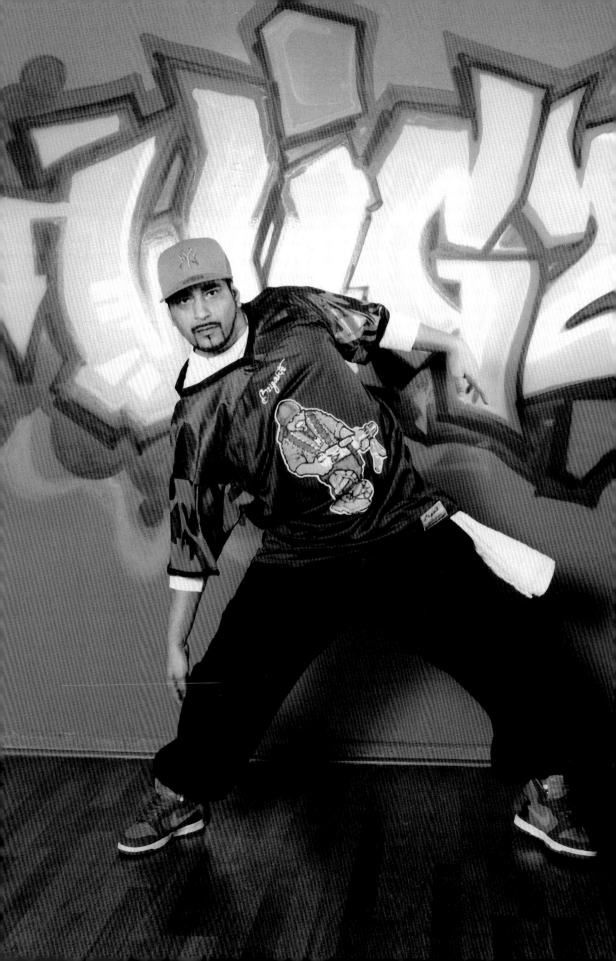

Mr. Wiggles (Steffan Clemente)

Wiggles greeted me at the front door of his quiet suburban home in Las Vegas and invited me into his studio.

"This looks like an offbeat neighborhood for a hip hop dancer from the Bronx," I said,

"My neighbors would definitely agree with you," he said with a laugh. "Truth is, I was raised in a bad environment and I wanted something better for my kids. So when I got the opportunity to work in a Las Vegas show, I moved my family out here. At the time we were living in a small-ass apartment in a bad section of the Bronx. After the show had its run, I thought to myself, 'Why should we go back?' Here we could live in a nice house and the kids could go to good schools. I didn't buy into that mentality that just because I was a B-boy I had to live back in the 'hood. So many dudes I knew are always bragging about their 'hood and how crazy it is. But that's like bragging about having cancer or AIDS. I wanted to make sure that my wife and kids didn't see the kind of shit that I saw growing up. And I didn't want to be one of them dudes caught in the gang war crossfire."

"What was your childhood like?"

"I was born in Spanish Harlem in 1965," he began. "But when my family got evicted from our apartment, we moved out to the Bronx. The Bronx was a scary place for a little kid—like the dungeon of New York. I thought of it as a place where all the bad people were sent to live. I was thrown into this crazy-ass neighborhood that looked like the pictures we see on TV of war-torn Iraq—destroyed buildings and rubble everywhere. Slumlords were burning down their own buildings to collect insurance, and crime was rampant. We lived by East Tremont and Grand Concourse near Echo Park—crazy-ass park. I remember seeing guys crawling—not walking—out the park. Curfews would be announced by gangs so you usually knew ahead of time when there was going to be a rumble. The next morning I'd play in the park and pick up clackers and 007s."

"What are those?"

"A clacker is a toy with a string connecting to heavy balls that you clack together. They were used as weapons by the gangs and were eventually banned. 007s were big-ass knives. Remember, this was the 1970s. Fighting

during those years weren't shoot-outs and drive-bys. Rumbles in the Bronx were hand-to-hand combat like the battle scenes in the film *Braveheart*. We're talking stabbings and beat-downs with baseball bats."

"Tough turf for a little kid."

"Oh, yeah. I never really knew what direction to take, but I got swept up in what was going down. I was really young when I became a *writer*—tagging walls and buildings with my little pen. The media termed us vandals and graffiti artists, but that was my first exposure to something creative."

"How did you start dancing?"

"My older sister Wanda taught me how to rock. 'Rockin'' or 'uprockin'' was a dance that originated in Brooklyn but was popular in the Bronx."

"What did rockin' look like?"

"Rockin' was a highly aggressive dance that gangsters did before they rumbled. They'd get a couple drinks going at their socials clubs and then they'd *rock*—act out what they were going to do to their opponents with the use of weapons. I had a talent for it and quickly became known as the little dancer kid on my block. When someone new stepped into the 'hood looking to battle, they'd come and get me."

"Rockin' was different from breakin'?"

"Yeah. The Puerto Ricans in my neighborhood were into rockin' and doing the hustle and the southside, but the brothers (African Americans) was into breakin', which was performed on the ground—you know, drops, footwork, top rock—spinning on your head and things like that. When I saw breakin' for the first time I jumped on it. I hung out with the brothers and soon breakin' became my claim to fame in the neighborhood."

"What did you like about dancing?"

"Dance became my escape from the realities of the 'hood. I witnessed stabbings and shootings. I remember seeing one guy get smoked right in front of me. I looked down at him lying on the ground with blood pouring out of him and imagined his parents and brothers and sisters going to his funeral. Was I going to end up like him? The only way to cope with life in the Bronx was through dance and art."

"You were really lucky to get out of there in one piece."

"Well, the older cats in my 'hood appreciated my dance skills, and even though they were the ones committing violent crimes, they were telling me to stay on the straight and narrow. 'You've got something,' they told me. 'You've got talent, Stevie. You don't need to do this shit.' They looked after me and protected me. If I got into battles that were a little wild, I knew I could always count on my block to back me up. I had a ghetto pass," he said with a laugh. "I didn't have to do anything crazy to gain

their respect. All I had to do was rep the block—represent my neighbor-hood when I danced."

"Dancing instead of fighting?"

"No one ever said, 'Instead of fighting, let's dance.' That's a myth. If a guy slapped your mom, you'd fight. But because of dance, dudes spent less time on the streets committing crimes and more time indoors prac-ticing their moves."

"How did a dance battle generally get started?"

"I liked to bounce around in neighborhoods outside my own looking to target someone for a battle. And wherever I went, my crew went. I didn't have to worry about no beef, no problems, because I rode deep, which meant I had my boys with me. Typically people gathered in a park socializing and kicking it where a DJ like Flash or Bambaata would plug up their system to a street lamppost. And if the right music came on, peo-ple would start dancing and form a circle. So I'd target a kid that I wanted to battle and move in right next to him. Then I'd throw moves at him in his peripheral. If he's ignoring me, then I know I've got him. Once I've got him shook, I throw the next move in his face. I was very tactical. I wanted to get on his nerves to the point that he really didn't want to mess with me. By that time I'd already won the battle. Back then, battles was a very thuggish, ghetto thing. Today it's done in competitions and contests where you win prizes."

"Sounds like you were on a pretty big ego trip back then."

"Oh, I was a very gassed-up, supped-up, a cocky knucklehead. I had a big click so I didn't have to worry about fighting and beefs. And I wasn't scared. I'd deliberately set things off, spark a confrontation, because I knew some guy wouldn't step to me. I was a spoiled little kid."

"Did you also consider yourself an artist?"

"No. I was just a street thug that danced. Dancing meant fighting. Dancing was a way to survive. I learned most of the dances from stickup kids—kids who committed stickups, you know, robbing people. This was the mind-set of a B-boy (hip hop dancer). And it looked as violent as it was."

"Was dance also a way for you to express yourself?"

"Oh yeah, expression of oppression. We were poor kids looking for outlets. If I wasn't doing this, I could be in your living room robbing you. We didn't have money for the baseball or football teams. Our outlet was dance. We didn't know we were creating art. In our minds, this was just our activity, and we were out for fame and to get girls."

"Did you spend a lot of time practicing your dance moves?"

"Sure, but there were no dance studios in my neighborhood. We did it in our hallways and rooms. After a battle, I'd go straight to my hallway, three or four in the morning, work on some stuff and then go to sleep. In the morning I'd practice some more and get ready for the next battle."

"How did you make the big leap from street thug to professional dancer?"

"Well, by 1979, breakin' had played out. Dancing was dead in the Bronx. So I started focusing on my writing—graffiti. A lot of writing styles and lettering were created during that era, and I was going to Art Design High School, where all the talented vandals ended up. Then one day I met Doze, this famous graffiti artist who was a member of Yoke City Mob, which was a group of stickup kids that were tagging up the New York subway system. This dude told me that he was still dancing but with a group in Manhattan called Rock Steady Crew. Rock Steady Crew epitomized what we consider breakdancing today: they did a combination of breaking, poppin', locking, backspins, and windmills. He helped get me into the group and my first performing gig, which led to a tour to L.A. and then Europe. I couldn't believe they were offering me money to dance."

"What was that experience like?"

"The reaction of audiences to our dancing was incredible, especially in Europe. They looked at us like we were aliens from another planet. I realized we've got something big here and then the media got a hold of it. Hip hop dance became a sensation."

"So you contributed to the resurgence of hip hop in the early eighties."

"Yes, that's right and we had our heads in the clouds. We were just teenagers that were being treated like rock stars and getting paid crazy money. We went from having absolutely nothing to shopping for clothes in Italy, London and Japan."

"So you never finished high school?"

"No, I dropped out to go on tour. Dance that had been a way for me to survive in the 'hood suddenly turned into a way for me to make money. We were thinking creatively, but we were also thinking about all the things we were going to be able to buy. As soon as one tour ended, we tried to figure out how to book another."

"And you were making dance history."

"Yeah, but then hip hop dance was seen as just another fad, and it died again in the late eighties. Everyone slowly drifted back to the 'hood, broke. Dancers who had performed in films like *Beat Street* ended up in prison or dead. These cats who had played a major role in the evolution of

hip hop dance have all but been forgotten: people like Buck 4, Kuriaki, Kippy Dee, Dino Rock, and others. We thought this ride would never end, and when it did, four members of our crew were murdered. We were back living in a war zone. I stayed locked up in my house, scared to go outside. I remembered all the paths I'd crossed and all the people I'd pissed off."

"So what was happening to the dancer inside of you?"

"I never really understood the dancer within me. I only knew the streets and how to get what I wanted. I did a lot of soul-searching during that time, thinking about everything that had happened and how I was going to survive from here on out. Then something happened that changed my course. I got a call from a Broadway choreographer inviting me to be in a show. Her name was Graciela Daniele and the show was *The Mystery of Edwin Drood*. I came in as a straight-up B-boy and was put in several scenes. After that show closed, I got another and then another. I started hanging out with great people like Bill Irwin, Lynne Taylor Corbett, Ann Marie D'Angelo, and Rob Marshall."

"How did these successful Broadway artists influence your way of thinking?"

"Lynne Taylor Corbett took me on as her protégé and schooled me for two years on how to create a show and add a more theatrical sense to my dancing. Bill Irwin helped me pace my performances and taught me that less is more, and how to hold my expression on the stage. Rob Marshall mentored me on how to stay in the business and land jobs. Ann Marie D'Angelo helped me to understand the universality of dance and how important it was to know a variety of movement styles. This period proved a real turning point in my life. These people showed me how I could take my personal experiences and develop them into a theatrical production. They encouraged me to go back into the 'hood and find the cats I used to dance with—Crazy Legs, Fabel, Ken Swift, and upcoming dancers like D Incredible, Kwickstep, and many others—and put together our own company and show, Ghettoriginals: *Jam on the Groove*. Award-winning PBS film director Margaret Selby helped us apply for a grant to fund the production, and before long we were booking dates. The *New York Times* even wrote an article about us. We performed off-Broadway and toured all over the world. At the same time, Rock Steady Crew and the Electric Boogaloos were on the scene, pumping life back into hip hop dance. Hip hop once again was sizzling."

"What's it like for you today when you dance?"

"When I get on that stage, I've got to blow shit up. That means *this*," he said, pointing to his shirt emblazoned with a gangster holding a machine gun.

"That's a pretty scary-looking character," I said, noticing it for the first time.

"Yeah, he is a scary character. The message behind this image is that hip hop dance is a *weapon* to get kids out of the 'hood. My dance is to reach these young people that are troubled and aggressive and show them by my own example that dance can be a creative outlet. You don't need violence. It's not just poor kids that have problems. I've encountered rich kids that are suicidal. I get e-mails from kids all over the world who have seen my videos and write, 'I was on the verge of suicide and then I saw you dance on your video. I heard you speak and it saved me. Dance has become my outlet too.'"

"You've taken hip hop dance to a new purpose."

"My belief is that you can't go to heaven unless you raise godly children, and when I say this, I'm talking about taking responsibility for all the little kids out there, not just my own biological ones. The real key to getting into paradise is by helping young people stay on the straight and narrow. In my heart, this is what I dance for. I've been through so much shit in my life. I've lived through war in the streets and I'm still at war—against senseless violence and destruction. That's what this dude on my shirt represents. This is my mind-set every time I hit the floor."

Las Vegas, Nevada, 2006

Bibliography

Acocella, Joan. *The Diary of Vaslav Nijinsky.* New York: Farrar, Straus and Giroux, 1999.

Ailey, Alvin. *Revelations.* N.J.: Citadel Press, 1995.

Atkins, Cholly, and Jacqui Malone. *Class Act.* New York: Columbia University Press, 2001.

Baryshnikov, Mikhail. *Baryshnikov in Black and White.* New York: Bloomsbury, 2002.

Billman, Larry. *Film Choreographers and Dance Directors.* Jefferson, N.C.: McFarland, 1997.

Boorstin, Daniel J. *The Creators.* New York: Vintage Books, 1992.

Brown, Jean Morrison, ed. *The Vision of Modern Dance.* Princeton, NJ: Princeton Book Company, 1979.

Bufalino, Brenda. *Tapping The Source.* New Paltz, N.Y.: Codhill Press, 2004.

Clarke, Mary, and David Vaughan, eds. *The Encyclopedia of Dance and Ballet.* New York: Putnam, 1977.

Cohen, Selma Jeanne. *International Encyclopedia of Dance.* New York, Oxford University Press, 1998.

de Mille, Agnes. *Martha: The Life and Work of Martha Graham.* New York: Random House, 1991.

Desmond, Jane C, ed. *Meaning in Motion.* Durham, N.C.: Duke University Press, 1997.

Duncan, Isadora. *My Life.* New York: Boni and Liveright, 1927.

Dunning, Jennifer. *Alvin Ailey.* Reading, Mass.: Addison-Wesley, 1996.

Easton, Carol. *No Intermissions: The Life of Agnes de Mille.* Boston: Little Brown, 1996.

Eichenbaum, Rose. *Masters of Movement: Portraits of America's Great Choreographers,* with a foreword by Clive Barnes. Washington, D.C.: Smithsonian Books, 2004.

Evans, Bill. *Reminiscences of a Dancing Man.* Reston, Va.: National Dance Association, AAPHERD Publications, 2005.

Emery, Lynne Fauley. *Black Dance From 1619 to Today,* 2nd rev. ed. Princeton, N.J.: Princeton Book Co., 1988.

Garafola, Lynn. *Diaghilev's Ballets Russes.* New York: Oxford University Press, 1989.

Gilvey, John Anthony. *Before The Parade Passes By: Gower Champion and the Glorious American Musical.* New York: St. Martins Press, 2005.

Gottfried, Martin. *All His Jazz: The Life and Death of Bob Fosse,* 2nd ed. Cambridge, Mass.: Da Capo Press, 1998.

H'Doubler, Margaret. *Dance, A Creative Art Experience.* Madison: University of Wisconsin Press, 1957.

Hill, Constance Valis. *Brotherhood in Rhythm: The Jazz Tap Dancing of the Nicholas Brothers.* New York: Oxford University Press, 2000.

Kent, Allegra. *Once a Dancer—.* New York: St. Martins Press, 1997.

Kurth, Peter, *Isadora: A Sensational Life.* Boston: Little, Brown, 2001.

Jamison, Judith, with Howard Kaplan. *Dancing Spirit: An Autobiography.* New York: Doubleday, 1993.

Lawrence, Greg. *Dance with Demons: The Life of Jerome Robbins.* New York: Putnam, 2001.

La Fosse, Robert, with Andrew Mark Wentink. *Nothing to Hide: A Dancer's Life.* New York: D.I. Fine, 1987.

Long, Richard A. *The Black Tradition in American Dance.* New York: Rizzoli, 1989.

Long, Robert Emmet. *Broadway, The Golden Years.* New York: Continuum Press, 2001.

Luigi, Lorraine Person Kriegel, and Francis James Roach. *Luigi's Jazz Warm Up.* Pennington, N.J.: Princeton Book Co., 1997.

MacLaine, Shirley. *Don't Fall Off The Mountain.* New York: Norton, 1970.

Magriel, Paul. *Nijinsky, Pavlova, Duncan.* New York: Da Capo, 1977.

Makarova, Natalia. *A Dance Autobiography.* New York: Knopf, 1979.

Martin, John. *Introduction To The Dance.* 1933; reprint, Brooklyn, N.Y.: Dance Horizons, 1965.

McKayle, Donald. *Transcending Boundaries: My Dancing Life.* New York: Routledge, 2002.

Mitchell, Jack, photographer. *Alvin Ailey American Dance Theater.* Kansas City, Mo.: Andrews and McMeel, 1993.

Morgan, Barbara. *Martha Graham: Sixteen Dances in Photographs.* New York: Duell, Sloan, and Pearce, 1941.

Mueller, John. *Astaire Dancing.* New York: Knopf, 1985.

Needham, Maureen, ed. *I See America Dancing.* Urbana: University of Illinois, 2002.

Prose, Francine. *The Lives of the Muses.* New York: HarperCollins, 2002.

Sorell, Walter. *The Dance Through the Ages.* New York: Grosset and Dunlap, 1967.

Taper, Bernard. *Balanchine.* New York: Times Books, 1984.

Tracey, Robert. *Goddess: Martha Graham's Dancers Remember.* New York: Limelight Editions, 1997.

Tune, Tommy. *Footnotes.* New York: Simon and Schuster, 1997.

Villella, Edward, with Larry Kaplan. *Prodigal Son.* New York: Simon and Schuster, 1992.

Waldman, Max. *Max Waldman on Dance.* San Francisco: Chronicle Books, 1988.

Warren, Larry. *Anna Sokolow: The Rebellious Spirit.* Princeton, N.J.: Princeton Books, 1998.

About the Author

Rose Eichenbaum holds a bachelor's degree in ethnic arts/dance and a master's in dance from UCLA. She is an accomplished dance photojournalist whose work has appeared in such publications as *Dance Magazine, Pointe, Dance Teacher,* and *Dance Spirit.* She is also the author of *Masters of Movement: Portraits of America's Greatest Choreographers.*